W9-BCB-686

Discovering the Present

Three Decades in Art, Culture, and Politics

Harold Rosenberg

Discovering the Present

Three Decades in Art, Culture, and Politics

THE UNIVERSITY OF CHICAGO PRESS
Chicago and London

HAROLD ROSENBERG is professor in the Committee on Social
Thought and in the Art Department at the University of Chicago,
and the art critic for *The New Yorker.* His first book, *Trance above
the Streets,* a collection of poems, appeared in 1942, and his other
works include *The Tradition of the New* (1959), *Arshile Gorky*
(1962), *The Anxious Object* (1964), *Artworks and Packages* (1969),
Act and the Actor (1971), and *The De-Definition of Art* (1972).
[1973]

The University of Chicago Press, Chicago 60637
The University of Chicago Press, Ltd., London
© 1973 by Harold Rosenberg
All rights reserved. Published 1973
Printed in the United States of America
International Standard Book Number: 0–226–72680–0
Library of Congress Catalog Card Number: 72-92852

This book owes its existence to Mr. Michael Denneny, who, while working on his Ph.D. at the University of Chicago, conceived the idea of bringing together my uncollected writings, tracked them down in magazines and anthologies, and arranged them in the sections where they now appear. As an editor of the University of Chicago Press, he then negotiated the publication of the volume and prepared the manuscript for the printer. To do any more to bring a book to light, Mike would have had to write it himself.

Harold Rosenberg
Chicago 1972

Contents

Contents

Introduction
The Cultural Situation Today

The cultural revolution of the past hundred years has petered out. Only conservatives believe that subversion is still being carried on in the arts and that society is being shaken by it. Today's aesthetic vanguardism is being sponsored by the National Endowment for the Arts, by state arts councils, by museums, by industrial and banking associations. Foundation grants are made to underground films and magazines, to little-review contributors, to producers of happenings and electronic music, to the Merce

This piece appeared in the summer 1972 issue of *Partisan Review* as part of a symposium, "Art, Culture, and Conservatism."

Introduction

Cunningham dance group. The art-historical media have become thoroughly blended with the mass media and with commercial design and decoration under the slogan of community art programs. Reciprocally, commercial movies, thrillers, even TV advertising spots have become so daringly experimental in the formal sense as to elicit not the comprehension of a message but the immediate total response of a work of art.

Partisan Review recently spoke of "a growing conservatism in discussions of what's happening in the arts." Yes, perhaps in the *discussions,* but not in what's *happening.* For instance, the Sunday *Times* arts page is conservative, but that's why it constantly has its foot in its mouth. Advanced art today is no longer a cause—it contains no moral imperative. There is no virtue in clinging to principles and standards, no vice in selling or in selling out. Decisions on this score depend entirely on how an individual feels about himself—wretches recycled on the couch can usually be depended on to take the path of unconcealed cheapness. Contemporary culture is in the hands of professionals. Some of the best writers, thinkers, artists make the most money; so do some of the worst—but all deliver the goods.

The cultural professionals serve the rich and have the radical ambition to be able to tie up the "community" from top to bottom in a single aesthetic package for delivery on order. Professionalism is a value in and for itself, and is neutral in regard to values of the mind or the spirit. Exhibitions of art and publications of literature are quite pleased to be absorbed into the teaching and entertainment industries. Professional art lovers are less interested in their responses to works of art than in knowing what to tell people about them—to take an early example, Leo Stein lecturing on Matisse the moment he began to acquire works by him.

Most art collectors today are also art dealers who sell as well as buy--what better way to prove that you understand a subject than to make money out of it? Money is also the yardstick applied to the art critic—what's happened to the prices of the artists he sponsored? If only it were possible to sell short on the art market! One could make a fortune betting against the judgment of certain critic-tipsters. Curators whose acquisitions wind up too soon in the museum's basement ought to be fired for incompetence. Museums gamble with other people's money, and their judgments ought to be at least as sound as those of a mutual fund.

With the cultural revolution at an end, contemporary creations fall into place as technical ("formal") variations ("advances")

on the art of the past. Every work of art exists under the shadow of the historian of its genre. Conservative and radical attitudes count for nothing as against the weight of data accumulated in support of interpretations that replace the work itself through the hearsay of the media. Who reads a novel, a poem, or a collection of critical essays except to collect evidence for or against its author?

Cultural Old Bolshevism hangs on; the manners of subversion are mimicked; there are even efforts to appear atrocious, as by praising crime and boring movies. An assistant professor of English, writing in the *Times Book Review* on a work by the Marquis de Sade, finds the Marquis' tortures of servant girls to be tame, and is prepared to fit him into middle-class reading lists. Is the professor radical or conservative? His performance is a form of professionalism, a conformist way of making it. In the absence of cultural revolution, both the friends and the foes of traditional values can at best supply the daily bread of columnists and TV discussion programs.

In art, "conservative" and "radical" ought to be abandoned and attention concentrated on *déja vu*. The purpose of education is to keep a culture from being drowned in senseless repetitions, each of which claims to offer a new insight. In America an almost total absence of genuine education in modernist creations and attitudes of the past hundred years is responsible for wave after wave of *déja vu* novelties. The *déjavunik* exploits his audience's lack of education by appealing to its desire to be advanced and its expectation of being repelled by new work. Today, cultural professionals can count on avant-garde *déja vu* to arouse the enthusiasm of undergraduate movie makers, post-art aesthetes, far-out curators, and collector-dealers for whatever makes the grade as *Time-Newsweek* shock.

Social and aesthetic far-outness is a public relations technique aimed at the presumed indignation of a stable middle class that ceased to exist four decades ago. The indignation of the same nonexistent middle class is exploited by both social and aesthetic conservatism. The only real choice is whether to accept a part in the radical-conservative playacting or to affirm the tradition of critical secession.

There are no objective issues in contemporary culture, and there is no need to take a position. To champion new works because they are new is as orthodox an approach as to attack them for the same reason. There is the question of the creative individual, but on this question advocacy is absurd. What can

one do to help make individuals creative? One may as well be in favor of genius. Who is *against* creation? From the Pentagon to the rug industry, everyone is enthusiastic about the creative. Hippies are for creation as against everything else. Conservatives who are opposed to hippies see themselves as champions of "real" creation. Clem Greenberg is for "high art" and denounces Duchamp as a backward influence.

If creation is an issue, it is one in which only negative behavior is publicly feasible, that is, persistent attack on institutions, ideas, and personalities that are obstacles to creation. But society as a whole constantly produces and reproduces these obstacles. Even what is begun with the best intentions turns out to be detrimental—support of art by banks promotes bank-type art, and so on. So one is obliged to be opposed to society as a whole; one assumes a radical political stance, for cultural reasons. Yet one is aware that no political changes are going to make individuals more creative or less bedeviled by antagonistic forces. The politics of art are politics of frustration, though nonetheless culturally indispensable on that account.

That there is no radical presence in society seems to give the conservative an edge in the argument. He can revile the mistakes and foolishness (Romanticism) of those who still hope for more humane social arrangements and for forms more responsive to actualities, high and low. But though the radical consciousness is stymied, the events of the epoch are radical. The values to which the conservative appeals are inevitably caricatured by the individuals designated to put them into practice. The cultural conservative wins the argument, but, like the political conservative, he repeatedly finds himself betrayed. Hence he is in a constant state of paranoia. The most he can hope for is that nothing will happen—that Nixon will not go to China—and that fewer knives will flash in the dark.

1972

I
Mirages
of Identity
U.S.A.

1 Literary Form and Social Hallucination

Dostoevsky, in *The Diary Of A Writer,* complains about literature that it does not lead to truth. "The apparent impotence of art," he writes, "made me wonder about its usefulness. Indeed, trace a certain fact in actual life—one which at first glance is not even very vivid—and if only you are able and endowed with vision, you will perceive in it a depth such as you will not find in Shakespeare."

Dostoevsky does not, like the Greek philosophers, accuse art of lying. He uses (assuming that the translation is correct) the word "impotence," and this means to strive toward an objective but to

The text of this essay is based on a lecture delivered at Brandeis University as one of the Ludwig Lewisohn Memorial Series in April, 1960. It was first published in *Partisan Review* 27, no. 4 (Fall 1960).

be too weak, or too distracted, to attain it. For Aristotle, in contrast, the trouble with art is not that it lacks the power to present things as they are, but that it has other interests. Speaking of rhetoric, he says: "In fairness we ought to fight our case with no help beyond the bare facts"; but, he explains later, "the arousing of prejudice, pity, anger and similar emotions has nothing to do with the essential facts." It has to do with the arts of language, which were introduced by the poets and which "owing to the defects of our hearers" win out against mere evidence.

If, to the Greek, art subordinates the facts to the emotions, to the modern writer it subordinates both facts and emotions to art's own ends. In some remarks on the poetry of Marianne Moore, T. S. Eliot gives reasons why literature does not, and ought not, go to the limit in "tracing a certain fact." In a good poem, he says, there must be a "precise fitness of form and matter . . . which means also a balance between them." Like Dostoevsky, Eliot refers to Shakespeare, but he points out that in a Shakespearean song, "the form, the pattern movement, has a solemnity of its own, however light and gay the human emotion concerned, and a gaiety of its own, however serious or tragic the emotion." The form, in short, carries its own independent feelings, which play against the feeling aroused by the subject; and the artist, according to Eliot, is most interested in the "fitness" of these contrasting feelings to each other, so that a "balance" may be reached.

If this is the case, the form of a literary work acts directly contrary to Dostoevsky's desire to get to the bottom of a particular state of affairs. Indeed, the very function of form would be to cut across the reaction aroused by the subject and suspend the mind in a riptide of feelings belonging to art itself.

In emphasizing balance Eliot is consistent with the attitude of literature toward truth throughout most of its history. For it is clear that writers have not, traditionally, regarded themselves as crusaders against mystification. Their way has been rather to appropriate illusions inherited in the patterns of story-telling and in the usages of words and to contribute to deepening these illusions. It is not by chance that the meaning of "form" and the meaning of "hallucination" overlap in their connotations of an appearance or "show" without substance. There is a natural alliance between art and deception: and one needs no prompting from modern radicalism to see this alliance as the ideal extension of the relation of the arts to their historic patrons: courts, priesthoods, and, in more recent times, capitalists and bureaucrats.[1] The celebrated

1. Writing about the traditional attitude toward the nude, Paul Valéry

phrase about poetry inducing a "suspension of disbelief" need only be given its socio-political dimension and it becomes a formula for the service rendered by art to holders of social power. If it weren't for art, men's disbelief would not be suspended. Would not curiosity press them then to chase after the hidden truth? Form, beauty, calls off the hunt by justifying, through the multiple feelings it arouses, the not-quite-real as humanly sufficient.

> Thou, silent form! dost tease us out of thought
> As doth eternity.

Wasn't it in I. A. Richards' discussion of Keats's drugged lines about beauty being truth, truth beauty, in which the poet so perfectly draws the curtain of ecstasy over his vision of painful fact, that "suspension of disbelief" first entered the contemporary vocabulary of literary criticism?

Plato's *Republic,* which was organized "transparently," and hence had no disbeliefs to suspend, banished the poet. Actual states tolerate him, not because their rulers are more sympathetic than Plato's sages to the semi-stupors of creation but because no historical community has ever so totally perfected its means of coercion (its "order") that it could dispense with the pacifying influence of dreams reflected in broad daylight from one art to another. In the past, governments took for granted the cultural Chinese walls which the arts built around them; today, the cost of reinforcing these walls against the siege of rival concepts is included in every defense budget.[2]

Considering the function of the arts in transferring into familiar experience the hallucinations bred in the centers of authority, one might decide that the arts are by nature reactionary. Such a conclusion would be neither far-fetched nor particularly novel— I suspect that most liberals feel this, though they shrink from admitting it to themselves. Lionel Trilling's *The Liberal Imagination* was a recondite discussion of the likelihood that the interests of art—or as he put it, with the help of a phrase of Henry James,

observed: "Everyone had a muddled conviction that neither the State, nor the Law, nor Education, nor Religion, nor anything else that was serious, could *function* if the truth were entirely visible." (His italics.) See *Dégas, Manet, Morisot,* trans. D. Paul (New York: Pantheon Books, 1960).

2. Note to ideology-enders: In the war of ideologies, history grows more and more talkative, i.e., rhetorical, which means that image assaults image, until all have lost their sacredness and none inspires a defense to the death. Thus ideological conflict, which promotes rather than suspends disbelief, is the only kind of conflict among great powers in which hope can exist for a nonviolent resolution.

of "the vision of the world 'raised to the richest and noblest expression' "—might be inconsistent with the interests of progress. Instead of condemning art, which would put them in uncomfortable opposition to Culture, liberals prefer to interpret or criticize its *content* and to develop programs for introducing truth and right-thinking into existing forms. Despite these efforts, there persists in liberals an embarrassed self-consciousness in regard to what art actually does, and this may be the reason for the strain and suspicion with which progressive organs such as *The New Republic*, or even *Partisan Review* and *Dissent*, tend to greet formal innovations in painting and writing. A generous enough reason: they want to be in favor of art and to forget that all of it bears the taint that Thomas Mann exposed in music, that it is "politically suspect."

Art is politically suspect—I mean, from the liberal point of view—not only because it evokes and plays upon moods of sensuality and passivity; not only because every creation involves a descent, at least temporary, into superstitions, fixed ideas, perverse fantasies, self-hypnosis, and other outlived areas of the psyche; not only because, no matter what advances are scored by science, technology, and social organization, art must still be fabricated by hand by a single individual in a manner no more efficient than in the temple of Pharaoh or a medicine man's hut. Art is above all suspect because, besides its *inherited* reactionary tendencies, it constantly arms itself anew against the world of fact; since for there to be a work of art, some degree of reality must have been conceded to form. In short, the temptation of art to betrayal of the social conscience is irremediable.

But, you may be thinking, what about revolutionary literature, revolutionary painting? Is there such a thing? Not only does literature not make revolutions, or, regardless of what historians say about Rousseau and the Encyclopaedists, contribute to them beyond the "balanced" phrases and slogans that may be equally useful to the counter-revolution—literature is hardly even hospitable to revolutions after they have been made. *Dr. Zhivago* is but the latest example of how the literary imagination conceives social upheaval, that is, as a landslide of brutal fact by which all the gay-solemn effects of century-old forms have been crushed. It was not, as the "Left" fallacy would have it, Stalin who made the Russian Revolution unpalatable to Russian literature. Trotsky, who never hesitated to lay blame at Stalin's door, had this to say in 1935: "It takes some time for a complete overturn of social foundations, customs and assumptions to produce an artistic crys-

tallization along new axes. How much time? One cannot say off-hand, but a long time. Art is always carried in the baggage train of a new epoch, and great art . . . is an especially heavy load . . . The influence of the October Revolution upon literature is still completely a thing of the future." The longer the Revolution lasted the farther would it put off the day when literature could come into being.

In sum, the literature of revolution appears when the revolution can be seen by looking at it as an event of the not-too-recent past, when the revolution has stabilized itself, when it is likely that a new revolution is needed. Then literature becomes the voice ("crystallization") of the old revolution and of the social relations and fantasies it brought into being. In cutting down the pace of the Revolution, Stalin offended the intellect but made a Soviet literature of sorts possible.

The sigh of Keats and the logic of Eliot represent art's willing acceptance of the merger of substance into form—and the fabled lightheartedness of the artist, his childlike spirit, his "innocence," have to do with this professional yielding to the falsification, play-acting, and charmed distortion inherent in his medium. The abnormal thing is not the pressure upon art to falsify, but that art should have come to resist that pressure. The doubt of Dostoevsky about the usefulness of art belongs to a new era in the history of art. Such a resistance to form—and it is the complex development of this doubt and resistance that one has in mind in speaking of *modern art*—this resistance could not but entail a conflict with art itself. In the past hundred years, art has more and more conducted wars against its own nature under the banners of various truths or of the search for experience. If Eliot, anxiously restating art's need for "precise fitness of form and matter," is typical of modern art, so, too, is Dostoevsky, in his impatience with art's inability to "trace a certain fact of actual life." One contemporary aims at restoring the rule of literature; the aim of another is to defeat literature in behalf of revelation. Often the motives criss-cross in the same work—the documentation in *Moby Dick* goes against its "Elizabethan" soliloquies. In addition, there is the work that makes a theme of the opposition of art and fact and drives new forms from the ambiguity; Pirandello built his theater, as well as his philosophy, upon this contradiction. Theoretically, Eliot stands at one pole, Dostoevsky at the other; in their practice they move toward a common center. Especially in his early poems, Eliot is deep in the art of anti-art, in which the poetically unassimilated fact plays a large part; while Dostoevsky in one

of his grandest novels provides a serio-comic pantomime of art pretending to get rid of itself. Here is the opening of *The Raw Youth*:

It has suddenly occurred to me to write out word for word all that has happened to me during this last year, simply from an inward impulse, because I am so impressed by all that has happened. I shall simply record the incidents, doing my utmost to exclude everything extraneous, especially all literary graces. The professional writer writes for thirty years, and is quite unable to say at the end why he has been writing... I am not a professional writer and don't want to be, and to drag forth into the literary marketplace the utmost secrets of my soul and an artistic description of my feelings I should regard as indecent and contemptible. I foresee, however, with vexation, that it will be impossible to avoid describing feelings altogether and making reflections (even, perhaps, cheap ones), so corrupting is every sort of literary pursuit... [After more of this he goes back to the "facts," pretending to state them as baldly as possible.] I am beginning—or rather, I should like to begin— these notes from the 19th of September of last year, that is from the very first day I met—But to explain so prematurely, who it was I met before anything else is known would be cheap; in fact, I believe my tone is cheap. I vowed I would eschew all literary graces, and here at the first sentence I am being seduced by them. It seems as if writing sensibly can't be done simply by wanting to.

Apparently, the recital of facts is inadequate, if not impossible, and art will get you if you do watch out. Dostoevsky is protesting that art *has* got him, but like all anti-artists he is protesting with his tongue in his cheek; his attack on "literary graces" has become a defense of them, because he really wants most of all to create a work of art, though he has a bad conscience about it. Dada, with its famous program of finishing art off, split on this same issue that some (most) of its members were dealing from under the table by taking their work as constituting a new art movement.

Artists' suspiciousness concerning art has led not to the abandonment of art but to radical experiments with form. It has produced anti-formal art, a contradiction in terms, but a fruitful contradiction. It has also given us "pure" art, that is, an art that asserts the exclusively formal character of art. Recently, *in*formal art has come into being to such an extent that in France *art in-*

8

formel has been tried out as a term to describe the latest painting.

Beneath these ironies there is the pressing circumstance that artists in our time have become increasingly sensible of the other-world of form as a check on, or distortion of, experience. "Con*form*ism," significant word, manifests itself in the first instance in the use of language. The writer must choose in every sentence between the automatism of his craft and his sense of reality.

Perhaps the resistance of art to form is heightened by the presence of the mass arts, in which the powers of the traditional forms are employed for aims which artists no longer recognize as their own.

The mass arts are "formal" through and through—it is only the ambiguous advanced art that has been willing to sacrifice form to reality. There are, of course, critics who maintain that aesthetic forms have taken flight or disintegrated in modern democratic society—they like to think of present-day civilization, and particularly in America, as wallowing in a morass of fact. Yet too much reality is less the issue than the desire of these critics to substitute the fantasies of some other period—Greek, say, or Renaissance—for the prevailing ones. For the mountain of fables and images which the public absorbs daily, and which confronts it with its conception of itself and of the world, has one unfailing characteristic: obedience to traditional concepts of form. A short story in the *Saturday Evening Post,* a Western on TV, has a beginning, a middle, and an end; its characters are social types recognizable from earlier literature to a greater degree than "from life"; the action, however, superficially grounded, is motivated by issues of good-bad, honest-dishonest, hero-coward, that is, by conventions of morality and manliness. A poem in the mass media will be constructed in an established verse form (if not in the free verse of 40 years ago) and develop a theme more or less "universal." In short, this stuff, which is disavowed as art but of which our dream of life is made, draws at all points on art's illusory powers, and without those powers it could not exist.

An essay on Russian Socialist Realism in a recent *Dissent* showed how Soviet literature evolved a spurious classicism hospitable to the stereotypes of Communist ideology, though without succeeding in creating a form suited to that ideology. American novels likewise consist of ingredients that are formally pre-selected and pre-directed, if not pre-digested, and we, too, need an analysis of the specific social images brought into being by prevailing assumptions regarding literary art. American official literature (e.g., acceptable to book clubs, big-newspapers reviewers), though con-

joined to no stated philosophy, has certain fixed concepts regarding what a novel or drama *is*—and its canons regarding scene, background, character development, etc., are sufficient to exclude both new kinds of data and unassimilated attitudes. As Socialist Realist fables promulgate hallucinations regarding the building of Socialism, American romances further delusions concerning the content of individual freedom. The large difference between Soviet and American literature is that we have from time to time a literature that openly goes against the forms that society accepts. Besides this, we have two sets of accepted forms, the openly escapist and the pseudo-serious, while the Russians have only fake seriousness in which they must combine both what they mistake as reality and yield to as dream.

We have spoken above of the traditionalism of escapist literature. As for American pseudo-serious writing, its form is the Life History; one reads life histories of Van Gogh, Jimmy Hoffa, lawyers by love possessed, a car hop, a call girl—aren't the personality story and the "profile" the chief invention of that portion of American journalism that seeks to give itself literary and intellectual airs? The composer of life histories, actual or fictitious, goes against the classicism of the popular media, in which "action" predominates over "character," and this loosening of plot to let in evolution marks it as literature and not mere entertainment.

To give the briefest sketch of the message of this form: the myth of America is that the individual exists; that anyone is entitled to say "I" and tell his tale in public; that one, no matter what his talents or condition, is somebody, not in the future nor as the result of what he has done, nor by family or place definition, but by the mere biological fact of having been born.

The fable of the gift of absolute being includes the opposing fantasy of being deprived, the nightmare of being nobody; in no other literature is there so much suffering from ontological handicaps, the handicap of being an artist or an adolescent or a Jew or a Negro or a wife or a husband or of not having gone to Princeton or of having been changed into a G.I. The biographical perspective of our seriously intended novels (and of our plays, which try as hard as they can to be novels) strengthens this vision of injured being with its primary resources of introspection and retrospection. The form of contemporary American fiction of itself presents the individual as infinitely free subjectively but constricted and wounded by "interpersonal relations" the minute he touches the outer world. This is as typical of tales of hucksters and flannel suiters as of poets and junkies. Here, from a prominent

10

young fiction writer, is an example of narrative conceived as a blend of free self-examination and remembering, on the one hand, and painful interaction, on the other—that the event takes place on the meanest domestic level makes it all the more "true to form" in that the life story is taken to be interesting *per se* without larger connotations.

"Sit down, please," she said. [This sets the interpersonal scene.] "Make myself at home?" [The speaker is being ironical, since he *is* "at home" with his divorced wife.]
She smiled tolerantly. He wondered if she had any imagination of how it disturbed him to visit the place which had been his home, which in some way still was, which was so mysterious, like a room dreamed of and then found and then you're suddenly unsure of whether you really dreamed of it or only now think you did.

The story consists of an agitated pacing back and forth between the husband and his wife and the husband and his "dreamlike" past, the assumption being that the reader will feel interested in these people because he has "met" them.

By comparison with other literary forms, that of the life history seems to demand a minimum of patterning, and its great models in American fiction are eruptive writers like Dreiser or Wolfe. An author in this vein is permitted to dip into the informal and even the unformed, as does Mailer in *Advertisements for Myself*, and it is here that the "serious" mass writer and the literary artist tend to merge. Since meaning is held to be inherent in the life story, a major requirement is that solemnity shall not be violated —when Saul Bellow in the best of his longer works, *Henderson the Rain King*, parodied the life history by piling half a dozen lives into his hero, the reviewers did not know whether to treat the book as an allegory or resent it as literary subversion—they ended by doing both.

Contempt for form is the program of new literary generations in search of spontaneity and the facts of life. In practice, however, formlessness is simply another Look and a temporary one at that (in time, organization begins to show through the most chaotic surface). Today's automatic writing merely reminds one of the *simulated* automatism of Joyce. Nor can social hallucination (thinking and acting like a square) be overcome by suppressing the mind that might be hallucinated. The author who shakes off popular forms may wind up with popular anti-form

11

(as in "experimental" TV). As we saw in *The Raw Youth*, the denial of "literary graces" only tends to make one coy.

To honor fact, art must honor itself. After noting that, given the vision, actual life may reveal greater depths than Shakespeare, Dostoevsky backs away: "But the whole question," he exclaims, "is *whose* vision? Indeed, not only to create and write artistic works but also to discern a fact something of an artist is required." That modern literature has decided to pursue reality is only half the story; the other half is its discovery that the subversion of literary form cannot be accomplished except by literary means, that is, *through an effort essentially formal.*

Yet it is precisely art's testing of its forms that awakens the wrath of realists of all stamps. In Russia, as everyone knows, the prime foe of official art and literature is "formalism," that is, work in the experimental styles, from Futurism through Action Painting. American editorialists often wonder why the Russians raise so much fuss about an art "empty of content." What harm could come to the Soviet State if a few childish minds, "escaping from reality," were allowed to forge incomprehensible metaphors or to exhibit canvasses covered with red and yellow squares or splashes and dribbles of paint? Communism must feel very feeble if it finds itself menaced by an atonal score. Reasoning such as this fails to take into account that, historically, "formal" art, in undermining accepted forms, has been a powerful agent in dissolving also the social stereotypes maintained by them. The Soviet propaganda chiefs have correctly estimated the threat of "vanguard" art to whatever suspends disbelief in the Party image of life.

In the democracies, aesthetic revolts are always the order of the day. Yet "formal" art lives pinned down by the drum-fire of the press. Angry Young Men are welcome, nay institutionally indispensable, so long as they rage within the recognized modes. Indignation, however, that finds expression in stale technical devices may as well save its steam. "More respectable novels are being produced now than in any previous period," states a report on the literary situation in Britain.[3] Quickly, the author finds himself discussing the relation of form to truth. "Twenty years ago writers as different from each other as Joyce and Aldous Huxley, Isherwood and Virginia Woolf were all making experiments with the treatment of time. For them the straightforward chronological narrative of the conventional novel was a falsification of real experience. In our minds we do not move forward so mechanically: we leap from point to point, somersault suddenly

3. Gabriel Gersh, *The New Leader*, 28 March 1960.

backwards, bring together moments widely separated in objective time. Following the theories of Bergson and the great experimental novel of Proust, these novelists tried to treat time in a personal way. What remains today of these extraordinary attempts? The drab technique of the flashback. It is typical of the modern British novel's ossification that all these attempts to find a more truthful treatment of time have been left without a sequence."

America in its businesslike moods disregards the problems of form altogether; when it wants to "get the facts," it turns to eye-witness reporting and to the social sciences; the daily and weekly press and studies like *Middletown* or *The Organization Man* give Americans a strong, even bitter, sense of being in touch with the real thing. Actually, of course, news and surveys contend with fact in accordance with forms of their own.

The effort towards fact is the most intense problem of American literature today. "Nothing, I submit," testifies a writer in answer to a question on the special needs of writing today, "nothing is more difficult than deciphering what the citizens of this time and place actually feel and think. They do not know themselves; when they talk, they talk to the psychiatrist; on the theory, presumably, that the truth about them is ultimately unspeakable... The writer trapped among a speechless people is in danger of becoming speechless himself. For then he has no mirror, no corroborations of his essential reality; and this means that he has no grasp of the reality of the people around him."

It is intresting that the author then draws the currently popular conclusion regarding artistic spontaneity. "What the times demand," he goes on, "and in an unprecedented fashion, is that one *be*—not seem—outrageous, independent, anarchical. That one be thoroughly disciplined—as a means of being spotaneous. That one resist at whatever cost the fearful pressures placed on one to lie about one's own experience. For in the same way that the writer scarcely ever had a more uneasy time, he has never been needed more."

How will being outrageous, anarchical, disciplined, and spontaneous help the writer to grasp the reality of the people around him? Particularly of people who are the opposite of disciplined and spontaneous? To get to their truth, one should, it would seem, take hold of the forms that beset their consciousness, rather than cleanse oneself through immediacy.

If, however, there are misunderstandings in this statement (by James Baldwin), criticism shares the responsibility. Its way has been either to lay siege to the writer in the name of technical skill

or to expound "content" as if form were a mere market basket. But to miss the point about the meaning of form is, inevitably, to miss it about fact. A critic who snubs a work for its formal audacity, who sees the preoccupation with form as the antithesis of the large "human" statement and as indicative of a taste for distortion, will, most likely, shrink from the radical events and personages of the age. Such a critic dreams of an identity of beauty and truth; in practice he admires works and ideas in which the edges of both have been softened.

Having once set itself against social hallucination, literature will never recover its easy conscience of the epochs of "higher truth." Literature will go on lying—history, however, has deprived it of the capacity to adore its lies. Literary truth, a contradiction in terms, has become a moral issue for every writer, but the will to sincerity, which gives him such an "uneasy time," cannot satisfy itself except by aesthetic means.

1960

2 The Herd of Independent Minds

The basis of mass culture in all its forms is an experience recognized as common to many people. It is because millions are known to react in the same way to scenes of love or battle, because certain colors or certain combinations of sounds will call up certain moods, because assent or antagonism will inevitably be evoked by certain moral or political opinions, that popular novels, movies, radio programs, magazines, advertisements, ideologies can be contrived. The more exactly he grasps, whether by instinct or through study, the existing element of sameness in people, the more successful is the mass-culture maker. Indeed, so deeply is he committed to the concept that men are alike that he may even fancy that there exists a kind of human dead center in which

Originally published in *Commentary*, September 1948.

everyone is indentical with everyone else, and that if he can hit that psychic bull's eye he can make all of mankind twitch at once. In the democracy of mass culture, the proposition "All men are alike" replaces the proposition "All men are equal," thus making it possible for rich or politically powerful mass-culture leaders to enjoy their advantages while still regarding themselves as "men of the people."

On the other hand, the producer of mass culture has no use for experience, his own or another's, which cannot be immediately shared. What is endured by one human being alone seems to him unreal, or even an effect of madness. The "alienation" of the artist, his characteristic neurosis, which we hear so much about today, is an essential axiom of mass-culture thinking: every departure from the common experience appears to be an abnormality requiring some form of explanation—medical, sociological, etc. Actually, the concept that the artist is "alienated from reality" has little to support it either in the psychology of artists or in the history of art. As Thomas Mann said, it depends on *who* gets sick; the sickness of a Nietzsche may bring him much closer to the truth of the situation, and in that sense be much more "normal," than the health of a thousand editorial writers.

The theory of the "alienated individual" is, in American critical literature, largely derived from Marx. Marx, however, sees alienation as the condition not of the artist but of the common man of industrial society; for him it is the factory worker, the businessman, the professional, who is "alienated in his work" through being hurled into the fetish-world of the market. The artist is the only figure in this society who is able *not to be alienated,* because he works directly with the materials of his own experience and transforms them. Marx therefore conceives the artist as the model of the man of the future. But when critics influenced by Marxist terminology talk of alienation, they mean something directly contrary to Marx's philosophical and revolutionary conception. They mean not the tragic separation of the human individual from himself, but the failure of certain sensitive spirits (themselves) to participate emotionally and intellectually in the fictions and conventions of mass culture. And this removal from popular hallucination and inertia they conceive as a form of pathos.

Nothing could be more vulgar, in the literal meaning of the term, than whining about separation from the mass. That being oneself and not others should be deplored as a condition of misery is the most unambiguous sign of the triumph in the in-

dividual of the ideology of mass culture over spiritual independence. It is a renunciation of everything that has been gained during the past centuries through the liberation of mankind from the authoritarian community.

The opposition of mass-culture-making to anything individual goes far beyond mere rejection or even social condemnation. It claims to assert a truth regarding the very nature of human reality: that the real situation of the individual is that in which he is aware of himself in mass terms. The most explicit and aggressive formulation of this metaphysical bias is to be found in the Soviet Union, where the mass-culture principle has been carried to its logical conclusion. There, individual experience is denounced officially as an aberration from real life.

Discussing "plays dealing with the situation arising from the return home of Russian soldiers," Drew Middleton reported [1] that "the fidelity or infidelity of the soldier's wife, his own amorous affairs at the front, were not considered essential problems of *real life* by the dramatic critics of the Kremlin" (my italics). Middleton then cited the list of situations with which Soviet art is bidden to concern itself: the victory in World War II, socialist reconstruction, and so forth. The list comprises only situations common to Soviet citizens, and the artist is directed to create an emotional and pictorial equivalent of this "real" experience. Needless to add, the recent attack on "formalism" in music means that too much individuality must not be allowed to sneak into even the *manner* in which the artist deals with the mass experience.

It may be argued that what is wrong with Soviet art is not that it restricts itself to the common experience but that its version of that experience is false; were it faithfully to reflect the true experience of the Soviet masses, it might be valid art. But how can one speak of a common Soviet experience without taking into account that it itself is formed by Soviet mass culture? Mass-cultural statements are constantly *in the process of making themselves true* by causing people to experience their common lives in those terms. To illustrate: several years ago the WPA Writers Program interviewed old Negroes who had been slaves in the South before Emancipation. A large majority had an image of their own slavery identical with that of the romantic apologists of plantation life. One was left to assume either that the romantic picture is a true description of what slavery was like, or that it became true in regard to the ex-slaves by absorbing their actual experience into itself.

1. *New York Times,* 11 February 1948.

Thus we may take it for granted that the collective experience of the Russians resembles at any given moment the version of it presented by Soviet novels and movies to roughly the same degree that the common experience of Americans corresponds to the Hollywood, TV, or Sunday Supplement presentation of it. Each American knows that these slick and *understandable* portraits are not faithful to *him*. But he does not know that they do not truly picture other Americans. In sum, mass-culture-making operates according to certain laws that cause it to be potentially "true" of the mass but inevitably false to each individual. It is not just Soviet mass culture that is false. What is "experientially" (moral and political values are something else) wrong with Soviet mass culture is simply that it is mass culture—and what is wrong with the Soviet Union is that its mass culture is ordained by a political force that checks the creation of any other kind of culture. But we, too, have less of "the other kind" than we imagine, as I shall show later.

Let me make it clear that the difference between mass culture and authentic art is *not* that the first deals with the community or mass while the second depicts only the single individual. There is a mass culture of "individuals" too, obviously—as in the myriad applications of the Boy Meets Girl formula. On the other hand, there is an authentic art, even in modern times, of masses and of crowds—e.g., the battle panoramas of Tolstoy, Zola, or Malraux, or the street movements of Romains.

What counts is not the number of people involved in the situation but the nature of the experience that goes into the work. The significant distinction is between the formulated *common experiences* which are the substance of mass culture and the *common situations* in which human beings find themselves. The common situation is precisely what the common experience with its mass-culture texture conceals, *and is often intended to conceal.*

The genuine work of art, going past the formulated common experience, may succeed in communicating the common situation— all too clearly from the point of view of the promoters of social myth. I doubt that those in authority would be so systematically opposed to authentic art if, as they claim, it revealed only the private personality of the artist and had no further reference. On the contrary, I am inclined to believe that when modern art is condemned as "lacking broad meaning" or as "unrelated to real life," these accusations often disguise the fear that the exact opposite is true—that this deviation from popular forms has too

much meaning and bears too acute a relation to life to be re-
conciled with the common beliefs.

To penetrate through the common experience to the actual
situation from which all suffer requires a creative act—that is to
say, an act that directly grasps the life of people during, say, a
war, that grasps the war from the inside, so to speak, as a situation
with a human being in it. But the moment an artist, ignoring the
war as an external fact known to all, approaches it as a possibility
that must be endured in the imagination by anyone who would
genuinely experience it, he puts the existing mass conception of
it into question. Consequently, the result of such a creative act
is to arouse not only hostility on the part of officials who have a
stake in the perpetuation of some agreed-upon version of the
war, but also a general distrust and uneasiness. For the work of
art takes away from its audience its sense of knowing where it
stands in relation to what has happened to it and suggests to the
audience that its situation might be quite different than it has
suspected, that the situation is jammed with elements not yet
perceived and lies open to the unknown, even though the event
has already taken place.

Exactly insofar as he touches the common situation of man in
the twentieth century, Kafka goes against the common experience;
he undermines the self-confidence of official high culture, which
rests on a system of assumptions which are as "false to reality"
as the formulas of behavior in a best seller; and for this reassur-
ing common experience he substitutes only the tension of an
individual struggling for self-knowledge, a cloudy and painful
seeing and not-seeing. Along this rocky road to the actual it is
only possible to go Indian file, one at a time, so that "art" means
"breaking up the crowd"—not "reflecting" its experience.

If the essential principle of mass-culture-making is that only
experience recognized to be common is real, the operation of
this principle is a means by which to distinguish items of mass
culture from genuine works of art. In the Soviet Union there is
no confusion on this score. Non-mass art is outlawed, and any
expression of non-mass experience is dangerous. Here in the
United States, the principle of the common experience operates
more or less in disguise to produce different levels of mass culture,
including a specifically anti-mass-culture mass culture. From
"significant" novels, through "highbrow" radio programs, to
"little" magazine articles and stories, a variety of mass-culture
forms pits the mass culture of small groups against the mass
culture of the masses. The result is not the creation of an artistic

19

culture but of a pyramid of "masses" of different sizes, each with expressions of its own common experience.

Now the interesting thing about this pyramid is that the farther each level gets above the mass base of the multi-millions *the closer it is presumed to get to genuine art*. Thus even radio and Hollywood have their Norman Corwin and Orson Welles, who by the scale of the mass-culture structure are true artists because they appeal to "small" audiences. And magazines designed for college professors and writers are assumed to be more culturally pertinent than those whose audiences are housewives or prurient *bon vivants*.

Yet a single conviction falls like a plumbline through all the levels of the pyramid, from its apex to its base: the conviction that the artist ought to communicate the common experience of his audience level, and that if he fails to do this it is because he is an egoist and irresponsible." On the basis of this conviction, each level of mass culture holds the level above it to be filled with "nuts," that is, with artists and an audience "cut off from the people," snobs who insist on "expressing themselves" and shirk the true labors of art and enlightenment. Thus an editor of *Look* once disclosed to me his mingled awe and contempt for the esoteric highbrows who write for the tiny audience of the *Atlantic Monthly,* and the same feeling prevails in the advertising agencies toward Corwin as a writer of "sustainers."

The irresponsible-artist, or artist-nut, formula, based on audience scale, works both ways: on the one hand, anybody who has a "small" audience (from a million in radio to five in poetry) is automatically credited with being a genuine artist; on the other, any artist whose experience seals him off from the mass, big or small, is regarded as a megalomaniac. A literary agent said the other day of a writer appearing in little magazines: "Oh, he writes for posterity. An even worse egotist than the rest."

It is amusing, however, to trace this same artist-egotist formula into an anti-mass-culture organ like *Partisan Review.* In issues closely following one another, *Partisan Review*ers meted out the following judgments: that Dostoevsky and Kafka were neurotics; that there was little in Thomas Mann's *Essays of Three Decades* that had meaning beyond the author's literary exhibitionism— "In the end," said the review (entitled "The Sufferings and Greatness of Self-Love"), "[Mann] continues to love only himself"; that Paul Valéry failed "to convey any substantial doctrine beyond the existence of the particular man and writer" and therefore fell down both as artist and thinker; that "in the *Journal* Gide's

self-analysis too often begins and ends with Gide," so that André Gide too had been destroyed by self-interestedness.

Each of these artists, according to *Partisan Review's* intellectual captains of thousands, is an egotist lost in himself, "alienated" from others, incapable of a valid formulation of the common experience of the modern intellectual and of a "substantial doctrine" for him, and to that extent is a failure as an artist. In the phrase once popular in radical circles, it is "no accident" that these estimates of Dostoevsky, Kafka, Mann, Gide, and Valéry are shared with *Partisan Review* by Soviet criticism. Mass culture, whether of the flat plain of the One Big Mass or of the pyramid of the Many Small Masses, must deny the validity of the single human being's effort to arrive at a consciousness of himself and of his situation, and must be blind to his practice of a distinctive method of giving form to his experience. The insight of the "particular man" must be crushed by the "substantial doctrine," even when, unhappily, one happens to be, as are the *Partisan Reviewers*, without such a doctrine.

Thus the reduced audience scope of a mass-culture undertaking, be it a radio program or a publisher's book list, does not alter its mass-culture character; just as the popularity of a Jimmy Durante or Charlie Chaplin does not prevent him from being a genuine artist, regardless of the attitude of the little mass. True, *the* masses do not read Kafka or Henry James. But a literary magazine, no matter how "little," does not escape being a mass-culture organ simply by interesting itself in these writers, when in discussing them it reduces their work to formulas of common experience. This reduction is the very method by which Hollywood or the Church or the Communist Party appropriates the artist and his creation to its own uses—e.g., the capture of Dostoevsky by Hollywood, Rimbaud by the Church, Van Gogh by the CP—under the pretext of "bringing culture to the people." The peak of the mass-culture pyramid and its base are made of the same material.

Intellectuals who set themselves against mass culture become contributors to it by shifting small-mass perspectives to previously neglected fields, as in the "novelization" of the Okies by Steinbeck or of the Chicago Irish by Farrell. This activity might be understood as part of the general expansion of mass culture, its imperialist dynamic, so to speak, by which humanity is increasingly converted into "the common man" through the discovery and penetration of new areas of experience in order to derive from them the raw materials of new cultural commodities.

Mirages of Identity, U.S.A.

The area which intellectuals have most recently staked out for themselves as belonging to culture *par excellence* is the common *historical* experience. While down below one still hears about love, crime, and ambition, the top of the pyramid is reserved exclusively for the history-conscious small mass. There, the talk is of "*the* experience of the twenties" or of "the thirties," "*the* experience of the younger generation" or of "the depression generation," "*the* epoch of the concentration camp," and so on. To be accepted by the intellectual mass, experience must come wrapped in a time package.

It is to the credit of a writer like Jean-Paul Sartre that when he makes contemporary historical experience his point of departure for literature, he does so with full consciousness of what this means. Sartre knows that beginning with the common experience implies mass culture. Hence Sartre is in favor of reaching a big audience, of writing for the movies and for radio in order to inform and convert the popular mind. He rejects the individual as an object of literary interest and attacks Valéry and Gide on principled grounds. He insists on the "engagement" or participation of the artist in the social problems of his time and place and in political activity. In this respect his view corresponds to that of the Communists and the Gaullists against whom he is struggling.

American intellectuals are, however, reluctant to face the mass-culture consequences of their historical self-definitions. They retain a nostalgia for the personal and unique, for esoteric art, for small-group attitudes, even while they deplore the inadequacy of these standpoints. As individuals they see themselves in terms of what they have in common with others; in the mass they sense themselves despondently as individuals. Thus they cannot act creatively either for the individual or for the mass.

This spirit of mass-individual evasion is expressed poetically in the verse of Auden and Spender, which has had the widest and to my mind the most stupefying dead-end influence upon the so-called younger generation. Here is an excellent example of the voice of this spirit, picked at random out of a review of Spender's poems in the *New York Times*:

> The shame of what I never was
> That when I lived my life among these dead
> I did not live enough—that when I loved
> Among these dead I did not love enough—
> That when I looked the murderers in their eyes
> I did not die enough—
> I lacked

That which makes cities not to fall
The drop of agonizing sweat which changes
Into impenetrable crystal—
And every stone of the stone city
To moments held through time.

According to the *Times,* Spender here "rises to magnificence and *responsibility*" (my italics). To me this poem is pure cant. It brings in "these dead" to bestow significance upon the poet's feelings, which had nothing to do with them and which are *not described*—thus avoiding the individual experience through giving the impression of solidarity with mass experience; and then it claims for this nonexistent individual a fantastic power over the destiny of others, by his passion to "make cities not to fall." Such a combination of avoidance of responsibility for individual experience and avoidance of responsibility for social thinking is now known as "responsible" poetry. And, of course, every truly independent mind must believe in "responsible literature," as well as in "alienation," the "failure" of radicalism, the obsolescence of the individual, and so forth.

Writing of "The Legacy of the 30's," [2] Robert Warshow expresses an antagonism to mass culture *per se*. Unlike the French Existentialists, Warshow feels not only hemmed in but internally invaded by the intellectual commodities of contemporary society. Mass culture for him is the alien within the gate, the slot machine on the altar, the Trojan horse that brings the ready-made into the halls of the original. "Its mere existence—" he says, "this climate in which one had to live—was a standing threat to one's personality, was in a sense a deep personal humiliation." Warshow correctly notes the presence of a "mass culture of the educated classes" and recognizes in its surface seriousness a further obstacle to individual experience.

Yet despite his horror of mass culture, Warshow's entire approach is an "us" approach, that is to say, a mass-culture approach—though his "us" is not the masses but the small mass of the intellectuals. "For most American intellectuals," he begins his article, "the Communist movement of the 1930s was a crucial experience." He is referring, obviously, to the fact that American writers, artists, and students, had various relations with Marxist parties and Marxist ideas. I don't know, and neither does Warshow, what this contact has meant to each of these people in terms of the total structure of his consciousness—that is, we cannot say whether for any individual his "Communist experience"

2. *Commentary,* December 1947.

was crucial or not. Perhaps it was crucial for certain men who went to Spain and got killed. But even then, in the instances I happen to be familiar with, other experiences played at least as important a part in such decisions as "the experience of Communism."

Warshow is able to state flatly that this was "crucial" only because he is discussing "the" Communist experience as *a mass event*. Yet from this point of view, it seems that Marxism in the United States became a renunciation or negation of experience, a plunging of the individual into mass inertia, precisely because he yielded himself up to the general intellectual "climate." There wasn't any significant group experience of Communism in America except in the negative sense, and this is one of the main reasons why people ran away from it. Then why talk about it as "crucial"? Or, better still, why not talk about some other kind of experience? Because since it happened to a historical "us," it seems to Warshow most significant: "It is for *us* what the First World War and the experience of expatriation were for an earlier generation. If *our* intellectual life is stunted and full of frustration,[3] this is in large part because *we* have refused to assimilate that experience . . . never trying to understand what it means as part of *our* lives." (My italics.)

Warshow then goes on to measure the success of Edmund Wilson's and Lionel Trilling's "assimilation" and expression of "that experience" as efforts in an essential task that lies before the modern intelligence.

Now I too was alive in the thirties and also underwent the intellectual impact of the Marxist movement, as well as popular-front novels and movies, the New Deal, peculiarities of the erotic in the urban human being, and a good portion of other contemporaneous phenomena. Yet I find that there is very little that is of interest to me in my thoughts and my feelings that is dealt with by either Edmund Wilson or Lionel Trilling.

Yes, what they describe sounds familiar; one had heard about it, even run into it personally. But somehow the experience of these men does not communicate with mine nor seem very pertinent to it—to think it important, I should have to impose upon my reactions some external literary or historical or social "value." Maybe this is because Wilson and Trilling are dealing with "that experience," that is, with something common in the

3. In my opinion, if someone's intellectual life is "stunted and full of frustration," it may be because he belongs to a crowd, but it is not because of something that happened to a crowd.

thirties, but not with any significant experience or hypothesis of their own. Perhaps the faintness of my response to this historical souvenir only proves that my experience lacks universality or is even out of date. All right, I confess—the tension of my experience never belongs to the right time or place. Besides my experience of "the thirties," it contains all sorts of anachronisms and cultural fragments: the Old Testament and the Gospels, Plato, eighteenth-century music, the notion of freedom as taught in the New York City school system, the fantastic emotional residues of the Jewish family. If one extended and deepened this compendium, one might get to a kind of tiny *Finnegans Wake*, which, incidentally, in contrast to *Memoirs of Hecate County*, I do find very communicative.

At any rate, the rhythm of my experience is broken and complicated by all sorts of time-lags, symbolic substitutions, decayed absolutes, experimental hypotheses. Because I am so peculiarly (and also not so peculiarly) mixed up, I confess, too, that it doesn't matter to me much whether I belong to Wilson's and Trilling's generation or to Warshow's. There was a journalism of Americans in the First World War and an even wider journalism perhaps of American expatriation. Yet when the "assimilations" of all these literary epochs and generations that take me back to the cradle are added up, for some reason they seem to have communicated less to me about my situation, to have less deeply penetrated my experience, and to have contributed less to my verbal and intellectual resources than, say, Poe, Rimbaud, Dostoevsky, Gide, Miró, Klee, and a lot of other people who didn't participate in this American experience of "ours," or William Carlos Williams or Wallace Stevens, whose poetry contains scarcely a word about their "generation," or E. E. Cummings, who said some very private things about his.

What I am getting at is that when someone says, as Warshow does, of any one common experience that "that experience is the most important experience of our time," such a statement can have only a mass-culture meaning. And once you've taken this position, to call for a writer to communicate that experience "as it really is, as it really feels," is simply to ask for a "better" mass culture, in the way that Hollywood or some Soviet writers' union periodically calls for a more real and more passionate and even a more original and inspired rendering of The Most Epic Event Of Our Times. If Warshow, having properly rejected Trilling's novel for dealing with modern life as if it were entirely a question of which opinions to hold, is really interested in "making

it possible for the writer himself to have a meaningful experience in the first place," he should stop trying to decide in advance what is meaningful to everybody and concentrate instead on what is meaningful to him. For individual experience it is necessary to begin with the individual. Maybe there is no individual in the old sense of the term. This cannot be gone into here. But whatever there is, one will not arrive at it by reflecting oneself in a "we."

No one will deny that common situations exist. It may be, too, that the most profound, or even the most ephemeral, individual experiences are, or may prove to be after they have been authentically set down, in essential respects duplicated in many men and sometimes perhaps in all men. In fact, "most profound" may *ultimately* turn out to be the same as "most common." The question is not of uniqueness as a goal, of the artist as a lone wolf programmatically dissociating himself from society and the pathos of human life; it is a question of where to begin and toward what kind of communication to move.

Acceptance of the mass-culture dogma that the artist must become the medium of a common experience will result in the same contrived and unseeing art, whether the assignment is made by a movie producer, a party cultural official, or by the artist himself as a theoretician of social relevance. That genuine art can be created to order *in modern times* has never been demonstrated. Apologists for popular art are fond of referring to Egypt, Greece, medieval or Renaissance Europe, where the artist-as-craftsman was the creator of a high art, officially commissioned, and more or less immediately accessible to its intended audience. But these apologists neglect the fundamental differences between the sources and content of inspiration in the authentic communities of the past, on the one hand, and within the relations that exist in modern industrial society, on the other. Under present conditions, a true work of art may accidentally attract a large audience, but more and more elements in it tend to fall outside the range of the audience's responses. Even works once popular become increasingly esoteric by comparison with, and under the pressure of, the mass consumption of manufactured novels, movies, radio programs, and so on.

The writer seems confronted by the following alternative. He may accept the common experience as a point of beginning, embrace mass culture, start "enlightening" some public about itself, and forget about art and about experience "as it really is, as it really feels." The writer who makes this choice will obtain from

26

outside his work—from politics, from sociology, from religion, from "public opinion," from the policy representative of some corporation or group—a set of "values" which he will endeavor, through such feelings, fancies, and "ideas" as he can muster to his subject, to communicate to a prefabricated audience of experience-comrades. Here communication means a formula, whether in the images of a work of art or in the rhetoric of opinions, by which the member of the audience learns from the author what he already knows, or could have found out—that together with others he is an exradical, or a Jew, or feels frustrated, or lives in a postwar world, or prefers freedom to tyranny. Repetition of these mass-cultural themes with all the resources of fancy may prove of practical value to humanity—as when a group of "bad" fictions, like antiminority caricatures, are replaced with "good" fictions, images of men as equal—and to this service the writer may choose to dedicate himself.

Or the writer may choose to break through mass culture. In that case he will reject the time packages and sociology packages in which experience is delivered fresh every morning, and begin with the tension of what most agitates and conceals itself from him. He will enter into a kind of Socratic ignorance. For he will accept the fact that he cannot know, except through the lengthy unfolding of his work itself, what will prove to be central to his experiencing; it is his way of revealing his existence to his consciousness and of bringing his consciousness into play upon his existence. And this art communicates itself as an experience to others, not because one man's experience is the same as other men's, but because each of those others, like the author, is unique to himself and can therefore recognize in his own experience the matchless experience of another human being and even perhaps the presence of some common situation and the operation of some hidden human principle. The authentic artist arrives at the common situation *at the end* of his effort—e.g., the emergence of decadent French society in *Remembrance of Things Past*—or rather he does not arrive at it, for no one can arrive at the whole, but by way of his own humanity he moves spontaneously towards the humanity of others.

Only the individual can communicate experience, and only another individual can receive such a communication. The individual is *in* society—that goes without saying. He is also isolated and, like Ivan Ilyich, dies alone. I find it no more noble or picturesque to stress the isolation at the expense of participation than to stress the sentiment for the social at the expense of isola-

tion. Poses are a matter of taste, sometimes of achieving spiritual efficiency. I should like only to make sure that nobody is bullied by the abstract concept of social responsibility into becoming useless to himself and to his fellow men, or even becoming a menace. Obviously, the isolation of an artist's work, or his personal loneliness, if that happens to be his fate, does not deprive his accomplishment of social meaning. Nor in rejecting the "responsibility" of the representative of mass-thought for the sake of his concrete experience does he make himself an "irresponsible." (It is humiliating to have to repeat these truisms and to mention such examples of artistic responsibility by way of concrete experiencing as Gide's *Trip to the Congo* or Cummings' *The Enormous Room*—but I here testify to my own social responsibility by acknowledging the power of vulgar antitheses and doing my bit about them.)

The mass-culture maker, who takes his start from the experience of others, is essentially a reflector of myths, and lacks concrete experiences to communicate. To him man is an object seen from the outside. Indeed it could be demonstrated that the modern mass-culture élite, even when it trots around the globe in search of historical hotspots where every six months the destiny of man is decided, actually has less experience than the rest of humanity, less even than the consumers of its products. To the professional of mass culture, knowledge is the knowledge of what is going on in other people; he trades his own experience for an experience of experience. Everyone has met those culture-conscious "responsibles" who think a book or movie or magazine wonderful not because it illuminates or pleases them but because it tells "the people" what they "ought to know."

The makers of mass culture are its first and most complete victims. The anonymous human being to whom they bring their messages has at least the metaphysical advantage of being forced to deal daily with material things and real situations—tools, working conditions, personal passions. The fact that his experience has a body means that mass culture is, as far as he is concerned, like a distorting mirror in an amusement park; whereas the formulators of shared "crucial experiences," whose world is made up of mental constructions, live inside the mirror.

1948

3 Roadside Arcadia

The small town is the stage set of the American Dream. Even for the city-born the good life waits in a community with a village look. There the success drama (enacted elsewhere) reaches its fairy tale epilogue, in which the hero wins place and recognition in the bosom of The Folks.

Fantasy of a nation of immigrants and wanderers, the dream small town has not weakened its hold in the steady movement of population from the countryside to the cities and suburbs during the past twenty years. On the contrary, the more people quit the rural setting, and the more the small town itself sheds its original character, the brighter glows the imaginary treasure left behind on the porch. I do not hesitate to link America's

Originally published in *Partisan Review* 25, no. 4 (Fall 1958).

despondency about conformism, organization men, consumption-dazed housewives nudged by hidden persuaders, and rebellious children oversensitive to the cues of taste with the increasing depletion of the small town. With the country virtues fading, what but machines will human beings turn into? The Orgamerican Fantasy is the recoil into nightmare of The American Dream, with its idyll of neighborliness, naturalness, individuality, and face-to-face dealing. An Arcadia of solid folks and an apocalypse of robotism are the poles of the contemporary American social imagination.

America's small-town craving is both prophetic and pathological. Through it the United States undergoes in advance of other countries the longings, regrets, and despairs of an epoch of transformation in which peoples everywhere have begun to break apart and enter into motion. Cleansed of the evils of historical communities, the village of The American Dream preserves the warm heart and extended hand of pioneer caravans and of settlements on the edge of the world. As a social ideal it is a model of generous moods and relations which the future must copy: in it classes and rank have vanished, manners are plain and direct, sociability and hospitality are taken for granted, contribution to the common good is the only measure. The order of the small town sustains the freedom of the uprooted individual while restoring his heritage of basic human sentiments.

At the same time, however, the small-town idea locks the American mind into opposition to its own vanguard experience as the originator of new social powers and possibilities. Under its influence the builders of cosmopolis live in suspicion of the city, and a nation of technicians and organizers kowtows to the inanities of "grassroots."

Repelling the radical implications of the total American reality, the nostalgia for the village weakens the nation by forcing every program to come to terms with the rural pretense. Second thought of people who *have* migrated (their first was for what works), the illusory village transforms The American Dream into a reverie of seclusion and rest that cannot fail to affect as reactionary peoples in other continents who are just starting out. Thus, for all its actual innovations, America through its small-town charade acts against itself in the revolutionary drama of the century.

To enrich The American Dream with a historical self-consciousness and the conception of a new human scale, the fiction of the small town must be dissolved. Instead, this fiction is systematically reinforced as the foundation of The American Lie. A

ceaseless propaganda exploits the floating sentiment for the recaptured community in order to consecrate the American small town as the habitation of a culturally unified and contented Folk in exclusive possession of the secrets of "real living." Defending these verities against big-city artifice and subversive ideas, The American Lie replaces the ambiguities of The American Dream with a rigid ideology and solidifies its delusions into a code of mass-belief.

The power of this process is comically demonstrated in Spectorsky's account in *The Exurbanites* of how the Madison Avenue professionals who fabricate the glamor of the whistle-stop Utopias are themselves seduced by it into a fake idyll of farm animals and split-rail fences. A still greater triumph of The Lie is its ability to delude actual small-towners into mistaking their village for Cockaigne and mimicking themselves as Maw and Paw. Day-dreams of being King For A Day at the Waldorf do not disturb their conviction that compared with the satisfactions of Court House Square, the delights of the city are tinsel.

In any case, there is scarcely an American so sophisticated or so simple that there is not laid out in his conscience an illusory village where he stands trial for the superficiality, egotism, and eccentricity of his (modern) existence. To demolish this bogus agrarian authority is one of the first tasks of intellectual liberation; but one much more difficult to accomplish today than in the time of Mencken and *Main Street,* when America's small towns still had real substance.

There is a sense of the power of the present-day rural myth in *Small Town In Mass Society,* by Arthur J. Vidich and Joseph Bensman. *Small Town* is a grimmer tale and a truer one than Whyte's *Organization Man* or Riesman's *The Lonely Crowd.* Each of the last two composed an image which swallowed up its facts; both the orgman and the crowdman are inventions of unhappy authors. *Small Town* does not invent; it takes its subject's image of itself and places alongside it the reality which that image is designed to hide. The themes of Whyte and Riesman were carried along by their rhetoric; Vidich and Bensman deny any thesis and stumble along in the non-language that passes for a normal vocabulary among the pros of social investigation; when they hit their most telling points, their prose seems to turn in on itself and becomes even thicker than usual, as if it were trying to camouflage its content. *Small Town* will never reach the bestseller lists; caricature, however, is one thing, social criticism something else.

Mirages of Identity, U.S.A.

Vidich and Bensman begin with the lie of the small town that prevails in the small town itself, and they end by showing how this lie drives everyone there crazy ("externalization of the self"). Their chief distinction as sociologists is their sense of mirage. "Springdale," the town in upper New York State they have chosen to rake over (I am reminded of Jules Romains' *Les Copains,* in which a band of French intellectuals comically wrecked their version—how different from ours!—of such a town) is a spot on a major highway. Once you notice it, you see "the image of the typical New England town: a well-kept, clean, neat place; a small shopping center; white colonial style, freshly painted houses, interspersed with houses of each of the architectural eras up to the ranch house. One cannot escape the impression of the small town with one main street that has largely escaped the general hustle and turmoil of American life. . . . The beauty of the village rests on a picturesque stream."

The correspondence of Springdale physically to the dream setting of the movies and the ads is perfect. So is that of the Springdale mentality to the accepted "copy" concerning country-fresh air, the comradeship of neighbors, the corruption of the cities, and the probity of "just plain folks." It is only when you have been brought inside the picture that the town breaks down into a nasty little hive of smugness, greed, conniving, gossip, self-enslavement, sloth, pettiness, frustration, and hopelessness.

Classless, indigenous, independent, unified Springdale is dominated by its class of "rational" farmers (those applying the latest production and marketing methods), most of whom are Poles and almost all newcomers, who keep themselves and their families so geared around the clock to what it takes to make a profit under the state's milk-price formula and the changing cost of feed that "social activities and participation, except in churches, play no or only a minor part" in their lives, though the foreigners do try when they get the chance to shine up to the older inhabitants, "the Americans."

Next to these prosperous farmers stand the storekeepers, a broken-backed breed of businessmen who have never recovered from the Depression and the ever-increasing competition of out-of-town supermarkets, and who jump to the whistle of the mass distributors who fix their costs and selling prices; to stay in their losing game these folks work themselves and their wives far into the night in the conviction, unscarred by war, bankruptcy, or boom, that success, like virtue, is the reward of hard labor. As to their sociability, "in their relations with each other, the business-

men are highly suspicious and distrustful," and if you have ever lived in a small town you know how they feel about neighbors who drive off on Saturday to the cut-rate stores down the road.

Such unity as does exist in Springdale is largely the work of the small segment of professionals who, believing in it as an ideal, stick their noses into everything ("plan and execute most of the community's nonpolitical organizational life") and "are the functionaries who run the town." Despite the myth of community, these loyal lawyers and druggists tend to be petty snobs, with an exclusive "book club" for their wives, though without the courage to stand openly against "the public ideology of equality."

The rest of the populace consists of a few skilled industrial workers employed outside the town and having little to do with it; persons (about 25 percent) who have failed to make it as farmers, businessmen, or artisans but who, as best they can, keep up with these classes in respectability and kitchen appliances; a scattering of nuts whose "activities lead to their social isolation"; old inhabitants who "seclude themselves" out of a sense of superiority; "traditional farmers" who work their land the old-fashioned way and who are "socially isolated from the rest of the community."

The only element with any human appeal is "the shack people," rural Bohemians who live on the outskirts of town, don't give a damn about its standards or self-delusions, take jobs when they need cash, and spend the rest of their time hunting, fishing and getting drunk; these genuine countrysiders are "the object of universal derision in Springdale, a declassed group." To the others they personify the social void that lies in wait for those who fail to keep up with their various levels of "stylized consumption."

Half of Springdale live from hand to mouth, the other half are misers: the well-to-do farmer because he plows back every cent into expanding his "plant," the storekeeper because he exists by the pennies he shaves off his fixed costs, the traditional farmer because he learned to be a skinflint in the cradle, the "old aristocrat" because he's hoarding his inheritance. The only subjective unity Springdale achieves, apart from the common lie about itself, is in its policy of "don't spend a cent if you can help it." Never paying for itself, the town sponges off the state for its roads and its school system, its two largest expenses. We, of the city, pay for Springdale—I'd rather give my dollar to the devil—but this is no more than just, considering the gas-bombs of delusion that the city lobs into the place daily in order to confuse its inhabitants and keep them there.

Mirages of Identity, U.S.A.

"A central fact of rural life is its dependence on the institutions and dynamics of urban and mass society." In all important respects Springdale is controlled from the outside and has no power to decide its actions—and the futility of disagreement conspires with the pervasive niggardliness to perpetuate the fiction of unanimity that paralyzes the brains of its citizens. *Small Town* examines in detail the conflicts that underlie this fiction and how the lid is kept on them by the operations of a sham democracy. Three men constitute "the invisible government" of Springdale and settle in advance what each meeting of each town and village board shall resolve. The same hands have picked the candidates and propelled the voters to the polls; placed some in town jobs, fired others out of them; chosen the committees to run the town's social events and collect its charities—all without controversy and with a show of spontaneous public decision.

The single area where conflict might be worthwhile, and where it constantly threatens to break out, is school politics, since the school's quarter-of-a-million-dollar budget makes it the major industry of Springdale and the pork barrel for feeding relatives who can sweep, teach, drive buses, or make the furnace, as well as a prime target for food suppliers, contractors, and sellers of acreage. "No year passes without the occurrence of a crisis . . . and this leads to further demands of unanimity and concealment." Here The American Lie plays its part in holding down issues to the scale of triviality. Farmers who manage their lives by the latest manual of the Department of Agriculture cite the need to "perpetuate the rural tradition" by crushing resistance to useless courses in farm training; and under the same obsession preference is given to the teacher with a farm background. Even the principal, an outside "expert," grovels before the common image and piously presents his offering of intellectual corn (*this precious term reveals the degree to which "rural" and "fake" have become synonymous*): "Our many pleasant memories of a childhood on the farm," drools this blood brother of a Russian collective farm leader, "color our thinking to the point where we have little sympathy with urban living."

Having taken The Lie upon himself, the school principal adds progressivism to the arsenal for subduing conflict. Without disturbing the common illusion, he bores from within the PTA to plant his liberal ideas among its members so that they will seem to have thought of them themselves: then uses the PTA to bore from within the school board in behalf of the same ideas. If PTA gets too heated in favor of the new program he holds it back; if

his ideas don't go over with the board he pretends he was always opposed to them. "Through the operation of such intricate processes, Peabody has succeeded in instituting a number of his ideas: hiring a professional cafeteria manager to replace a local person and introducing several new courses."

For the sake of such puny benefits, the American small town, like any anthill ridden by superstition, has to put up with, and even be thankful for, this hypocritical priest of "progress," whose victories rest on translating "sex" into "health," and who deludes people into thinking they are thinking when they repeat the clichés of watered-down social science.

Peabody fools everybody. But only because they need him to fool them. Between the dream small town and the real mass society he introduces a gelatinous sheath of compromise under which daily life is amended while leaving the myth unscratched. This underhanded way of accommodating collective life to new situations without open declaration or battle is the source of American conformism.

Peabody also fools nobody. The PTA resents him, Vidich and Bensman report, the teachers dislike and distrust him, and a member of "the invisible government" whom he has won over has put the finger on him as "a little too inhuman—has never got into anything in the town. He's good for Springdale until he gets things straightened out. Then we'll have to get rid of him." Condemned by the dream for which he has testified, Peabody is the stuff that "people's court" defendants in totalitarian countries are made of.

Though Vidich and Bensman deny seeking "solutions" for Springdale, I suspect them of regarding Peabody as a hero. If this suspicion is correct—"Life," they conclude in deadpan, "consists in making an adjustment that is as satisfactory as possible within a world which is not often tractable to basic wishes and desires"— if Peabody represents to them the hope of Springdale, Vidich and Bensman might as well have advised Sodom and Gomorrah to institute classes in interpersonal relations. Condemned by its vices of falsehood, boredom, and pointlessness, Springdale deserves to disappear and no doubt will. Or, if this is not to be its fate, other men must appear there than those described in *Small Town*'s groupings, and these can emerge only by tearing apart Springdale's fetters of belief. What the town needs is not more efficient cafeteria management but struggle, the fiercer the better. Without a war banner, the few dissenters noted in *Small Town*— a couple of ministers, a school teacher—turn into Peabodys or

take their place as harmless oddities, intellectual equivalents of the shack people.

As the reward of their unity, the citizens of Springdale are in bad shape. "Adhering to publicly stated values while at the same time facing the necessity of acting in immediate situations places a strain on the psychological make-up of the person." They have gained the terrain of The American Dream but lack the means of laying hold of its promise. Each social layer has its own way of giving up and going to pieces. As for the town as a whole, it "simply adjusts to mechanisms which are seen only dimly and rarely understood. . . . Indeed because of the experience of war, depression, unemployment, and an uncertain dairy market, almost the entire community is sensitized to the underlying forces which create the chasm between objective realities and socially stylized illusions."

The reader of *Small Town* may find it hard to take the socioterminororhetorical rag of "sensitized to the underlying forces which create the chasm." But the Springdale credo which *Small Town* repeats near its end is more than compensation. I hereby proffer it in slightly versified form as an incantation to be chanted every Saturday afternoon at 2 PM in front of the A & P under the leadership of the ladies selling raffle tickets on the twotone Chrysler hardtop for the benefit of the LVIS (Ladies' Village Improvement Society):

> Springdale is a wholesome friendly place
> The best place to bring up children
> Made up of ordinary people, just folks
> Trying to make their community a better place
> To live. Nobody here has to worry
> About having friends, all you have to do
> Is be friendly yourself. No problems are too big
> For Springdale it's the outsiders that cause all the trouble.
> People here have a lot of community spirit
> You can always get people to take part
> But the busiest people are the most reliable.
> Nobody is excluded this is a democratic town.
> Anybody who tries to run things gets pushed down
> But fast. If you join clubs you can learn things.
> Everybody was invited and fun was had by all.

1958

4

The Erect Odalisque: Transcendence plus Liberation

Loving may interfere with a woman's career, but being loved *is* a career. It is a vocation that begins in being discovered—Cinderella, the Sleeping Beauty. The rewards that follow vary with the character of the society in which the discovery takes place and with its institutional means for consecrating for a lifetime the excitement of that first moment.

Being loved is a species of fame. Adoration by a single person is not different in kind from adoration by a public. Being loved and being famous are also interchangeable psychologically. An author whose mistress has left him is fully consoled by the attention he receives if his novel becomes a best seller.

Originally published in *Vogue*, vol. 149 (May 1967), under the title "The American Woman's Dilemma: Love, Self-love, No Love."

Mirages of Identity, U.S.A.

The art of inducing love in an individual is called seduction, that of winning a crowd, public relations. Seduction is in bad repute among people who fear being carried away by pleasant sights, sounds, activities, or arguments. Nevertheless, Plato made it clear that Socrates used seduction as a means for teaching philosophy.

Public relations as an art is not yet sufficiently understood to be regarded as a menace. Moreover, in addressing itself to the many, it seems less dangerous to individuals. These may be among the reasons why public relations is considered by modern women to be more efficient than seduction as a technique for satisfying their desire to be loved.

In all societies woman personifies the powers of seduction and champions their manifestation. In this lies her essential relation to the arts. Aristophanes, who hated Socrates, was obsessed by the power of seduction wielded by women and the danger that they might feminize the arts, that is, make them seductive.

Nonseductive art is, of course, a contradiction in terms. This does not prevent its being advocated, at present, for example, by the theoreticians of so-called minimal painting and sculpture. Throughout the centuries moralists have demanded that art be purged of its sensual charms. Their real target has always been women. In Semitic and medieval Christian cultures both art and women were subjugated by systems of abstractions. Rationalist art represents the reign of the medicine man and the homosexual (the medicine man of aesthetics).

The odalisque is a favorite theme of romantic painters because, like the artists themselves, she attracts through a combination of intimate appeal and public display. The odalisque is never pictured without attendants. Her posture is always one of relaxed and absent-minded waiting for a lover who will soon arrive.

The American woman is an odalisque who has reduced the aspect of privacy and converted absent-minded immobility into busyness. While thus transcending the traditional odalisque, she has retained the attendants of the latter and her absent lover.

Surrounded by hairdressers, manicurists, cosmeticians, and other stylizers of her person, she directs her seductiveness not toward any individual but to the public at large—in more modest circumstances, *a* public consisting of her social circle, whatever that happens to be.

Instead of devoting her efforts, as did her grandmother, to maintaining continuity of feeling in her suitor or husband, she seeks to evoke a pattern of responses from her total environ-

mental field. She realizes her goal when she is applauded not only by the human creatures she passes in the street but by the sidewalks and buildings as well.

Built on public relations, the love life of the contemporary woman is identical with celebrity. To her an embrace is a form of applause; less physical forms may be equally gratifying. Released from dependence upon one man—according to the National Organization for Women (NOW), 46.5 percent of all American females between eighteen and sixty-four, a large proportion of them from the lowest economic strata, now work outside the home —she is aware of the boundless possibilities of self-enactment.

The new wide-angled focus of the female psyche has produced dramatic changes in woman's outlook and demeanor. Critics comment on her vagueness and impersonality, which they misconstrue as affects of conformism. More likely, she is engaged in recapturing on a new plane the absent-mindedness of the odalisque suspended in a mist of expectancy.

In any case, performing in a tête-à-tête or a nursery demands a different kind of concentration than playing to a packed house of strangers. It is from the audience restricted to one man or the family that woman seeks to be liberated.

If applause is not forthcoming, the post-dependent woman has herself for an audience. For years the cosmetics and fashion industries have taken note that women adorn and perfume their bodies in order to excite their feelings about themselves, either for the satisfaction it brings them or as a preliminary to being fascinating to others. Like seduction, self-love is frowned upon in principle. Yet amour propre has always been taken for granted in aristocratic societies as the natural attribute of woman. To condemn vanity in its democratic manifestations is mere snobbery. A factory hand with a soufflé hairdo has as much right to be carried away by the mirror as a duchess in her emeralds. To be both independent and loved leads logically to do-it-yourself.

Unfortunately, self-love is not entirely reliable. Like the applause of the audience, whether consisting of one or of many, the applause of the "I" for itself is susceptible to fluctuations. Glances from the figure in the mirror are not inevitably flattering.

Whether alone or in public, woman today participates in the uneasiness of the celebrity regarding his power to hold his audience. As a result, her attitude toward her liberation from dependence is ambivalent. On the one hand, she is proud to have surpassed the traditional husband-wife relationship in which her identity is contingent upon the emotions of a being whom she

cannot accept as her superior. On the other hand, she is frustrated by the need perpetually to seek approving reflections of herself in the eyes of others. In what, in whom can she achieve a lasting realization of the unique being that she knows herself to be?

Perhaps only in having children, and only while the children are children. No wonder many are impelled to become mothers while refusing to become wives.

The situation of women in regard to themselves is not, however, essentially different from that of men. In our mass society anonymity threatens everyone, and men and women alike achieve identity either through their actions or by manipulating the means through which people are recognized.

The handicap of women is that, in being desired, illusory solutions become too readily available. The handicap increases in direct ratio to the attractiveness of the woman. Beauty can sustain a woman indefinitely in the public-private drama of the expectant odalisque.

Those attempting to solve the "woman's problem" have usually refused to deal with the woman as beloved, in order to concentrate on her status as a citizen. The model of reformers has been the woman who through homeliness or poverty has been compelled to labor in the fields or to dedicate herself to activities of the mind or the soul. Toil and study would, in their view, rescue women from dependence upon the graciousness of men or their lust. Seductiveness, where it is mentioned at all—NOW does not mention it—is treated as something illicit and, by an odd reversal, a devilish fraud perpetrated upon women!

Thus, to reformers women are a "minority group" in need of help in achieving social justice. NOW, for example, seeks to eliminate discrimination in job and educational opportunities in order to win "full equality for women in truly equal partnership with men."

No doubt the first step in such a "partnership" would require women to purge themselves of the Cinderella dream of being discovered and transformed through love—a dream which is as practical an outlook as most others, in view of the frequent instances of its realization. In place of relying on her gift of desirability, she would adopt the male ideal of competitive striving. Man, according to Hegel, is made what he is by combat and work. No wonder women have refused to respond en masse to offers of "full partnership."

NOW points out that, with women's life span lengthened to seventy-five years, to discriminate against them in occupations be-

cause of the time they spend in childbearing and rearing is un-
realistic and unjust. Undoubtedly, this is true. But the position of
women in industry and the professions is not determined exclu-
sively by the quantity of time they are able to give to their work.
It has to do rather with the form of their lives and with the limited
degree to which they identify themselves with roles that are pro-
ductive in a merely external sense. It has to do also with the
woman's sudden self-revelation as odalisque, which modern in-
dustry finds upsetting except under special circumstances.

So long as being loved continues to be the central preoccupa-
tion of woman, she will remain a "part-time" worker, regardless
of what portion of her hours and energy she devotes to her voca-
tion.

Poets, too, are part-time workers in this sense. Also heroes.
Like women, their vocation is waiting—for the right word, the
right moment. Economically, the odalisque is obsolete, like practi-
tioners of other luxury trades. Yet it is doubtful that her existence
can be comprehended in terms of wages and hours.

Women, poets, and heroes are involved with passivity and with
the unknown. They do not exactly grasp what they are doing and
are confused about who they are. Is it they who do what they do?
Or is it done through them by a more positive and purposeful
force? Perhaps their audience will tell them the answer.

Except to bring practical benefits to women as workers or pro-
fessionals, the idea of equal rights for women is an empty equa-
tion. It rests upon a fallacy regarding *man*: that he is the one
who possesses powers that women lack.

Today, whatever prevents women from perfecting their inner
condition prevents also men from perfecting theirs. The conflict
in woman between the impulse to play a part before an audience
of potential admirers or to retreat to a contingent but more stable
(perhaps) identity through marriage is matched by the conflict in
man between giving himself to a public role or striving for an
inwardly ordered self. Both conflicts cannot be resolved within
the existing cultural framework. But in the correspondence be-
tween their problems and those of men, women have already
achieved full equality.

1967

5 Masculinity: Style and Cult

Societies of the past have admired different personifications of the manly virtues: the warrior, the patriarch, the sage; the lover, the seducer; Zeus the Thunderer, Jehovah the Lawgiver.

In America, masculinity is associated primarily with the outdoors, and with such outdoor trades as cattledriving, railroading, whaling, and trucking. The outdoor type is presumed to possess masculine character traits: toughness, resourcefulness, love of being alone, fraternity with animals, and attractiveness to women and the urge to abandon them. To the man of the open spaces is also attributed the ultimate mark of manliness, the readiness to die.

Originally published in *Vogue*, vol. 150 (Nov. 1967), under the title "Masculinity: Real and Put On."

From the outdoors America derives the boots, lumber jackets and shirts, sailor's caps, pipes, and guns that are its paraphernalia of masculinity. Oddly enough, in the United States, military and police uniforms do not confer masculinity, as they do among Cossacks and Hussars. One can as readily imagine women in our army uniform as men. To prove that he was all man, General Patton had to augment his battle costume with a pearl-handled revolver. (It is true, however, that he wrote poetry and may have felt the need to overcome this handicap.)

As to hair, masculinity is ambivalent. Long hair belongs to the style of frontier scouts and trappers, the most male of men. Yet "longhairs" is the name applied to intellectuals, a breed always suspected of sexual inauthenticity. Beards used to be a material evidence of maleness; today they are as frequently an appurtenance of masquerade.

In the last century the outdoors represented genuine hazards. It took self-reliance, identifiable with masculinity (though the pioneer mother had it, too), to venture very far from the farm or town.

Today there are still risky occupations—piloting spaceships, handling nuclear substances—but these trades have become increasingly technical and depersonalized. As for the rugged outdoors, it is used chiefly for sports; and a vacation at a ranch or ski lodge, or shooting lions in Kenya, is about as hazardous as a trip to the Riviera.

The outdoors, representing once-hostile nature, has been transformed into a stage set. Masculinity in the American sense has thus lost its locale and, perhaps, its reason for being. On the neon-lighted lonesome prairie, masculinity is a matter of certain traditional costume details: the cowboy hat, jeans, and guitar. It has become clear that the traditional traits of the man's man (and the ladies' man) can be put on, too. One *plays* manliness, with or without dark goggles.

Big-game hunters, mountain climbers, horsemen, and other representative male types are actors in a charade of nostalgia. Old masculine pursuits, like baseball or wrestling, when carried on at night under the glare of fluorescent tubes, come to resemble spectacles on television and wind up in the living room. In the epoch of the picture window, outdoors and indoors have lost their separateness.

In modern mass societies the uniforms of all kinds of cults compete with one another. Masculinity is one of these cults, and to create an impression the practitioner of maleness must stand

out in a crowd. Persons with other interests are not disposed to make an issue of their sex. Only psychiatrists and sociologists complain that boys and girls today look alike and are often mistaken for each other. Even tough adolescents, like members of big-city gangs, don't mind if their girls wear the same shirts and jeans as the men. All are more concerned with identifying themselves as outsiders than as males and females.

Masculinity today is a myth that has turned into a comedy. A ten-gallon hat still seems to bestow upon its wearer the old male attributes of taciturnity, resourcefulness, courage, and love of solitude. At the same time, the virility of the cowboy and the truck driver, like that of the iceman of yesterday, is a joke that everyone sees through.

A person uncertain of his sexual identity dresses up in boots, bandanna, and riding breeches not so much to fool the public as to parade his ambiguity. Those who have gone over the line may advertise their desires for male company by wearing a beard in addition to sheepskins. Women can be masculine too, of course, in the degree necessary to make them irresistible to feminine men.

Hemingway, who constantly kept the issue of masculinity alive in his writings, flaunted both the look of the outdoor man and his presumed character qualities of daring, self-detachment, contempt for the over-civilized, and eagerness to court death.

Hemingway's he-man performance was, among other things, a means of combatting the American stereotype of the writer as a sissy. In the United States, the artist and man of ideas have always lived under the threat of having their masculinity impugned. Richard Hofstadter, in his *Anti-Intellectualism in American Life,* lists a dozen instances in which the "stigma of effeminacy" was branded upon intellectuals by political bullies, ranging from Tammany Hall leaders in the nineteenth century, who attacked reformers as "political hermaphrodites," to Communist Party hacks in the 1930s, who denounced independent writers as "scented whores." Evidently, it has always been possible to convince the common man that his intellectual superiors fall short of him in manliness.

To the overhanging charge of being contaminated by a ladylike occupation, Hemingway responded by injecting the romance of masculinity into the making of literature. At least as far as he was concerned, the sexual legitimacy of the male writer was to be put beyond question. Besides lining up with traditional outdoor types, such as bullfighters and deep-sea fishermen, Hemingway's strategy included identification with the new activist male

image of the Depression decade: the leather-jacketed revolutionist allied with the peasant and factory worker. One might say that each of his novels originated in a new choice of male makeup.

Unfortunately, demonstrating his own manhood was not enough for Hemingway. He found it necessary to challenge the masculinity of other writers. Like Theodore Roosevelt earlier in the century, he became an instance of the intellectual who slanders intellectuals generally, in the hope of putting himself right with the regular guys. During the Spanish Civil War he forgot himself to the extent of sneering publicly at Leon Trotsky for remaining at his typewriter in Mexico, implying that the former chief of the Red Army lacked the manliness to go to Spain and fight. He, himself, of course, went to Spain to write. In *For Whom the Bell Tolls* he identified himself with the dynamiter Jordan who also shook the earth by his love feats in a sleeping bag.

Thirty years ago not all of Hemingway's contemporaries were convinced that he had established his masculinity through displaying an appetite for violence, sex, and death. In *no thanks,* E. E. Cummings translated Hemingway's romance of maleness back into the daydreams of boyhood:

> "what does little Ernest croon
> in his death at afternoon?
> (kow dow r 2 bul retoinis
> wus de woids uf lil Oinis"

To Cummings, Hemingway's heroics were not only childish ("lil Oinis") but feminine ("kow dow r").

The post-Hemingway he-man has labored under the handicap of a masculinity that is generally recognized to be a masquerade. The adventurer living dangerously has disintegrated into the tongue-in-cheek élan of James Bond. Neither at work nor at home is maleness any longer endowed with glamour or privilege. The cosmonaut is less a birdman than a specialist minding his signals and dials. The father who has entered into a diapering partnership with his wife has nothing in common with the patriarch. To the public of Norman Mailer (more male?) the outdoor rig (Mailer in sea captain's cap on the jacket of *Advertisements for Myself*) and chronicles of supersex are suspect, both psychologically and as playing to the gallery. It is no secret that a Bogartean toughness with women may represent the opposite of male self-confidence.

The mass media exploit the ambiguity of the male role and the sexual sophistication that goes with the increasing awareness of it. In male comedy teams, one of the partners almost invari-

ably plays the "wife," confident that the audience will know when to smirk. Analysts of mass culture speak of the decline of the American male and of the "masculinity crisis" as topics capable of arousing libidinous responses. The public is given the image of luscious females starving in vain for the attention of men, and of men who, egged on and deprived by frigid seductresses, end by falling into each other's arms.

Masculinity-building is urged, a theme which the media are not slow to adapt for their own purposes. Masculinity is the alfalfa peddled in Marlboro Country. It is the essence of worn leather laced with campfire smoke that provides the aroma of the man of distinction. It also comes in powder form, none genuine without the Shaggy Dog on the wrapping.

To those who resent the fact that their pretension to masculinity is not taken seriously, one means is available for gaining respect: violence. The victim of rape is not inclined to question the virility of her assailant.

The relation between masculinity that has been put into doubt and violence reveals itself most clearly in the recent history of the Civil Rights movement. The black has derived from white America the lesson that physical force is the mark of manhood. White society is "the Man," whose insignia of power are the club, the whip, the bloodhounds. The presence of the Man impeaches the masculinity of the young black and demands that he prove himself. He becomes full grown when he resolves to fight the Man. To confront the Man, the black militant has resurrected the figure of the radical activist of the thirties, the model of Hemingway's he-man, honor-bound to risk his life in physical combat.

An article in the *New York Times Magazine* on the Black Panthers is illustrated by photographs of its two leaders. Both wear the traditional leather jackets and berets of the Left fighters of thirty years ago—these could be photographs of two Lincoln Brigade volunteers. A statement by one of the Panthers touches the philosophical essence of the romantic conception of masculinity: to be a man one must dare to die. "The ghetto black," said Bobby Seale, "isn't afraid to stand up to the cops, because he already lives with violence. He expects to die any day."

In our culture all human attributes tend to be over-defined and become a basis of self-consciousness. The behavioral sciences collaborate with the mass media in making a man anxious about his sex status; both then provide him with models of aggressive-

ness by which to correct his deficiencies. Yet the present uneasiness about masculinity, coupled with theatrical devices for attaining it, may be more harmful than any actual curtailment of manliness discovered by researchers and editorialists. The real damage may lie in the remedy rather than the ailment, since the desire to have one's masculinity acknowledged may lead, as we have seen, to absurd postures and acts of force. It is hard to believe that Americans would be worse off by becoming more gentle. Nor that mildness in manners and social relations would make them less manly. In the real world nothing is altogether what it is. True maleness is never without its vein of femininity. The Greeks understood this and made it the theme of their tales of sexual metamorphosis, the remarkable account of Hercules, of all men, taking on temporarily the character of a woman and wearing women's clothes. Total masculinity is an ideal of the frustrated, not a fact of biology. With the cult of masculinity put aside, maleness might have a better chance to develop in the United States.

1967

6 Psychoanalysis Americanized

In addition to being practiced by professionals, psychoanalysis is used to some degree by most of us to explain things. We know how on the basis of the sexual hypothesis, phenomena can be traced to previously unsuspected origins—that, for instance, the suicide of a girl might have been caused by the death of her mother just before the girl reached puberty. The habit of seeing mysterious connections of this type has now been instilled even in the less educated. The unconscious erotic motivations of assassins and jewel thieves are casually identified by high-school students and cab drivers. On the other hand, the most learned non-practitioner can rarely convince himself that his psychological reconstructions are altogether free of fantasy. A conception so

Originally published in *Commentary*, April 1965.

widely shared and comprising both certainty and doubt belongs to the order of living myths. Whatever be its status among the higher intellectual forms, from mathematics to medicine, psychoanalysis today is an aspect of American popular culture.

Dr. Hendrik M. Ruitenbeek, who edited the large Delta paperback anthology, *Psychoanalysis and Contemporary American Culture*, is eager to have psychoanalytical thought become even more pervasive than it is. "Psychoanalysis," he tells us in his introduction, "is no longer confined to the therapeutic frame of reference." In its beginnings it was a method of treating individuals suffering from psychic abnormalities: today, it must undertake the task of educating "normal" people in how to live. "Freud and his colleagues . . . saw a preponderance of hysterical patients. We see few of these in private practice now." Who comes? Individuals distracted by the problem of who they are—that is to say, anybody. The therapist will help his client recognize himself. He may also introduce him to natural feelings—e.g., love—which he had only heard of before. Because while the new patient is not sick as an individual, he is deprived of his biological and human heritage by that twofold *mal de siècle,* alienation and the crisis of identity. For this historically tormented person the concepts of psychoanalysis, Dr. Ruitenbeek contends, occupy the place once held by tragedy, religion, philosophy, tradition.

But though Dr. Ruitenbeek appeals for this comprehensive role of psychoanalysis in American life, psychoanalysis is so cut to pieces in the articles and speeches assembled in his book that there seems hardly enough left of it to fill out a prescription. Perhaps intellectual conquests of society take place this way, that is, through the dissolution of the conqueror. I do not know to what extent, if any, the effect was intended, but the total impression created by this group of writings by two dozen thinkers influenced by Freud is that the collective assurance of psychoanalysis as an exclusive key to human behavior has by now completely disintegrated. Here, it's every man for himself, and overboard with anything he can do without. "Thanks be to God," writes one contributor to *Psychoanalysis and Contemporary American Culture,* "there does remain some chance of improving the social structure by means of appropriate action and without first visiting the psychoanalyst's office." Progressives, go home—your politics have made you whole. One recalls, in contrast, that twenty years ago the political-activist hero of Koestler's *Arrival and Departure* had to undergo a session on the couch in order to understand what he was really after as a party member.

Mirages of Identity, U.S.A.

With political action no longer to be meddled with by the doctor, another contributor, Franz Alexander, explains why "psychoanalyzing society" has been a sad mistake. Ruitenbeek himself takes generosity out of reach of the analyst's peephole by complaining that "altruistic impulses often are taken as evidences of hidden hostility," which means that goodwill is now immune to analysis. Ernest van den Haag (many of Dr. Ruitenbeek's selections are by sociologists and writers on the mass media) attacks Freud's notion of art as a substitute gratification equivalent to dreaming, and Campbell Crockett recalls that "much nonsense has been written about the relation between neurosis and creativity." David Riesman takes the offensive against the mechanical quality of Freud's thinking: "While he [Freud] accused intuition of arbitrariness, the very logical and often pedestrian rigor of his own treatment of symbols led repeatedly to highly arbitrary, indeed quite fanatical constructions." Another critic of the master repudiates "the universal determinism on which Freud prided himself above all." To cap the retractions, but by no means to exhaust them, a leading neo-Freudian speaks of "the present contradictory, and to my mind deteriorating, form of many psychoanalytic concepts."

Retreat all along the line seems to mark the cultural offensive of psychoanalysis. No less an authority than Erik Erikson points the direction of the withdrawal. "The ego in psychoanalysis, then, is analogous to what it was in philosophy in earlier usage." Psychoanalysis is being grafted onto philosophy, especially existential philosophy, with occasional cuttings from tragic poetry (for example, in Rollo May). "The great philosophies of [sic] world history," writes a metaphysically inspired therapist, "have recommended various techniques to learn the endurance of suffering." Another cautions that "it is important for psychiatrists to recognize the normalcy of realistic worry."

The consensus is, plainly, that philosophical and religious *Angst* is in, the pursuit of happiness out. The "new dimension in twentieth-century life," as the subtitle of Dr. Ruitenbeek's book describes psychoanalysis, is the dimension of painful profundity added to the shallow American Way. Guided by an ultimate vision, psychoanalysis acquires through collaboration with sociology a concrete understanding of the social realities surrounding the patient. The nub of this understanding is that it is futile to adjust the individual to the contemporary environment, as illustrated by the voyeur who came to Freud afflicted by spells of blindness and was cured by being turned into a dealer in

optical instruments happy to mind his business. With today's patient, the existentialist analyst knows, the social environment itself is the origin of his malady. Hence, the revised psychoanalysis abandons to the clinics and drugs the task of patching up emotional casualties and seeks to lead men to values based on the truth of the human condition.

All this sounds very thoughtful and even austere. By the evidence of the literature, art, and political theory of the past one hundred years, the crisis of identity is the spiritual hallmark of our time. But are the neo-Freudians, in adopting this as their leit motif, really able to bring "a new dimension" to American life? Given the loosening of the psychoanalytical system, the "deterioration" of its concepts, its absorption of ideas and rhetoric from other forms of thought, it seems more likely that American culture has subtracted a dimension from psychoanalysis. The alien "science" has been filtered through fashionable intellectual outlooks—for example, the loss-of-self theme. Instead of *Psychoanalysis in Contemporary American Culture,* Dr. Ruitenbeek's book might more correctly have been called *American Culture in Contemporary Psychoanalysis.* While psychoanalytical assumptions have become part of our common sense of things, a conformist common sense has been pressing psychoanalysis into the mold of accepted moral and social beliefs.

The upshot of the matter is that in the neo-Freudian literature, deteriorated psychoanalysis has been mixed with deteriorated Puritanism, deteriorated individualism, deteriorated Marxism. To note this may be only another way of recognizing with Dr. Ruitenbeek that psychoanalysis has by now been fully naturalized. In modern times a "culture" is nothing else than the sum of decayed ideologies that have washed into the inherited intellectual soil. While an ideology is still ripening, it defends its differences against hostile ideologies and against tradition. When, however, it has commenced to decay, it consents to blend into its surroundings. In keeping with this principle, *Psychoanalysis in Contemporary American Culture* marks off the role of psychoanalysis in a cooperative division of labor. Its province is the individual (as the province of sociology is the community)—but only the secular individual; the churches and synagogues can keep the believers.

To enter fully into American culture, ideas must popularize themselves. The contents of Dr. Ruitenbeek's book belong for the most part to popular culture. His contributors are all professionals, many of them eminent ones, but theorizing about the condition of man in the mid-twentieth century is not their profes-

sion. They earn their living as therapists, sociologists, researchers, teachers, but on the subject of contemporary cultural, social, and political trends, as on the subjects of tragedy and of artistic creation, to which they like to refer, they are Sunday thinkers. Like those of Sunday painters, their products are likely to be au courant in a kind of meager imitation of surface effects. "The conception of schizophrenia as a way of eluding an Absurd world, or as alienation from it—that is, as a form of existence—poses to the therapist the problem of his own existence and his defensive maneuvers. . . . But no therapy of schizophrenia can long endure without the dedication of the therapist and his personal conviction that in the Absurd there is meaning and beauty." Maybe so, but though the author's subject is schizophrenia this reference to "the Absurd," the self-knowledge of the therapist, and his faith in the beauty at the heart of the void is literary talk; and to be sure, many of his pages are given over to discussing Camus. Nor is it very interesting literary talk—in fact, it consists mostly of platitudes.

Erikson's contribution on "The Roots of Virtue" is on the same level—it attempts nothing less than "A Schedule of Basic Virtues" (hope, skill, fidelity, purpose, etc.) based on The Ages of Man (Shakespeare was too frivolous to work out the details). Under a section entitled "Love," Professor Erikson goes in for stuff like this: "While many forms of love can be shown to be at work in the formation of the various virtues, it is important to realize that only graduation from adolescence permits the development of that intimacy, the selflessness of joined devotion, which anchors love in a mutual commitment." Or "Animals, too, instinctively encourage in their young what is ready for release; and, of course, some animals can be taught some tricks and services by man. Only man, however, can and must extend his solicitude over the long, parallel and overlapping childhoods of numerous offspring united in households and communities."

Such thinking is identical with the common output of sermons, women's magazines, TV panels; one contributor, Judd Marmor, enters into direct debate with Norman Vincent Peale. The only difference in the neo-Freudian writings is occasional patches of clinical reference or traditional psychoanalytical metaphor, as in this example from Dr. Ruitenbeek: "He [the American male] no longer carries the world in his pocket. He does not possess his penis securely." (Somehow, I kept getting mixed up by what's in the American's pocket.) Erich Fromm, the outstanding figure among the neo-Freudians, is, of course, more theoretically and

stylistically sophisticated. Yet his essay on "Individual and Social Character," written in 1932 and respected as a classic of the present turn in socio-psychoanalysis, is simply popularized Marx ("If a social order neglects or frustrates the basic human needs beyond a certain threshold, the members of such a society will try to change the social order so as to make it more suitable to their human needs") combined with simplified Freud ("Freud had recognized something that the great novelists and dramatists had always known," etc.). The conception of social types put forward by Fromm is full of weaknesses and hardly up to the level of modern discussions of character in the drama, for example, Strindberg's. The various authors of *Psychoanalysis and Contemporary American Culture* contradict one another as frequently as editorials in different liberal newspapers; as individual minds they seem to have nothing in common, though they revert to the same terminology and fill in gaps with the same ideological cement. The most convincing passages in the book are those knocking down earlier psychoanalytical nonsense and procedures derived therefrom.

In overflowing the therapeutic frame, psychoanalysis has converted itself into an ideology. Like all modern ideologies it centers on the problem of identity and alienation. The rise of psychoanalysis as a candidate in this field coincides exactly with the postwar deflation of socialism as the alternative to "free enterprise." The historical content of "cultural" psychoanalysis thus lies in its reversion to traditional American individualism as weakened and demoralized by the Depression and the new mass society.

Faced with the "permanent crisis" of the postwar world, psychoanalysis aspires to become the tragic knowledge of the epoch, comparable to those forms of tragedy and ritual by which the human being was in the past purged of his false ego (egos) and lifted into self-recognition. All that psychoanalysis lacks is the art; that is to say, the potency of form that gives to vision a reality beyond mere talk. In the absence of art, the high moral and philosophical aims of post-Freudian analysis can only bring about the substitute purge of uplift. In sum, the contribution of the new psychoanalysis lies in that upper realm of popular culture which provides the sermon for the times, the appeal to "values," the call for fortitude.

1965

7 Leisure and the Split Man

Is writing about leisure a leisurely pursuit? Not these days. As automation takes over factories, offices, TV stations, and shipping, the dwindling of human employment toward a vanishing point of total free time has become a subject of anxious research, analysis, and speculation. Among government officials, labor leaders, sociologists, economists, cultural historians, moral philosophers, the prospect of a no-hour workweek has become more urgent than was the seventy-two-hour workweek a century ago. "For most men and women presently engaged in physical or manual labour," wrote Georges Friedmann, sociologist and Director of Studies at the Sorbonne, "work in the traditional sense of the term is fated to disappear."

Originally published in *Vogue*, vol. 147 (Feb. 1966).

Leisure and the Split Man

A nostalgia is developing for the good old machine that needed "hands" to tend it, instead of being run by tapes and transistors. What are the dispossessed—or, if your prefer, liberated—operatives and clerks going to do with their spare time? *Spare* time! It's not "spare" any more when the greatest portion of one's waking hours has ceased to be used up by any regular occupation. Once work has diminished beyond a certain point, freedom from work changes its character. A person who has nothing to do does not behave like one with time off. And if it becomes the rule for man, who has been defined as a "maker," to become removed from both work and leisure, man himself can no longer be the same. "With automation," wrote labor economist Ben B. Seligman, "man not only loses irrevocably his function as *homo faber*; he no longer even possesses the character of *animal laborans.*" No wonder the experts are troubled: the new servo-mechanisms and feedbacks confront them (and us) with a tomorrow in which the human world will be as unfamiliar as the craters of the moon. To many, the forty-hour week has come to seem the last line of defense for mankind as it has been known throughout the ages.

On the other hand, there are some who contend (and most of us instinctively agree) that leisure alone would be sufficient for a good life. Freedom from work is not merely a negative condition. Not only has leisure provided—as a gift of the gods, said Plato, "who took pity on mankind, born to work"—a respite from the fatigue of toil, it has generated its own set of values, contrary to those associated with work. Leisure exalts contemplation, as against the physical and mental busyness that binds the mind to the surface of things; it promotes introspection and self-knowledge; it is a prerequisite of the aesthetic and the spiritual. "I loafe and invite my soul," sang Whitman. In bustling nineteenth-century America, the soul, banished by activity, needed to be "invited"; and Whitman defied the alienating ethos of doing by raising the banner of loafing. He identified himself with the idler and the tramp, with those Americans who in each generation, from the colonial ne'er-do-well to the contemporary beatnik and dropout, have found life to be worthwhile only when it was freed from involuntary exertion. For his idling, Whitman claimed spiritual profundity, as have Thoreau and Emerson, Henry Miller and Jack Kerouac.

Release from the world of work, making oneself materially useless can, then, be regarded as more than escape and dissipation. In *Leisure: Basis of Culture,* by the German philosopher

Josef Pieper, leisure is considered in essence time set aside for divine worship and celebration. For Dr. Pieper, time delivered from work finds its equivalent in space set aside for building a temple. Leisure is, too, he maintains (harking back to Plato), at the root of philosophy, which is an unhurried ambling after truth, a kind of gentlemanly pace of the intellect that seeks no end but its own satisfaction. Thus leisure has shaped the forms of religion, art, and speculation, without which the activity of the "intellectual worker" brings nothing but impoverishment and frustration.

Testimonials to the contributions of leisure do not, however, alter the fact that idleness, whether beneficent or mere shirking, presupposes work, either at some other time or by other people—a "leisure class," for instance, represents freedom from toil in a *working* society. The earth was not fashioned on the Sabbath but on the workdays (six of them); and the creator of the universe was conceived by Greek philosophy as an artisan—philologists say, a carpenter. Whitman's "loafing" was taken up with composing the "Song of Myself," and Pieper's "active leisure" proves upon examination to be the antithesis of "laziness, idleness, and sloth," that is, of doing nothing, and very close to the mystic's enterprise of alert waiting. With poets and philosophers, leisure is actually a condition of striving, even if it be striving not to strive. Their higher idleness reflects the morality of work, though it shows it in reverse as in a mirror. For through *their leisure* they seek to bring into being things, images, ideas, but to do so in magical ease and delight and without the sweat of ordinary human production. Yet, even in the state of inspiration neither the poet nor the mystic is leisurely in the sense of being relaxed and carefree. With them work has passed over into its most intense form—into creation.

The glorifying of "the creative" in American education and the popularity of artists, actors, and inventors are expressions of the value placed by this nation not on free time but on productivity. For the sake of the latter, we have been prepared to overlook the licentiousness of Hollywood as we have the high living of the Robber Barons of the nineteenth century, who "built the country."

The psychically opulent leisure conceived by the creative mind has, however, little in common, unhappily, with the idle hours of the person who has lost his job or who never had one. With the "disemployed" the absence of the discipline of job or vocation deprives his personality of its psychological as well as its social

foundation. The part played by work in the identity structure, and even the physical health, of individuals has been receiving increasing emphasis in current psychotherapy. Upon a man's relation to his daily task commonly depends his gratification and his self-respect. Under existing conditions, the substitution of idleness for work, as in loss of the job or old-age retirement, frequently results in demoralization and breakdown.

In America the mere enlargement of spare time has already, we are told, led to wholesale stultification. August Heckscher, America's cultural chief under the Kennedy Administration, encountered a "widespread feeling that leisure creates the very conformity which it should have the effect of abolishing." In his opinion, holding second jobs or volunteering for civic and charitable tasks, like exhausting oneself with social engagements, is motivated by a desire to escape from leisure which many find intolerable. By the testimony of Friedmann, conditions are no better abroad. In France, membership in the immensely popular sports organizations results in indifference to larger political and cultural issues and in turning adults into "retarded children playing under strict supervision." And beyond all the wretched consequences of overgrown leisure, observers are haunted by the nightmare of a populace twitching to the stimuli of the mass media, with their predigested news, canned philosophies, calculatedly infantile entertainment.

If the gifts of leisure are placed on one side of the scale and the rewards of work on the other, neither side seems capable of decisively tipping the balance. We are confronted by an equilibrium or duality of values which to all appearances is matched by a division in man himself. The apparently hopeless splitting of the human psyche between two sets of irreconcilable impulses has been wonderfully elaborated by Thomas Mann, the twentieth century's epic poet of leisure versus work. In Mann's *The Magic Mountain* the protagonists are all invalids forced to while away their years in a luxurious sanitarium. Another novel, *Royal Highness,* is the portrait of a prince whose function is representing rather than doing. *Death in Venice* and *Mario and the Magician* are stories of vacationers in Italy cut off both from their native environment and their customary routines. In each of these narratives the abandonment of work and duty (or its transcendence in the case of his Highness) brings a loosening of the moral fibre that has its counterpart in physical illness or deformity and in fevers of the mind. But it brings, too, poetry and love, symbolic being rather than mere existence, and a vision

of truth drawn from the immediacy of the senses and the experience of dying. Thus for Mann, work and leisure, though both are life-nourishing, are, taken separately, lethal—the former brings death through rigidity, the latter through dissolution. To survive, it is necessary to alternate between incompatible demands, for discipline and for relaxation; and these are reproduced in man as conflicting appetites. Man's nature is to be a creature of "on the one hand" and "on the other hand," of mind-satisfying order and heart-appeasing chaos. Idealizing both the labors of Hercules and the spells of Aphrodite, Man achieves unity only in art and myth.

Can the future release of man from work transform the myth into reality and unify the human person on a plane beyond work and leisure alike? The change would amount to nothing less than a revision of human nature and of human fate, in a word, of man's metaphysical condition—a change greater in magnitude than any in the history of the race. The experts are right to be disturbed. For they have no way of determining in what quality of life the ancient division between work and leisure will be resolved. Will automation restore us to Eden? Eden is, among other things, a garden of primitivism and ignorance. West Coast Indians, who subsisted effortlessly on shellfish and neither hunted nor cultivated the soil, were among the least developed culturally of the Indians on the North American continent. With modern devices for killing time, a paradise of the utmost degradation has become possible.

One hears a great deal today about meeting the enlargement of leisure through an expansion of cultural programs. Mere crowds are to be transformed into art audiences. In certain American universities, art appreciation is already a required course for all incoming freshmen. and folk-singing and guitar playing are proliferating with such speed they may have to be curtailed. Museums and art centers, branching out into the food and entertainment business, grow continually more aggressive in recruiting attendance. Vacation trips are tied in with lecture subjects, and group tours arranged by cultural societies explore the treasures of the five continents. Nor is sedentary culture restricted, as it used to be, to reading a good book: educational radio and TV; hi-fi symphony, opera, and drama clubs; slide-viewing packages; painting, sculpting, and handicraft kits reach into the home to keep leisure filled with things of the mind. There seems little doubt that culture is gaining ground in the United States, in numbers and equipment at least.

No doubt, this is all to the good. But we have been trying to show that the issue is much deeper, that it involves changes in the character of culture itself, as well as in the consumers of culture. Mere forced feeding of cultural commodities to more and more people is no guarantee against despair and passivity. Universal education to the baccalaureate level can be the means for mass training in intellectual servitude. Reading the world's best books, attendance at museums and concerts, even do-it-yourself in the arts do not necessarily make a person at one with himself and conscious of his situation and its possibilities. On the contrary, the utilization of masterpieces as cultural spectaculars—as in the instance of the *Mona Lisa* in New York—deprives them of their inner substance and incorporates them into the mass media.

Utopians, past and present, "solve" the problem of workless time by occupying it with labor that is, presumably, pleasurable or uplifting rather than a hardship. In totalitarian societies man is *totally* employed by a combination of compulsory and "voluntary" labor. For free men, however, a solution, no matter how ideal, that eliminates a person's freedom to dispose of his time is worse than no solution.

It is the absence of a solution that we shall have to embrace—and perhaps even defend politically. No scheme or system can overcome the work-leisure division in man. For a morality to emerge that is independent of both the necessity to labor and the liberation from that necessity, an evolution of unpredictable duration will be required.

Fortunately or otherwise, the issue is more pressing in theory than in practice. Most Americans, and even larger numbers abroad, still toil for long and arduous periods each week. Time off the job is consumed in marginal, but necessary, forms of work—chores, home crafts, training courses—and in moonlighting. Undoubtedly, the workweek is getting shorter, but the time freed is for most employees not really given over to leisure in *any* sense of the term. Before we are deluged by total idleness we shall have the time (if not the leisure) to reflect upon it.

In sum, the vision of the end of work as we have known it ("not only hours of work," wrote Friedmann, "but the very nature of work is being transformed") has raised the issue of the moral ambivalence of man as a laboring and idling animal. We have not at present the means to foresee the forms in which this duality will be resolved. But we can predict that universal leisure will create the condition that will allow each human being

to seek the principle of his own inner unity, to devote himself to the question, "Who am I?"—a question hitherto reserved to poets, philosophers, and those undistracted by the obligation to satisfy material needs.

1966

8 Art and Work

The prospect for the arts is bound up, of course, with the direction of the culture as a whole. There are many people who have a rather rosy picture of America's artistic future. In contrast to such an outlook, there is an opinion, apparently growing in strength, that the way things are going, the arts have *no* future. We live, we are being told constantly, in a scientific and technological civilization which is systematically reducing man to the most primitive appetites and functions. Cultural decline used to be the theme of European romanticists and Americans visiting

"Art and Work" is an expanded version of a talk entitled "Vistas in the Arts," delivered at a session of the First World Congress of Craftsmen (1964). It was first published in *Partisan Review* 32, no. 1 (Winter 1965).

the great Renaissance cathedrals. Since the war, novelists, play-wrights, thinkers, both here and abroad, have been competing with one another in finding the absolute symbol with which to re-present the nonentity of the modern person. He has been drama-tized as rubbish in a trash can—and as a volunteer rhinoceros. Philosophers have written volumes on loss of the self, and when committed by modern man even the most unspeakable crimes have been held to be "banal."

An element in this mood has no doubt been the memory of the Nazi death camps and the threat of nuclear war. But the dark prophecy of the fall into subhumanity antecedes Auschwitz and Hiroshima. Indeed, it is customary to see these atrocities as effects of the current human condition rather than as its initiators. The true source of the man-made disasters of the twentieth century lies, the philosophers of downfall inform us, in what the advance of technology has done to man himself. This is another way of saying that the so-called decline of man has to do with the subject of this Congress—that is to say, with the crafts. To many of the critics of contemporary civilization the practice of the crafts is the activity by which the human creature is defined. Man is a maker, *homo faber,* an artist. Put this proposition in reverse—when man ceases to be a maker he is no longer man—and our present crisis is explained. The fall began not in Eden, when man was condemned to labor, but in the nineteenth century, when the machine first threatened him with leisure. With "soulless manu-facture," as Ruskin called it, turning out endless quantities of copies of objects to which the human touch was alien, man-the-maker commenced to lose his skills, through which he also gave shape to himself, and with them his dignity and independence. He was converted into an atom of mass society, a unit of energy susceptible of being put to use for any purpose—and to being replaced by other energy units generated from nature.

The dissolution of the human essence based on man's handling of materials now reaches its climax in automation, by which even the most rudimentary operative skills are eliminated. In regard to man as a tool-using fabricator, the outlook is thus one of absolute blackness. He may preserve his skills out of sentimen-tality, and even revive abandoned ones, but these exercises no longer have a role in the serious realm of necessity and can no longer hold the human being to an ultimate definition.

If the arts are identified with the crafts—and they can never be altogether detached from them—their role too is in doubt. This doubt pervades the art of the past hundred years and is the

essential content of the advanced writings and paintings of the half-century since the First World War. Our time has given birth to the concept of the last artist. His work takes the form of reducing to zero the tradition of skillfully contrived objects. A splash of paint or a ruled rectangle asserts the terminal proposition reached by the logic of art history. Then art and the artist are no more.

This doubting of the kind of making called art is felt in all the arts. Under the name of anti-art, it has exerted a constantly revolutionizing influence. It has resulted in the endeavor to carry art beyond fabrication into the realms of action and revelation. In painting and the drama it has caused the psychology of the gesture and the metaphysics of the void to emerge as keys to form. The symbol of art in which making has reached its last gasp is the work of the New York painter who literally conceives art as an all-black picture, which he repeats in a uniform size, shape and suface: five feet wide, five feet high, five thousand dollars. This artist could announce if he chose, "I have met the machine and it is I."

I should like to be able to prove that the prophecy of mechanized man and the death of the arts is baseless. As against aristocrats who lost hereditary appurtenances when their handicraftsmen went into the factories and against the ideologues who became disillusioned when the workingmen ceased to be an object of commiseration, my interests put me on the side of widespread consumption and plenty of free time for all, such as cultures based on the crafts could not allow. As to art, the masterpieces of modern music, painting, and literature are not to my mind mere shadow images of a megalopolitan spiritual desert.

Still, some kind of deterioration in the quality of people and their behavior does seem to be taking place together with the lowered quality of their products. Bureaucracy is growing, and the arts are by no means immune to it. The man who handles and shapes the materials, be they leather or steel, or words, paint, or sounds, has less and less control over the use to which his product is put, including its intellectual use. The artist is isolated from his public by the very processes and institutions through which his work is brought before it. The larger the influence exerted by his work the less accurately that influence communicates the idea or sense of things embodied in the work itself.

One keeps hoping that the decline in excellence of people and things is an effect of transition. All we have on the positive side is the individual's capacity for resistance. Resistance and criticism.

Mirages of Identity, U.S.A.

Most modern masterpieces are critical masterpieces. Joyce's writing is a criticism of literature, Pound's poetry a criticism of poetry, Picasso's painting a criticism of painting. Modern art also criticizes the existing culture.

Because it lives through its criticism, modern art cannot be used as an argument to prove a case in favor of modern times and modern man. Like the art of all periods, it has the characteristics, including the negative characteristics, of the culture in which it was created. One who hates the modern world will find its most odious qualities mirrored in Joyce or Picasso, and will see only disintegration, distortion, and the absence of form and nobility.

In sum, vis-à-vis the past, the future and its creations are, to say the least, in question. When labor is no longer needed, or when its character as machine-tending has reached its ultimate—for example, when work consists of watching lights flash on and off and pressing a button when something goes wrong—when the use of skill in production is no longer even a rarity, changes in mankind of the profoundest magnitude may be postulated. All relations between man and nature, as well as between the individual and himself, will be transformed in unimaginable ways. Whether one considers this to be the bottommost point of human history or its height, one thing is certain: that the values of the future, including its aesthetic values, are all in the making. We may be headed toward a society of dehumanized robots or toward a community of intellectual supermen. But whatever be the outcome, the arts cannot be expected to carry on as they did before the industrial age. And even works produced in earlier epochs are bound to appear in a state of alteration and serve different functions from those they did in their own time.

A situation so drastic will, naturally, tend to generate extreme ideas. Given the forecast of Everyman as an utterly passive consumer inhabiting a vast supermarket that fills up automatically each morning with synthetic goodies, it is not absurd to retort with the prophecy of Everyman as creative artist. The effect of universal automation must be to make geniuses of us all—as an alternative to converting us into amoeba-like digestive apparatuses. There is evidence that both conditions are in the process of being realized—which means, of course, that neither can be.

For the purpose of this discussion, I shall therefore assume that history will continue to behave like history; that is, that it will bring forth everything except what is logically expected of it. With history as history, the vista consists of a mixup of the new and the old, of the outworn, the revived, and the original.

Thus the development of art in the decades to come will tend to parallel the three major phases of production in general: the crafts, scientific technology, free creation (including improvisation, games, totems). I shall comment on these briefly in relation to art today.

In much of contemporary painting and sculpture, art retains its ancient tie with the crafts. Reacting against machine-produced copies of things, art functions as a workshop for fashioning hand-made ornaments and pushing forward possibilities in design. In this approach the fine artist and the inventive craftsman are indistinguishable from each other. It is regrettable that an inherited hierarchy of terms makes it more desirable to be called an artist than an artisan—for instance, much of the fuss about Pop art has been due to the ignorance among critics and curators of what is being done in advertising and in the display industry. For an art historian to justify his admiration for Lichtenstein by praising the latter's draughtsmanship is laughable—as if the workshops of Madison Avenue and Hollywood were not full of the prize students of America's art academies. That the painter or sculptor creates a single object rather than a model for machine production is not in itself sufficient to distinguish his work from that of the designer-craftsman in the automobile or space industry or in "the communications." The enormous improvement in techniques of reproduction in art further decreases the significance of the handmade as such in determining what is and what is not art. In their originals both artist and craftsman can preserve the quality of the human touch and a control of their materials more flexible than that of the machine.

What defines art as craft is placing the emphasis on the object and its qualities, to the exclusion of the personality of the artist, his unique consciousness, his dilemmas. For instance, since Leonardo, painters have consciously made use of accident to arouse suggestions that would either help them to begin a painting or to redirect it during its creation. Certain effects of accident—splashes, runs, etc.—are now used by potters to enhance their surfaces. The accident is induced for the sake of what it does to the appearance of the object, rather than as an element in the artist's thinking and feeling: it becomes a category of decoration and a technical device. But painters in the last few years have also been using accident in the same way, that is, not as part of a searching or imagining effort but in order to obtain a certain look. With the intellectual-emotional motive eliminated, so is the difference between the painter and the potter.

Mirages of Identity, U.S.A.

There is nothing in art that cannot be reduced to inconsequence if understood in how-to-do-it terms. Like accident, "painterliness" ceases to be a virtue in the hands of one who paints according to recipe. But by the same token so does non-painterliness. Feeble painting can be done in pigment an inch thick or in a wash as thin as the reasoning of certain art critics.

In connection with Pop art and various kinds of pattern-making abstractions in painting, there has been much talk of an "anonymous" approach to art. This "new" idea reasserts the aboriginal relation of the craftsman to his product, a relation of skill in making an object for use. Under present-day conditions anonymously conceived art can be nothing else than a euphemism for commercial or industrial art brought into cultural areas formerly occupied by serious work. Art of the anonymous type, and the attitudes that produce it, may be expected to appear under any social conditions that provide a market for visual novelty and ornament.

The link of art with the crafts will persist no doubt as a force in art criticism and education. Regardless of its mode of creation, any work of art, even the most expressive or exploratory, can be interpreted as a fabrication and judged in terms of the techniques by which it achieves its effects. Art criticism seems to be much slower than art itself in casting off the spell that identifies the artist with making and the maker.

The merger, at least in retrospect, of the "studio" and the workshop goes back to the beginnings of human history. Since the Renaissance the studio has also been linked with the laboratory. The use of art to investigate nature led almost from the start to investigation of the means of conducting that investigation—for example, study of perspective as a system for apprehending the physical world. The research of art into its own means has constituted a powerful motive in modern painting, poetry, music, the novel, the theater. In our century artists have often emphasized these means as part of the content of the work itself—as in the exaggeration of brush strokes in painting, or in making the composition and acting of the play part of the plot of the play itself.

Research into the means falls roughly under three heads: (1) experimenting with the formal elements of the art in question —space, scale, color relations in painting, nonmetrical rhythms in poetry; (2) free play with the characteristic materials employed by each art—for example, pigment, sound, words; (3) the introduction of new raw materials, such as found objects in sculp-

ture or street noises in music. There can be little doubt that art will continue to experiment with the means of art and with the independent capacities of these means to simulate nature and evoke aesthetic response.

Perhaps the latest among the conscious interests of art is the formative effect of its creative processes upon the artist himself and upon his audience as individuals. Free work, whether in the studio, the workshop, the laboratory or the industrial plant, is work done because the worker wants to do it, when he wants to do it, how he wants to do it. It is done not in obedience to external need but as a necessity of the worker's personality. It is work for the sake of the worker, his means of appropriating nature and the heritage of other men's ideas and skill—thus his means of developing himself.

Faced with the dissipation of local cultures and the mass recruitments of modern industry, art has found in its own practices the discipline for a continuous formation of individuality, as well as a direct means of communion with artists of other times, places, and cultures. Art aimed at self-creation has thus been inseparable from awareness of man's changed relation to production. Conversely, this historical consciousness has led art in our time toward an increased subjectivity. As against art conceived as the making of attractive objects, or as the vision of things as they are or are believed to be, history-conscious art has isolated in painting or in poetry the psychic experience of creation. It is art for making artists. In that it seeks to change the quality of living, it is art that is political in the deepest sense—as contrasted with propaganda art, which delivers preconceived messages through craftsman-like presentations. At the same time, genuine art reawakens the primitive motive of art as magic and celebration. In work inspired by this new-old motive, art goes against its past as a making of things and takes on the characteristics of action. At the same time it preserves the essence of artisanship through its respect for the traditional media and its need to keep them alive as sources of suggestion. Thus art today continues to supply models for the crafts at the same time that the latter often take on the gratuitous quality of art.

Whether or not art for the artist's sake will remain an important strain in the future depends on the strength of our will to individual independence and social freedom. Art as craft and, to a lesser degree, art as experiment, can function under any social system. Art as action, however, is the offspring of this revolutionary epoch and can flourish only so long as individuals

are determined to be responsible for their own development and to interpret the past in relation to this aim. The ideal vista for the future is clear: it is that self-development shall be the motive of all work. If that ideal prevails, the distinction between the arts and other human enterprises will become meaningless.

1965

II
The
Geography
of Modern
Art

9 On Space

The guiding law of the great variations in painting is one of disturbing simplicity. First, things are painted; then sensations; finally, ideas. This means that in the beginning the artist's attention was fixed on external reality; then on the subjective; finally, on the intrasubjective. These three stages are three points on a straight line. . . . After Cézanne, Painting only paints ideas—which, certainly, are also objects, but ideal objects, immanent to the subject or intrasubjective.

—José Ortega y Gasset

The following essay was originally published as catalog notes for an exhibition presented by the Samuel Kootz Gallery in Paris at the Gallerie Maeght.

The painter who sees something that inspires him will copy it, you can be sure. He will reproduce landscapes, nudes, apples, merchants, battles, angels, hunting dogs—on one condition: that this image put him in touch with grace, glamor, solidity, whatever it is that arouses him beyond himself.

All art is, of course, subjective—or, in Leonardo's term, a mental thing. When there is a thing outside the painter's head that awakens the mental thing, the spectator may recognize it in the painting. As the painted hills speak to him, he hears also the hills of "nature." This happy duet makes painting "intelligible."

The modern painter is not inspired by anything visible, but only by something he hasn't seen yet. No super-lively kind of object in the world for him. Everything of that sort has to be put there. Things have abandoned him, including the things in other people's heads (odysseys, crucifixions). In short, he begins with nothingness. *That is the only thing he copies.* The rest he invents.

The nothing the painter begins with is known as Space. Space is simple: it is merely the canvas before it has been painted. Space is very complex: it is nothing wrapped around every object in the world, soothing or strangling it. It is the growing darkness in a coil of trees or the trunk of an elephant held at eye level. It is the mental habit of a man with a ruler or a ball of string—or of one who expects to see something delightful crop up out of nowhere. Everyone knows it is the way things keep getting larger and smaller.

All this is space or nothingness, and that is what the modern painter begins by copying. Instead of mountains, copses, nudes, etc., it is his space that speaks to him, quivers, turns green or yellow with bile, gives him a sense of sport, of sign language, of the absolute.

When the spectator recognizes the nothingness copied by the modern painter, the latter's work becomes just as intelligible as the earlier painting.

Such recognition is not really very difficult. The spectator has the nothing in himself, too. Sometimes it gets out of hand. That busy man does not go to the psychiatrist for pleasure or to learn to cook. He wants his cavity filled and the herr doctor does it by stepping up his "functioning" and giving him a past all his own. At any rate, it was knowing the nothing that made him ring that fatal doorbell.

Naturally, under the circumstances, there is no use looking for silos or madonnas. They have all melted into the void. But, as I said, the void itself, you have that, just as surely as your grandfather had a sun-speckled lawn.

1949

10 The Avant-Garde

The primary quality of avant-garde art is freshness. The advanced work represents a *new* reality, in contrast to the "eternal" reality of traditional art. It is creation in a style which, regardless of its aesthetic merit, makes creations in other styles seem not so much inferior as obsolete. One attends a performance of Varèse and marvels that listeners can still moved by the *Ninth Symphony*. This wonder, as in the presence of a world suddenly laid bare, will not last, hence a post-Varèse music will soon be demanded. But at the vital moment—and avant-garde beauty *is* a moment, a response keyed to time—there was an awakening, an opening of the eyes.

Previously published in Louis Kronenberger, ed., *Quality: Its Image in the Arts* (New York: Atheneum, 1969).

Intoxication! Here space quivers
Like a giant kiss.

Mallarmé

Poor Beethoven will never be the same again, though an avant-garde genius may discover the new in the *Ninth* and thus *renew* it, as Picasso renewed Velázquez or Pound, Cavalcanti.

Avant-gardism is an addiction that can be appeased only by revolution in permanence. Historically, the concept of an avant-garde is fused with the consciousness of a changing world and of the need for men able to anticipate and perhaps control that change—at least the portion of it (poetry, politics, sexual morality) that constitutes their field of action. The term "avant-garde" was coined by social philosophers in the period when the construction of a new order had been thrown open to competition by the French Revolution. In every crisis since, the world has echoed with the watchword of the forward-charging elite: EVERY-THING MUST BE CHANGED. This slogan has its subjective equivalent, formulated by Rilke in the 1920s: CHOOSE TO BE CHANGED. One becomes a member of the avant-garde through reaching toward things as they shall be. Every avant-garde embodies an attempt at prophecy. It wagers its survival on the relevance of its intuition of the future, of which its creations are presented as models.

In remaking the world, the avant-gardist begins by remaking himself. In avant-garde art the "I" of the artist is magically enhanced—or is wiped out by a discipline of objectivity. Modern art oscillates between the two poles of omnipotent identity and the selfless eye and brain. At the extremes, the enhancement of self and the elimination of self converge: "Expressionism" becomes abstract and impersonal, constructed art becomes "Expressionist." Speaking of the poet Mayakovsky, Trotsky said that his megalomania was so complete he became objective. Cézanne paints to "develop his personality," and his paintings become in time an impersonal filter of space.

Systematic tampering with the self is what distinguishes the avant-garde artist from the romantic genius on the one hand and the craftsman on the other. (Also from the academician who goes on trying to harmonize romantic inspiration with impersonally acquired craftsmanship.) To the avant-gardist, remaking the maker is the primary art act, the basis of style in the things to be made. Brancusi declared that to make art is easy but that the difficulty was to be in a state to make it. The artist himself is the ultimate "work," the object of a continuing creative

activity of which the paintings or poems are notes or sketches. Through him art and life are joined in a radical re-creation of forms. "Extravagant as his [Duchamp's] gestures sometimes seemed, they were perfectly adequate to his experimental study of a personality disengaged from the normal contingencies of life."[1]

The avant-garde transforms not only the present but the past as well. It ressurects energies imprisoned in the formats of outlived conventions, ideologies, and etiquettes. Aiming at refreshment, it finds the nerve center still alive in the sonnet, in cave paintings. To release possibilities inherent in patterns ossified by time, it does not hesitate to amputate and distort.

> My sonnet is A light goes on in
> the toilet window, that's straightacross from
> my window, night air bothered with a rustling din
>
> sort of sublimate tom-tom
> which quite outdoes the mandolin—
>> Cummings

Impressionism was the first art movement to elevate freshness as the sovereign aesthetic quality. Its techniques in painting and writing were designed to clear the senses and to convey their unique reflexes uncontaminated by compositional sludge. An "impression" is more vernal than an object solidly embedded in the categories of reason. But to prefer sensations to bodies requires that a taste for novelty should have replaced respect for the long-lasting in the hierarchy of values. Impressionism was antifeudal, and antibourgeois insofar as the bourgeoisie had adopted the aristocratic cut of the heirloom.

> Elle a passé, la jeune fille
> Vive et preste comme un oiseau:
> À la main une fleur qui brille,
> À la main un refrain nouveau.
>> Nerval

Subordinating intellect to the pulsations of the sense organs, Impressionism already contains the core of primitivism present in most modern avant-garde movements. Product of a highly sophisticated aesthetic culture, it disciplines the eye in a preference for the half-formed and crudely delineated, for a sketchiness that flouts the logic of confining contours in favor of passages of color animated by mood and feeling. With Impression-

1. Gabrielle Buffet-Picabia, in Robert B. Motherwell, *The Dada Painters and Poets* (New York: Wittenborn, 1951).

ism the identity of objects is on the verge of disintegrating into a single field of vibrations. Later, Mallarmé deepened the enchantment of ambiguous presences by stripping things of their bodies in order to leave them fluttering like rags in a landscape of metaphors.

Oriented toward the future, avant-gardism is a mode of sensibility that experiences existing entities as foreshadowings—it sees in Cézanne an anticipation of Cubism, in a Cubist painting an early phase of an art that will grow increasingly mathematical. In the avant-garde mind, objects, people, events keep disappearing into the future, are already half vanished at the moment they are apprehended. In their flight they are signals announcing forms still unrealized. Behind modern things is their being-to-come, as behind things in the jungle is their "spirit." All vanguard art is in some degree symbolist and keyed to abstraction. What seems to the ordinary mind solid fact is with the avant-gardist infiltrated with process. Besides being itself, each phenomenon represents the principle by which all such phenomena, or our responses to them, are regulated. In a scrap of newsprint one may see as in a crystal the industrial system, the workings of the unconscious, the impact of electronic communications.

Thus, avant-garde creations have the quality of ephemeralness. Both in the subject matter of the works and in their physical character, three-dimensional substance gives way to images cast upon the screen of time. The bodylessness of modern art, whether represented by the "flat" dramatic persons of Joyce or Beckett or the two-dimensional compositions of Braque or Mondrian, has, since the dawn of vanguardism, drawn the fire of "humanists"—including "humanists" of the Communist "vanguard of the proletariat," such as George Lukács; to them the characters of Dostoevsky and Proust, the figures of Picasso and Miró, are mere flickering wraiths, aesthetically inferior to the monumental personages of Balzac and Tolstoy.

The qualities cherished by the avant-garde make the question of the "weight" of a work of art highly relevant. Vanguard sensibilities are captivated by lightness, as by freshness, sketchiness, and ambiguity. With Simone Weil *"la pesanteur"* was the opposite of *"la grace,"* and to Buckminster Fuller the continued high tonnage of city skyscrapers is a sign of the backwardness of contemporary architecture. In contrast, humanists, regardless of their political ideologies, respect entities that are firmly grounded in an unshifting order, and they are appalled by the flimsiness of a world composed of energies (psychic or physical), actions,

The Geography of Modern Art

and space-time intervals. In the opinion of humanists of both the left and the right, change must be geared into the material foundations of society, and the idea of a rebellious art, or an art anticipating transformations still not fully perceptible, is repugnant to them. To the humanist the transitoriness of works in the modern mode embodies not a radical response to the dynamics of social and physical reality but a decadent wish for death and disintegration. Nor can he appreciate that the weightlessness introduced by vanguard art has made possible vital fusions of human and natural data, as in *Finnegans Wake* or the poems of Rilke.

> And the flutes of the sea sing through my veins.
> Tzara

Still, it cannot be denied that in the modernist universe of psychic states, forces, and processes the individual is devalued. A human being, an object, a work is meaningful not for itself but through its position in the scheme by which future reality is being shaped, whether that scheme is the new social order of some revolutionary ideology or the changing order of poems which T.S. Eliot characterized as "the poetic tradition." A vanguard painting is not only itself; it contains the paintings that will be influenced by it. Should there be none of these, the significance of the painting shrinks to zero. Seeing particulars in the perspective of their historical outcome, the avant-garde has brought into being the arrogant notion of the utterly worthless. Works, actions, persons, whole races for whom the future has no use are cast upon "the rubbish heap of history," and the sooner they are gotten rid of the better. The elimination of historical discards is a necessity of sanitation, and the ability to recognize this necessity and the courage to respond to it are among the qualifications of the future-building elite. As the personification of the advanced forces of time, the avant-garde is thus obliged to adopt ruthlessness as a moral principle, the ruthlessness dramatized by Raskolnikov in eliminating the old-woman pawnbroker as a "human louse." The Nietzschean strain in avant-gardism is expressed in the following musical passage from Canto XXX of Ezra Pound:

> Now if no fayre creature followeth me
> It is on account of Pity,
> It is on account that Pity forbiddeth them slaye,
> All things are made foul in this season,
> This is the reason, none may seek purity

Having for foulnesse pity
And things growne awry...

Time is the evil.

Here pity, which preserves "foulnesse," is the enemy of freshness. Shock, another outstanding quality of avant-garde art, often arises from the compulsion of the avant-garde to wipe the slate clean. The newest movement passes the death sentence on the doings of predecessors and reviles contemporaries of opposing tendencies as living corpses. The rule of no quarter for the outlived reached its extreme in the Dada denunciation of art itself and of reputations formerly regarded as sacred, as in Picabia's pin-up of a stuffed monkey labeled Cézanne, Renoir, and Rembrandt. But in all the avant-gardes, demolition is an accompaniment of innovation. The vanguards are by nature combative. Each is bent on destroying its rivals, and stands on guard against being replaced. Thus the vanguards have infused into art the passion and momentum of radical politics. Their intellectual do-or-die is among their major contributions; it has restored seriousness to the arts and prevented them from degenerating into mere crafts under the pressure of the industrial age.

The chief antagonist of the avant-garde is the middle class. The vanguard is committed to change, but during the epoch of the avant-gardes (the nineteenth and twentieth centuries) it is the middle class that has actually transformed both nature and man. Hence every avant-garde movement is defined by its relation to that class, its outlook and preconceptions. Bourgeois change is dominated by the static fact of property ownership. Thus, against the actualities of change limited by the need to preserve property, the avant-gardes demand the realization of ideas measured only by their own logic. Against the pragmatism of the proprietors, they counterpose the unhampered conceptions of the mind. In sum, against the slowly developed bourgeois social and aesthetic forms, they advance the claims of their elites.

Since the middle class is the rival of the avant-gardes in deciding what the world shall be, the thinking of the avant-garde is specifically antibourgeois. The intellectual history of the vanguard movements is the history of their degrees of hostility to middle-class society, a hostility that extends from outright assault to self-exile. With the future at stake, indifference is excluded. An avant-gardist who ignores conventional opinion wishes it known that he ignores it; his indifference to middle-class values is a maneuver in a war of nerves. Avant-garde art may be defined as art in the creation

of which awarenes of the presence of the middle class as audience is an essential ingredient. The avant-gardes are actors in the bourgeois drama. To be obsessed with the conformity of the middle class, the baseness of its tastes, its concupiscence and frustrations, the clichés of its sentiments and ideas, the absurdity of its politicians and military men, the hypocrisy of its preachers, the chicanery and petty careerism of its intellectual representatives is to be avant-garde a priori. Periodicals such as *Scrutiny* and *Evergreen Review*, although at opposite poles in style and values, are alike in that their basic content consists of an avant-garde harrying of the middle class in regard to its aesthetic prejudices and moral weakness.

The tie between the vanguard and the middle class becomes visible in the processes by which the movements expand and develop their singular idioms and costumes. Attracting the attention of the bourgeoisie and its patronage becomes, increasingly, the major concern. The result in every case is a dilution of the movement and a dulling of its edge. In the last analysis, all modern art movements are movements toward mediocrity. It is their destiny to be absorbed into bourgeois life, or, in the case of the Bolsheviks, to develop forms corresponding to those of bourgeois life. This may explain why most of the advanced thinkers, writers, and artists of the past century and a half, from Marx, Rimbaud, and Van Gogh to Picasso, Klee, and Kafka, have preferred to function *on the fringe of the avant-garde* rather than as members of a movement, and even to abandon movements which they themselves initiated.

Joined to the bourgeoisie by bonds of antagonism always on the verge of being transformed into love—for example, the ex-bohemian painter who admires the courage of collectors of vanguard art—the avant-garde plays upon the nervous system of its partner like a dissatisfied wife. Its basic ruse lies in evoking the nightmare that new universes have come into being of which the middle class knows nothing but which threaten it and are shaping its future—the latest application of this ruse is the communications theories of McLuhan. Through works inducing shock, mystification, and a sense of crisis, the avant-gardes loosen the grip of outworn social, moral, and aesthetic dogmas—for example, that color in painting must conform to the color of things.

In their sweeping away of ancestors and their undermining of bourgeois self-confidence, the avant-gardes embody the cruelty and tragedy of modern life, that is, of life trapped in the consciousness of the dissolution of forms and the temporariness of

things. The stimulation of metaphysical uneasiness is an inevitable effect of avant-garde creations. Uneasiness is a more fundamental effect than shock, for it is the quality of the artist's relation to himself; whereas shock, when deliberately induced, is a way of playing upon an audience and may therefore be an evidence of careerism. No work is avant-garde that does not induce uneasiness, at least to the extent of arousing doubt that it is art, and once its effect of uneasiness is lost the work ceases to be advanced. Thus the painting and sculpture, now in vogue in modern-art museums and international exhibitions, that claim to be avant-garde through their handling of formal problems are disqualified on the grounds of complacency.

There is an affinity between shock and freshness in that both occur when the mind has passed its customary boundaries. This condition gives rise to another typical avant-garde quality, that of estrangement or cultural distance. Every genuine vanguard movement begins as an adventure into the unknown. Self-displacement, either as physical exile or as psychological alienation, is a recurrent experience of the avant-gardes, an aspect of their combat with the social environment and the immediate past. One of the earliest vanguard appeals to abandon this "exhausting landscape" is the poem of Baudelaire significantly entitled "Le Voyage"; it ends in the vow

To plunge to the bottom of the abyss, Hell or Heaven who Cares? At the bottom of the Unknown to find the new.

In avant-garde thinking, movement, the "Open Road," is at once an escape and a malediction hurled at the "dark confinement" (Whitman) of social artifice. Strangeness arises either from a journey to the exotic place or from recasting existing form; that is, it arises either from travel or from revolution. Thus vanguard internationalism spreads its wings over rightist globetrotters (Salvador Dali) and subversive professors (Sartre). Painters from Gauguin to Klee and Gottlieb travel in fact and idea to alien islands, cultures, and solar systems; while Rimbaud inscribes on modernism the slogan "I is another" and takes figurative leave of Europe in his "drunken boat." Migrations to virgin lands complement flights to unexplored outposts of the mind, and both species of "distancing" come together in Rimbaud's gun-running expedition in Abyssinia, in the immersion of the two Lawrences in the civilizations of Arabia and Mexico, in Malraux and Hemingway circling the globe in pursuit of proletarian insurrections, and in Eliot and Pound becoming, in Wyndham

Lewis's happy epithet, "time travelers" to the sites of superior cultures. As avant-gardism in the form of light shows, mixed-media performances, and discothèques becomes a style in the mass-entertainment repertory, its principle of displacement is realized through the "trip" supplied by drugs, which provide American youths with a stationary alternative to the Peace Corps.

The avant-garde quits or negates the industrial civilization of the West in order to conquer new psychic territories in which physical nature rules. A Surrealist map of the world drawn in 1929 omits the United States and shrinks Europe but vastly enlarges Alaska, Russia, Mexico, Labrador, and the Easter Islands. There is in the avant-garde sensibility, from the nineteenth-century colorists to the latest psychedelic effusions, a strain of lushness inimical to classical-Christian measure, a desire to revel in sheer sensuousness, in an invocation of eros and nakedness as an antidote to the complex and rigorous routines of civilized life. This hunger for substance-denied manifests itself in the disposition to reduce each art to one essential element, the impact of which will not be diffused by secondary effects. Painting is reduced to color, music to rhythm, poetry to exclamation.

> Qu'il vienne, qu'il vienne,
> Le temps dont on s'eprenne!
> Rimbaud

Van Gogh dreams of trapping the despair in the green of a billiard table, Rimbaud of exposing the "latent births" in the hues of the vowels. "A touch of the finger on the drum," cries the latter, "awakens all the sounds and starts a new harmony." The mediums of the painter or the musician are transformed by energies infused into them by the disorders of the psyche and metropolitan environments. In time, paint and canvas begin to give way to sheets of newsprint and wallpaper, industrial products, discarded objects, projected light; the poetic figure of speech is replaced by catch phrases and advertising slogans; and the musical passage is put aside for patterns of noise.

The reduction of the arts to their material components corresponds to an awareness of the decomposition of inherited art forms, an awareness that keeps growing constantly more acute. A young contemporary composer, Morton Feldman, states the proposition that "sound *in itself* can be a totally plastic phenomenon, suggesting its own shape, design and poetic metaphor" (his italics). Equivalent ideas are presented in painting and sculpture by "colorist" abstractionists and minimalists, and in

literature by practitioners of "concrete poetry" (arrangements of words and letters which create a visual effect). Art reduced to its elements (so-called "pure" art) is regarded as the antithesis of the "media mix" responsible for assembled sculpture, happenings, rock music. Actually, both purist and adulterationist avant-gardism stem from the conviction that existing forms of painting, poetry, and music inevitably distort experience and that it is necessary to start afresh with the raw matter out of which a painting or poem is made. To frustrate the senses by diminishing painting to a few bands of color, or to overwhelm the senses by a color-light-film-dance-noise mix—these are equally emphatic affirmations of the absence of meaningful form. The medium itself becomes the "mind" that, as Feldman asserts, "suggests its own shape, design and metaphor." In sum, it delivers its own substance as its "message."

To be drunk with colors, sounds, words accords with the avant-garde conception of the artist as a civilized savage (*"Moi, je suis barbare,"* says one of Dostoevsky's characters to a "Monsignor" in Paris), whose work communicates with the savage "other" (the repressed, undeveloped, or unconscious self) in each member of his public. But dissociating the physical substances of the arts is consistent too with a taste for exactly calculated effects flowing from precise causes, that is, with the affiliation of the arts with the sciences. From Poe's theory of poems as quantities of sounds and syllables assembled to stimulate preconceived moods in the reader, through Rimbaud's "alchemy of the word," Seurat's programmatic disposition of spots of color, and Valéry's practice of poetry as a "game" analogous to mathematics, to the present-day chase after new materials and kinetic devices in painting and sculpture, art vanguards have tended to crystallize around discoveries in the sciences—optics, political economy, anthropology, psychoanalysis—and to designate their activities as "experiment" and "research" rather than art. In its will for a new world, avant-gardism is drawn to the sciences (though it may attack "scientism" and the calculating intellect), as it is drawn to mysticism and magic (though it may denounce superstition) and to distant Edens and Utopias (though it prides itself on dealing with realities). "We surrealists," wrote Salvador Dali, "are not exactly artists, nor are we exactly real men of science. . . . Like the sturgeon we are carnivorous fish who swim as it were between two waters, the cold water of art and the warm water of science, and it is precisely in that temperature, and swimming in that current, that the experience of our life and our foundation

reaches those murky depths, that moral and irrational hyperlucidity which can only be produced in the climate of Neronian osmosis." It is interesting that Dali should have thought of science as warmer than art, which implies that it is closer to living beings. In conceiving itself as the outpost of human experience, the avant-garde tends at times to be overcome by the chill of abstraction and to envy vocations, from voodoo priest to steeplejack, that more directly impinge on life.

The self-consciousness of artists in the face of the more effective intellectual procedures of the sciences, as well as their attraction to the simple absorption with things of the man of action, accounts for the anti-art outbursts that mark the history of avant-gardism. The conviction that in modern times the life of the arts is hanging by a thread goes far deeper than the assaults of Dadaists and Constructivists and the recent attempt to amalgamate the arts into the mass media. Long before the vanguardism of the twenties had made contempt for art the test of avant-garde authenticity, Dostoevsky questioned the credentials of art as a serious activity. "The apparent impotence of art," he wrote, "made me wonder about its usefulness. Indeed, trace a certain fact in actual life—one which at first glance is not even vivid—and if only you are able and endowed with vision, you will perceive in it a depth such as you will not find in Shakespeare."

A fact "not even very vivid" which leads to profound discoveries suggests occurrences in the laboratory. Such a fact reappears in Cézanne's concept of *"la petite sensation"* which gives a clue to the painter. The opening out of forms from "tracing a certain fact" (exemplified by Proust's unfolding a world from the flavor of the madeleine) implies the obsolescence of traditional art modes—"depth" no longer lies in traditionally ordered relations of the parts to the whole, in attaining a divine or rational harmony; it is achieved through grasping the interaction of phenomena upon one another. We have reached the modernist domain of the mixing of art and life, out of which has emerged the concept of the masterpiece which must, like nature and history, remain unfinished (Gide's *The Counterfeiters*, Kafka's *The Castle*), or which is a compound of significant fragments plucked from the art of the past and from everyday events (Pound, Eliot, Joyce). On the one hand, countless new forms lie hidden in phenomena accessible to the naked senses, to the microscope, to introspection; on the other, discovery of the new cannot be confined to art but calls for what Rimbaud termed "magical studies."

In response to this unbounded universe of data, advanced art has devised various techniques of *transformal improvisation,* increasingly important in the vanguardism of the past fifty years. Experiments, from Surrealist automatism and chance combinations to Action Painting spontaneity and attempts at "object" art, have demonstrated that no such thing exists as pure fact or pure form, that immediate perceptions are mixed with bits of "art" that have persisted in the mind like buried ruins of old civilizations.

Taken as a whole, avant-gardism is an aspect of the modern historical consciousness. It is an attitude founded on the constant awareness of the birth, blending together, and passing away of creatures, styles, values—the attitude which Eliot attempted to sum up sardonically in the refrain of "Sweeney Agonistes":

> Birth, and copulation, and death.
> That's all, that's all, that's all, that's all.

The qualities of avant-garde art which we have been discussing represent phases of life as seen in the historical perspective: the freshness of new forms, the estrangement of the transformed, the blankness of the superseded. Ultimately, it is by their synthesis of these phases, and by the tensions they put into play between the new and the old, that avant-garde works are judged. Picasso, for example, and Joyce grasp "the nightmare of history," yet their enthusiasm for the contemporary world overcomes the "aging" produced by their use of quotation and parody. In contrast, Eliot, backing away from the new, exaggerates the pitch of his estrangement and sense of doom. The orientation of all vanguardists is toward the new, whether in hope or antagonism, but what "new" encompasses in each instance determines the content and tone of the work. The range of references—formal, factual, metaphoric—to past and present and the emotional textures which these references take on come as close as possible to providing a single measure by which to compare creations as widely different as a Moroccan interior by Matisse, Jarry's *Ubu Roi,* and Rilke's "Orpheus" sonnets.

In all its qualities—ephemeralness, shock, exoticism, competitiveness—avant-garde art is haunted by fashion, the chief resources of which are also novelty and attention-getting. In its ambition to influence change, the avant-garde cannot repudiate fashion, which serves it as a recruiting agency. In becoming fashionable, an avant-garde, no matter what its outlook, attracts to itself a segment of that floating clientele for novelty which is

found in all the capitals of the world and which is today bound together by a global network of semi-esoteric communications. In winning the allegiance of this indeterminate mass which constitutes the vanguard audience, the aesthetic vanguard spreads its views in ever widening circles and enters into the current of world thought and taste. Adoption by fashion is the gateway to prestige, wealth, influence, and, above all, a place in history.

But in entering the world of fashion the avant-garde finds itself in a trap. Fashion injects vanguard creations with a transience different from the epochal span that each avant-garde expects its revelations to define. In the fashion world, freshness and shock do not represent the emergence of the new but are mere artifices for refurbishing the familiar, as in the instance of the "daring" neckline. Hence, to collaborate with taste molders is to accept being reduced to a reflection in the mirror of public faddishness. Moved by their appetite for publicity and by the counter-impulse to defend their exclusivity by an exaggerated esotericism, avant-garde movements tend to split apart in clouds of accusations of opportunism, posturing, and bad faith. Two years after its birth, Dadaism was torn by furious disputes concerning its own history—who did what? who did it first?—and such questions as who is genuine, who a renegade. The movements are doomed to an early death by the conditions of their social existence, and this has been the case with every avant-garde from the Impressionists to the hippies.

As the information media have grown more sophisticated regarding the role of culture in public life, the period required for "fashionablizing" an avant-garde has become shorter and shorter, until today the duration of a vanguard *qua* vanguard is about equal to the length of time it takes for it to form itself, that is, an interval approaching zero. (Vanguards tend increasingly to make their public debuts in a half-developed state.) Almost from the moment of its birth, a vanguard movement now becomes identical with the social reflection of it in the organs of publicity; and vanguardists and their audiences are merged in a common pattern of responses to purveyors of information to the general public—for example, when Pop artists and their patrons appear together on TV to explain the significance of Pop.

In sum, avant-garde today means a flurry of fashion, whether in painting, sex, or insurrectionary politics. Freshness is replaced by the recombination of familiar elements aggressively marketed as new, and shock has been all but abandoned as unattainable. (Occasional attempts at shock by revivers of avant-garde move-

ments produce not uneasiness but nostalgia.) Current avant-garde styles identify themselves less by their programs than by jargon and costume, and the tendency, as expressed in the comparatively huge circulations of such publications as *Evergreen Review* and *The Village Voice,* has been to blend together elements from past vanguards, aesthetic and political, into a habitual mode of expression for a wing of the mass public.

In general, the ideas, attitudes, and tastes of a century of vanguards have now coalesced into a single tradition. Like all traditions, that of vanguardism stimulates automatic responses, as illustrated by the wholesale admiration by the vanguard audience of the products of conflicting art movements from Fauvism to Minimalism. But while the vanguard tradition can be a means for avoiding thought, it also provides the vocabulary in which the modern sensibility responds actively to the radical events of our time. In the ideological debates, slogans, entertainments, and grafitti of students' revolts both here and abroad, the undifferentiated avant-gardism of the present popular phase manifests its intellectual ferment. It remains to be seen whether the heritage of advanced art and thinking can be extended without giving rise to new self-segregating elites.

1969

11 1914

What could be luckier for an art institution than to have its fiftieth anniversary fall in 1964? An occasion is provided to look back to the year which most people agree was the turning point or watershed that separates the twentieth century from a past as remote in some respects as the Age of the Caesars. So much was smashed by the guns of August that the West has never been the same since, nor, because of the alteration of its most "advanced" portion, has the rest of the world. Yet, how different is the art of today from the work created on the edge of the big break-up? Which of the novelties of contemporary art belong specifically to our half century of catastrophes and Utopias, and

Originally published in *Art News Annual* (New York: Macmillan, 1964).

which of those that seem to belong to this unique period of crisis were already there before it began?

Founded fifty years ago, the Baltimore Museum has taken advantage of its date of birth to assemble a huge exhibition of paintings and sculptures (some 250 by 115 artists) created in 1914. It is interesting that the show was suggested by a philosopher, George Boas. Dr. Gertrude Rosenthal, chief curator of the museum, planned the exhibition not as an over-all survey of what was being done in 1914, but as a choice of work which "in 1964 has retained its validity and artistic importance." In short, the show was organized in the perspective of NOW, not as a reconstruction of THEN. It brought 1914 and 1964 as closely together as possible, thus emphasizing the vital issue of resemblances and contrasts.

An interval of time is composed of layers of past, present, and future. Dr. Rosenthal found that art in 1914 belonged to three categories: paintings and sculptures in styles of the nineteenth century, transitional pieces, and avant-garde. The inclusion of nineteenth-century modes allowed a generous representation of Americans—with such artists as Sargent, Eakins, Hassam, and Davies added to vanguardists like Dove, Lachaise, and Hartley, they constitute about a fourth of the artists shown. The work of most of the Americans is no doubt "valid," but I'm not sure about the artistic "importance" today of Sargent or Hassam. Be that as it may, what concerns us specifically about the year 1914 is not nationality nor the quantity of good art accumulated in that year, but how far ahead the avant-garde of a half century ago was able to reach from that historical plateau—the degree of vision, accomplishment, and renovation in attitude attained by the list that begins with Archipenko, Arp, Balla, and goes through Chirico, Duchamp, Malevich, Picabia, Kandinsky, Matisse, Mondrian to Severini, Joseph Stella, Weber.

What is immediately (and somewhat disconcertingly) apparent is that the advanced art of 1914 was far advanced indeed. Art history holds that, looking forward from 1914, the following art movements were still to come: Dada, Surrealism, Social Realism, Abstract Expressionism. None of these modes, however, made any startling contribution to the formal repertory of 1914, in which Fauvism, Cubism, Futurism, and Expressionism were already in full bloom. Besides, some of the effects of Dada (and of later neo-Dada street art) were anticipated at Baltimore in Malevich's *An Englishman in Moscow* and by Picabia's paranoiac mathematics. Surrealism and *art brut* were present in Chagall's

The Acrobat and in Picasso's pencil sketch of a seated man, which combines Cubist plane construction with automatic drawing, much as Gorky was to do hesitantly twenty years later. The thesis of Abstract Expressionism was stated by Kandinsky (*Painting No. 199*) and with somewhat less assurance by Marin. There was even an Expressionist *Self-Portrait* by Edwin Dickinson that called to mind recent heads by Lester Johnson.

A cross-section of what might be the typical art exhibited in a season of the sixties was fairly thoroughly covered by Baltimore's 1914 exhibition. Color areas and masses played against one another were there in La Fresnaye and Morgan Russell; dynamic abstraction in Balla and in Stella's rotating *Abstraction—Mardi Gras*; calligraphy in Mondrian; organic shapes in Brancusi and O'Keeffe; geometrical reduction in Malevich (*Suprematism, 18th Construction*); gag art in Duchamp; rhythmic linear composition in Klee; emblem painting in Hartley. In sum, 1914 already possessed its plasticists and handwriters, its Pop- and gag-artists, its *art-brut*ists and hard-edgers, its romantic landscapists and scientist decorators. With present-day production, from Dubuffet to Robert Indiana, from Noland to Jenkins, thus invoiced for delivery, what was missing among the ancestors except the actual working-out of the variations?

Or, put another way: what's new in the art of fifty years of crises and revolutions in the human condition? The answer is: in terms of formal innovation, not much.

The art represented by the items gathered in Baltimore laid down the canons of modernist aesthetics. The formal insights there exemplified have been carried forward bit by bit along logically predictable channels in the great proportion of paintings and sculptures created since 1914. Abstractly considered—that is to say, apart from the content supplied by particular artists—the vanguard art of 1914 foresaw everything. Perhaps to an artist who could read the signs in the intellectual soil enriched by the ideas of Marx, Nietzsche, Freud, Einstein, and Bergson, the transformation of all existing relations was already a fact—one to which the large actions and collapses of the next fifty years could add only physical confirmation.

The one new thing that remained to be done was for the artist to attempt to project himself into the changed historical situation foreseen in the transmutation of art forms. He could do this either through abandoning art or through making his art part of the action. It is notable that all the post-1914 art movements either attacked the art idea (Dada, Surrealism) or surrendered

it in favor of an aim beyond art (Social Realism, Abstract Expressionism). By contrast with the art that occupied the vanguard positions in the following decades, the Baltimore exhibition, even including the entries of Duchamp and Picabia, was eminently an exhibition of *pictures.*

The 1914 canvases and sculptures are representations of things, or conceptual renderings of how things are. They evince an unmistakable confidence in a world, including, as in Balla, the world of astronomy, or, as in Arp or Goncharova, the world of signs, and there is confidence in the ability of art to take hold of the world and even to change it. A few of the artists, the Germans especially, communicate social unrest: the paintings of Dix (*Cannoneer*) and Klee (*The Desperate Ones*), the portrait of a man by Meidner, are as loaded with angst as any mid-century composition. But even these affirm the world in deploring its state. Mostly, there is a firm belief in the creative idea as manifested in the discovery of new potentialities of the art mediums. Redon's pastel *Flowers and Butterflies* requires nothing more than to be admired for the beauty of its hues and tones, nor does Picasso's *Still-life with Table* ask more than response to its vivacious play of planes and lines.

In sum, 1914 was the last year before the Age of Doubt. The subsequent breach of continuity occurs not in the manner of the art, but in the attitude of art toward itself. Van Gogh in his deepest misery retained the hope that art could save him. I lack proof that no painting or sculpture done in 1914 is as agitated as *Woman I* of de Kooning. But I do not hesitate to say that no painting in the Baltimore exhibition was as disturbed by doubt about both art and reality. Or communicated so deep a sense of displacement. Nineteen-fourteen art is more adventurous aesthetically than that of the epoch that followed, in that it arose out of a revolt still in its springtime and which might have come to naught. Yet it ran its risks on the solid ground of belief in the worth of art and its tradition. Today, even the more credulous creations are comparatively uncertain in mood; the imagination is drier, more self-conscious, even apologetic. We have no young painters psychologically comparable to the Chagall, Chirico, Macke of those days—the last with that sort of temperament was Baziotes or, say, Balthus. Francis Bacon is at once more conventional in form and more metaphysically depressed.

In short, the difference between 1914 and 1964 is primarily a difference of spirit. Three years after the work exhibited in Baltimore was executed, Dada had begun to probe the irreparable

crack in Western civilization produced by the war. Since then, the sufficiency of art as a groundwork of values has been under attack by the strongest talents. Into the vacuum created by this negative insight has entered the radical social, psychological, and metaphysical content by which the modes of 1914 have been transformed from within. A typical collage of 1914 is Carlo Carrà's *Pyramidal Construction,* with its strictly aesthetic statement; by 1919 collage was being used by Schwitters for the socially eloquent *Unbild* and the *Merzbild* and "construction" was being parodied in the junk-built *Merzbau.* From the Cubist portraits and still-lifes of 1914, Picasso was to venture into classical myth in the 1920s and into the political diatribes of *Guernica,* the Peace Dove, and *Korea* of the thirties through fifties. The mechanical fantasy of Duchamp's *Chocolate Grinder* was to lead to his exile's valises of the thirties and to his retirement into chess. The aromatic vibrations of Redon would reappear as the ritualistic whispers of Rothko; the reductive analysis of Mondrian's *Composition 8* was to eventuate in his total exclusion of visible nature and the organization of his canvases as models for rational cities.

The forms of 1914 stand today as the aesthetic tradition of twentieth-century art. All major innovations of the past fifty years are innovations of content within already established idioms. Such innovations have come about largely through transformations of motive, whether in Gorky's translations of Picasso or Newman's of Mondrian and Malevich. Ignore the specific action element, the psychology, the politics, the metaphysics in post-1914 art, purge the content of the new compositions, and you have left only decorative variations of the forms of fifty years ago—in short, works of the modernist Academy. How impressive in their scope are the originating creations of this Academy—and it is precisely their richness in suggesting forms that can be derived from them that misleads critics and artists into discovering innovations in every contemporary parody—was evident in the samplings of the Baltimore show.

1964

12

The Academy in Totalitaria

A distinction needs to be made between academic art based on classical and Renaissance models and the academizing process by which all styles are in time tamed and made to perform in the circus of public taste. Academic art is exemplified by Mac-Monnies' *Civic Virtue*; the academizing process by the conversion of Pollock's drip paintings into teaching aids for cool canvas-stainers. People who speak of "academic modernism" or the "modern academy," meaning run-of-the-mill Abstract Expressionism, Pop, or Op, confuse the academic convention with art that has become conventional through the academizing process. The true academician will fight like the devil against conventions

Previously published in Thomas Hess and John Ashbury, eds., *The Academy* [*Art News Annual*] (New York: Macmillan, 1963).

other than his own no matter how old hat his is. To him the question is, "At what point did art history go off the track?" And his answer up to now has been: "After Impressionism." Picasso, to the academician, is still a faker, Braque and Mondrian, rug designers: they have violated the canons of Beauty and verisimilitude and nothing that has happened, or that can happen, in art or in the history of mankind will ever redeem them.

Compared to the academician, the academic modernist is an aesthetic rebel, that is, one who modulates an authority derived from the past with the superstition of Progress. Modern art is inconceivable without an impatience, at times amounting to disgust, with that vast pile of gilt-framed or marble-pedestaled images of noble and powerful personages, allegorical dramas, glorious landscapes, and piazzas known as the Art of the Past— impatience even with the best of it. The task of the modernist academician, whether painter or critic, is to behave as if this impatience never existed, or, if it did, that it is illegitimate. Like the academician, the academic modernist believes in Beauty— the word, as well as the word "inspiration," has lately been reappearing among vanguardist aesthetes—and he too cannot tolerate art that has gone off the track. But he swallowed Picasso and Mondrian long ago and is convinced that by a teleological magic Beauty changes to correspond to the kind of art called for by his aesthetic timetable.

Between the genuine academician and the academic modernist, the former is by far the more serious—his views by their very nature verge on the political, and solicit practical support from conservative social forces (including conservatives who count themselves as progressives and even radicals). The academic modernist merely slows down the pulse of art by functioning as a coagulant of its vital fluids; he represents the natural slackness that overtakes periods of creation. The academician wants to stop certain things from happening in art, and he believes that society ought to help him accomplish that aim. He is an embattled idealist, a believer, potentially militant, in a set of values capable of surmounting the "decadence" of the times. His position is fixed; he stands rooted in the eternal, as embodied in rules and procedures abstracted from the masterpieces of all the ages— in his imagination the art of Greece, Egypt, Babylon, the Far East, and the Renaissance have been fused into a single substance. The academician opposes modern art, not out of love for the past (which is, after all, the present of those who came before), but out of distaste for all periods, except insofar as they appear

in forms uplifted by art. It is as the representative of this up-lifted sphere that the academician offers his services to the rich and powerful, as well as to the pious masses. His art is a mold in which personages and events may be reshaped into glory. Unlike the academic modernist, who is a mere purveyor of the fashion-able, the academician, like the priest, holds the keys to eternal life, to a grandeur above history.

The affinity between the academy and totalitarianism lies in their common wish to transcend the modern world. Both seek to legitimatize themselves through affiliation with noble ancestors. In a cathedral in Braunschweig a few years ago I was shown the tomb of Henry the Lion, a medieval German nobleman whom Heinrich Himmler had elected as his historical alter ago—identi-fications of this sort meant big commissions for the sculptors and architects of the Third Reich. In this revivalist aspect of total-itarianism the academy is its natural ally, although individual academicians may be morally repelled by the repressive activities of the patron State.

It was during the first modern-style totalitarian regime, that of Napoleon III—described by Karl Marx as a "regime lifted above classes"—that academic art, the art lifted above the real, reached the height of its prestige and blew itself up into an inter-national style. The *luftmensch* Emperor, in whose reign the bal-loon became a topic of popular interest, was the grand patron of academic painting and sculpture. Napoleon the Little needed to inflate himself with the prestige of Napoleon Bonaparte as Cabanel needed to evoke Titian.

Bonaparte himself had needed to resurrect the noble Romans; even in their revolutionary heyday, Marx pointed out, the bourgeoisie could not play their part in history without dressing up in old costumes. The spirit of the academy thus hovers over the modern state as the expression of the will of its rulers to elevate themselves above the social realities of the time. The refusal of artists since the middle of the nineteenth century to serve as accessories to the transcendental masquerade of bour-geois political, military, industrial, and religious powers is at the root of the split of the art of our epoch into academic and modern.

The fact that twentieth-century totalitarian political parties have without exception (though in varying degrees of fanaticism) chosen academic art as their official mode exposes far more de-cisively than any analysis of their ideological statements the fraud-ulence of their revolutionary pretentions, their fear of change, and the half-demented impulse of their leaders to perform under

the shadow of super-historical doubles. The situation is summed up in the portrait of Hitler by Fritz Erler. The Führer, standing on a parapet in no-place, a construction no doubt commemorating the talents of Adolf the Architect, in his concocted uniform with hat and gloves held properly in his hands, could be anything from a marshal of the Wehrmacht to the chauffeur of a fashionable actress. Behind Mr. Anybody, however, looms the mythical hero in stone profile, an eagle on his palm like a bomber on the deck of an aircraft carrier, and with a mace or a fasces in his other brawny fist. "Never," said Hitler in 1937, "was humanity in its appearance and in its feeling closer to classical antiquity than today."

A similar conviction about the resemblance of the present to the classical past (a resemblance celebrated in the theory of "Marxist Humanism") animated the Soviet Union when it drove out or silenced its "Leftists," artists like Kandinsky, Malevich, Tatlin, Rodchenko, and (long before Molotov and von Ribbentrop signed their pact against the democracies) encouraged an art that would in time blend with that of the Fascists and Nazis. In the USSR academicism had to struggle against the conscience of a generation of radical intellectuals who shared Marx's contempt for idealization and hero worship. This handicap was soon liquidated, however, by the megalomania of the party leaders and by the Bolshevik obsession with providing edifying models for the masses. At the outset of the Revolution the majority of the academicians had run off with the Whites; it was only after the White counter-revolution had been defeated that many began to filter back. But it was they who represented Art to the Communist leaders, not the radical painters and sculptors who had ranged themselves on the side of the upheaval (a similar relationship developed in New York in the thirties when the Communist-organized artists and writers "Congresses" pushed the left-wing painters and poets out of sight in favor of commercial illustrators and Hollywood script writers).

There was an element in Lenin's philosophy that closed the door on modernist experimentation in art, and traces of it even in Trotsky. But it was under Stalin that the academy developed the exclusive power by which Russian art is still strangled. Soviet painting and sculpture, at first restrained from indulging in the ugliest aspects of academic transcendentalism by the Socialist tradition and the Russian folk spirit, were soon loaded with demigods manifesting themselves in humble settings—in its sheer bathos Efanov's double portrait of Stalin and Molotov among

the daisies needs only an outdoor barbecue and Nixon's dog to be a match for anything in American election-year publicity.

To suppress the actualities of contemporary life, totalitarian academicism transposes them into school-book illustrations. The picture of the hero as educator reappears again and again; it is a motif into which the academic artist as tutor of the ideal can wholeheartedly project himself. Hitler brings the word to representatives of all classes; Lenin, according to the lying painter backed up by Stalin, exhorts the workers, peasants, and soldiers; and an academic painting in the Tretyakov gallery lectures Red Army men on Art.

A painting superior to the general run of Social Realist illustrations, Gerasimov's *Lenin on the Tribune,* raises the ante by sinking the crowd way down in the distance and directing the hero's address, Prospero-like, toward creatures of the upper air: waves of the Red Banner assume the shape of the sea and a ship —which Lenin, mounted above history and already transformed into a figurehead of the revolution, rides like Nike, goddess of Victory.

Educating the masses and inspiring them to more heroic efforts are the stated purposes of totalitarian art programs, and the pictorial and symbolic idealizations of academic art are, of course, best suited to this end. In the democracies most of the functions of educational and propaganda art have been taken over by commercial studios. But there is one thing that commercial art cannot do, and that is to elevate ruling personages and selected historical events into the lasting realm of Great Art. It is to preserve the immortalizing power of "fine" art that totalitarianism attacks modern styles in painting and sculpture, while often permitting them to flourish in poster design, illustration, caricature, and advertising.

Yet it is an error to regard the totalitarian's preference for academic art and his assaults on modernism as based entirely on practical considerations. Russian Futurists and Constructivists could have been extremely useful in Soviet life, and their enthusiasm for Communism, while they still mistook it as a force for freedom, might have provided a powerful moral asset both among the Russian people and abroad. For their part the Nazis made use of Expressionist rhetoric in their political posters while denouncing Expressionist paintings as degenerate. In relation to art, however, the instinct of totalitarianism is not to exploit modernism but to do away with it. To the bureaucratic state the academy represents an aspiration toward high culture, while the

assertion of independent meanings by avant-garde art fills it with rage and philistine hatred.

To the Communist, art is a weapon or a luxury to be enjoyed in the future. Only when society has satisfied its material needs can it "afford" a free, that is, non-utilitarian, art. Hypnotized by the ideological function of art in earlier societies, Marxist totalitarianism is blind to the influence of art in democratic societies upon the dynamics of production and upon innovation in science and technology. To the commissar, the free artist is guilty of wasting materials and units of energy on the vanity of "self expression."

Philistine hatred of modern art reached its most feverish pitch in Nazi Germany, whose Führer was himself a bottom-grade illustrator and where the academy had been the most firmly entrenched in Europe. Reinforced by the Party's dream and practice, Nazi art carried the academic ideal to the peak of brutal lumpishness. Soviet Socialist Realism has tended for the main part, like academic art in the United States, to reflect the uncultivated idealism of a new ruling class that demands of art the flattering of authority, the beautification of life, and the encouragement of laudable sentiments. In contrast to the dull, well-intentioned technical skill of Soviet academicism, the academic art inherited by Hitler brought with it ferocious metaphysical ambitions far beyond those of a mere elevated trade. As the sculptor Kolbe, a "master" who prospered under the Nazis, put it in describing his *Zarathustra*: "A high plane has therewith been entered . . . the great, powerful man who liberates himself, that was the task, that was also the way to my own freedom." Egomania of this sort is not inconsistent with Nazi servitude; it is heightened by slavery and made more concerete. The world-hunger of the German academician converted to Nazism vented itself in a malignant glamour that is on the verge of the super-real. The heroic figures of Nazi painting and sculpture bear the features of a peevish emptiness that seems aggressively directed, like Nazi politics itself, against every fact and idea of the twentieth century. A conscious ennobling of murder exists almost on the surface of the works of these horrible professors dreaming of the heroic—I have not the slightest hesitation in stating that artists like Breker and Thorak should have been arraigned among the war criminals at Nuremberg.

Another revolting feature of Nazi art is its surpassed sex, "sublimated" in the exact dialectical meaning of the term; that is, it is sex uplifted (*aufgehoben*) into something "higher" than

the erotic yet retaining its original prurience. (The lady who photographed Breker's *The Victor* for the National Socialist publishing company took care to locate his penis in the exact diagonal center of her print, no doubt as an inspiration to German homosexuals and genetically-minded housewives.) The male and female of Joseph Thorak, Nazidom's Number Two sculptor after Breker, with their smug self-righteous expressions, prim hairdos, heavy flesh, over-prominent but concealed sex, are perfect examples of the pornography of aesthetic and ideological "uplifting." Wilhelm Reich, in his early *Mass Psychology of Fascism*, provided rich data on the Nazi strategy of generating violence through aseptic obscenity.

Neither Fascist nor Soviet art achieved this degree of degradation. In Italy, under Mussolini, goddesses, heroes, big-chested ethnic types, breedworthy naked girls, largely displaced the work of the experimental modernists. Yet Italian academicians were held in check by Italy's sincere longing for modernization, by the ideological slackness and relative lack of ferocity of Italian Fascism, and by the tolerance displayed toward Futurists who had been patriotic precursors of the Black Shirts. As for Soviet art, the prudery of the Bolsheviks and their hostility to inherited myths inhibited the academic lust for symbolic nudes. Though Marx and Engles, done up in plaster, were converted into a pair of Olympians underwriting the crimes of the Leader in a manner equivalent to Hitler's eagle-launching Titan, at least they kept their sublimated clothes on. Only in Germany did the academic counter-revolution reveal itself in the full range of its tasteless and content-less grandeur, from man-gods to striptease genetical specimens, as the deadly foe of modern art, the modern world, and life itself.

1963

13 Tenth Street
A Geography of Modern Art

Saint-Gaudens and Alden Weir, E.A. Abbey and William M.
Chase had all foregathered near the village duck pond [in East
Hampton, L. I., in the late 1870s]. They had found touches
of Europe there, *for they could see America only when they
saw it as European* [italics mine], and the lanes brought back
England to some of them, while the dunes and windmills
suggested Holland and the meadows recalled to others Pont-Aven.
 —Van Wyck Brooks, *Days of the Phoenix*

Founding of a Colony

Choosing a place to live has been for the American artist a
problem of the first order—in Europe it achieves comparable

Originally published in *Art News Annual* (New York: Macmillan, 1954).

insistence only in times of invasion or revolution. Where in this country can one "live like an artist"? "Like" suggests imitation—the question is therefore one of style. The setting chosen by the artist reflects his conception of art.

If the East Hampton group that Brooks recalls saw the United States in the mirror of Europe, they had seen Europe itself in the mirror of Europe's masterpieces. Long Island became visible to them in satisfying their nostalgia for British or Dutch landscape painting. The place for the artist in America was where he could be *encompassed in a picture.*

Someone had written of de Kooning that he was nostalgic for the art of the past. Passing a half-finished apartment house on the site of the Lafayette Hotel, he was reminded of the subject. "Nostalgic for old art," he snorted, "—I'm nostalgic for cement."

Kids in big cities during the building boom after World War I climbed around constructions without floors, drank from hoses running into sand piles in the gutter, watched laborers sprawling on the sidewalk at noon with huge sandwiches and beer pails. This idyll was the same in de Kooning's Rotterdam as in Brooklyn.

American artists mentally importing Holland's dunes and windmills; a Dutchman finding *his* Holland on a street corner in Manhattan—this comedy marks two distinct eras in American art.

After World War II new work appeared in America by artists who had no more impulse to "find touches of Europe" in their surroundings than to touch things up in their paintings in order to make them look like European masterpieces. De Kooning's *Excavation* (1952) translated neither the landscape of another continent nor the art of another century. It was a creation from scratch.

The big-city artist had emerged in America, an artist whose "roots" are anywhere and who discovers this fact through displacing himself. If anything makes him nostalgic, it is the sight of the new—the "surrealist" look of some Broadway signs, the "collage" or "neo-plastics" of a wall exposed alongside an empty lot. A mind of this character is not peculiar to the United States, but it reached expression here without traditionalist *Schmerz,* and this is what has brought world cogency to American art.

The new American "abstract" art, the first art to appear here without a foreign return address, constituted, interestingly enough, the first art movement in the United States in which immigrants and sons of immigrants have been leaders in creating

and disseminating a style: Gorky, de Kooning, Hofmann, Rothko, Gottlieb, Lassaw, Reinhardt, Newman, Baziotes, Guston—and widening the current in random recollection: Vincente, Tworkov, Grippe, Lewitin, Resnick, Cavallon, Schanker, Fine, Marca-Relli, Kaldis, Leslie, De Niro, Schnabel, Kiesler, Sterne, Rivers, Spaventa, Sander, Biala, Brustlein, Cherry, Pavia, Kotin, G. Cohen, Goldberg, Bluhm, Agostini, Ippolito, Stamos, Bultman, Miriam Schapiro, Marsicano, Nivola, Carone, Marisol, Cajori, Pasilis. Earlier American artists *traveled;* the present development in American art is inseparable from having *moved.* This applies also to native settlers from the far west—Pollock, Motherwell, Still, Ferren—and other sections—Tomlin, Kline, Smith, Greene, Hare, Brooks, Mitchell, E. de Kooning, Littlefield, Reynal, Little, Hartigan, Zogbaum, Ray Parker—all of whom figured in the New York development. Apparently, the role for newcomers in the aesthetic affirmation of America has been as significant as in the physical exploration and building of it.

Tenth Street: The Metaphor

All the artists I have named in the last paragraph have been active in the geographical concentration in downtown New York City which now pivots on the art colony on East Tenth Street. In addition, there are on Tenth Street and its nearby pockets dozens of younger artists whom I "see around" but don't know by name; but whose work, exhibited in the Tenth Street galleries, testifies to a continuity with the art and influences we have been discussing. It is the sprouting of this later mass of active inheritors that might be said to have changed Tenth Street from a mere congeries of studios into a "colony."

To recognize Tenth Street one must begin by distinguishing it from Greenwich Village, which is adjacent to it and from which, in a sense, it dribbled down. The Village, too, was big-city, of course, or at least became so in this century, though its name is a reminder that it preferred to be something else. Greenwich Village, however, was not just big-city, not just cosmopolitan, not just "anywhere." The modern Village was imitation Paris—and in a manner which showed that what it adored in Paris was a smaller town than New York and an older one. Its little trees and crooked streets were décor for the first stage-landing for pilgrims on their way to Paris from the West, the Middle West, or the Bronx; Greenwich Village was a grounded *Liberté* or *Ile-de-France,* attested to be a GENUINE COPY by the Arc de

Triomphe on Washington Square. The Village artist was pledged to the School of Paris, whether, like Max Weber or Alfred Maurer, he actually went there and entered its contemporary streams, or, like the Soyers, stayed home to become a New York-scene painter of the era of the Impressionists. Marin proved that the French recipe was also marvelous for Maine lobsters. And even those who, having reached the Village, turned around and retreated to the sagebrush, had trouble deodorizing themselves of the scent of Pernod.

Greenwich Village was the gate through which American artists entered the twentieth century as semi-Frenchmen. United States intellectuals who, seeking a niche today in Anglo-American traditionalism, turn up their noses at the French ought to be mindful that, in owing to Paris the Village and reproductions thereof in Chicago, St. Louis, Los Angeles, San Francisco, etc., we owe to her the classroom in which Americans learned to speak in the modern idiom instead of in a fake English accent.

Nevertheless, Greenwich Village was still, like the East Hampton duck pond of the 1870s, habitation as art-setting and a distraction for the artist who wished to begin with his own reality. Not so Tenth Street; no one could mistake it for an aesthetic creation. Or if one did, by a stretch, associate it with painting, it would be with painting that Tenth Street was not interested in: a Hopper on a dead Sunday morning, a Reginald Marsh aggregation along a basement railing. The block to the east of the artist's block, with St. Mark's Church on the corner, still carries the Parisian flavor—now laced with Puerto Rican pepper—of an earlier Greenwich Village enclave; there are skylights in one or two top-floors of the rooming houses, but there are no painters there. The Block of the Artists, in contrast, has not even the picturesqueness of a slum, and East Side beard-and-baby-carriage-painters of two decades ago would find nothing to their taste there.

The last thing conceivable in these low, red-brick buildings, hacked and engrafted out of shape, is a bit of "folk." Their desperate metamorphosis has made them hospitable to anything, except what might denote a norm. Apart from the two pawnshops facing each other on the Third Avenue western corners, everything on Tenth Street is one of a kind: a liquor store with a large "wino" clientele; up a flight of iron steps, a foreign-language-club restaurant; up another flight, a hotel-workers' employment agency; in a basement, a poolroom; in another, something stored;

in the middle of the block, a metal-stamping factory with a "modernistic" peagreen cement and glass-brick front; on the Fourth Avenue corner, to be sure, an excavation.

Identical with rotting side streets in Chicago, Detroit, and Boston, Tenth Street is differentiated only by its encampment of artists. Here de Kooning's conception of "no environment" for the figures of his *Women* has been realized to the maximum with regard to himself.

Devoid of local color, Tenth Street is, at the same time, the antithesis of the abstract locale, no longer a novelty in the America of Mies Van der Rohe and Philip Johnson; one finds there no "composed" structures, no significant planes, no strips of color, no planned bareness, no new-design lampshades or coffee tables, no geometrical nooks. The modernism of Tenth Street has passed beyond the dogma of "aesthetic space," as its ethnic openness has transcended the bellicose verbal internationalism of the thirties. Its studios and its canvases have room for the given and for the haphazard, as against the clean-up of the advanced Look or the radical Idea.

Art World and Underworld

Bohemias and underworlds tend to grow into each other like cedars and apple trees; it is almost a century since Rimbaud proclaimed the artist's desire to "walk with an air of crime." Greenwich Village, especially during its Prohibition heyday, was a rookery of gangsters and tough guys, while its artists went in for whacking the bourgeoisie in jest and in earnest.

On Tenth Street the ancient relation between art and the anti-social has attained a curious evolution. Instead of hoodlums—bums. Living on the street, the working stiff is the most conspicuous human feature of the Block of the Artists. This transposition of underworld substances in the environment of its creation reflects the changed social character of art in our day. The Village law-breaker was a rooted type, a son of Little Italy. In his person a transplanted Naples jostled an imaginary Montparnasse. The bum carries upon his person no such communal insignia. He could have come from upstate New York, from Poland, from Mexico—as the artist who steps over his body on the Tenth Street stoop might be a gentleman from Spain, an Italian artisan type, a middle-class New Yorker, or a Russian Jew of the Intelligensia.

Tenth Street qualifies for all, not as their dreamed-of Happy Valley but as a practical accommodation made available by the

block's lack of character. In this neutral zone, whose feature-lessness would drive a simple criminal into depression, the tramp may pursue his surrender of personality while the artist engages in finding the point at which his begins.

The contemporary artist and the contemporary bum—the bum, too, has changed from the injured individualist depicted by O'Neill and the inseparable couple memorialized by Samuel Beckett; today's artist and bum are related as opposites, in which each is the mirror of the other.

The criminal has only the law against him; the bum struggles with space. The instant he stops moving, his very right to be on the earth becomes problematical. One might say the criminal is a mere social outlaw, the bum a metaphysical one.

American art used to place itself in opposition to American society; it attacked "Main Street," the "materialist spirit," "bour-geois values." This was a progressive, healthy social service. Today's vanguard has abandoned efforts to trouble others or to improve them. Like the Tenth Street bum, it has entered into a kind of metaphysical retirement, a dissident self-insulation from as many areas of social contact as possible. On Tenth Street, politics, news, issues, popular enthusiasms have been shifted behind a screen, nonetheless impenetrable for being transparent. In the studios and among the sidewalk loungers, public events are noted spasmodically as occurrences "outside." Something like this separation may be the case with the "interior immigration" of intellectuals in present-day Russia and Poland.

Frustration of the Band

Tenth Street draws on deeper sources than the negative sociability of West Coast hang-out literature (Kerouac, "Beat," etc.) with its generation-propaganda. On Tenth Street, the individual pre-vails against the band, and it is to him that art there owes its inspiration and its vocabulary. "Younger artists" (under 30? 20 to 40?) keep trying without success to affirm themselves apart —most of the local galleries are run by and for them—but their self-definition has less to do with chronology than with reputa-tion, and their difficulty is to settle on an obstacle common to all of them.

All bohemias and underworlds transmute the ranks established by social class into a hierarchy based on talent or daring. The formation of gangs or cliques is a device for controlling this process of natural selection and for re-establishing the traditional

claims of mediocrity. The absence from Tenth Street of fixed group identities, whether of nationality, race, class, ideology, or age, is one of the superiorities of this colony and its novelty. Bohemias exist on an edge of city life, but within themselves they tend to form mob-centers. The artist thus finds it necessary to exist on the edge of the edge if he is to avoid being swept by collective currents. For this purpose Tenth Street is ideal: it is all edge.

Fashion Note

The individualism of Tenth Street is so complete, backed as it is by the mixed histories of its inhabitants, that it excludes bohemian-ism itself as a common style. Elsewhere, beards and tight pants publicize professional difference. Tenth Street has no costume—either for its artists or for its stiffs. Members of the older groups conserve their elegance; some, particularly the lady artists, have assumed for daytime wear a workman-Western garb that features paint-stained blue jeans and open-neck colored shirts, an aspect of rough-and-ready action-décor popularized by pro-letarian ballets and Hollywood's new Westerns; others could lose themselves in any New York crowd.

Mores and Meaning

Every twentieth-century myth flutters about the ideal of The Community: its decline is considered the cause of our "crisis of values"; its instauration is the objective of all modern mass revolutions. Tenth Street is the opposite of a community. No one willed it: its coming into being took everyone by surprise. It has no history—though the neighborhood has—and, as we shall see, it is impossible for it to have a future. No "values" appertain to it; that anyone should put the interests of Tenth Street ahead of his own (imagine an artist sacrificing himself for it!) is inconceivable. No one wants it to be better. Perhaps no one likes it; although, when it has ceased to be, there will be an immense sentimentality about it, especially among people who were never there.

Tenth Street is not a community, or it is a community of some stage of civilization both earlier and later than ours. In inner structure it mostly suggests a tribe, in that it centers upon its chiefs, its idols, upon the potency of its "medicine" as against that of other aesthetic tribes. Yet its chiefs have no authority, and no tribesmen ever evinced comparable degrees of disloyalty. One might conclude that Tenth Street is a tribe based on the rugged

individualism of American pioneering—an impossible contradiction and therefore most likely to fit.

But every bohemia is also a small town. Tenth Street has its public lounges that serve as gossip exchanges and gardens of romance; its cocktail- and evening-party circuits with their snobberies; its mutual aid. The conversation is not commonly about art, unless one regards as such the chatter about "openings," prizes, inclusions in or exclusions from group shows, "mentions," or reproductions in magazines.

The topic of largest interest is real estate: tracking down and/or fixing up a loft, spotting "a place in the country" for the summer. This concern with self-location often dismays visiting friends of art who expect discourses on the "philosophy behind the new art," i.e., transcendental sales talk. As if anything could be more profound or appropriate for those whom geography has released from its grip than this eternal theme of migrants and exiles, the question of where to situate oneself. Besides, these critics forget that though artists may not talk to each other about art, their pictures do.

The Importance of a Place

Other art colonies have been workshops of *the arts*: the Village, Provincetown, Chicago's Near North Side, Taos, and San Francisco are noted at least as much for their writers—Cummings, O'Neill, Anderson, Lawrence, George Sterling—as for their painters. Tenth Street belongs exclusively to painters and sculptors, with a sort of open house for a handful of poets, composers, and dancers (all exceptional among the mass of their professions for their investigation of new creative modes). On Tenth Street, a fraction of America's art life has found a place and in doing so has also found its time. Or perhaps they discovered their time, and this led them to Tenth Street. In any case, place and time have come together.

To grasp what this means, it is only necessary to take a sideglance at American literature. Unable to locate themselves, writers today have lost touch with their epoch. "Almost every book," writes a *Kenyon Review* critic, surveying a score of new volumes of poetry, "gives notice of others which might have an equal claim to consideration at this time, and I cannot be at all confident that what I have before me is honestly representative of any tendency or movement." Scattered throughout the states and across centuries of literary history, poets can no longer determine which way is forward, and their art has disintegrated into ec-

centric exercises in the medieval science of metrics. One polishes triolets, another fancies himself a Norseman. It is as if painters were to begin to grind their own pigments and discuss underpainting and glazing. Such things happen in an art when it has relinquished every creative idea. In the antibohemian literary counter-revolution, emanating from the sickness and remorse of former American Left-Bankers and globe-trotters, poetry is ruled by a phantasy of authority and class—of upper class at that, with its parlor games and paranoia. In the literary quarterlies, nothing has anything to do with anything else, save for the endless birdcalls of academicians across the technical void.

In the light of the example of Tenth Street, the present condition of literature is ludicrous, particularly since its anarchy and helplessness are visible effects of urgings toward "tradition." For what could be plainer than that Tenth Street *is* tradition? If not the tradition of bookworms and neo-Christians, unmistakably the tradition of more than a century of art creation. Like modern art itself, Tenth Street stands against the university and its passivity and as a counter-concept to aesthetic and political reaction. This fact has begun to dawn on the universities themselves, whose scouts increasingly comb Tenth Street for artists to give point to their art courses.

For artists of other regions, Tenth Street is a trading post of ideas and of the latest moves in art. But it is something more—it represents an insistence of individuals on being artists. This insistence materialized by a place often lends support to talent that is decisive in the development of individuals or a movement.

Destiny

When the artists' "Club" was still on Eighth Street, Joseph Cornell, fabricator of dreaming cabinets, showed there an early silent film named *The Automatic Moving Company*. An express van without a driver pulls up in front of a brownstone, the rear doors open and pieces of furniture come out. They skitter in file across the sidewalk and shimmy up the steps. Inside the house the pieces arrange themselves room by room in conventional order. All except a small tabouret or end-table, which provides the comedy by wandering around in the orderly shuffle vainly trying to find a place. Whenever it is about to come to rest, an armchair beats it to the spot or it is shoved out of the way by a sofa or a piano. At the end, when everything else has settled down, the little table jigs to an uneasy stop.

In Europe's cities, bohemias grow like fungi among stones un-

touched for centuries. Here, as with the homesick end-table, a foothold is gained only when things obeying more powerful laws of social motion have come to a momentary halt. Art on Tenth Street is perched in an interstice of time—it became possible only because the block had reached a condition in which no one was prepared either to do anything with it or to do away with it. Once its history begins again, artists and bums will have to get out.

The inevitability of its doom keeps Tenth Street pure. Other Latin Quarters decline through gradual infiltration by remodeled and new "studio" apartments (chalets or glass huts in the country), to which come commercial artists, dealers, school teachers, amateurs. The artists' hangouts turn into night clubs, with price lists, cover charges, and crowds that leave no room for simple idling. Masses of proto-bohemians stuff themselves as wads between artists and their friends and deaden conversation and personal relations. Public and private life become objects of journalistic and tourist prying. Like the American Indians, the artists find themselves aliens on their own soil.

Against this gradual death Tenth Street is insured, though it has experienced the usual symptoms. Its dilapidated lofts hold no promise for sophisticated luxury—its environs are too barren to produce a Bourbon Street or a St.-Germain-des-Prés. Its social climate will continue to repel the shoals that follow the big fish of art.

The artists' Tenth Street will not deteriorate; it will be extinguished. It will be swallowed in the yawn of a steam shovel. Its future is—an excavation.

1964

14 The American Art Establishment

The American art establishment is in the process of construction. Much of it is still unfinished. Key posts are currently occupied by squatters. Permanent positions in it have not yet been assigned. One reason for its condition is that this establishment is the newest among America's cultural-economic edifices; in its present form it dates no farther back than the five or six years since money began streaming into American art and art education, and trends in art prices (reaching $135,000 for a Wyeth, more than $100,000 for a Pollock, $70,000 for a de Kooning, $30,000 for a Johns) began to attract the attention of *Fortune*, *The Wall Street Journal*, and *Barron's Weekly*. A deeper reason for its incompleteness is that the American art establishment lacks a solid

Originally published in *Esquire*, January 1965.

foundation in public taste and values, and rocks back and forth on tides of fad.

Within the unfinished whole, there are a few older segments: the Museum of Modern Art, the Whitney Museum of American Art, the Solomon R. Guggenheim Museum; half a dozen galleries dating back to the thirties and forties; a handful of pre-1950 collectors; two or three writers of the same vintage. Even these, however, have little that is venerable about them; to hold their places they have had to be in a state of constant refurbishing. The museums, continually undergoing momentous expansion in physical size and function, keep filling up with new people. The older galleries are jostled by hundreds of latecomers (the one with the biggest current artists—the Marlborough-Gerson—opened late in 1963). Earlier collectors are ridden down by people rushing to anticipate the market. Perhaps the least-built-up area is in the constantly increasing space devoted to art in the daily and weekly press, in magazines and, most recently, in radio and TV. Art education of the public through the mass media offers the establishment a virtually unlimited field for colonization. In sum, we are speaking of an establishment that isn't established— and, even where it is, tends to develop cracks as it settles.

The outstanding characteristic of the American art establishment is its shakiness. This shows up most clearly in regard to creating reputations. Some people are convinced that a conspiracy is responsible for every big name and that no one ever achieves success except through wire-pulling (the award to Robert Rauschenberg of the Venice Biennale Grand Prix in 1964 once again made the air thick with rumors). Manipulated fame exists, of course, in the art world. But it is probably less the rule than it is elsewhere, not because the impulse to pull wires is lacking, but because pulling them does not necessarily cause any wheels to turn. Though people are made through the establishment, the establishment does not possess a reliable machinery for making people. One never knows who or what is going to succeed in putting an artist across. The same device or agency that works for painter A will fail to produce results for painter B. Some artists win their reputations through being consistently plugged by a dealer. Charles Egan, Sam Kootz, and Betty Parsons brought such artists as de Kooning, Pollock, Hofmann, Gottlieb, Rothko, Guston, Kline, Newman, Motherwell, Tomlin to public attention long before the museums, the press, and the majority of collectors were aware that anything was stirring in American art. Hans Hofmann, for instance, was sold at steadily rising prices from

the forties on, yet it was not until 1963 that the Museum of Modern Art took individual notice of him. On the other hand, the museums often have a good deal to do with lifting an artist out of obscurity. Dorothy Miller's "16 [or 14] Americans" shows, given every few years by the Museum of Modern Art, have put younger talents on the map for dealers, reviewers, and buyers. Lately, collectors and foundations have begun initiating recognition of individual artists through buying their works and making them available for public exhibition. Pop art was mainly promoted by two dealers—the Leo Castelli Gallery and the Green Gallery—and one collector—Robert C. Scull. The big break came when the Sidney Janis Gallery got on board in the fall of 1962. Then the Guggenheim and half a dozen out-of-town museums anxious not to miss the boat came tailing along. But all these forces—dealers, museums, collectors—have notoriously failed to affect responses of the art world in at least as many instances as they have succeeded. Dealers who have had sensational success with two or three artists have had to give up on five or six for whom they tried equally hard. Over the years, the Museum of Modern Art's "Americans" have included a heavy percentage of busts. Collectors, after striving to put over their favorites, have ended by hiding their work in the cellar. The sum of it is that no dealer, curator, buyer, or critic, or any existing combination of these, can be depended upon to produce a reputation that is more than a momentary flurry.

The result is widespread anxiety—the anxiety of individuals and groups concerning both their own status and that of the art which they exhibit, deal in, comment on, create. Like a newly installed revolutionary government, the art establishment is not fully convinced that it knows what it is doing, where it is going, or if the things it is handling are real. It is affected by developments outside itself and over which it has no control—the condition of the stock market, the change in social moods and attitudes (for example, from revolt to conformity). Museum directors, dealers, critics, artists live with eyes and ears permanently cocked for trends. The general art public (gallery goers, art-book buyers, museum members) is subject to the same uneasy watchfulness; though, having no material or status investment in how things turn out, it is more relaxed and ready to take things as they come.

Each appearance on the art scene of a new look or personality compels the establishment person to take inventory of his resources and to decide whether it is to his advantage to embrace

the novelty or to fight it. The museum director finds himself under pressure to show works featured as the newest thing in the picture weeklies; but if he goes along he risks critical attack should the press build-up collapse too soon. Similarly, the anxious dealer, collector, artist must weigh the advisability of a new move as against the likelihood that the style with which he is identified will continue to arouse interest. To take a wrong turn may prove fatal. On the other hand, to allow oneself to be by-passed by art history before one has become firmly embedded in that history is not only to be deprived of a place in the establishment but also to be condemned to extinction.

Thus the big question for the establishment is: Has the time come to unload and take on something new? If so, whose judgment ought one to follow? One's own? That of the consensus? Some current Loud Noise? Especially outside of New York, the preferred solution is to accept *en bloc* whatever has gained prestige in the metropolis. To get on board early and to play the whole field—for example, Pop art *plus* Abstract Expressionism *plus* hard-edge—is the best insurance against being outsmarted by a sudden change of fashion. If these modes of art seem to represent irreconcilable premises concerning art and life, one can claim to have been guided by personal taste in choosing the particular examples.

Owing to its condition of unremitting anxiety, the art establishment is easily swayed (as no established establishment would be) by aggressively stated opinions, attention-getting stunts (e.g., Tinguely's self-destroying mechanized sculpture that fizzed out in the garden of the Museum of Modern Art), sheer brass (Warhol's imitation Brillo boxes). Praise by a critic or museum employee of an artist or a tendency is bound to fetch some support, providing the praise is all-out and without critical reservations. The claim that a work is historically significant is sufficient to clinch a sale, regardless of the poor condition or lack of attractiveness of the work itself, as is a confident forecast of capital gains. Periodic mentions in the press, expensive catalogs and reproductions, dealer-subsidized "critical" biographies, large private and gallery parties influence an artist's standing despite everyone's awareness of how these things are arranged. A mediocre talent suddenly hailed as representing the ultimate phase in the evolution of world art will be accorded new respect not only by dealers, curators, and reviewers, but even by fellow artists.

One substance overlies all the elements of the establishment,

from museum personnel to dinner hostesses. That substance is talk. The art establishment subsists on words—much more, in fact, than it does on pictures. Talk within the establishment has more power than elsewhere because decisions are less sure and the consequences of acting on them more uncertain. In this sense, everyone in the art world has power—at least the power to pass the word along, mention names, repeat stock judgments, all of which produce an effect. The first qualification for entering the art establishment is to be familiar with its jargon and the people and things most often referred to. Getting in deeper depends on having a head start on the current gossip and an enlarged repertory of anecdotes about leading figures. The establishment's lack of equilibrium puts a premium on name- and event-dropping.

To drop names effectively one must, of course, drop them in the right places. Good spots to unload gossip and renew one's supply are those exhibition openings, parties, bars, and beaches where to be seen creates a presumption of belonging. In the preferred locations certain conversational tags can be depended on to distinguish establishment people from the public-at-large. In the Hamptons a couple of years ago the standard "in"-question was: "Is Bill de Kooning in town?" Last summer it was changed to: "Has de Kooning finished his house?" In-questions that become popular to that extent actually brand the questioner as out. More ingenious establishment candidates seek an esoteric switch. As I came up out of a wave off the Coast Guard beach in East Hampton, a body floating by asked: "Have the David Hares gone to Wyoming yet?"

Having the inside story on an event everyone has heard about is proof of weighty connections. Fringe personalities will go to almost any length to be let in on a fresh scandal. One suspects that a significant percentage of establishment love affairs originate in a lust for information. At the Cedar Bar or Chez Madison it is politic to modulate one's voice out of a consciousness of poised eavesdroppers. One Sunday afternoon on the Barnes Landing beach in Springs, Long Island, a group of artists and their wives was approached by a lady bather in dark glasses who was a total stranger to them. "I am a friend of X and Y," she introduced herself, giving as reference a couple of establishment people. "Please tell me what really happened at O's last night." One of the women quickly filled her in. An artist, however, muttered audibly, "A fine thing. Now gossip panhandlers!"

To enter more directly into the center of the establishment,

talk needs to be complemented by deeds, such as buying pictures, opening a gallery, winning the proper job or lover. (Giving parties, even elaborate ones, cannot be relied on, unless one is in possession of a nucleus of important guests and, above all, knows the people to keep out—the strongest establishment person-age can score a minus with a party too self-indulgent in respect to relatives, old friends or non- or sub-establishment casuals.) A functioning relation to art or to artists (among the mysterious personages who loom large in the establishment, through knowing everything that is going on, are tax consultants, lawyers, frame makers, hairdressers, psychiatrists, chairmen of museum "friends" organizations, silent partners of galleries) confers an advantage over the mere ambitious onlooker. Thus the art world swarms with fake collectors and entrepreneurs, people who visit studios and, on the pretext of intending to buy pictures or arrange deals, induce artists to pull out and display every scrap of their work, with no further result than to supply the visitors with material for insiders' talk.

A deceptive aspect of the art establishment is that there is nothing to prevent anyone, whether serviceable or not, from getting right into the middle of things. Most establishment events and hangouts are public or can be crashed easily. Even the homes and studios of top establishmentarians are vulnerable to penetration by persons who feel, or pretend to feel, an interest in what the important figure is doing. Thus newcomers will often be found comfortably ensconced in coveted positions, while older members ask one another behind their hands, "Who is this fellow (or dame) I keep running into lately?" Some of the infiltrators persist in manifesting themselves in situation after situation; in time they become permanently affixed to the estab-lishment structure and are greeted as a matter of course, though no one knows their names or their business. Usually, however, outsiders who have made their way into the core of the establish-ment discover in bewilderment and consternation that the center is no different from the outer edge — in short, that there is no center, only individuals and institutions without a dominant authority or etiquette. With the effort to gain reflected glory thus proven wasted, the disappointed art (or artist) lover is likely to return to his normal habitat equipped to disseminate the intimate story of the art world, its doings, its heroes and its "phonies" (favorite outsider epithet). The large turnover in establishment hangers-on thus results in a significant contribution to public art education in America.

The Geography of Modern Art

Artists dislike formal organization. The last really comprehensive association of artists in the U.S. was the Artists Union of the thirties, active around the government art projects. The Club, which was a lively factor in the rise of Abstract Expressionism in the fifties, always kept a hazy area between members and non-members, and the repeated theme at the meeting of its "voting members" was how to keep out strangers and who would fold the chairs and sweep up the cigarette butts. But though artists are touchy about rules and obligations, herd impulses are very strong in the art world. Cliques are constantly being formed, mostly based on convictions regarding what art ought to be and which style would prevail.

Intellectual get-togethers are most numerous among the young and the unknown: later, the primary motive for assembling is overcoming boredom. Youth coteries subsist in varying degrees of potency around the Tenth Street galleries and are sprinkled through the upper East Side. Their attitude toward the establishment is uniformly hostile — whenever an occasion arises they attack it publicly as a means of gaining its notice. In these sallies, they are supported by perennial anti-establishment establishmentarians. Youth cliques, however, tend to dissolve quickly through the uneven success of their adherents.

Groupings based on sex were unknown in the art establishment until very recently. Though in the postwar years women became for the first time prominent on a large scale in American painting and sculpture, they insisted on being considered as artists, not as women artists. In contrast, a feature of the past four or five years has been the banding together of homosexual painters and their nonpainting auxiliaries in music, writing and museum work.

Another recently emerged power is the artist's widow. The widow is identified with the painter's person, but she is also an owner of his art properties — in the structure of the establishment widows stand partway between artists and patron-collectors. Commonly, the widow controls the entirety of her dead husband's unsold production; this enables her to affect prices by the rate at which she releases his work on the market, to assist or sabotage retrospective exhibitions, to grant or withhold documents or rights of reproduction needed by publishers and authors. (Mrs. Jackson Pollock, besides being a painter in her own right, is often credited with having almost single-handedly forced up prices for contemporary American abstract art after the death of her husband.) She is also in a position to authenticate or reject unsigned paintings or drawings in the hands of

116

others. Finally, she is the official source of the artist's life story, as well as of his private interpretation of that story. The result is that she is courted and her views heeded by dealers, collectors, curators, historians, publishers, to say nothing of lawyers and tax specialists. It is hard to think of anyone in the establishment who exceeds the widow in the number of powers concentrated in the hands of a single person.

The widow's straddling of categories is duplicated by other establishment people with multiple functions: the collector who acts as a dealer when the opportunity for a profit arises; the curator who doubles as a critic in magazine articles, speeches, and catalog introductions; the critic (this is a new development) who, operating as combination art director, dealer, and promotor, instructs a stable of painters on how to paint and praises their work in the art press and from the lecture platform.

A map of the establishment would show it as extending outward from New York in dots and splashes across the country and around the globe. Exhibitions put together by metropolitan institutions are booked on a package basis by modern-art museums in Washington, Buffalo, Minneapolis, Chicago, San Francisco, Dallas, Los Angeles; smaller shows may dock at a dozen university galleries in as many states. Other exhibitions are set up, with or without State Department collaboration, to cover Latin America, Europe, Asia. Along with the shows go the educational (publicity) services of the originating institution: catalogs, reproductions, slides, essays defining the place of the work in art history, human-interest biographies, statements by the artist, and, on occasion, visiting lecturers. New York recommendations pull down posts for painters as teachers and resident artists in universities throughout the United States and in countries on the Fullbright and foundation circuits. Out-of-town dealers strive to balance representation of local talent with offerings of New York Names. Across the seas each summer stream dealers and museum advance agents to spread their favorites' fame and case the ground for new artists to take on, hot possibilities for shows and commission-splitting, allies in copping international prizes. In addition to its salesmen abroad, the establishment has its advance men and resident agents, both Americans and foreigners, engaged in the dissemination of its products and reputations. In turn Europeans, Near Easterners, Australians, Asians keep scouting New York and points west on commercial assignments or educational grants. Despite all this activity, however, the international distribution of American art is still largely un-

developed, owing chiefly to the reluctance of some leading New York dealers to share their cut with dealers overseas.

The power of the well-placed member of the establishment to start an artist on tour around the country and the world, without necessarily a word of sense in support of his choice, constantly breeds in the art functionary the temptation to be the independent instigator of trends, styles, and reputations, with the artist as his submissive instrument and grateful beneficiary. Even the art of the past seems susceptible to establishment control through the practice of assembling works under tendentious labels. The non-artist element of the establishment has been swelling vastly in numbers, resources, and self-adulation. Recruits come increasingly armed with academic degrees conferred by the mushrooming art-history departments of universities throughout the country. Yet the single most potent force in the art world is still, in the last analysis, the artist. One might say that in the trembling jelly of the establishment he is the sole semisolid substance. It is to him that dealers and collectors, curators and art department heads turn for recommendations. It is his judgments of his colleagues that reviewers listen in on before committing themselves in their columns. A painter with prestige among painters is bound to be discovered sooner or later by the tastes of those who determine when an artist deserves to be bought, hired, or chosen as one of the four or fourteen Americans currently entitled to museum fanfare. And beyond his effect on the public acceptance of work, the artist has the last word on that still more important aspect of art — its creation.

1965

15 Virtuosos of Boredom

At first encounter, masterpieces of this century are likely to fatigue the reader or spectator rather than to tempt him. Not that Joyce or Stein, Schoenberg or Varèse, Mondrian or Pollock ever *intended* to bore their publics. Even Kafka, with whom tedium is a spiritual substance, is never purposely uninteresting; the greyness of his narratives is lighted by distant cries and subsurface jests. *The Castle, Finnegans Wake*, the *Cantos, Déserts*, are difficult works; but to confuse difficulty with tediousness, as is done by conservative critics, is merely to exalt a taste for the facile and the familiar. The audience of modern art might legitimately complain that its tastes have been ignored and its sensibilities burdened, but not that it has been put upon.

Originally published in *Vogue*, vol. 147 (September 1966).

The Geography of Modern Art

Recently, however, an aesthetic of boredom has been gaining prestige in all the arts as the most advanced approach. Tedium has become a goal, either as an affirmatively calculated effect (as in compositions of John Cage or "underground" movies of interminable length and homemade awkwardness) or as the inevitable consequence of the deliberate elimination of all qualities likely to be attractive to the mind, the senses, or the imagination (as in the wave of "reductive" paintings and sculptures). Samuel Beckett, declares critic Leo Bersani in the *Partisan Review*, "has been developing in his novels more and more effective strategies designed to make us find them unbearable." A well-known painter announces that his current canvases present "cold zones, mostly reduced to black and white, from which have been excluded, to the maximum possible degree, lyricism, humanity, and warmth of expression." Examples of similar intent can be multiplied each week from among new films, concerts, dance recitals, even lectures.

Art has always run the risk of boring some people—or all people under adverse psychological conditions. It was Poe's great contribution to criticism to point out that a reader's genuine poetic response was limited to a matter of minutes. What is distinctive about today's art is that boredom is no longer left to chance. The new works insist on their utter greyness. Today it is the artist, not some hostile critic, who underlines the nonpresence in the work of every insight, feeling, or association that might make it interesting.

One might confirm the boredom of concerts consisting of a pair of reiterated sounds, or the boredom of exhibitions made up of purged canvases, to the extent of staying away from them. The motives behind such works are, however, thoroughly intriguing. In painting, "inexpressive" art arose as a reaction against the intensity of Abstract Expressionism, particularly its Action Painting aspect. The emotional disengagement of the artist from his work was conveyed in the sleekness of Pop Art and of Optical painting, the machine-shop spirit of kinetic sculpture, the rationalized impersonality of various forms of geometric and color-field abstraction. The deletion of one layer of individuality after another has, as is customary in art, followed a steady logical progression. Pop reflected the artist's environment in dead pan; Op proclaimed his affiliation with the laboratory; current shaped canvases and "primary structures" have brought his back to the wall of the $2+2=4$ of space, "flat" and "deep." In accompanying movements the spectator has passed from the imaginative tension of

Action Painting, through the amused relaxation of Pop clichés, to the dazzle of Op, to, finally, the bafflement and boredom of paintings and sculptures deliberately denuded of sensibility.

As already indicated, however, the aesthetics of boredom extends over a far wider range than present developments in painting. Indeed, Abstract Expressionism is a stubborn aberration in the drift in all the arts toward monotony, repetitiveness, and shedding of content. For years commentators have been proclaiming the continuous erosion that has been reducing to the vanishing point the mighty ego of the Romantics and of "inner-directed" man. With the ultimate neutralization of the self, any choice is futile and, as in the "chosiste" novels of Robbe-Grillet, human beings and events are alike mere extensions of *things*. The steady attrition of the qualities of man and nature, this view holds, determines both the direction of the arts and their meaning. Works closest to zero, or in Beckett's phrase the "endgame," are the most profound. In sum, the aesthetics of boredom and the quality-purged work of art are offshoots of the literature of alienation which has flooded Western civilization since World War II. Though its coolness appears as the antithesis of Existentialist anxiety, both have essentially the same source.

Action Painting was an attempt to overcome the individual's loss of identity by concentrating on the act of creation and self-creation as the exclusive content of painting. It discarded recognizable subject matter, compositional harmony, and, on occasion, color and drawing. It retranslated form and motif in order to make them serve the needs of the artist as the representative of contemporary man faced with anonymity. Affectless art adopts the negative views of Action Painting but, resigning itself to loss of identity, it denies the creative act, too, as a fraud and a self-deception.

Confronted by dance recitals consisting of random shufflings and sculpture exhibitions of shapeless substances, the audience experiences that combination of lassitude and impatience known as boredom. "How do we know," asks a writer in *Art News* about an Andy Warhol film, "anything was going on at all in *Blowjob*? All we saw was the image of a face, peculiarly blank." The point is not, as Allen Ginsberg is reported to have felt, to be stirred to enthusiasm by the artist's daring to be so empty. It is rather that the audience in being bored bears witness to the sober truth—that of the universal vacancy. Its ennui is a sign of philosophical profundity and of insight into the modern world.

Boredom is also an evidence of aesthetic virtue. It is proof that

the artist has made no concession to popularity or success. In being bored the audience comes as close as possible to behaving as if it were not there. In the midst of America's hectic art boom, the tiresome art work evokes the heroic days of modernism when art was created without thought of the spectator's response, and the artist was solitary and free. Andy Warhol does not ignore his audience but deprives it of peaceful enjoyment of its visual platitudes. With his genius for giving what one critic has called "a ratty look" not only to paintings but to the glamour-media of advertising art, the news photo, the comic strip, the film, the discothèque, he is a veritable Leonardo of boredom.

Through its Puritanism, boring art is associated with "pure" art, in the sense of art that is self-contained, obeys its own laws, and exists with, in, and for itself. "In painting of this persuasion," writes an art critic of the *New York Times,* hailing the significance of paintings "derived" from the shape of the stretcher to which the canvas is attached, "the metaphorical element in art, or indeed all reference to anything that suggests the interpretation or transmutation of experience, is totally and cheerfully rejected, and a complete divorce is effected between the work of art and its commerce with the world of extra-artistic meaning." This rather cumbersome statement could describe the art for art's sake of the last century, except that for the concept of beauty there has been substituted the concept of the void. The virtuoso of boredom is a neo-aesthete who, caring for nothing but art, strives for an art that cannot be cared for.

Collective boredom deliberately induced is a species of scandal. It is a way of committing a nuisance, an act of assault, albeit one in which the victim collaborates. Boring the audience is a device favored by artists moved to revenge upon society, for example, in payment for the hardships suffered because of sexual peculiarities.

Also, art that is boring is almost invariably an art of double meanings, one (the blank) for the public, the other (winking reference to friends, intimate incidents, shared opinions) for the family of insiders. This ambiguity is present regardless of the mode in which the work is executed—it is as characteristic of paintings of zones and stripes, which allude to concepts favored by a faction of critics, as it is of Pop films acted by a cast of pals or a sculpture consisting of a table covered with after-breakfast items. The work is a masquerade that keeps the stranger at arm's length, yet prevents him from taking his leave by hinting at a significance that is never disclosed. Its impenetrable surface defeats him psychologically and humiliates him as a hopeless philistine.

Behind this barrier the band of initiates, pampered by semi-initiates, romps happily in an atmosphere as relaxed as socks on the bathroom floor. By erecting a wall of incomprehension between those in the know and humanity at large, the boring painting or performance serves to strengthen the inner unity of the various ideological, sex, and taste groups that constitute the world of the arts.

The aesthetics of boredom is inconceivable without the enormous efflorescence of critical and interpretive writing in all the arts that has marked the cultural boom since World War II. From the moment of its appearance, a painting, a novel, or play is appropriated as an object of dissection by academically trained specialists with professional and intellectual interests of their own and equipped with a vocabulary increasingly more complex and self-sufficient. Several years ago, in a widely read article, Saul Bellow cried out against "deep readers" who refused to allow a work of literature to mean what it said—subsequent antagonism to *Herzog* came in large part from critics who found it too interesting in itself to require their services.

To the critic, the bareness of a work is an opportunity to display his powers of exegesis and to top other critics who might have given up the work as hopeless. In a recent instance, an art reviewer who had championed "minimal" art finally threw up her hands before the "literality, repetition, and boredom" of a sculpture exhibition of containers in rudimentary shapes; she was promptly challenged by another reviewer who expatiated for columns on the visual subtleties and depth of conception which she had missed in the objects in question. The ideal situation from the point of view of the new critics would be for works of art to vanish completely and for nothing to be left but the critical interpretation.

Today, no degree of dullness can safeguard a work against the determination of critics to find it fascinating. Even when boredom is the artist's explicitly stated objective, his intention will be frustrated by decorative inlays from the critical workshop. "It is . . . disconcerting," protests Bersani, "to read so many admiring, undaunted analyses of a significance for which Beckett . . . expresses only boredom and disgust." While Robbe-Grillet, in a preface to one of his novels, pleads with the reader to swallow the bald facts without interpretive dressing, "to see in it only the objects, actions, words, and events which are described, without attempting to give them either more or less meaning than in his own life, or his own death."

Nothing is boring to the specialist practicing his vocation. Under

close scrutiny, an inch of skin or a page of the telephone book will yield wonders of accidental combination, alphabetic pattern, symbolic suggestion. Nor does boredom exist for the partisan or the promoter. The speeches of Stalin contained an infinity of wisdom for the Stalinist, and the emotional possibilities of Father's Day are inexhaustible to the public-relations representative. One who denies the reality of boredom confesses to being dedicated to a cause or to having something to sell.

Boredom is experienced only by persons whose attentiveness is tuned to the human scale without the distortion of professional interest. It is an effect of disrupting the normal movement between the self and the external world. One is bored when the mind is forced back upon itself, the condition of children who "have nothing to do," or when it is trapped in a situation which it is powerless to affect. Art inspired by the aesthetics of boredom is evidence of how widely prevalent is the disruption between the "I" and things in contemporary mass society. Boring art is the mirror of the repetitiveness, unexpressiveness, abstractness, and obsession with detail of daily life. The "message" of this art—and since it is devoid of pleasure, it is in all instances an art with a message—lies in urging its own rejection as a first step in the development of a free individual sensibility.

1966

16 Spectators and Recruiters

It is pleasant to speak to an educated public about an educated public, that is, about itself. One is assured that whatever one says will be listened to with a high degree of attention.

You may have noticed that the title of the topic presented for discussion ("Scholarship, Criticism, and an Educated Public") lacks a verb. Evidently, the organizers of the Conference did not choose to commit themselves. The only active word in the title is the conjunction "and." It implies that a connection exists between

The text of this essay is based on a lecture delivered in a conference on "the Arts and the Public," sponsored by the University of Chicago Division of the Humanities, 16–21 October 1966, in connection with the seventy-fifth anniversary of the University of Chicago. It was first published in *The Arts and the Public*, ed. James E. Miller, Jr., and Paul D. Hessing (Chicago: University of Chicago Press, 1967).

scholarship, criticism and an educated public. In the broad sense, this is, of course, self-evident. A public that lacks learning and discrimination can hardly be termed educated. The practical question is whether the public, such as it is, has been, and is being, educated by scholarship and criticism, such as they are. Or, put another way—What are scholarship and criticism doing to educate people in the arts?

The first thing to recognize is that in our time the opposite of being educated is not being ignorant. It is having a different kind of education than the one under consideration. Whatever might have been the case in the past, America today is not inhabited by untutored primitives. Today, primitivism itself, or know-nothing-ism, whether in culture or in politics, no longer represents an absence of knowledge, or a low level of it, so much as a stubbornly cultivated attitude, one that continually makes use of systems of concepts to shield itself against the infiltration of enlightening facts and ideas.

Whatever the contemporary public does not know, it always knows something, and usually rather well. Nor is its knowledge of the same order as that of the peasant who knows his cows or the Indian who knows his trails. Today even Americans on the lowest cultural plane have been continually and systematically subjected to verbal indoctrination, if by nothing else than by radio, TV, motion pictures, comic books, mail-order catalogs, and direct-sales letters—agencies that have identified them as objects of their interest and have studied them with the aim of directing their thoughts and their tastes. They are an educated public, though not educated in the same way that the public in this auditorium is educated.

In the sense of which we are speaking, the contemporary public is largely a public of connoisseurs, professionals, and even experts. Doctors, skin-divers, policemen, dog trainers are familiar with the techniques and the lore of one or more special fields of interest—what used to be called "arts"—and are capable of competently weighing performance in them. In short, they possess scholarship and criticism, as do, too, horse bettors and the social scientists who study them.

Ernest Hemingway, you will recall, aroused in his readers an envy of his scholarship and selectivity in bullfighting. Norman Mailer pursues a program of expertise in sex, professional boxing, and public personages. Other writers are hip in sport cars and drugs. One who wishes to assert that learning and discrimination in poetry are more profound or intellectually needful than skill

in love or hunting is obliged to explain why and in what respects. I may touch on this later.

In any event the public today is highly educated. It is sophisticated, eclectic, and mentally mobile. It is prepared to absorb quickly new fashions and points of view. It is intensely conscious of itself and does not hesitate to assert its right to defy authority by declaring, "I know what I like." (Whether it likes what it knows is a different matter.) Today's public is as opinionated as an aristocracy; and upon every intellectual level, and sublevel, it has professional spokesmen who defend its prejudices and attack as prejudices the ideals of other publics.

The nub of it is that the public today is a public of educated people. Yet it is not an educated public. That is, not if we mean by the latter a public whose responses have been shaped by formal scholarship and critical writing. It includes experts in transistors, in twelfth-century Japanese poetry, in the statistics of base-stealing in the National League. But it lacks uniformity, and its members have arrived at their preferences largely through individual peculiarities and accidental encounters. Enriched by the availability of a vast range of printed matter, this public has read fiction of all sorts, has dipped into the sciences, has opinions on ethics and social change, has discussed the assassination of President Kennedy and the illuminating affects of LSD; it has seen art movies and the plays of Beckett and Arthur Miller, has listened to medieval music and the gongs of the Far East.

In sum, the mentality of this audience is of the same order as that of the artists who produce works for it. But while this culturally absorbent mass can contain everything, the artist is obliged to purge his art of most of what is in him in order to be able to complete a work. *He* has a problem of form; *they* are content to be themselves. There does not exist between artist and public a common outlook as to what is appropriate and important. The result is that the public as presently constituted cannot provide a perceptive audience for activities of the mind based on a disciplined choice.

We have numberless audiences, from readers of *Popular Mechanics* to collectors of electronic recordings, but no central body of learned responses. Each art has its own public, and within each art there are additional publics, perhaps more completely separated from one another than are the publics of the different arts. A concert of Cage and Boulez attracts one assortment of listeners; a performance of Mozart and Brahms another; a program of medieval music a third. At an exhibition of Salvador

Dali, one sees people who never appear at any other exhibition, and collectors of Ben Shahn would not be caught dead at an exhibition of Barnett Newman. Advanced painters and their admirers know nothing about advanced poetry, and underground film people regard the theater, off-Broadway as well as on, as obsolete. Such crossovers as do take place from genre to genre— for example, the dance recitals of the painter Rauschenberg— reflect not so much the interest of an artist in a medium other than his own, as a broadening of activity in order to encompass more firmly the audience already captured and to bring new people into a single aesthetic corral.

These phenomena suggest that *the* public is defined for each art activity and each organization of taste as the mass of those who have not yet identified themselves with it. From this point of view, what makes the public the public is precisely the inadequacy of its appreciation of the matter placed before it. When an artist or a scholar says "the public," he means persons ignorant of his specialty, whether it be the relation of Gorky to Surrealism or the proper reading of *Timon of Athens*. A biology teacher is the public to a harpsichordist, an abstract painter to a dental surgeon. The ignorance of the public is not an absolute ignorance; but it is an effective ignorance. It is rooted in irrelevant knowing, and it arouses a nostalgia for the unblemished simpleminded.

It is his circumscribed ignorance that qualifies the reader, the spectator, the patient to be a member of the modern public. Banish this bald spot and straightway he is dropped from the category "the public" and becomes an insider, an initiate. Even getting rid of his *sense* of being ignorant, without destroying his ignorance itself, may achieve this result.

The sum of it is that today anyone who becomes educated in an art ceases to be a spectator and becomes in some respect a participant. The collector of paintings ceases to be a mere admirer; he takes part in promoting trends, is a force in making art history. Not uncommonly, he delivers lectures on values in art, predicts future developments, and recounts the experience that led him to take up the art of collecting. To his old vocation, be it physicist or manufacturer, he has added a new one. The world of experts has been augmented, but the public remains the same, minus one member.

The processes of modern culture by which spectators are converted into participants seem to demand a re-examination of what is meant by an educated public. That in our society one is

effectively educated only when one has been recruited for an additional specialty renders obsolete the traditional image of the educated public as represented by a nobleman, a merchant, a clergyman, a philosopher, a scientist, and an artist communing in a common idiom about all that concerns the mind.

Whatever we say about educating the whole person, in practice the ideal of our serious cultural institutions has been the production of the two-letter man, the specialist in business, mathematics, medicine, or government who is, to use the popular term, also "knowledgeable" in one of the arts. To go beyond this limited aim with the present strategies of criticism would be to submerge the arts in meaningless popularizations.

With the public as a reservoir from which to swell the ranks of the insiders, the arts find thmselves in competition with all other specializations—including sports, hobbies, vices—the ultimate goal of each of which is participation by the entire populace as principles or auxiliaries, as when the police insist that each citizen has a police role and the armed forces insist that every man be a serviceman, every woman a servicewoman. If this process is carried to its logical conclusion, there will some day be no spectators but only doers.

In the face of competition, and in the absence of a public of informed amateurs, the tendency of criticism in the arts has been to strengthen each genre as a field of study by emphasizing its separateness and tightening its concepts of expertise.

While the public relations programs of art museums, musical societies, adult education institutions, and book and record clubs address themselves to bringing in the neophytes, scholarship and criticism assume the role of processing them into permanent and, if possible, exclusive adherents. A litany of key terms is contrived which serves as a means of initiation. Descriptions of works are composed in a jargon that embodies some forced version of the history of art and contains allusions to a family tree of heroes. Thus qualities are sanctified as advances upon the past and need no justification in experience or theory. The repetition of admiring phrases acts as an incantation that solidifies the ranks of the believers and holds out to newcomers the promise of certainty. "Educated" in this manner, each audience tends to take on the characteristics of a brotherhood or sect.

Much of the acrimony in literary and art journals today stems from the new role of criticism in molding audiences, upholding their morale, and repelling the raids of rivals. The bitter controversy between C. P. Snow and F. R. Leavis concerning "the two

cultures" turned the spotlight upon the battle of the "disciplines" for public allegiance and material support.

The overall cold war between the literary and scientific cultures —a war all the more empty of issues in being comprehensive— is reproduced in hundreds of border struggles between the arts themselves and within each of them. In literature, painting, music, the theater, cultures of individual self-expression are at war with cultures based on formal objectives, cultures of intuition contend against cultures of rationality, cultures of surface texture against cultures of suggestive depth. Only a semi-outsider like Snow would dream of dealing with literary and aesthetic "culture" as if it were a single entity, and only a cultist like Leavis would dare to offer readings of literary texts as the alternative to, or the precondition for, other forms of understanding and action.

Simultaneity of divergence is the rule in modern styles. In the art world today all past modes of painting and sculpture are converted into the contemporary. Such a historically conscious expansion of the present is unknown in earlier periods, and nineteenth-century aesthetics contains no guide for coping with it. The mind oriented to the past is thus disposed to reject "modernism" in its entirety as a manifestation of cultural disintegration.

The embattled division among contemporary publics reflects the divided condition of the arts themselves. Keeping the arts going in the twentieth century is a desperate enterprise. Modern technological society exerts a constantly increasing pressure upon each of the arts to merge into processes with which they bear a historical affiliation but which have been transformed by more efficient techniques. Every work of art overlaps on the crafts or the sciences, on information or entertainment. One step further— and often not an overtly decisive step—and the novel is displaced by the community study, the psychological case history by the spy thriller; painting blends into room decoration, the handicrafts, commodity design, color and light demonstrations.

Often the only line of separation between a work of art and some related product it style. And regardless of how much or how little it knows, the contemporary public, as well as the majority of scholars and critics, regards style as largely an inconsequential quality. Modern society accepts the styles created for it by the mass media, architects, city planners, and product designers.

What is called a painting or a poem is usually an object made for sale in a certain category of room decoration or an exercise

in a traditionally recognized skill. None of the arts has a guaranteed life as an intellectually significant idiom. Indeed, all have shown themselves susceptible to sinking into routine and being practiced as minor crafts.

In terms of their traditional functions, the arts have largely lost their reason to exist. Art works are no longer needed by society as cult objects, as ornament, as commemoration of events or persons. Omitting the issue of style, works of art satisfy no demands which the modern world cannot satisfy by different means. Hence the art of the past cannot serve as a model and as an incentive for continuing efforts by artists living today. The art of the past is simply *there,* as the sum of accomplishments of men with inferior technical resources. In terms of inherent energies, all the arts are dead—they are brought back to life only through being re-invented. Each art constantly awaits rebirth at the hands of an artist.

The absence of continuity based on functions which the arts used to enjoy as traditional crafts tempts modern criticism to supply art with a continuity conceived by critics. Seen in retrospect, any sequence of works, like any sequence of events, takes on the appearance of a single development guided by innate laws.

A species of fetishism generates the illusion that each artist, no matter what his views, is *used* by his genre for the purpose of elaborating its own possibilities. Thus criticism is led to shore up the shaky state of the arts with demonstrations of the self-development of forms. In much of the writing on the arts today, the genre (e.g., painting, poetry) is dealt with as if it possessed an independent will transcending that of its practitioners.

Criticism founded upon readings of the oracle of art history issues edicts to artists reinforced by threats of critical oblivion. A priesthood of historico-criticism undertakes to protect the arts against its practitioners. Such a development affects, of course, the relation of the arts to the public. It separates the history of art from the history of man and interprets the former as an activity concentrated upon itself.

It has been a cliché of journalism that advanced poets write for other poets and that painters paint for painters. Today it would be more correct to say that poets write for poetry critics and painters paint for art critics.

With the stress upon characteristics that fit works of art into the various systems by which they are interpreted, the public is encouraged to seek access to art through mazes of critical dogma. The continuity of criticism replaces the sporadic life of creation,

and writings about art claim more attention than the works themselves. In the past twenty years, critics have not hesitated to assert publicly that criticism is more interesting and intellectually profound than literature or art. They have even succeeded in gaining the collaboration of artists enticed by the notion of a directed art for which criticism has guaranteed a favorable reception. Painting has almost reached the point in which it exists as art solely through what is said about it. It is no doubt fruitless to look forward to the return of an educated public modeled on the image of the salon or gentlemen's club—the image that is probably in the back of most minds when a "cultivated public" is mentioned.

Each art has come to require specialized knowledge and insights, including an insight into the predicament which the medium presents for its practitioners. One need only read the occasional comments on painting by literary men to realize that a first-rate familiarity with writing will not carry over into an adjoining art.

Yet despite these conditions, criticism today can, it seems to me, do something more than provide phrases for museum-cafeteria conversations or advice to speculators on the art market.

Criticism is related to scholarship, but it is also joined to action. Scholarship is valuable for its own sake, criticism for what it effects. The blandest book review ends in inducing someone to read the book or to ignore it. Criticism, as Baudelaire suggested, is by its nature polemical—as a phase of action it looks to the future as well as to the past. Like the arts themselves, criticism asserts its power of action through its effects upon style—a factor whose political bearing needs no underlining for a public that has experienced the rhetorics of Ike, JFK, and LBJ. It is as the watchdog of styles that the critic represents the public.

Instead of seeking to forge new cults of believers, criticism might dedicate itself to bringing into being a consciousness of those factors of experience that are related to style—for example, the liberation of individuals from dead forms in expression and social behavior.

Poetry, the novel, painting are more significant than bullfighting not because they are superior in style—the opposite is usually the case—but because the fine arts are themselves species of criticism and able to affect the styles of society. In the arts, the *manner* of doing is able to touch consciously upon the total human situation; by means of their critical ingredient, the fine arts have over the centuries succeeded in revealing the struggles of the mind against collective obsessions.

No matter to which art it applies itself, criticism has a social and psychological role to perform. Today, consciousness of its history is the most decisive single factor in each of the arts. It is the function of criticism to focus the history of the separate arts upon one history, the history of man, and the insights of the past upon the understanding of the present.

This is another way of saying, with Matthew Arnold, that the ultimate purpose of criticism is to help to produce an intellectual situation favorable to creation. It is this purpose that gives meaning to reflections upon a text or a painting.

<div align="right">1967</div>

17 Reverence Is All

I quote the *Art News* questions I am answering:

1. "What contributions has it [the Metropolitan Museum of Art] made to education . . . of the general public?"

From age six to ten, when my family moved to Brooklyn, I spent many Sundays at the Met. My father was interested in the tombs of the Pharaohs, hieroglyphs, and the obelisk (the original, not the broken one by Barnett Newman). My brother and I preferred medieval armor and Japanese swords, which we had read about in fairy tales—seeing them proved the tales were true.

The basic effect of the Museum lay, however, not in particular exhibits but in the silence that surrounded all of them—in the glass cases, the marble columns and smooth floors, in the lofti-

First published in *Art News*, January 1970.

ness and filtered light, in sum, in the physical properties by which the past isolated itself and proclaimed the sacredness of things from Other Times. In America, especially, a place had to be set aside to instruct people that there is such a thing as Time, beyond timeclocks and timetables and snobberies based on Who arrived When. Goebbels envied the Americans their skill in turning the past into a tool or weapon of the present. A museum is an institution designed to retard this talent.

In those years the trade unions used to parade on Labor Day, carrying objects repreresenting their crafts. I remember a parade on upper Fifth Avenue in which the Bakers' Union bore aloft a twist-bread that was a whole block long—a magnificent creation; in today's terms, a work of art. But the aura of this edible sculpture was entirely different from that which surrounded objects at the Metropolitan, and it did not occur to anyone to deliver the bread there. The Union's product inspired such practical speculations as, Where did they find an oven big enough to bake it? How are they going to cut it up? Who's going to eat it? In an Egyptian frieze, baking had nothing to do with matters of this sort: it belonged to the realm of the fox-headed god and the dead Pharaoh's voyage around the sun. Had an early twentieth-century Hoving set up a contemporary bread collection at the Metropolitan, I doubt that it would have contributed to the education of the general public (me). Part of education is to learn to detect differences, for example, between crafts and cosmic systems and between breads and breads.

Apart from museums, the past is also to be met in junkshops. But in the junkshop it is devalued. In the junkshop an old thing goes "as is" at a reduced price compared to new products in department stores. The difference between the junkshop and the museum is reverence. When an object from the past is found to be deserving of reverence, it is transferred from the junkshop, barn, or attic to the museum. Should its status—or that of the category to which it belongs—later decline, back it goes to the junkshop or to the basement of the museum, which is the equivalent of a junkshop.

With regard to public education, the museum has one paramount function: to disseminate a sense of reverence in regard to the past, to make minds aware that what was done remains and cannot be altered, though its material relics can be eroded or destroyed. In the museum, as King Claudius said of heaven, there is no shuffling—things and events become solidified by time, and what men did they *are* forever. A museum exposes the limits

on the power of the living to change things at will, a lesson that becomes more urgent for Americans each day.

2. "What do you feel about its [the Metropolitan's] current programs and policies?"

It is reverence for the truth that restrains the scholar from tampering with the object he is studying and makes him indignant at seeing it shifted out of its proper place in time and used for some practical purpose. At the Metropolitan, reverence has been replaced by public relations. The current policies of the Metropolitan are calculated to erase the distinction between a museum and an efficiently inventoried junkshop. Perhaps half-consciously the Metropolitan has evolved what might be called a junkshop metaphysics—that is to say, it approaches the past without reverence but with the hope that the objects which it accumulates will be esteemed in the future as deserving of reverence. Every junkshop proprietor is sustained by the dream that a rag negligently stuffed into a drawer will turn out to be a priceless tapestry— in similar spirit the Metropolitan has found it expedient to gamble on the potentialities of such treasures as a collection of annual prize-winners in fabric-design chosen by *Vogue* magazine. But gambling on future reverence is not compatible with reverence for things inherited from the past. An artifact or document is precious for what it is; for the gambler any number may turn out to be a winner.

Moreover, as a gambler, the Metropolitan has not the slightest notion of what the chances are that history will follow its expectations. In placing bets on the future, men of affairs are likely to have more reliable instincts than products of contemporary art departments. If the Metropolitan is incapable of recruiting reverential scholars, it might consider seeking some lucky junk dealers.

3. "If the Metropolitan were to embark on a program that would, in the next hundred years, transform it into your ideal museum, what should be its first steps?"

There can be no such thing as an "ideal museum." In a sense, everything that ever existed is worth preserving, since no one knows in what directions future investigations will turn and in which categories of leftovers men will search for clues. The ideal museum of Darwin was Nature itself, and to satisfy fully the needs of social historians, the whole world would have to be turned into a museum. A museum is a more or less arbitrarily marked-off extension of nature as transformed by man, and the marking off takes place according to practical not ideal considerations. Also, like nature, the museum is in a permanent state of incompletion and relatedness.

In nature, however, past and present tend to be grown together, while in a museum the present had better be excluded as rigorously as possible, in order to resist having earlier events melt into the present and thus lose their shape, or risk being discarded for the sake of serving current interests. A "first step" for the Metropolitan would be to recognize that a museum should be the natural enemy of the temptation, which liberals share with criminals, to let bygones be bygones—in other words, the temptation to hasten the erosion of unpleasant facts, so as to be able to begin again with a clean slate. The obligation of a museum to maintain the integrity of the past as it was, including its stupidities and malefactions, imposes absolute limitations upon its capacity for invention and showmanship (e.g., the "Harlem on My Mind" exhibition). Nothing must be re-interpreted, either in the interests of higher ideals or higher attendance figures. In the museum Greeks still fight Greeks, and Eichmann transports Jews to gas chambers without the slightest yielding to the pressure of being watched by Sunday afternoon crowds of New Yorkers. What space is for the painter, exact distances in time are for the museum. Persons with the impulse to blur these distances should be barred from the museum as if they were carriers of a contagious disease. Whatever be the case in painting, in the museum objects must be seen in temporal depth, and attempts at "flattening" into the now must be condemned as vandalism.

Another "first step" for the Metropolitan is to recognize that *a museum is not an artist*, that what is right and necessary for artists is an abomination when performed by museums—and that a great museum ought to conceive a philosophy appropriate to its function instead of being guided by a pastiche of fashionable clichés. Unlike the museum, the artist has no reverence for the past; for him all time exists in the present. The aim of art is to cause whatever is still alive in the art of the past to come to life anew as a power of creation. The aim of the museum is to keep the past in its place and to preserve the dead without regard to their use or their possible resurrection. In sum, the artist and the curator see from opposite poles. *At the first sign that he thinks of himself as an artist, a museum staff member should be summarily dismissed.*

4. "What is the role of a large museum in an urban center?"

The obsession with expansion—bigger collections, bigger audiences, more "services," bigger staffs, bigger budgets—constantly undermines the activity of intelligence in America. Institutions that permit themselves to be dominated by the spirit of annual statistical growth (see the Met's annual reports) are doomed to

lose sight of their original reason for existence. The basic "service" of a museum is to provide an opportunity for individuals to be alone with creations of the past and with their responses to them. The less whispering in the ear the better. When the individual is ready to exchange wonder for information, he ought to be able to find sources of knowledge—but he should be allowed to seek them a bit and ought not to be rushed.

The notion that a museum ought to change its character in a democracy is based on the fallacy that the museum's obligation to the past is a relative one. This is an insult to democracy, derived from the traditional belief of reactionaries that in a free society all institutions inevitably sacrifice their integrity in order to pander to the mob. For bureaucrats, "urban center" means mass audiences—that is, fictitious collective minds that can be gulled and manipulated by means of superficial effects. But in urban centers as in small villages, individuals need to grasp the absolute nature of experience, and a democracy has as large a stake in a clear apprehension of the past as any other social order—in fact, a larger stake.

One of the embarrassments of museums today has stemmed from their ambition to take the lead in contemporary art. Painting and sculpture have long been their stock in trade, and they are reluctant to see them pass out of their hands. It happens, however, that there are many things that can be done with art today besides putting it in a museum. So the museum must either renounce handling contemporary art, or restrict it to its own physical accommodations, or expand into an art showhouse, equipped with film screens, lights, sound effects, stages for Happenings, and be prepared to compete with rival entertainment ventures.

I have been attempting here to provide the theoretical basis on which museums can choose among alternatives. I have no quarrel with showmen in the art world, providing they do not deface the past or offer themselves as ultimate judges of what constitutes creation in our time. Can a traditional museum enter into art show business without defacing the past? I suggest that instead of trying to answer this question, museums dissociate themselves at once from their art showmen, desist from reckoning their own value by the figures in the turnstiles, and do their best to deny the title "museum" to institutions in which the battles of the future of art take precedence over custodianship of the past.

1970

III
In the
Service of
Society

18 Community, Values, Comedy

Sociological studies expose their areas of inquiry as under a huge searchlight. There is an absence of shading, but this only makes the image presented by systematic research seem more complete; compared with it, the social novel or literary essay offers merely a smudge of emotionally charged individual instances. Literature reincarnates Madame Bovary or Anna Karenina—*The Kinsey Report* passes all restless wives through its turnstile. Having persued a "study," the reader is likely to conclude that while literary works have their use in exploring individual oddities, or for entertainment, if one really wants to know about his human environment, about Puerto Ricans in New York, suburbanite Jews, bohemians, agricultural villagers, Madison Avenue exurbanites,

Previously published in *Commentary*, vol. 30 (August 1960).

in fact, about anybody (since none escapes category), he had better get a hand from the social scientist.

The literary man himself often reacts to a social study with dismayed admiration. So many excellent details—how can a writer as a single person keep up with the revelations of teams of specialists? Perhaps sociology implies the end of the novel, at least, of a certain kind of novel. Perhaps the writer ought to follow on the heels of the sociologist and attempt to make his contribution in terms of manner of presentation.

The fiction writer's chagrin, however, is short-lived. Soon he observes that though the study has lighted up a few unnoticed corners, there is much in it that he knew all along. And not only he—indeed the study consists mainly of commonplaces. A novel written on this level of discovery would be dismissed as a bore. What takes people in about the scientists is the grand display they make of the machinery by which their petty findings are dredged up—explanations in technical language of how the data was collected and how much of it, how different factors were weighted, what safeguards were built against distorted interpretation, and so on. Actually, instead of a portrait of society, one gets a diagram of the sociologist's workshop with some charts on the wall. The matter contained in these charts could be quickly summarized, but the sociologist keeps redistributing his meager information into different percentages and statistical tables. In sum, most works in sociology are neither readable nor even meant to be read. Whatever they have to communicate comes out best in journalistic digests—who, for instance, went through the whole of *The Kinsey Report* or of Stouffer's *The American Soldier*?

Arguments such as these, Professor Lewis Coser has recently contended, are used by literary men in an effort to retain for themselves "the domain of cultural criticism and social commentary which has been [their] almost exclusive preserve." It is a case of a monopoly threatened by another power—and the writers' mockery of the bad rhetoric of the sociologists, of their superficiality, of their research paraphernalia is but a weapon against the superior industriousness of the newcomers. Instead of welcoming the researchers who have come to clean up the wild growth of social impressionism, the literary men keep firing at them as invading barbarians who must be kept from landing.

If all that the writers have found to object to in sociology is its jargon, its techniques, and its self-imposed limitations, it seems to me Professor Coser has a point. It is a case of an older calling

saying to a newer one, "Your professionalism is showing." To produce platitudes with much clanking is the way of all the intellectual trades, including that of writing. Each occupation develops a lingo of its own by which its members recognize one another and protect themselves against outsiders; coming too late for the Latin of priests and physicians, or the sign language of physicists and musicians, the social scientists have been compelled to compose a terminology through spoiling ordinary words. This they have succeeded in doing within a comparatively short time, thus enabling themselves to obscure their statements at will, like old hands of the vestry or consultation room, wherever a danger spot needed to be covered up or a research project kept going in a circle. It is difficult, however, to see how contemporary literary critics can protest if others avail themselves of the advantages of thickened rhetoric. Nor has current poetry or fiction shown any large will to break out of the kind of writing that keeps literary practice at a happy distance from meaningful statement. If jargon and tricks of the trade are the issue, it should be noted in favor of the sociologists that very little worth saying has been said in the common language of man. Aquinas and Hegel wrote in jargon, and our period is not the first in history in which each of the arts has found its proudest creations to be fully comprehensible only to its practitioners.

Aesthetes to the contrary, criticism of sociology must go beyond taunts regarding literary style; where a genuine exposure of social fact occurs—that is, where the study acts as criticism—its heaviness of manner should not be held against it, any more than the stuttering of Moses vitiated his tablets. Sociological writings have in the past thirty years often contained a more faithful reflection of facts disturbing to the American consciousness than the sum of our novels and plays—compare, for instance, Dollard's *Caste and Class in a Southern Town* with fictional apologies for the South. Still, as C. Wright Mills has suggested, sociology is a kind of *imagination* and must submit to investigation of its language, its assumptions, its moods.

Maurice R. Stein's *The Eclipse of Community* takes the literary bull by the horns. It proposes that community sociology shall acquire the finesse of literature and the breadth of history and philosophy. Yet it is a book by a professional sociologist, on the profession and for the profession—it departs neither from the vocabulary ("kin statuses," "compensatory rewards," "heterogeneous population aggregates") nor the methodological concerns of the community studies. Thus it raises the question whether

community sociology can think and speak on the larger scale of affairs and values, or whether Stein has supplied an insider's exposé of its inherent weaknesses.

The very word "community" lands us in deep thoughts concerning the human environment of individuals and what each owes to the many. Despite its title, however, Stein's book puts off to the end his speculations about what "community" means— we begin with actual American cities, towns, and neighborhoods, those that have been the most carefully examined. Summarizing the outstanding studies of the past forty years—such as Park's investigations of Chicago, Louis Wirth's *The Ghetto,* the Lynds' *Middletown,* Lloyd Warner's *Yankee City,* Stouffer's *The American Soldier,* Seeley, Sim, and Loosely's *Crestwood Heights,* and Vidich and Bensman's *Small Town in Mass Society*—Stein presents fascinating data on American life from the 20s to the present. To sociologists, one assumes, this information is old stuff, but laymen should be grateful for the chance to get the gist of the surveys, while avoiding the wear and tear of the studies themselves.

The Eclipse, however, is by no means a mere digest or popularization. Its feature is that Stein links the studies together into a kind of history of the nation's changing way and attempts to derive from them a conception of trends and values in America today. On the professional plane, by this "interpretation of American studies," Stein hopes to rescue them from the "limbo" into which they fall as cross-sections of transient modes of social life, by treating them as evidence supporting a theory of social development.

It seems to me that in his primary aim of meaningfully joining the studies to one another Stein has succeeded. A survey of a mill town in the Depression reveals the working of processes which reappear in more developed phases twenty years later in a plush suburb. The processes are those observed by Marx, Durkheim, Weber, Simmel, Mannheim: urbanization, industrialization, bureaucratization. Of course, the reason Stein can find these processes in communities separated in time, place, and social character is that each American community and sub-community is part of the nation as a whole and is subject to what is happening in it; so that the blocking off of any section for study is an arbitrary procedure to begin with—perhaps no community should have been analyzed except as a microcosm (as was done in *Small Town in Mass Society*). In any case, Stein has been able to reconnect the studies with one another, putting together what the profession set asunder.

The effect of urbanization, industrialization, and bureaucratization is to disorganize community life and to reconstitute it on a different cultural plane. Similar developments could be observed in Tuscany or Cambodia—the Chicago variation in the twenties was as follows: "with the process of growth of the city the invasion of residential communities by business and industry causes a disintegration of the community as a unit of social control. This disorganization is intensified by the influx of foreign national and racial groups whose old cultural and social controls break down in the new . . . situation in the city. . . . Delinquent and criminal patterns arise and are transmitted socially just as any other cultural and social pattern is transmitted."

Stein's review of the studies of subcommunities (ghettos, gangs, rooming-house districts) shows how they have been leveled over the years and re-formed along a common pattern, thus laying the ground for present day cultural conformity. Together with the integration of immigrant cultures has come the weakening of bohemian centers of resistance, as their life styles have been absorbed into conventional society through siphoning by the novelty-seeking mass media. All this is very instructive about phenomena of daily life: for example, the appearance of gefilte fish and matzos in countryside supermarkets represents the integration of immigrants; abstract art in churches spells middle-class absorption of bohemia.

To the individual the decline of subcommunities brings depersonalization and psychic decomposition. In their ghettos, the foreign-born of fifty years ago, though doomed to "marginality," had three-dimensional personalities; let out into the world, their grandchildren suffer from "diffusion." At the same time, identities based on the crafts and trades have been dissolved by mass production, which has also undermined the traditional "status systems." Bureaucratic management of work, consumption, education, has led to sameness in all activities and to a reliance on experts in the most private sectors of personal and family life.

In its larger aspects the community story thus becomes the familiar one of the steady dimming of folk culture and of personality and spirit under changes wrought by industrial civilization—and one is not surprised to find Stein invoking Hannah Arendt, Karl Jaspers, Martin Buber, and Erich Kahler as "contemporary philosophers whose work has important bearing on the theory of communities." Through an overlapping of German crisis-philosophy and American community studies, Stein presents "alienation" in terms of daily detail.

How has this combination of sociology and culture-theory been accomplished? Perhaps the answer is that Stein's "existentialists" are looking back to the ritual society for the measure of man, and that the sociologists (at least those who are not content with mere counting for the sake of market research or voting predictions) are doing the same thing. "One can hardly appoint oneself a social philosopher," writes Stein; then, after acknowledging his debt to the above-named humanists, he adds disarmingly, "Following established sociological practice, my philosophical position was smuggled into Part III, loosely disguised as chapters on anthropology and psychoanalysis." The philosophy of cultural eclipse can be palmed off as a value-scheme derived from anthropology only to the extent that both share a nostalgia for the "organic" community and instinctual behavior specifically. Arendt et al. have little use for primitivist or psychoanalytical concepts.

Apart from nostalgia, I can see no reason for judging modern community life by the bio-social standards of folk culturists or by socio-psychiatric standards of neo-Freudian theoreticians. Stein draws from Erik Erikson a synthesis of anthropological and psychoanalytic values: "Looking forward, the individual should be able to see a series of later phases of adulthood each with its own demands and rewards. The human life cycle is a social as well as a biological fact. Only the most gifted and courageous are able to carve out their own. Unless the groundwork for identity elaboration is laid in adolescence, the adult is condemned to permanent confusion. A community must then provide its members with, at the least, meaningful sexual and work identities if it is to ensure its own continuity as well as the psychic integrity of its members."

These, apparently, are aims no one would quarrel with. But are they? "The individual should be able to see a series of later phases." Why should he? Dostoevsky made fun of the Germans because among them every "phase" of a son's life was planned by the family from birth. But if the youth doesn't know where he's going, the adult will be "condemned to permanent confusion." When, since his departure from Eden, has man escaped confusion in regard to his identity? Heroin takers tell us that the allure of the drug is that it annihilates questions or empties them of personal anguish. Ritual has an identical effect. It is because confusion is inherent in man that he is given to narcotics and conversion rites. But the anthropological philosopher wants him back in an organic Eden where the different "phases"

of life are bridged so naturally that no one is upset by them. In his paradise, "identity elaboration" is taken care of through the community groundwork and without individual crises or separatist intoxications or cults. There are people, however, who would rather risk confusion and catharsis than find themselves consigned to a foreseen "series of later phases."

With the "life cycle" no longer under social management, "only the most gifted and courageous are able to carve out their own." Why not make it a "value," then, as did Lautréamont and Nietzsche, that everyone shall become gifted and courageous? This seems more desirable than for a community to "provide its members with, at the least, meaningful sexual and work identities." Developing my talents and courage puts the question of my identity up to me, where it belongs; while if the community "provides" my identity, it will, as in past societies, tend to be little more than a dog-tag in depth and belong more to my neighbors than to me.

For one to be able to judge the quality of life in it, a community needs to be seen in the perspective of other communities. But to turn to anthropology for values is to run the risk of utopianism, both of the scientific and the poetic variety. The danger is especially acute among those figures in American anthropology whose small-town or European folk sentiments have mingled with a lapsed Marxism in a fantasy of total social communion. Stein is much taken by theories stemming from a vision of the "mystical participation" of primitive consciousness in which the split between mind and feeling is unknown. On this score he leans heavily on Paul Radin: "Primitive social order as conceived by Radin rests on a dramatic synthesis in which everyday life is transformed and saturated with meaning. Individuality depends on the capacity to participate imaginatively in the experiences and satisfactions of the whole community." I cannot conceive what makes the primitive synthesis *"dramatic,"* but it is certain that an individuality that depends on joining in the "experiences and satisfactions" of all is not the individuality of anyone we think of as an individual. It would seem to exclude the idea of discovery or change; on the other hand, the demand for "imaginative participation" in the affairs of the whole community sounds exactly like the notion of "the people's artist" in socialist-realist aesthetics.

Retaining the total community of anthropology, Stein tries to give it a modern personalist inflection; his position, he concludes, "rests upon the assumption that human communities exist to

provide their members with full opportunities for personal development through *social* experimentation." Here Stein is trying to slide verbally over a contradiction of enormous magnitude. Once again the community is presented as a "provider" rather than as the focus of shifting needs and struggles. At the same time, the community is conceived as an ideal testing ground for individuals, a concept which lifts it into the possibility-world of the laboratory and of vanguard art. Were everyone to be guided by "social experimentation," the present "eclipsed" community would seem as vividly pervasive as an African village at high noon.

Personal development or "self-realization" is, of course, a grand aim; but if the actual common life is judged by how this aim is being advanced, man will be found to fail, as he does when judged by any ideal, say that of the soldier or the saint. Worse still, self-realization, if conceived as a community goal, *will contribute to make man fail,* as the community apparatus, seeking to articulate the individual's life toward its concept of maturation, augments his anxiety and rigidity. In aboriginal societies, Stein reminds us, "ritual dramas bind together the phases of life to assure growth," thus helping "the individual confront his own destiny." Perhaps. Yet what is the destiny of primitive man but to be the vehicle of abstract "phases"? and why speak of *confronting* where there is no disturbing consciousness of self?

The sense of civilized man's failure accounts for the despondent tone of many of the community studies, their persistent intimation of moral and intellectual grayness in the lives being observed. Explicit condemnation is ruled out by the scientific pretense of "objectivity"; nor, wearing his neutral mask, does the sociologist cite any code or comparison which justifies putting the Indian sign on his human subject. Yet his descriptions consistently pile up evidence of a worn-out and futile existence. "The intimacy of primary relations," wails *Crestwood Heights,* "can be punctured easily: the flow of after-dinner conversations will often be broken clearly and sharply at nine by a vigilant host who has scheduled a television viewing as part of the hospitality of the evening; a chattering group of students will be divided neatly into two halves by an ongoing bus (four minutes late), half boarding the vehicle, the remainder continuing on foot; family dinner is interrupted by long-distance phone calls for father."

Together with this owlish clucking comes a conviction of fatality—things will go on getting more and more this way, and there

is nothing that can be done about it. It is to Stein's credit that he calls attention to this fatalism in the community studies and that he connects it with the "objective" approach: "This picture is at least partly an artifact of the distance between the observer and the community." Exactly. For how can improvement be expected if the owlish critic keeps his own will out of the picture and concentrates on data trapped in his research apparatus?

Recognizing the concealed indignation in much of community sociology, Stein seeks ways of bringing it to the surface without violating the requirements of objectivity. In this connection, keen perception leads him to raise the question of literary style. "It is surprising that so little attention has been paid to the crucial role played by reportorial style, since it is at least as important as the more frequently noticed style for conducting the field work." Stein commends the Lynds for their straight-faced irony "through which they report what the people of Muncie are experiencing, while simultaneously critically commenting on that experience." In another place,[1] I have noted the resort to the dead-pan by Riesman and William H. Whyte, Jr.

The trouble with this type of irony is that its criticism is at once superficial and opaque. It underscores the routines and platitudes of the social group under observation and induces scorn for an existence limited to these mean experiences. In doing this, it intimates that the sociologist and the reader live quite differently and have in common an understanding of a higher way of life. As Stein points out, "There is an irresistible tendency for the reader of community study to assume an all-knowing attitude toward the community he is reading about." In short, the irony of sociology is that of a coterie, a system of double meanings comparable to that of addicts or homosexuals—Whyte complained that his irony too often went over people's heads. The strongest motive for the noncommittal style is self-protection, similar to the "neutral" face of delinquents caught with the goods (after all, studying one's neighbors is a species of spying or peeping). It is cute of Stein to approve of the sociologist's "smuggling" in his values, but the adequacy of these values is by no means guaranteed by the fact that his objectivity is a fake.

The oldest form of the social study is comedy. Like other theoreticians of society, Marx, for example, gave thought to the structures of prehistoric communities, but his sense of the human situation owed more to Shakespeare, Cervantes, Rabelais, Molière,

1. *The Tradition of the New.*

Diderot. Modern anthropology searches for *Man* in aboriginal settlements; literature has been knocking around with men and women for three thousand years. If the comedian, from Aristophanes to Joyce, does not solve sociology's problem of "the participant observer," he does demonstrate his objectivity by capturing behavior in its most intimate aspects yet in its widest typicality. Comic irony sets whole cultures side by side in a multiple exposure (e.g. *Don Quixote, Ulysses*), causing valuation to spring out of the recital of facts alone, in contrast to the hidden editorializing of tongue-in-cheek ideologists.

It is the absence of comic perspective, characteristic of moral reformers and utopians, that turns many community reports into records of sour failure. To return to Crestwood, that suburban haven of the well-to-do and sophisticated: in their will to conform and have their children conform, in their patronage of tutors in manners and of witch doctors and alchemists, in their putting social success before enjoyment of life and human feelings, in their anxious counting of signs of age and their fear of the contempt and indifference it will bring, these husbands and matrons resemble the pillars of society of all ages. For our sociologists, however, they personify horrors that seem brand new—the accounts of them even sound like *news.* "For both sexes," observes *Crestwood Heights,* "despite diets, cosmetics and facial surgery, age creeps on. [*O rage! o désespoir! o vieillesse ennemie!*] A critical period for the male, as it certainly is for the female, is the 'change of life.' Surrounded by more secrecy than is puberty, except when it is the subject of not too gentle joking, this period threatens, sobers, frightens. The crisis surrounding menopause is, however, more serious with the female, while the next general crisis, which comes at retirement, is almost exclusively a problem for the male."

As we look through the telescope, Stein interprets for us: "It is important to notice what is happening here. The human life cycle has been leveled by a cultural system which ignores the values that can be found in various ages." It is our system, not old age, that brings this sadness—I can think of other things that are wrong with the system. But isn't it true that people were also "ignoring the values" of old age in the days of Aesop, the Old Testament, Polonius? Advantages "can be found" in dying, but it is for philosophers to find them. However, as the title of Paul Radin's study suggests, in the dreams of anthropologists primitive man *is* a philosopher and solves the problem of dying, too, and without the strain of reflection.

In Crestwood, "male careers have a terrible inevitability with performance peaks usually being reached in the late thirties only to taper off in the fifties and with virtual obsolescence arriving at an ever-earlier age." If the suburban male had a sense of reality, he'd reach for the cyanide before he grew up. He is still here only because he deludes himself; and it takes a comedian with a zest for the life behind play-acting and deception to delight in these delusions. In his brief predictable span, the Crestwood paterfamilias has been seduced by all kinds of foolishness: he has been puffed up at his success, admired himself for his philanthropy, been distracted by triumphs at the office and in the club car, and by glances passed between himself and Mrs. X at cocktail parties. Poor fellow, he cannot keep his inevitable defeat as steadily in mind as can the sociological master of the facts—yet isn't his shortness of memory also a fact and worthy of study? If his wife didn't pester him so about his diet, he could have been painted by Chaucer or Franz Hals (though not by Niebuhr). Is he to blame that the search for scientific generality should have thrown him instead under the poky eye of the community-study team?

As we have insinuated once or twice, community reports have comedy in them in any case, if from no other cause than their way of computing human activities as if they were wind velocities or traffic over a fish ladder. What sociology needs is to bring the comedy into the foreground. For this, the first condition is that the professional "participant observer" *shall be a participant in life before he participates in the community.* This requires that he shall be constantly aware that the joke is on him too— if not this joke then another one very much like it: for instance, if he has avoided the comedy of the small town with its protective disguises, he has been caught in the comedy of sociology with *its* disguises. Through his own life alone could he recognize the common situation of man as victim-critic of his actions, his environment, and his destiny, and thus achieve an objectivity that is not a ruse.

Like dreams, the myths of primitive peoples reflect the passions of their interpreters. If, as Stein wishes, sociology is to make use of dramatic concepts, it must acquire different values than can be deduced from aboriginal imagery. For example, in creating social types, comedy takes for granted, and turns into a source of pleasure, the "impoverished emotional life" which the admirer of primitive culture reprehends as an effect of civilization's abnormalities. In anthropological imaginings the community appears

as the happy "dispenser of roles"; in drama all identities are false identities—individuals live happily in them. The peril, whether in *Oedipus* or *Tartuffe,* is that their true selves will be exposed. (Similarly, all bohemias are false bohemias; discarding a social costume only uncovers another social costume; Stein's fear that *real* bohemias are disappearing impels him to adopt the comical proposition that our society may have "to plan for bohemias.")

Above all, life for the dramatic thinker consists not in a "harmonious development of potentialities" but in enduring wounds—the returning hero is recognized by his scars; while social science cultivates a horror of blemishes and itself wears the "success and happiness mask" which it deplores in the middle class.

What the sociological imagination can gain from drama is its image of the community as a theater of conflict. No form of thought is more deterministic than comedy and tragedy, where the plot controls the behavior of the characters as their destiny. Yet in drama the force against the individual is not a system of impersonal processes but embodiments of those processes—not industrialization, organization, bureaucratization, but tycoons, gangsters, office-holders. The very meaning of the word "drama" implies that in every human encounter an action takes place through which the actors realize themselves as individuals. The metaphysics of the integrated community, however, translates actions (e.g., a Crestwood flirtation) into social processes. Thus it places its trust not in reality but in Utopian fantasies. "Given the conditions of rural surrender," writes Stein of the inhabitants of Springdale, "perhaps the retention of a mythology that allows a minimum of collective self-esteem and justification is the only real alternative to social disintegration." Viewed in this perspective, "the conditions of surrender" are irresistible. Yet the drudgery of the American community is owing not to its being overpowered by historic forces but to the failure of its members to struggle against those forces—and this passivity is promoted by sociology.

For comedy there can be no "terrible inevitability," since the exposure of the social imposture of itself works a change, through the purging of consciousness and the release of energy. The anthropological bias excludes this radical effect of self-knowledge. "People need to believe in the value of the communities in which they live," writes Stein, "the goals that they seek, and the satisfactions they receive. None of this would be possible if the true state of affairs was exposed; and it is ironic that exposure would not necessarily render the facts amenable to change." In a word,

Stein sees the Springdale folk as doomed and, like the Grand Inquisitor, settles for their consolation through illusion. Is this, as Dostoevsky thought, the inescapable conclusion of the scientific humanitarian? Must his objectivity end in the approval of mystification? That may be so, unless his understanding of Crestwoods and Springdales rests on the belief that if their inhabitants knew themselves as they are, they could give birth to a new community (or two or three), despite the limits set by the "socio-economic basis" or "urban dominance."

1960

19 The Anthropologist's Stone

I

The Soviet Union is a society that has within it a unique and separated entity, "the great whole," as Lenin called it, "which we are creating for the first time—the Party." This whole, says the official *Agitator's Handbook,* is "the organizing and directing force in the Soviet Government, the heart, brain and spirit of the people, the leader and teacher of the workers." It is the Person that rules the USSR; strictly speaking, the only person that exists there—no other group and no individual (not even Stalin himself) [1] is a person in the sense of being separate and

Previously published in a slightly different form in *Twentieth Century,* August 1952.

1. After Stalin's death and his denunciation by Khruschev, the Party

self-directed. Today there is great interest in knowing this Communist Person. Everyone is concerned with what it thinks, what makes it act, what it intends. Above all, there is the desire to know what it is likely to do (which is not the same thing as what it intends, since a person may act differently than he intends), especially about starting a war.

How does one grasp the character of such an abstract creature which leaves its tracks everywhere but which, like a god or demon, cannot be physically apprehended because it is not a thing but exists *in* other things—human beings, institutions— as a thinking, feeling, and decision-making power? It is a question of drawing the portrait of an invisible being, a dramatic portrait— that of, in the case of the Communist Party, "the vanguard of the proletariat," with its intellectual and emotional physiognomy, its belief in its historic role, and its consciousness of the magnitude of its strength and of the conditions under which it feels forced to exert that strength to its maximum.

Our deepest knowledge of Communism comes from individuals who have beheld the shape of the Party *within themselves* as well as from the outside. Whether it be Lenin, who first formed the image of the Communist in his mind and then brought it into being; Trotsky, who was repelled by Bolshevism, then embraced it; Stalin, who re-formed the image according to his interpretation of Lenin's acts and thoughts and according to the demands of his own struggle to dominate it; or the intellectuals who were invaded by it and then painfully expelled it as an alien spirit, a "God that failed," as their book of confessions appropriately entitled it—all these have tried to tell not only what Communism thinks, feels, and does, but *who* that collective being is that has dwelt in them. There exists, in short, a literature concerning the Communist Party which is a product of the imagination, more or less informed by experience, composed in longer or shorter historical perspective, colored with hopes, fears, reverence, dogma, will to power, hate, disappointment, contempt. The sum of these inwardly reflected images constitutes our knowledge of the figure of Communism and is the basis for forming estimates in regard to any new encounter with it.

Is there some approach more reliable than their testimonies, from which sentiment and subjectivity can never be altogether absent? Is there a way of looking steadily at "the great whole"

convicted him of having established a "personality cult," that is, of having functioned as an individual, and it made an effort to return to "collective leadership."

as a creation outside the observer and at a distance from him, revealed through its words and deeds alone, yet with its active principle exposed, so that it is recognizable as that entity able to exert so much force upon the human race?

In response to the desire for acquaintance with Communism (proportionate to the desire not to be acquainted with Communists), a new kind of savant of Communism has appeared: the scientist, the professional maker of predictions. He speaks not because he was visited by the Communist spectre but because people are asking questions and it is his job to answer them. If his colleague in astronomy can foretell that a certain planet, hitherto unseen, will appear in the skies on Tuesday morning at 3:46, why should not he, by applying a comparable method, be able to predict what Stalin and the Politburo are going to do? Perhaps not as precisely as the other foretells the positions of the stars, but surely with more accuracy than one whom the "whole" attracts or repels as if it were a person like himself.

Last year the RAND Corporation, an organization which carries on scientific enterprises "for the public welfare and security of the United States," published the first two studies of a series which, through the joint efforts of political and social scientists and other specialists, is intended to provide a functional characterization of the Communist Party and the Soviet state. The opening volumes were *The Operational Code of the Politburo,* by Dr. Nathan Leites of Yale, an anthropologist with OWI and UNESCO experience, and *Soviet Attitudes toward Authority,* by Dr. Margaret Mead, who has told us so much about Samoans and other males and females. RAND Corporation projects are, one gathers, paid for by the United States Air Force. Each of the books in question is subtitled *A RAND Corporation Research Study,* is referred to as a "report," and in appearance is a cross between a textbook and a printed memorandum intended for circulation among interested experts. All this suggests a very serious, almost confidential, investigation. For months before publication, Dr. Leites's *Code* was, it is said, the most-discussed "RESTRICTED" document in Washington. Just before the report's official unveiling, *Look* magazine featured it in a special article called "How the Politburo Thinks," headed by a statement from the editors declaring that "there is no more important document in Washington today," and that while it makes things look pretty black for freedom, we are lucky in that "it is already in the hands of U.S. policy makers." The publication of Dr. Mead's book was noticed in a *news* story in

the *New York Times,* though most of the story was devoted to a work yet to come on how their tradition of swaddling babies brought the Russians a dictator. Since there are many good books and articles in English on Communism, the fuss about the RAND studies has to do, obviously, with the aura of respect surrounding "science," especially since the atom bomb.

The dust jacket of Leite's *Code* describes it as "a systematic analysis of the political strategy of Communism and the rules by which it operates." The author's introduction, however, says something a little different: he is offering, he says, "*some* of the findings of a *still-continuing* study of the political strategy of Communism." Obviously, if the book were a "systematic analysis" of Communist strategy, one would get not just "findings," and only some at that, but the whole strategy, laid out and logically taken apart. The fact is that the book contains no analysis, systematic or other, except analyses quoted from Lenin and Stalin. Leites's "rules of strategy" consist of generalizations derived from Communist writings, and these generalizations are numbered and grouped under such headings as "Means and Ends," "The Control of Feelings," "Deception," "Violence," "Deals." One discovers, for instance, that the Party plans to keep in permanent fighting trim; that it expects agreements with it to be violated; and so on. I don't know what use the U.S. Air Force or the State Department expects to make of these summaries, but if they imagine that the *Code* constitutes an analysis of strategy, rather than an abstract of widely known Bolshevik formulas, we had better watch out. On the basis of his introduction, however, Dr. Leites can well deny that he personally sold it to them as such.

The jacket goes on to remind us that "we have been at a loss to understand how their [the members of the Politburo] minds work, what their goals are, and what they believe must be done to achieve those goals." Presumably, the *Code* is going to enlighten us on Stalin and Company's manner of cogitation, what considerations make an impression on their brains, and how their thoughts result in actions tending to achieve particular historical objectives. To know what these last are would be especially important, since the concepts "Socialism" and "Communism," never very precise to begin with, have become immeasurably beclouded by Soviet statements and practices. Here again, however, Leites is at odds with his blurb writer. He does not, he announces, propose to discuss the major theories of Leninism-Stalinism; he is willing to make the assumption—a very dubious

one—that his "rules which Bolsheviks believe to be necessary for effective action" can be understood without Bolshevik theory. Thus, contrary to the blurb's claim, no Bolshevik goals; just their how-to-do-it book. It is as though one set out to present the mind of the Pope without saying anything about Catholic theology.

After comparing the *Code* to Machiavelli's *Prince,* the publishers hand it over as "being made available to the public [instead of being hidden in a vault underneath Mt. Everest?] in the belief that it is a major contribution to our ability to understand and *to predict* Politburo behaviour." For this to be the case, two things would have to be established about the rule book: (1) that the rules mean what they say—that Trotsky, for example, was wrong when he argued that a statement meant one thing to Lenin, and something quite different when repeated by Stalin; (2) that the Bolsheviks actually behave according to those rules, since when people grab up table legs in a fight, Queensberry rules become meaningless. But even if the rules meant what they said and the Bolsheviks obeyed them, they still would not indicate what the Politburo was going to do, any more than the "code" of Hoyle suggests how a man is going to play his hand in a poker game.

Actually, Leites does not pretend to understand the Politburo mind; he does not even maintain that the rules are still in force. "Since the Politburo has abandoned the unusual frankness in statements of policy that existed up to 1930, any conclusions concerning present rules of strategy must remain, to some extent, conjectural." If the Russians aren't going to tell us candidly what their rules are, Leites won't take any responsibility for them. And, though at the bottom of his packets of rules he summarizes what the Russians have been up to since 1945 and suggests what can be expected of them in the future, he warns that "this study does not attempt to analyse recent or current behaviour in terms of the policy rules"; it only contains a "few suggestions in this direction." Besides, "these suggestions are simply *hypotheses* and further research is needed to test them. Moreover, they are merely illustrative." No one could be more modest than Dr. Leites nor carry scientific reserve farther. Indeed, if we take him at his word, he is hardly claiming to say anything. Yet his innocence is purely technical. It is one thing to make "a few suggestions" in a laboratory, with further research to come later; quite another when the partial exposure is made in an atmosphere of passion. Dr. Leites is presenting

provisional and partial knowledge under circumstances in which a strong urge exists to form a picture of Bolshevism and in which, therefore, his public will not be content to refrain from drawing conclusions from his data, as it would if the subject under consideration were one with which it is not emotionally concerned—the Minoans or the classification of beetles, for example.

Having failed to grasp the active core of the Bolshevik Person (inseparable from its "major theories" and its history), Leites produces a caricature of it. The effect is both to create delusions and to conceal important aspects of Bolshevism. For instance, Leites presents the Communists as hypocrites because they make deals with people they had previously denounced. But all political agencies make deals that serve their interests, and the hypocrisy of the Communists is not a trait peculiar to them. What is meaningful in Stalin's relations with the non-Communist world is that he has increasingly allowed himself to do *anything* (e.g. the 1939 alliance with the Nazis) in the name of Marxism, and has thus reduced Marxism itself to nullity. By his combination of dogma and opportunism he has, as Trotsky maintained, betrayed the October Revolution. This is the first thing that the American people and its leaders ought to know about him. Without the history of Bolshevism as a measure, the Operational Code of the Politburo might equally describe the tactics of Tammany Hall.

The imaginative writer *begins* with the unique collective "person" that his experience has made present to him. The advantage claimed by the social scientist is that he conceives the totality of the entity he is dealing with only *at the end* of his study, after all the facts have been gathered. Since Communism keeps adding to that sum of facts, the scientific methodologist cannot finish his study until Communism shall have ceased to exist. At the bottom of Leites's *Code* is the unscientific assumption that the code is a subtitute for the facts—in sum, that Bolshevism is a changeless entity that once and for all has expressed its will, habits, and beliefs through its written documents. That Lenin and Stalin should have said the same thing is enough, for Leites, for the statement to become a Bolshevik rule. But the history of orthodoxies shows that words go on being repeated long after they have lost their original meanings. In a state of decay, or when forced to modify its practices, a corporate being like the Communist Party more or less automatically disguises its altered condition under the phraseology of its heroic beginnings. One has only to read the

exchange of letters between the Cominform and Tito to realize that Stalinism has become immersed in a species of verbal hallucination, that the nightmare ambiguity of its language is only partly deliberate (the "Aesopian" language of Bolshevism is being overplayed in America, perhaps owing to our tendency to assume that every practice follows conscious rules). The weird meanings that words like "internationalist," "proletarian policy," or "traitor," have acquired under Stalinism are both a cause of its unreal world and an extension of it. By paralleling the words of Lenin and Stalin one arrives not at a "code" but a *trompe l'oeil.*

What remains of Marxism in Leninism, and of Leninism in Stalinism, is an extremely subtle historical question. To assert the identity of these political philosophies is to accept the Stalinist claim to "Marxist-Leninist" orthodoxy. The assertion that the "operational code" of the Communist Party today is still that of Lenin's Party is Stalin's primary weapon against Tito, and is his chief pretension to legitimacy in the minds of workers and intellectuals wherever a revolutionary situation arises. Excluding the imagination, Leites's method has brought him no closer to the Bolshevik whole than some thin shavings of its ideology. Nor do I believe that adding more shavings—Leites has given lectures psychoanalyzing "the Bolshevik élite"—will result in a solid representation of Communism. The hope that the scientist, by adding data, will correct his inadequacies and come forth with the truth is, in matters like these, a kind of pie in the sky.

II

Compared with Leites's *Code,* Dr. Mead's *Soviet Attitudes toward Authority* is a riper dream of what scientific method in politics can do. She counts on it both to overcome the absence of certain information, which the Soviet system does not make accessible, and to take the place of expertness in Marxism, in Communist history, and in the Russian language, all of which she readily admits she does not possess. The preparatory work on *Soviet Attitudes* was done by a team of specialists; Dr. Mead herself was able to do only a minimal amount of "first hand analysis of materials"; yet she is solely "responsible for the theoretical phrasing" of the report. What she has to offer, says Dr. Mead, is her "anthropologist's training in relating isolated items of behaviour to a systematic whole"—a capacity resembling that of the poet or dramatist, except that it is systematic. Thus equipped, she can take the "insights, research and formulations"

160

of others and reconstitute the shape of the invisible mastodon. Here the Method is clearly presented as an alternative to scholarship, intuition, and experience.

Reaching for the body itself of Soviet society, "the systematic whole," Dr. Mead makes claims much less reserved than Leites's —less, indeed, than the blurb on her book. Besides being an "attempt to examine contemporary Bolshevik character," her book "directs itself toward" answering dozens of interesting and profound questions, such as "how will individuals who embodied the old culture behave within the new revolutionary forms?"— or, what is "the meaning of the organizational changes [in the USSR], the extent to which different parts of the apparatus are rivals, the relationship between the actual clique formations and the official ideal picture"? Before the advent of the Method, it used to take the entire literature of a nation to illuminate subjects like these—for example, the "father and son" theme in nineteenth-century Russian fiction. In addition, *Soviet Attitudes* claims to help us *predict*—and with regard to very delicate matters too; for instance, "the type of loyalty of border populations or the sorts of pressure exerted upon a chairman of a collective farm, by central authorities on the one hand and the members of the collective on the other." And all this Dr. Mead thinks she has accomplished in exactly one hundred pages!

Needless to say, there are many kinds of answers to questions and many kinds of "predictions." How will conventional people behave after a revolution? "Unhappily." The loyalty of the border populations? "It will be doubtful." The chairman of the collective? "He will find himself often in a tough spot." Medieval wizards used to give predictions like these to the barons who poured out their treasures to them. What prevented recognition of the hoax was that the revelations came from research which promised some day to uncover the Philosopher's Stone. Without evaluating Dr. Mead's Method, one cannot decide whether to regard the following as a serious comment on the USSR or a speech intended for a modern version of *The Alchemist*:

A populace disillusioned regarding the hope of tangible rewards, subjected to terroristic pressure, living within a situation in which all are treated as subject—and most of all those who must also be the most incorruptible—may become steadily less responsive to positive motivation, more apathetic, and less able to participate with any enthusiasm in Soviet life.

One can imagine this being recited at the head of a long table

at the Pentagon. When Dr. Mead gets through—silence. Then an eager colonel asks, "Doctor, you said that the Soviet people, being disillusioned, terrorized, and enslaved, *may* become less enthusiastic. Wouldn't it be safe to predict that a people so treated *will* become less enthusiastic?"

Apart from emptiness, there is the more serious matter of spreading misconceptions. The key to her Method, Dr. Mead tells us, is its approach developed in studying "preliterate societies." Now, what happens when this approach is made to the USSR and the Communist Party? In the primitive community, the "whole" is the entire culture, and ideas (attitudes) and institutions are different aspects or "items" of behavior. Consistently with her Method, Dr. Mead assumes that the Russia of the USSR is a community and that the Party and its "authority" are to be understood in terms of Russia, including its social and psychological past, so that the way babies were swaddled in Kharkov in 1890 seems to cast more light on Soviet rule than Lenin's interpretation of "proletarian dictatorship." In place of the primitive community, we now have the totalitarian state, but the anthropologist's perspective is the same:

Primarily we are concerned with those regularities in the behaviour of citizens of a nation-state which can be attributed to the fact that such citizens were reared or have lived for a long time under the influence of a set of nation-wide institutions.

But to approach the Soviet Union, or any modern State for that matter, as if it were a community in the old sense is to begin with a basic mistake. It is to assume, by analogy and without any historical or empirical justification, that the Soviet Union is a social organism created by the usual processes of social life and defining itself in terms of its inner development. The USSR, however, did not flower from the past of Russia. In comparison with older societies the USSR is a quasi-community. It lays claim to the individual in the total manner of preliberal cultures; but in it the individual was not formed from birth by the whole communal life, as in the Samoan village, but was deliberately modeled by a discipline of directed thoughts and acts imposed by the Party caste which is the custodian of the Bolshevik idea. It is a society split into a separated elite and a dominated mass by its primary act of organization, and its unity can only be maintained through a constant application of force and repression, which is, of course, not true of preliterate societies. Soviet at-

titudes toward authority are established by the Communist Party and enforced by the secret police.

Failing to distinguish between a genuine community and a twentieth-century power area, Dr. Mead entirely misconstrues the character of totalitarianism and the situation of the individual in it. To her, totalitarianism means that "the whole of each individual's personality is conceived as being involved in anything which he does." If so, what is wrong with it? Old cultures, most religions, many artists (to say nothing of the theory of psychoanalysis) also conceive the whole personality as involved in anything the individual does. Anyone possessing an inner coherence joined with an external unity of action, any dedicated person, would fit Dr. Mead's definition of totalitarian. According to it, the Soviet Union is the land of modern personifications of Greek heroes, Christian saints, inspired creators. Dr. Mead's only antithesis to "totalitarian" is the fragmented democrat who gives part of himself to his job, part to his family, part to his country, until his soul looks like a checkerboard. The illusion that totalitarianism offers this choice between total involvement on the one hand, and fragmentation on the other, accounts for much of the attraction of totalitarian movements, especially among intellectuals. Actually, however, totalitarianism does not conceive the personality as *involved in* what the individual does; it conceives it as *arising from* what he does. The individual *is* his role, and his personality is erased as a residue of capitalist egotism. Identifying the totalitarian state with primitive cultural homogeneity, Dr. Mead shares the philosophy of "togetherness" of the Soviet rulers, and her criticism of Stalinism is limited to certain of its practices.

Soviet man [says a Communist editorial she quotes] feels himself an indivisible part of the industrial or social collective to which he is bound, with which he labours. . . . The personal interests of Soviet man must combine harmoniously with communal interests; the personal must always be subordinated to the social.

Reading this after thirty years of experience of how little individuality is valued in the Soviet Union, you might suspect that there being "an indivisible part" of something to which you are "bound," and having your personal interests "combined harmoniously by being always subordinated," would leave very little, if anything, of "you." On this ominous passage, however, Dr. Mead comments as follows:

It must be recognized that in such an ideal there should be no need for force, for physical coercion. . . . A character structure such as that described here is congruent with a complete respect for all human beings in a society, with a lack of hierarchy, and with a lack of any sense of gulf between a group ruling and a group ruled.

Yes, perhaps on an oceanic island you can have indivisibility, equality, and fraternity (just trading in liberty). But this is the twentieth century, and all of us have something "inharmonious" in us, so if someone wants to combine us "indivisibly" he *must* use force.

Unable to apprehend the *made* community of Communism, Dr. Mead is further confused by the fact that the Bolshevik Idea on which the USSR was founded is no longer what it was. The most powerful determinant of Soviet behavior is the absence of the idea that all are compelled to obey. People still join the Party and behave as if it held the clue to life, but

our best material [says Dr. Mead] on this requirement of absolute acceptance of the Party's right to dispose of the individual comes from Old Bolsheviks. Recent interviews with Soviet DP's suggest that Party membership to-day does not carry such completeness of dedication.

Evidently something is missing from the Party. The Old Bolsheviks voluntarily *became* the Party personality, while the present comrade holds back a morsel of self, though this morsel is the "traitor." The Party's Idea is therefore no longer embodied in its members. But what technique does the anthropologist have for studying an absent Idea? The focus of the Method is on individuals; its famous approach is to study a culture as a combination of "interpersonal events." Abstractions like "the Party" or "Soviet agriculture" are convenient ways of describing certain of the institutional activities of Soviet men and women. This implies that the relation of the individual to the Party is of the same order as his relation to his trade or family. The Communist Party, then, to Dr. Mead is nothing else than the name of a group of persons. But the fact is that the Party is not the reflection of the member's social life; its exists beyond the individual and his behavior; it is an entity that remakes him in its image. Hence, the vacuum left by the Party's loss of its Idea will not reveal itself in the interpersonal relations of the member, nor even in his thoughts—the comrade goes on behaving as he did

before. Only one aware of the dynamic center of the original collective entity can be conscious that what once moved it is now missing and that it is being animated artificially from the outside. The Soviet Union is a mystery because it is neither a community nor a cult, but a vast agglomeration of disparate forces and relations presided over by an Idea that is no longer there.

Leites treated the Bolshevik Idea as if it were still present, unchanged, as a code, because there it was, written down in books. For her part, Dr. Mead, if she cannot find Bolshevism among present-day Bolsheviks, will accept it as existing among those who have been shot. The Method makes no distinction between the Party of the living and the Party of the dead; its primary interest is in its own problem of collecting data. Dr. Mead concludes that a conflict exists between "Bolshevik Party ideal and Soviet State practice"—as if the "ideal" of October 1917 were still sitting like an angel on the roof of the Kremlin. But the behavior she herself describes indicates that the chief characteristic of Soviet life is not so much conflict between ideal and practice as chaos resulting from the failure and deterioration of any intellectual purpose.

Our RAND Corporation anthropologists have presented some surface features of Communism and some petty calculations of probabilities. Dispensing with the imagination, they have left to others the work of the imagination, essential in formulating descriptions of concrete situations. The prestige of the Method in America is a testimony to the weakness of our literary and theoretical culture. Everyone knows, of course, that prophecy is dead and that human affairs are no longer invaded by those transhuman entities which Marx called "the illusory community" and Blake "Mental Deities." Just the same, it is wrong to take it for granted that the scientific Utopia, in which nothing shall exist but human individuals, has already arrived. Unless people behave as "regularly" as the stars or the inhabitants of pre-civilized communities, the practitioners of the Method are certain to arrive at false conclusions. Prophecy has this advantage over "scientific projections" of human behavior: it sees the future not as an extension of the present but as *crisis,* as a breach of continuity. To deal with living events, it is necessary to comprehend that what determines the future is not the logic inherent in current patterns of behavior but the dying of the gods.

1952

20 Twilight of the Intellectuals

It will be a bad night when, lacking truth itself, man suppresses the superstition of truth.

René Char

Much of the potency of contemporary attacks on Socialism lies not in the points they score against Marx's ideas—since these points when valid could be made equally well, and often have been, by Marxists themselves—but in the fact that all ideas have turned out so badly. Ideas as such are suspect. A century ago Cardinal Newman thought that one might "look for a blessing through obedience even to an erroneous system, and a guidance even by means of it out of it." Today, from the truest system

Previously published in *Dissent* 5, no. 3 (Summer 1958).

nothing but evil is expected, if only because it is a system. As for guidance out of it, the more systematic it is, the deeper it leads you into its trap. Once inside, the only hope is to break the system to pieces.

Given this attitude toward ideas, does it matter whether a critique of Marxism is referring to the conceptions of Marx, of Lenin, or of Stalin? Any error, crudity, or malice found in the writings of one may as well be attributed to the others. For they have, indisputably, one thing in common: they are "ideologies," that is, interpretations in which all events hang together. In such a coherence itself one already sees the outlines of a prison cell.

This mood is typified by Raymond Aron's *The Opium of the Intellectuals*. Its pages gasp for the open air of a world cleared of ideologies. To him "ideology" is synonymous with "myth," and myth, with a fog in the brain. The largest part of his book consists of blasts at phantasies generated by Marxism: "The Myth of the Left," "The Myth of the Revolution," "The Myth of the Proletariat," "The Illusion of Necessity." Aron knows the weak spots of Marxian theory and the nightmares connected with it in practice, though the advantage of this knowledge seems diminished by the fact that he feels obliged to reject, for example, the term "capitalism" in favor of "the West."

Beyond Marxism, *The Opium* is striking at all ideologies, and at their creators and carriers, the intellectuals, particularly the French intellectuals. From the café tables of St. Germain des Prés, Aron sees rising the image-laden fumes that make all of France giddy. Will the French intelligentsia never stop playing with the colored balloons of doctrinal solutions? Until they give up this pastime and get to work, France will not regain her balance. But, Aron prophesies, "The End of the Ideological Age" may be approaching, and on this note *The Opium* concludes. In an article in *Partisan Review* ("Coexistence: The End of Ideology") he goes further: The extinction of ideologies must come or mankind itself will be destroyed.

By the end of ideologies M. Aron means an end to an interest in political theories and of "nostalgia for a universal idea." The model for how nations shall think in the future is America— and the model intellectual for M. Aron is none other than the contemporary American, the intellectual as "expert" engaged in doing his job and suspicious of abstractions and systems. "The United States," declares Aron enthusiastically, "knows nothing of ideological conflicts in the French sense of the word. . . . On the other side of the Atlantic there is no sign of either the tradi-

tions or the classes which give European ideas their meanings."
(I hope our Southerners are listening.)

America has solved the problem of the intellectuals—except
that, in M. Aron's view, there never was any problem here. Back
in the Depression, he recalls, some radical exhalations did blow
over from Europe; soon, however, our natural sobriety reasserted
itself. For, actually, there was nothing to lose one's head about.
"In the name of what European values could the intellectual turn
his back on the American reality?"

M. Aron admires us—with a vengeance. Not only don't American
intellectuals have ideas, nobody pays any attention to them in
any case. How superior to the situation in France, where "writers
with no authority whatsoever can obtain large audiences even
when they treat of subjects about which they quite openly boast
of knowing nothing—a phenomenon which is inconceivable in
the United States."

For those in America who continue to criticize, before tiny
audiences naturally, M. Aron "conveniently borrows" Louis
Bromfield's genial description of the American radical as "a
doctrinaire supporter of Middle European socialism . . . subject
to the old-fashioned philosophical morality of Nietzsche which
frequently leads him into jail or disgrace." Echoing our own ex-
Left, M. Aron dismisses these dissidents as out of date: "There
are some American intellectuals who remain faithful to the tradi-
tion of anti-conformism and who attack simultaneously digests
[readers'], the trusts, McCarthyism [written in 1955, *The Opium*
is also out of date, and in more ways than one] and capitalism.
But this anti-conformism is not without a certain conformism
itself, since it resurrects the themes of the militant liberalism of
yesterday."

In part, Aron's vision of us is simply the old European stereo-
type of Primitive America, land of cowboys and Indians and
millionaires, all of these being, of course, pragmatic people intent
on specific objectives and without appetite for ideas. That Aron
presents this image as an object of emulation rather than of
contempt does not alter its character. "In the name of what
European values could the intellectual turn his back on the
American reality?" Any criticism of America could only be
made in the name of European ideas—of themselves Americans
know only *things*.

But there is more to this conception than the Old World
platitude of American barbarism. Aron bases himself also upon
what American intellectuals have been saying about themselves

and doing during the past decade or so, as well as upon the temper of the nation that had elected Ike and was preparing to do so again. In a word, the sage of the League for Cultural Freedom is reporting America correctly, as least so far as appearances are concerned. The question is: has he understood what he is reporting? And is he correct in applying the measure of the postwar American to intellectuals elsewhere?

Let me make it clear without delay that I share M. Aron's ideal of the disappearance of the intellectuals. Who but one with a taste for priests would desire this peculiar caste to flourish? Except perhaps that portion of it that works quietly in the laboratory, the study, the classroom. The others, the ideological ones, those who want to remake the world, the revolutionists in everything from paint to politics, those who never stop talking save when someone puts to them a pertinent question, these people have proved themselves as a group more trouble than they are worth. With too few exceptions, they are false, fanatical, arrogant, greedy, emotionally unstable, morally sophistical, politically and socially untrustworthy—by nature they are traitors both to their ideas and to themselves, even without bribe or force, from an ineradicable nostalgia for community with other people, who essentially revolt them, and from sheer weariness with their aimless egos. This type has manifested the same disagreeable traits throughout the world, in the "new nations" as in the old, wherever the breakdown of authority has given prominence to ideas.[1] Is it an exaggeration to say that in no place where he has appeared is the intellectual loved? And if, besides, he now endangers the world, as M. Aron warns, that should certainly settle it.

Aside from his deplorable character which makes his presence in any society of dubious advantage, there is a deeper reason for desiring the elimination of the intellectual with his ideological carpetbag. He stands for deficiency in human life, a blank spot in being. The thought of an all-real world, from which abstractions, utopias, higher states, and other projections of the mind have been banished, has charmed every true humanist, including Marx, though not Aron's Marx. No ideas, no intellectuals. Only the concrete existence adequate to itself of individual men and women.

The goal of supplanting doctrines and superstitions with mate-

1. It may be, or it may not be, that intellectuals are, as Aron says, "closely linked to the national community"—as a type they transcend nationality, a fact that anyone may ascertain by dropping in at the U.N. building.

rial wealth belongs equally to the dream of America as a paradise on earth and to the dream of Socialism as an earthly paradise. The dreams differ only with regard to *when* ideas are to be gotten rid of—in the American dream they can be dispensed with now; while Socialism wants to hold on as the last idea and liquidate itself only when all other ideas have been defeated.

In practice, however, both America and Socialism have tended to behave, whenever things have gone well, as if paradise had already been attained and to dispose of ideas prematurely. In response to this demand, an intellectual without ideas appears, one whose function is indeed to stand guard against ideas as a disintegrating force. This "sobered" intellectual, serving society as a hired man, whether as expert or bureaucrat, is the figure of Aron's admiration in the United States and, in a reserved way, in the Soviet Union.

In believing that "the American reality" has permanently transfixed the American mind, this Frenchman is dreaming the American dream. Let us remember that this dream was a European product in the first place. "In the name of what European values could the intellectual turn his back on the American reality?"—the value of not having to think. The question reminds one of a certain mariner-theoretician debarking on the glistening sands of the West Indies one refulgent morning. The same question could be heard booming in chorus from these shores since the onset of post-War prosperity. "Why should we not shed our European illusions ('myths')? Daily life is enough for us, not to say too much. We don't need ideas and what's more we don't want any." And M. Aron sums up this rosy condition in prose: "These intellectuals are perfectly reconciled with the United States" (whatever that means).

Given this happy conclusion, it is hard to see why Doubleday brought *us* M. Aron's tract unless perhaps to indicate where we could find a foreign market for our mental vacuum cleaners.

Unfortunately, Aron's liquidation of the American intellectual as the vanguard of the vanishing intellectuals of the world is no more to be depended on than the related attempt by his American friends to liquidate themselves. If, as he says, "anti-conformism is not without a certain conformism," anti-ideology is not without a certain ideology. The notion that radical criticism is a symptom of doctrinaire hangover or mental ankylosis has been pressed upon us from every source, including philistine psychiatry, ever since the ex-Left discovered it had a part to play in the Cold War, the part of penitents and "responsible" underwriters of social

unanimity. But adopting this role did not result in the extinction of the American intellectual as a species—it was simply a new affirmation of his morbid character. Having raised to the level of a philosophy the old backwoods suspicion of the intellect and intellectuals directed against the city, the intelligentsia became more active than ever. If, as M. Aron insists, the American intellectuals have had to go looking for an enemy, it was because they decided not to find him where he lives but to take on instead the enemy's enemy, that is to say, "ideology," or the "isms"— whether it be Socialism, Fascism, Zionism, or even New-Dealism. Given the mood induced by the failure of ideas mentioned above, this antidoctrine has overflowed our borders and reappeared as a world idea.

In his identification with the outlook of our typical "integrated" prosperity intellectual, Aron exemplifies the phenomenon, about which too little is known, of the flotage of ideas from their original moorings and their fall-out in distant places. For almost four decades the Russian October was wafted around the globe in the form of abstract aims and illusory adventures; only since the parody of the Hungarian Revolution have the Ten Days that Shook the World begun to lose their hallucinatory power outside the USSR (in Russia the revolutionary charade faded much earlier). Why should not the unprecedented build-up of prosperity in the United States of the fifties, with its activation and absorption of the social premises of the New Deal—recognition of labor, pensions and benefits, G.I. rights and civil rights—win adherents outside the continent where it took place as realizing in practice advances which Socialism could only promise? The Russian Revolution left a residue of dead ideas, American prosperity the idea of no-ideas.

Aron is a fellow traveler of the American fact. An unanalyzed admiration of United States accomplishment is the groundwork of his nondoctrinal progressivism, his trust in common sense, his impatience with theory. It is also the basis of his Utopian view of American life—e.g., as devoid of social conflict— and his journalist's contempt for café radicals and "talkers."

"France exalts her intellectuals, who reject and despise her; America makes no concession to hers, who nevertheless adore her," Aron marvels. The assumption is: Treat 'em rough, they like it. Though we have already seen there has been no one here to make any concessions to. Still, one could mention congressmen who would consider the word "adore" too strong.

Adoring America or rejecting France has, of course, nothing

to do with the relation between intellectuals and their country; the psychology of patriotism, if one must so remind an expert in Marxist "oversimplifications," is much too complex to summarize in a word. What caused American social criticism to slacken was total employment. With individual talents supplied with resources to work *within* society, the very definition of the intellectual underwent a change in America—from the ominous outsider of the days of the "brain truster" and the Red, he became the inferior "egghead," that is, a social type identified by his look and his vocabulary.

If America can maintain the incorporation of its intellectuals in productive labor, there might continue to be nothing to ideologize about, except perhaps the menace of ideology—in their material paradise (i.e., reality without opium) they could go on living in a state of adoration.

The Opium of the Intellectuals fails even to consider whether the American intellectual's preoccupation with "fact" belongs to conditions of a particular period, rather than to a fixed status within the nation. This taking for granted that our paradise is here to stay reveals the idealistic underpinning of M. Aron's skepticism. Perhaps he has forgotten how in the years following the Russian Revolution the most ideological generation in history was drawn into "socialist construction" and "reconciled with its reality." Did this yielding to fact make the Russian intellectuals similar to the practical Americans, or did their ideological motives cause them to resemble the idea-intoxicated French?

Aron's contrast of adoring Americans with rejecting Frenchmen is owing to more than the mistaken impression of a foreigner taken in by the "typical attitudes" of a moment; his error is made possible by his static definition of the intellectual according to ancient categories of employment: "clerk," "expert," "man of letters," all three being groupings within society. While the intellectual is designated socially by his occupation, no definition by occupation alone can distinguish the modern intellectual from his "nonintellectual" counterpart in the vast array of professions and crafts that constitute the organization of work in contemporary society. The same function may be performed by two "experts" seated side by side in a newspaper office or advertising agency, yet one is an intellectual and the other is not. What distinguishes one from the other is precisely his nonidentification, open or veiled, with his métier and his self-separation from its values. This is strikingly apparent in a study like Whyte's *The Organization Man,* whose author, without any revolutionary in-

tention, defines himself as an intellectual, in contrast with socially identical Orgmen, *by the sole fact of his inner dissociation* from the organizational universe.

Aron has completely ignored the composition of the intellectual caste by which, under specific conditions, it becomes redefined as *a caste of social delinquents*. In a society that has reached a certain degree of literacy, which makes it susceptible to the formation of ideological bands, and in which, consequently, one may qualify as an intellectual in terms of social dynamics without having gone beyond the fifth grade, this redefinition on a large scale is inseparable from a "revolutionary situation."

To meet such a situation, heroes are needed. But by what, except by the consciousness of a "plot" in history—that is to say, by a "myth"—are men transformed into heroes? The aim of Marx's writing was that, in the predictable crises to come, a mass hero raised up out of the modern city should act in consciousness of itself and its possibilities. In it the humanitarianism of the nineteenth century was heightened to the pitch of world drama. Marxism offered the conception of a universal *acting of progress* to the point of universal victory. This has not been realized, and to Aron's mind it has stood in the way of real progress.

Suppose that Aron has his way and in a social crisis the intellectuals continue peering into their microscopes or analyzing the prosody of Virgil and nobody comes forward with the myth of a better world? (Or is it Aron's contention that without the ideological mists exuded by the intellectuals there would never be a crisis? Perhaps Algeria is the effect of an opium discourse that went wrong—and shop-keeping and ranch-owning colonials and poverty-stricken Moslems are only parts of the mirage.)

Be that as it may, suppose a crisis exists and no ideologist comes forward. Will the result be a calm development of wise solutions by the experienced men of affairs in whom M. Aron reposes such trust and whose hands he would have us untie by disappearing? Is that what has happened in France among, for example, the Centrist parties, whose ideologies are certainly blurred enough to satisfy anyone? Or does the absence of universals tend rather to result in a day-by-day yielding to events, until the steady erosion of principles becomes the accompaniment of a paralysis of the will? For what is a crisis but a situation in which the practical men of affairs, who are always the people in power, have already failed, exposing the limits of the practical intelligence.

Once a hero is needed, the absence of ideologies will not save

the day for the skeptic and pragmatist. Neither will a dream of unreason supply what the dream of reason could not. The anti-intellectual intellectual like Aron has no power to prevent history from going mad. In the end his common sense can have only the effect of promoting a distrust of ideas that brings capitulation to the myth of the man of action.

Since history has not achieved a steady sanity, the time for the extinction of the intellectual has not yet arrived. Unpleasant as it is to have us around, and anxious as we are to get rid of ourselves, society has no choice but to put up with us—if for no other reason than that we can at present be abolished only by other myth-makers. We are stuck with ourselves, and the world is stuck with us at the price of making itself perfect. Perhaps when everyone has defected from the common "reality," that is, when everyone has become an intellectual, the role of the intellectual will be ended, and with it that unhappy species itself.

For one who scorns ideologies Aron derives too much from the evidence of "opinion makers" and too little from the hints contained in historical analogies. He has performed the astonishing feat of writing a book on the modern intellectual without mentioning the disintegration of social classes and the estrangement of individuals—he has even forgotten to mention the Jews! Having no concept of the stranger, he misses the tension between the intellectual and his neighbors, even in a country he adores, and between one band of intellectuals and another. Hence he can only note as an oddity the vicious anti-egghead campaign of America's 1952 elections (erroneously set by Aron in '53), with its overtones of persecution for sedition and foreign alliance.

The poison of the intellectuals since World War I, the poison responsible for the catalepsy of the Third International, as for other collapses, has been the ideal of practicality, of a politics and social philosophy stripped of "myth" and "ineffectiveness," of a subordination to "reality," in sum, of their own disappearances as intellectuals. This is the drug that has transformed the fighting humanitarian Dr. Jekyll into the bureaucratic and "responsible" Mr. Hyde. The worst of it is that the somnambulist Hyde dreams not only that he alone is awake but that he is vigorously bringing into being the very same world that his original could only feebly imagine.

1958

21 The Threat of Culture

The saying of Goering—if it was Goering—"When I hear the word 'culture' I reach for my revolver," had a point. Culture can be dangerous; and while a pistol is not very effective against what the anthropologists define as "a whole way of life," one may wish for a weapon to protect oneself against it. This was proved when the fat air marshal, fleeing westward in hope of the immunity of military rank, fell into the arms of the Rights of Man.

Nazi brutality was a kind of culture, as are also. Pan-Slavism and White Supremacy. Even "Cosmopolitanism" is a menace, apparently, since Soviet "Internationalism" found itself obliged

Originally published as a review of Raymond Williams, *Culture and Society*, in *Nation* 188, no. 6 (February 1959).

to suppress it on the streets of Budapest. The record shows that a living connection exists between questions of form in poetry, in conventions of the bedroom, in assaults on police stations. The logic of his admiration for Renaissance art patronage led Ezra Pound to a decade behind bars.

Culture exposes its threat most openly in politics, that is, in the ideology and action through which a "way" of life attempts to establish itself as the law for all. The effort to dominate the human environment through administrative force is not restricted to totalitarianism. Culture-politics is equally at work in Sabbath laws, the ban on polygamy, compulsory education. That each of us can fight in favor of some of these and against others, instead of being compelled to accept the "whole" handed down by authority, is an indication, not that our culture has no desire to subdue people to its aims but that freedom counts for more in it than religion, marriage, or learning. A culture that shunned the force of politics would be the "way" of a dilettante or aesthete. Contemporary writers who, frightened by radical politics, denounce ideologies in general—as Raymond Aron in *The Opium of the Intellectuals* — fail to comprehend that *all* values, even the most liberal, are compelled to make themselves real through ideology and political struggle. Today, with cultures pressing upon one another, the *Kulturkampf* has become the rule in politics, both domestic and foreign. An appeal to style reinforces the argument of program, or even replaces it.

When culture is its subject matter, politics involves everything and forces everyone to choose. Thus modern politics is intrinsically revolutionary. Whether it be liberal, radical, or conservative, it contemplates a renovation of the common life, not merely the administration of it. To this end, it attacks the *being* of social elements which its scheme cannot absorb, and works to bring about their extinction. The result may be achieved through democratic uplift, by which sheiks, paupers, aristocrats, illiterates, are transformed into educated, job-holding citizens; or through race, class, or cult violence, by which "enemies of the people" are physically exterminated. Or through a combination of uplift and violence, as in Soviet "rehabilitation."

Raymond Williams's *Culture and Society* is worth a library of literary and political tracts in that it digs into the ideological layers that envelop modern politics. Written from an independent Left standpoint, this critical history of the concept of culture in England from 1780 to 1950 is exactly to the point of contemporary discussions of value. Nor is its significance for the United States

any the less for its being restricted to Britain, since Britain is the primary source of American conservatism. Williams's analysis of the social objectives of the great cultural figures of modern England should help Americans to re-evaluate a good deal of reactionary nonsense eagerly imported in wrappings of literature.

The idea of culture, Williams tells us, first appeared in England around the dawn of the Industrial Revolution. It is interesting that the word itself began to take on its modern meanings, as did such other words as "democracy," "art," "class," at the very moment when it turned into a polemical instrument. From Burke through T. S. Eliot, the history of the term has been a history of exposing the evils of industrialism for the purpose of resisting change and the popular diffusion of power.

Belaboring of the British middle class, whether from the Right or the Left, has consisted in presenting the claims of inwardness and "the whole man," as against the "external and mechanical" compulsions of the factory-centered society. The critical question has been, of course: Whose inwardness? Which whole man? The merit of Williams is that, passing down the line of Burke, Coleridge, Arnold, Carlyle, the Romantic arts, the nineteenth-century novelists of industry, to the library captains of today, he never forgets this question. His comment on the typical deplorer of the industrial spectacle is worth dispatching by wire to some of our recent re-examiners of liberalism: "It has passed too long for a kind of maturity and depth in experience to argue that politics and political attachments are only possible to superficial minds; and that any appreciation of the complexity of human nature necessarily involves a wise depreciation of these noisy instruments." Being "whole" in these instances is for those in a position to keep out of things.

With few exceptions—Morris, Wilde—the writers examined by Williams arrive by one road or another at the idea of a social elite, and most at an elite that rules. It is not too much to say that in England "culture" is dyed in anti-democratic passions at least as deeply as in anti-capitalist ones. Nor does the British artist or man of letters tend, like Whitman, the Russians, or the vanguard movements of the Continent, to see in the total overthrow of dead forms the beginning of creation under conditions of freedom. It may be a proof of its inherited skill in moderating social tensions, but in both art and politics modern England has played a negligible part in the radical testing of new relations—to get the measure of British assent to authority and to the past, one has only to speculate about what form a

history such as Williams's *Culture and Society* would take in the land of Napoleon, Baudelaire, and Sartre.

"When in doubt," says Williams, "the English imagine a pendulum." British social vision has swung steadily between conservative theories of an "organic society," managed by its hereditary aristocracy, sometimes augmented by cultured commoners, and radical Utopian fantasies of a reunited folk. Rarely has it had the energy to hurl itself out of the anti-modernism of Burke and Cobbett.

He [Burke] speaks from the relative stability of the eighteenth century against the first signs of the flux and confusion of the nineteenth century, but he speaks also against those rising doctrines which the eighteenth century had produced, and which were to become the characteristic philosophy of the change itself. In doing so, he prepared a position in the English mind from which the march of industrialism and liberalism was to be continually attacked.

In his opposition to "the rising doctrines" of the revolution of the eighteenth century, Burke had recognized the presence of another tradition; it, too, was a culture, with its own ambitions for human excellence. Any statement of its views is almost a direct antithesis to Burke. For example, Dr. James R. Killian, Jr., special assistant to Eisenhower for science and technology, was quoted in the *New York Times* as follows:

We have forged ahead because we wanted things to change. We have wanted to look forward and not backward. The revolution of modern man—the revolution which has found its fullest expression here in the United States—lies essentially in this: it is the revolt against things as they are when there are ways of doing things better. . . . It is a revolution against all the forces which hinder man in building a better life.

The enormous accomplishment of Burke and his followers lay in purloining the word "tradition"—the same word our Southerners fall back on—for the institutions existing prior to the nineteenth century and denying it to the values and modes of thought developed in the innovations of the past two hundred years. If he could not preserve the stasis of society, Burke did succeed in projecting that stasis into the minds of his countrymen. British thought continues to tick off the fruitless dichotomy of a nonexistent "organic" community (e.g., Lawrence's Mexico) versus an inhuman social clockwork (*Brave New World, 1984*).

The respect with which Williams makes his way among the monuments of British cultural agitation does not prevent him from exposing their defects. Welcoming Eliot's *Notes towards the Definition of Culture* for disturbing liberal complacency, and lauding its adoption of the social scientists' conception of culture as "a whole way of life," he calls attention to the "sliding of definitions" by which Eliot insinuates into the idea of culture his own version of worthwhile religion, art, and learning, and he deplores the disparity between Eliot's tentative arguments and his manner of presenting them, "often dogmatic to the point of insolence." His estimates of Arnold, Ruskin, T. E. Hulme, and Lawrence are similarly balanced between drawing out the author's contribution to the tradition and noting where he fails.

The most striking achievement of *Culture and Society* is its chapter "Marxism and Culture," which succeeds in discussing root issues while restraining itself to the proportions of the book. Marxism had no collective life in England prior to the 1930s—Williams shows that Morris's socialism was descended from the native tradition of protest. As in the United States, the emergence of Communist intellectuals did little to clarify Marxist complexities or to tie down thoughts hanging loose in Marx's system; elements from the old Romantic recoil from industrialism reappeared dressed up in Marxist phrases. Beyond the errors of the Party writers, Williams seeks out the central difficulties in Marx's own writings—for example, the notion of economic structure and cultural superstructure, the formula "existence determines consciousness"—and suggests that such concepts as these can be clarified by being studied in the context of contemporary culture as a whole.

In the past three decades, we have not only culture but "mass culture." To Williams the very term "mass," synonymous with "mob," is derogatory, and in his view "the whole theory of mass communication depends, essentially, on a minority in some way exploiting a majority." True communication implies not only reception but an opportunity to reply; the absence of this opportunity in the mass-culture audience induces a sullenness and withdrawal of interest which in contemporary society may lead to disaster. In other words, mass culture must be changed into the culture of democracy in practice.

With this as his goal, Williams is able to break out of the jungle of restorationist dreams into the actual problems of our day. Democratic culture raises the question of the working multitudes; Williams endeavors to distinguish an ethic of solidar-

ity, responsible for working-class achievements in unionism and politics, from the middle-class social ethic of service, in which he shrewdly discerns "real personal unselfishness . . . within a larger selfishness." Service, he argues, maintains the status quo and, lacking active mutual responsibility, cannot meet the needs of the time; nor can the middle-class principle of individual opportunity, since the ladder of success is the symbol of a divided society and each man climbs it alone.

Thus Williams, though aware of the danger of carrying solidarity too far, conceives a socialist unification of society. As a check against the crushing of dissent, he proposes that culture be understood in the sense of "the tending of natural growth," which, being an essentially unplannable process, would serve as a model for the need for deviation.

But if solidarity is the cultural principle to be introduced by the working class, how can this principle provide a desire for opposition? Would not the "tending" of a whole in which conflicts are embraced require the attention of an element outside the working class? If so, are we not back again in the British tradition of a community under the guidance of a culture-possessing elite?

That *Culture and Society* ends in the abstraction of a common understanding among like-minded men seems to me an effect of limiting its inquiry to British experience. Solidarity is another version of Burke's "organic society"; while it is an aspect of working-class feeling, in itself it is insufficient to initiate a new "whole way." The solidarity into which modern industry has organized the workers is a passive one; it turns into a voluntary unity, a "cultural" one, so to speak, only in the course of struggle —in the trade unionism Williams cites, the solidarity is real only for the duration of particular efforts. Hence, as Rosa Luxemburg insisted, it is from struggle that the ethics and the social intelligence of the workers are born. Action brings forth the unforeseen. Like any other culture, that of the workers' majority as presently constituted can prevail only by becoming a threat to rival cultures.

1959

22 Professors of Man Estranged

Though there exists in America a wide interest in that metaphysical state, or condition, known as "alienation," I doubt that it is going to become a required subject of study in our universities; yet I do know of one college where a course is being taught that comes close to being an introduction to the lore of the estranged one.

The difficulty is not the insufficiency of data to be surveyed. On the contrary, evidences of transformation and loss of identity appear in practically every field, from reports on brainwashing to statistics on divorce. Any scholar who chooses to do so may rev-

Originally published as a review of Erich Kahler, *The Tower and the Abyss,* and José Ortega y Gasset, *Man and People,* in *Midstream* 4, no. 1 (Winter 1958).

olutionize his specialty by reinterpreting it in terms of the slipped ego of contemporary man. In psychiatry, sociology, cultural anthropology, such revolutions have already become a commonplace. I should not be surprised, however, to learn that even in biology or chemistry the newer laws relate to the splitting and self-segregation of entities previously conceived as elements of larger wholes; just as in moral and aesthetic theory one keeps hearing that nuclear physics has established an errantry or "indeterminacy" in the atom that has something to do with the freedom of the individual to follow his own whim. With an alienated electron as the basis of the physical world, a system of concepts relating to estrangement could come as close as can be imagined to recapturing the seat once occupied by theology as queen of the sciences. The doctor of alienation could pass judgment on anything, whether in art criticism or multiple dwelling laws. Segregated unto itself, the study of the individual's segregation becomes the genre of profundity.

Perhaps its profundity is exactly what is keeping the topic out of American university catalogs. For the tradition of alienation-thinking itself decrees, as any adept will testify, that the United States, land of the pioneer and the immigrant, that is to say, of individuals alienated and cut off from the cultures and communities of their origin, is by this fatal circumstance the land *par excellence* of the superficial and the transitory; and to its inherent two-dimensionality, profundity is alien. A civilization so estranged by its nature and nativity from intangible guides, and vowed to the fragmentariness of mere "things," can have but a poor appreciation of such a negative reality as alienation and its aura of loss. It cannot comprehend absence *per se,* only deficiencies in what is there.

Hence, in America, philosophers of the void are compelled to disguise themselves as literary critics, sociologists, mental therapists. One examines the text of a novel and discovers it to be a lid on the abyss; abyss or no abyss, however, Literature is still there and the profession of literary critic. Or one charts the daily routines of a suburb and encounters *tohu-bohu* between the cars parked at the shopping center: this is good for a notice in *Time* and appointment to a full professorship. Dazzled by their own non-being and the non-being of art, American painters and poets chatter about the social rôle of the artist and the techniques of "making" a painting or a poem; while case-workers and ministers advertise the presence of vacancy by promoting personality-development and "togetherness." Jimmy Durante used

to point out that the Grand Canyon is a hole and that a hole is "nuttin'." American high culture reverses this reductive logic, and to study *nuttin'* takes a course in theology.

Now, however, that Outer Space has swept down on Capitol Hill, our prudishness concerning the vacuum may at last be overcome. The Inner Emptiness, too, may receive official recognition. Should this occur, what might be considered a textbook on the subject lies ready at hand. I refer to Erich Kahler's *The Tower and the Abyss, An Inquiry into the Transformation of the Individual*. A German, Professor Kahler serves alienation straight, without American doubletalk, French novelizing, or Kierkegaardian "indirection." If he has resorted to imagery for the title of his book, this is not, I am convinced, an effect of literary flightiness but in obedience to the tradition in alienation-thinking which holds that concepts cannot attain to the fullest depths of meaning without being supplemented by figures of speech.

Professor Kahler's alienation thesis is as orthodox as his title. Twentieth-century man, having gained inordinate power over nature, stands isolated on the turret of a Babel around which has risen the swirling night of a chaos presided over by the powers of scientification, specialization, standardization, functionalization, and anonymization. What brought him to this pass was the supplanting of the community (union derived from common origin) by the collective (organization for common ends). Social mechanization goes hand in hand with personal disintegration. *The Tower* recounts the operation of both processes in modern politics and public life, in poetry and the novel, in philosophy and sentiment. Two chapters, "The Split From Without," I and II, cover alienation from the world; two more, "The Split From Within," I and II, document alienation from oneself. "Man Without Values" completes the picture. To conclude, Kahler offers the solution of a new community, which shall transcend the individual while conferring organic unity upon him.

Familiarity with this line of thought, as developed through Professor Kahler's clear-cut dualities—values versus standards, sin versus crime, the total state versus the terror state—and his informed references to almost anything, should suffice to initiate the student into the mental bearing and vocabulary of the modern intellectual. In his three hundred pages the author of *The Tower* has sent out threads in every direction, between Werther's *Weltschmerz* and the indifference of Camus' "stranger," between the decline of the Holy Roman Empire and Nazi sadism, between Freud and abstract painting. No specialist would establish such

a mesh; yet if a contemporary consciousness exists, it must consist precisely in the apprehension of relations such as these.

Educationally speaking, the outstanding feature of Professor Kahler's book is the catholicity of its illustrations: Whitman for simultaneity, Hopkins for planned dissonance, Baudelaire and Cézanne for relentless objectivity, Pound, Eliot, Joyce for discontinuity, Picasso for dismemberment, von Hofmannsthal, Rilke, Camus, Sartre for otherness, Existentialism for the absurd—together with a variety of satellite examples. In one lump the reader of *The Tower and the Abyss* may gain the essence of dozens of critical and speculative works of the past two or three decades. If he happens to have read these, he may make a game of guessing which poem by Baudelaire, which aspect of juvenile delinquency, which testimonial to Nazi psychosis, which formula of the Existentialists, Kahler is going to cite.

Although he favors a renewal of individual and social life in a coherence comparable to that once achieved through religion and tradition, Professor Kahler refuses to turn the clock back on science and freedom. Unlike most alienation philosophers, he adheres neither to rightist ecclesiastical and authoritarian "order" nor to Communist or Fascist "social discipline." He is a humanitarian with a respect for contemporary form of knowledge and intelligence.

I am sorry to say that being neither reactionary nor futurist only compels Kahler to contradict himself; as when, having admired the revelations of the new aesthetic sensibility, he finishes by warning that "they [the arts] are about to destroy the human personality." Projecting this self-contradiction into an "ambivalence" of modern art does not help matters.

I do not object, however, to the fact that the solution to alienation proposed by Kahler is one which he himself recognizes to be fairly futile, that of a "communitarian" movement started here and there in Europe since the war with the aim of forming "oases of humanity in the midst of a collectivized world, islands of unanimity in a sea of raging hostility." That Professor Kahler avoids a mass-action outcome to his diagnosis of modern "chaos" is all to his credit and qualifies him to teach alienation without giving offense.

For it must be acknowledged that the subject of alienation is highly inflammable. Consciousness of estrangement from self and from other men, and from God and nature too, is a consciousness bordering on the psychotic—which, while normal enough for artists and original thinkers, implies trouble when it becomes

the basis of defining existing social relations. Social interpretations of estrangement have led to resurrectionist rabble-rousing. *Every violent political movement of the past one hundred years*—pan movements, national revivalist, Bolshevism, Fascism—*has arisen as an antidote to alienation.* This does not mean that antidotes may not be needed, but one ought to be aware of the logic of extremism inherent in this mode of thought.

For my own part, I regard communal "wholeness," even the peaceful and voluntary unanimity advocated by Professor Kahler, to say nothing of T. S. Eliot's "culture," as an unattractive and bad idea. A genuinely human society would be not a supra-individual entity to which all individual members conformed, but one in which, as the young Marx put it, nothing could exist independently of individuals. Moreover, it is an error, albeit a very common one, to contrast contemporary alienation with a presumed earlier wholeness within historical civilization. Every society—medieval European, Greek, Egyptian—has had its form of alienation, and it is against the images of their demons and alter egos, rather than against the imaginary whole man of an "original community," that our otherness ought to be measured. Begin with the myth of an earlier "cultural synthesis" and the present always appears as an infirmary of split men from which there is no place to go but Utopia.

In contrast to Kahler, Ortega sees estrangement as an aspect of the human condition rather than as a malady peculiar to our times. That is to say, alienation—*alteración* is the Spaniard's contribution to the lexicon of self-loss—is for him a subject of philosophy not of desperate outcries, specifically of epistemological analysis in the line of Descartes, Hegel, Husserl, and the Existentialists. In these lectures, delivered, one gathers, before rather large audiences, Ortega feels fine. He is speaking not of modern man, the victim-criminal, but of man, and to the perils and minus signs of the latter, jokes have never been inappropriate.

Man is alienated because each man in his thought and in his behavior is, now as in the past, subject to "people," to a consensus that acts upon him through usage and public opinion ("they say"), but which itself lacks a living subject, or "I," and is hence inhuman. "People" signifies a sum of abstract individuals, that is, individuals emptied of the unique and unmistakable identity of a person; "people" is anybody. All communities are made up of such alter egos—Kahler's distinction between "community" and "collective" could have at best only a reverse application with the author of *The Revolt of the Masses.* If the member of

a primitive village is less "fragmentized" than the citizen of the modern metropolis, his wholeness is hardly an advantage, since his self has been, so to speak, unanimized out of existence by the total impress and surveillance of the communal non-person.

No one can escape *alteración*, for no one lives in the solitary universe which is "the radical reality" of the pristine self. Even the hermit is infiltrated with the social through the very language in which he meditates. Language is but the residue of the dead actions of others which continue to exert force upon the living. "Man is constitutively, by his inexorable destiny, as a member of society, *the etymological animal*—i.e., loaded with actions whose meanings have worn away and need to be recovered by analysis." While Kahler conceives our being taken out of ourselves by innovations, such as newspaper-reading and technology, Ortega establishes the alienating phenomenon across the ages through philology and the analysis of a handshake.

Society is the enemy of the individual self, whether quietly, through constituting a universe that displaces the reality given in personal perception and feeling, or by open threat, or actual exercise, of force through the State. "In solitude, man is his truth; in society he tends to be his mere conventionality or falsification." If Ortega does not, like earlier romantics, advocate self-exile to the hills or ponds, it is because he knows that the social cannot be evaded that easily. Not physical flight but psychic struggle is his password; struggle not to form a new community but for the refreshment of "being inside oneself," where, away from all communities and all others, true ideas and actions are born.

Thus, entering into the labyrinth of otherness, Kahler and Ortega emerge at opposite ends: Kahler in the reconstituted community of Socialist and Utopian theory, Ortega in the re-covered "I" of Romanticism.

But whether one wishes to renew the self or to change the world, the lecture hall has its own interests. There, Kahler's communitarianism becomes a device for rounding out a course; while Ortega's withdrawal for the creative leap becomes a call for a revolution in sociology and phonetics. The teaching of both has more to do with changing opinions about situations than with changing the situations themselves. But didn't these thinkers set out to demonstrate that man is lost to himself and that this is a matter of life or death? Perhaps America is right after all and alienation is not a subject.

1958

23 The Intellectual and His Future

Since the war, and especially since Joseph McCarthy, a literature has been accumulating on the subject of "the intellectual." One of the most interesting features of the new writings is the way the intellectual has been transformed in them from a disreputable and often ludicrous outsider into a necessary "element" of the community, about whose fate everyone ought to be concerned.

Traditionally, the intellectual was a type that might show up in any layer of society, but under one indispensable condition: that he be out of place in it. To the extent that Marx's class-conscious proletarian was a species of intellectual, other workingmen regarded him with suspicion. The identifying mark of the in-

Originally published in *New Yorker*, 26 June 1965, under the title "The Vanishing Intellectual."

tellectual was the distance he created around himself, supposedly by his absorption in abstract ideas and purposes. He was the essential alien, the opposite of the regular guy; this gave him some resemblance to the aristocrat, the priest, the criminal. His natural habitat was a garret without an address, or an encampment shared with others like himself—in a word, a bohemia. It was about the new Russian intelligensia that Dostoevsky was thinking when he wrote that "everybody segregates himself, keeps aloof from others." These separated ones formed a subcommunity in which a single quality was exalted: the passion for originality. In this lay both the justification of the subcommunity, as against other hangouts, and its threat to the established order. Dostoevsky went on, "Everybody seeks to invent something of his own . . . never before heard of. Everybody begins with his own thoughts and feelings. Everybody strives to start from the beginning. . . . Everybody acts by himself." A similar rugged individualism of the mind prevailed in the American vanguard from the days of Poe, Melville, and Whitman through the twenties of Dreiser, Pound, Stein.

The recent writings on the intellectual have little to do with this lone-ranging, dubious type; when they mention the "segregated" man, it is to proclaim his elimination. In place of the underground original, akin to the clown (Picasso), the bareback rider (Chagall), the malefactor (Rimbaud), there has emerged the intellectual as professor, laboratory specialist, and consultant, heir to the savant and the counselor of kings. Beginning with the Depression and the New Deal, American intellectuals developed —in political movements, in government agencies, and in "unions" of artists, writers, and university teachers—a group identity, and it was heightened in subsequent years by common experiences in wartime assignments and cold war investigations, and by the group's prestige since Sputnik. This collective existence, with its accompanying professional self-consciousness, has gradually thrust into the shadow the intellectual as one who "begins with his own thoughts and feelings." When the topic of the intellectual is raised in current articles, books, lectures, panel discussions, it is the academically trained caste that is under scrutiny.

The issue is: What is happening to the mass of mentally qualified people in our mass society? Studying himself in the group mirror, the intellectual has been thrilled by his own merits while feeling on his neck the chill breath of extinction. First came the menace of suppression under the bludgeoning of McCarthy and the un-American committees. When that peril faded, a more subtle danger loomed on the opposite side: that of loss of identity

in the all digesting cultural and scientific establishment. The threat to the intellectual became the threat of metamorphosis. In an article in *Commentary* in 1956, after the McCarthy flood had abated, cultural historian H. Stuart Hughes raised the question, "Is the intellectual obsolete?" Ph.D.s, Professor Hughes emphasized, were multiplying at an unprecedented rate and being put to work as fast as they ripened, but though these people might seem to be intellectuals, they were not the real thing. There is a difference, said Hughes, between the "true intellectual," characterized by a "freely speculating mind," and the mere "mental technician," trained for a narrow, specialized function. Our universities, as well as our laboratories and official agencies, were becoming filled with the latter, he concluded, while the earlier academic and scholarly type, softened up by the warm climate of social acceptance, was losing its outlines and merging with its technically useful double.

In the ensuing self-scrutiny of the intellectuals, the prospect of metamorphosis through social acceptance was brought up again and again. "Many of the most spirited younger intellectuals are disturbed above all by the fear that, as they are increasingly recognized, incorporated, and used, they will begin merely to conform, and will cease to be creative and critical and truly useful," reported Richard Hofstadter in *Anti-Intellectualism in American Life,* published in 1963. The worry of the contemporary intellectual seems to be that he cannot depend on himself to remain what he is. Adding another twist to his problem of retaining his identity, some writers advise him that he could not do better than to go along with what is happening. Raymond Aron, in *The Opium of the Intellectuals,* published in 1957, praised the American intellectuals for having at last abandoned the futile theorizing of their counterparts in the cafés of Europe, with their "nostalgia for a universal idea," and having made themselves over into practical men of affairs. A similar thought was expressed by President Kennedy in his famous Yale commencement address when he denied the significance of ideological differences and urged intellectuals to apply their minds to furthering socially useful programs. The president and M. Aron agreed in taking it for granted that American intellectuals had already changed and become part of the national enterprise. In that perspective, Hofstadter's bright young men were frightening themselves needlessly about ceasing to the critical; they could be proper intellectuals just by doing their jobs. As for being "creative," Jacques Barzun's *The House of Intellect* had listed the fetish of cre-

ativity as one of the three plagues of American culture.

Whether his absorption into the establishment is to be resisted or welcomed, the intellectual as he used to be seems doomed. Neither his environment nor he himself has any use for the old habits of dreaming, sulking, and inefficiency. Even if he holds fast to "free speculation," criticism, creativity, he will have to be different as a type—a creative professor or other organization man, not a solitary fabricator of ideas or of works of art. The weight of the testimony is that in contemporary America the process of transformation is very far advanced. Authors who today estimate the chances of survival of "the true intellectual" frequently give the impression that each has in mind himself and a handful of his friends making a last-ditch stand.

But hasn't the intellectual seen in the perspective of his social group always been in a state of ceasing to be an intellectual? Hasn't every intellectual community, even in its heyday, lived constantly on the verge of being taken over by its Tartuffes, pedants, and con men? Is it not inherent in the nature of the salon or of bohemia that its great days are back there before the present mob arrived? Is the individual intellectual ever completely free of motives that define him as other than a disinterested seeker after truth? Dostoevsky knew that to cover the colony of intellectuals, the net of definition had to be wide enough to encompass counterfeits and hangers-on. "Everybody acts by himself," he wrote, then added, "If he doesn't act, he wishes he could act. . . . True, a great many people are not starting anything and never will start. . . . They stand apart, staring at the empty spot."

The tendency of the intellectual to slip out of every category, leaving its shell for the observer, raises essential questions about the latest book on the species, Lewis A. Coser's *Men of Ideas: A Sociologist's View,* which approaches intellectuals of the past two centuries as groups inhabiting different "institutional settings." The author, a professor of sociology at Brandeis University, is in accord with the current belief that the independent intellectual has been all but replaced by the university professor and the specialist. In this, Coser finds nothing abnormal. Like Hughes, he takes as his model the public savant and idea man, from the ideologues who advised Napoleon to the New Deal Brain Trusters.

A leading theme of *Men of Ideas* is the intellectual's relation to power, a subject to which much thought has been directed since the wholesale transformation of Russian intellectuals into bureaucrats following the victory of the Bolshevik Revolution,

and the apparently comparable movement in the United States starting with the New Deal. Coser, who is also an editor of the leftist magazine *Dissent,* is at home in the history of Communism and other political movements of the past two hundred years. He is at his best in giving capsule summaries of currents of thought that have prevailed in various intellectual circles and the traces they have left on the societies around them. He is less interested in the theories of individual minds and in the wars of each against all which mark the emergence of new ideas. Indeed, *Men of Ideas* seems at times antagonistic to the man of ideas; it inclines, though with ambiguous feelings, to reduce the role of the originator of thought in favor of that of the representative of a trend. Though it undertakes to weigh the contributions of intellectuals acting in concert, it is primarily a tract designed to convince the reader (and perhaps its author) that "the death of bohemia did not mean the death of critical and rebellious thought, as some who cling to the remnants of bohemian life-styles seem to believe." (Given current fashions in interior decoration, art, movies, cocktail parties, and campus attire, one wonders what Coser considers the alternative to "clinging to the remnants of bohemian life-styles.") The radical intellectual, Coser argues, not only can survive in the present-day university but is now carrying out the "innovative function" that used to be performed by the detached thinker and artist.

This thesis, rather than Coser's training in sociology, determines, in my opinion, the form of *Men of Ideas.* Two-thirds of the volume is devoted to vignettes of intellectuals assembled in earlier environments: eighteenth-century salons, nineteenth-century coffee-houses, scientific societies, and dining rooms, cafés of the nineteen-twenties. By featuring group habits and collective beliefs (e.g., self-expression in the Village of the twenties) and, on occasion, the activities of intellectuals in behalf of some common cause, such as abolitionism or the Dreyfus case, Coser seeks to make it appear that togetherness in thought and purpose has been the rule in intellectual life since before the French Revolution. As "men of ideas," intellectuals are those who share in the heritage of mental artifacts; like "men of property," they are known not by their creative powers but by their acquisitions. Sociological data that might disturb the image of the intellectual as a dignified investor in mental enterprises are conspicuously missing; there is no discussion of the social origins of the different groups of intellectuals and the effect of these backgrounds upon their thinking and behavior—a subject of profound im-

portance in this century of ideological drives that cement together persons from all levels of culture and education, and pit intellectuals against each other in battles to the death. Though not a sociologist, Dostoevsky, in reflecting on the Russian intelligentsia, traced this new cultural category to "the degeneration of the whole former landowning class into something different, into an educated class," and deduced from its social composition that "the caste [might] take an uppish attitude and become again an authoritative power." In contrast, Coser, like Hughes and Hofstadter, sees the intellectual not as an individual emerging out of a specific environment that shapes his style, but as an abstract type identified by the virtues of disinterestedness, moral integrity, social concern, and so forth. Thus, *Men of Ideas* also omits any examination of the characteristic rhetoric and costumes of the Philosophes, Jacobins, Saint-Simonians, Fabians, and other ideological aggregates presented in it. We meet them only through digests of their theories and a few verbal snapshots of their leaders.

In its third, and final, section, *Men of Ideas* arrives at its real objective: "The Intellectual in Contemporary America." Data are offered on American scholars, thinkers, and artists in their chief occupational categories: academic, scientific, civil-service, mass-media, recipients of foundation grants. The information is spread over a wide area, ranging from the growing percentage of university teachers among contributors to little magazines to the attention (or lack of it) that is paid to intellectuals employed in government agencies. Coser has accepted the idea of belonging— though, of course, "critically" and "rebelliously." Like the criticism offered by William H. Whyte, Jr., in *The Organization Man*, his is directed at the deprivation of freedom and individuality suffered by the insider. This, it turns out, is considerable—at times almost enough to convince the reader that the intellectual cannot make it in these settings, that if he doesn't get out, he is finished. "The aspiring academician may be deflected from planning a large-scale intellectual undertaking that may take years to mature, in order to publish narrower contributions that can be of more direct use in the advancement of his career." But anybody so careerist and narrow would seem to fall short of Coser's definition of the intellectual as one who "lives for ideas," and one wonders why he is brought into the discussion. Indeed, the section of *Men of Ideas* dealing with contemporaries is given over largely to methods practiced in Coser's institutional setting for producing non-intellectuals. "Lip service may be paid to 'cross-

fertilization,' but in actual fact young scholars are generally advised to stay within the boundaries of the 'field.'" Even more devastating to the free mind is the following: "As a particular academic field becomes professionalized, those active within it are expected to take their colleagues in the profession . . . as their main reference groups." (*Men of Ideas* itself has not escaped this pressure; its footnotes are loaded with citations of second-rate writings by Coser's colleagues.) "These rules require . . . above all, respect for the boundaries of the various specialized fields. Those who attempt to create *ab ovo* are likely to be considered 'unreliable' 'outsiders' to the mistrusted." These accounts of university practice ought to end any illusions about the critical and rebellious academician; one who accepts such conditions belongs to a gang, not to himself.

Obviously, Coser is unhappy. Dostoevsky's separated intellectual, who begins with his own thoughts and feelings, may have perished in the twenties, but though the cock has crowed, his ghost hovers over *Men of Ideas*. Whenever Coser is speaking of his colleagues in programmed research and coordinated creation, his favorite word is "frustration." He believes that the university intellectual ought to have more time for "free speculation" and be less caught up in the round of college administration, professional meetings (Coser is president of Eastern Sociological Society), visiting lectureships, roundtable conferences (with the publication of *Men of Ideas*, he will no doubt be flooded with invitations to participate in panels on "The Intellectual and His Future").

None of Coser's liberating suggestions are likely to be accepted in the rapidly expanding American cultural establishment; on the contrary, what he calls "countertrends" are becoming increasingly prominent. The issue, however, goes deeper than the constraints of the American university in the second half of the twentieth century. As soon as the intellectual identifies himself with any group or institution and subjects himself to group rules, group ambitions, and a group style, he is changing into something different. Coser himself is as good an illustration of this process as one might wish. There is no doubt that he is an intellectual—besides being a professor, he is a writer and an editor of *Dissent*—yet he subtitles his book *A Sociologist's View*, preferring to identify himself with a profession and with a professional angle rather than speak as a "freely speculating" individual. By his own choice, Coser introduces himself into the classification whose credentials he questions. "The great majority

of these men," he writes about today's scientists, "are not intellectuals, nor do they aspire to be such." He finds this to be true as well of government "intellectuals," teachers, writers for mass media: "The vast majority of those employed in the mass-culture industries can, by no stretch of the imagination, be called intellectuals." Then why bother with these settings? Because Coser has started with the erroneous idea that the intellectual is a person who holds an academic degree or who produces cultural commodities. It has not occurred to him that in our highly literate society anyone is potentially an intellectual and every intellectual is potentially a mere "mental technician," or square. "They hail from all corners of the social world, and a great part of their activities consists in fighting each other," Joseph Schumpeter has said. One suspects that today there are at least as many intellectuals among cabdrivers and jazz musicians as there are among holders of doctorates. Like Hughes and Hofstadter, Coser is looking in the wrong places, because he doesn't know whom he is looking for, though he does know that those he encounters are the wrong people. No wonder he and his colleagues worry about the future of the intellectuals. The independent intellectual feels no anxiety about the possible vanishing of his breed; there are moods in which he wishes that it would vanish, since he thinks intellectuals are fakes and invalids anyway—including himself and the marvelous minds that have produced humanity's art and ideas. As Kafka noted: in his fight against the world, the intellectual backs the world.

The intellectual cannot be stabilized as a type, a style of behavior, or a member of a social category. By nature, his condition is ambiguous and subject to change; one does not *possess* mental freedom and detachment, one participates in them. No "setting" and no set of conditions can protect the intellectual against disappearance.

By the same token, there is no sure way of getting rid of him; after decades of Stalinist suppression, the intellectual suddenly manifested himself in many parts of the Soviet world. Men of ideas may exist in a common situation, but the experience of each is his own experience and his creation is his own creation. Coser has effectively listed the institutional obstacles with which the individual must cope if he wishes to function in the learned professions in America today. The intellectual, however, is adept at finding the cracks in society through which to crawl around the obstacles, whether he eludes them in the university, on a park bench, or in an insurance office. An issue of *Dissent* carried a

description of the band of nonstudents around the University of California at Berkeley who were accused of fomenting disorder during the student revolt. There is at Berkeley, said the *Dissent* author, "a melting pot of campus intellectuals, aesthetes, and politicoes." And he continued, "any afternoon in the week this crowd is found lounging between classes on the Terrace [an outdoor cafeteria with "a touch of Left Bank atmosphere"] or in Telegraph Avenue's two coffeehouses arrayed in styles from classic beat to classic Harris tweed. Admittedly, its ranks contain a quota of the hipsters and revolutionary zealots concerned with little but the right names and phrases. . . . But here also are a surprisingly large proportion of the most intellectually serious and morally alert students on campus, fellowship holders as well as veterans of the Mississippi wars. And sometimes the lines are extremely hard to draw." So much for the "death of Bohemia" in the twenties and the vanishing of the organizationally un-attached intellectual. So much, too, for the attempt to identify the intellectual by his setting, his costume, or even his words.

1965

IV
Themes

24 Themes

I

What is "usable past"? The phrase seems to me most intelligible if it is taken to mean a literary tendency to which a writer deliberately attaches his own work in order to derive something new from it. Thomas Mann consciously *used* the romantic movement of the nineteenth century, and T.S. Eliot used French symbolism and English metaphysical poetry.

For an original artist, using the past is an unusual orientation, not far removed from that of the academicians. The writer stands outside his work and builds it from carefully selected materials.

Developed in response to various questionnaires distributed by literary reviews—or culled for magazine publication from the author's notebooks.

His posture implies a readiness to regard himself as a representative figure, an historical landmark. It implies also that literary practice has been raised to the level of a philosophy—a theory of what is needed and ought to be done to supply that need. The writer sets out to use (and change) the past of literature in the interest of its future; and through this he hopes to change the world or our consciousness of it.

Merely to imitate, to derive nourishment from favored models, is not to "use" the past in this sense. Imitation is more naïve than using, has a closer resemblance to life itself. Long before we have cultural or even conscious aims, we imitate. And the writer who does not seek primarily to affect the history of literature tends *to live in* his work rather than to use it. Baudelaire establishes himself inside Poe as a base of operations; he apes him but does not use him. Through Poe he achieves a heightened sense of himself, whereas the "users" favor "objectivity," a belief in the "self-abnegation of the artist." Despite his deep and luminous consciousness, Baudelaire is simple in his mimicry, which absorbs Poe into an act of knowing. It is natural for a writer to be conscious of literature by means of past literature but not of past literature as a means.

Imitation is always of individual things or persons, while to elect a section of the past as usable indicates an intent to capture and exploit, for the sake of special interests, a specific historical area—as in Southern regionalism, for example. In short, the idea of a "usable past" is shot through with politics.

The American cultural past was brought into being by a combined collective using and inspired individual aping of the European past. Beginning with Independence, American writers and artists have behaved in the native tradition by exchanging the following masters: British and French classicism, Rhenish romanticism, the Great of All Ages (transcendentalism), Italian classicism (mainly in sculpture), French realism (social and psychological), French symbolism, et cetera. To be an American has always meant to be a properly dated European. Yesterday, for instance, some people believed it meant to be a Russian or a German.

Outside of American high culture—always under two or more flags—have lived the millions of native and immigrant Americans who missed the chance to study with Thorwaldsen or at the Ecole des Beaux Arts or to enjoy the regulation *Wanderjahre* at Göttingen and Montmartre. These frontiersmen, tillers of the soil and builders of the towns, have been for the main part

neither Americans nor non-Americans in the cultural sense—their culture has consisted of homemade, transitional folk ways, lacking national scope. Or they have had no culture at all, except for racial or sectarian residues, such as those of Pennsylvania Germans, Huguenots, Mexicans, Scandinavians, Africans, Mormons, Quakers. These lower-case americans have been and remain "aliens."

Because the cultured Americans have been, almost exclusively, members of the upper class, while the americans are workers and farmers, storekeepers and country doctors, many writers believe that the "soil" and the folk are more revolutionary, as well as more American, than the library, the museum, and the idea. This is a grave mistake. The sharecropper and the philistine executive-type are equally opposed to European art and literature, and the cultivated American often likes to stage himself as a plain guy, a member of the cultural rank and file. In literature, the "people's writers," from Mark Twain to Sinclair Lewis, *start* with the soil, but they climb in the direction of respectable literary standards, which allies them with the middle class rather than the uncultured folk.

On the other hand, writers, such as Poe, Whitman, or James, who take off from the contrast and tension between Europe and America, remain relevant for individuals of all classes. America can be known only in the perspective of international culture. Conversely, it can understand world ideas only if it applies them to itself.

Every writer today who is worth anything shows in some way the influence of the overturn that took place in American prose and poetry via Joyce, Pound, Stein, and other modernists. This movement is essentially an upper-class (European-minded) aping of american proletarian speech. Modernist American writing, which at its best goes farther in the direction of aural accuracy and precise imagery than Whitman's private lingo, represents a cultural synthesis, a new era in the self-consciousness of Americans and their consciousness of the world. Our living language is brought into focus with the living literature of the past; it need no longer fear that looking back to the masterpieces of Europe and antiquity will turn it into a pillar of salt. On the other hand, American letters need strive no longer to reshape every experience into a plaster-of-Paris model of a European original. Through Modernism, art in a developed America has an identity of its own.

Unfortunately, however, in novels, Hollywood, Broadway, TV, this experimental "cultural proletarian" language is being aca-

demicized, made "natural," made 100 percent American—that is, zero.

A writer remains vigorous so long as he is aware of the presence of a section of the population whose cultural energies match his own. In this lively, soluble mass he hopes that his work will create a coagulation of taste and thought. The number of people who understand the International-American rhetoric is growing. This, as noted above, also increases the rewards for, and consequently the chances of, popularization, which has started to drain the meaning out of the new vanguard literature.

American newspapers and news weeklies have never been serious about literature; seriousness has been confined to the reviews and "little magazines." It is easy to see why: mass-circulation organs of news and opinion, in orienting themselves on "American interests," are obliged to assume a smug proprietary defense of "our" literature, while all serious efforts in American letters have been directed, more or less humbly, towards the European-American equation. A more immediate reason for its lack of seriousness about literature is that liberal journalism assumes that all questions can be solved through "moderation"—even lies and philistinism must be treated moderately; and this creates a hatred and fear of ideas carried to their conclusion. Literature, in contrast, tends, especially in modern times, towards exaggeration and finality (its moderation, too, is exaggerated).

Yes, there is a place for literature as a *profession*. In fact, it is one of the few professions that can be confident of its future—along with military aviation, demagogy, patriotic preaching, spying, and so forth. The worse society gets, the more professional literature becomes, and the greater the demand for this type of service.

In time of war, the writer has at least the obligation *not to find the "good side" of it.*

II

Contrary to the suggestion contained in the term, the "middlebrow" is not a halfway person. The notion that all the middlebrow wants is to mediate between the inventor of difficult truths and a public intellectually unprepared to receive them is a delusion—a delusion fostered by the middlebrow himself.

The fact is that the middlebrow is a fanatic and has his own truth. It is the truth of those seeking revenge, of the insulted and the injured. For the middlebrow has been scorned by both the

ignorant and the educated; by the ignorant for showing off his education, by the educated for yielding to ignorance and failing to pursue ideas.

The working maxim of the middlebrow is: Knowledge is a commodity that can be purveyed at a profit. But you will not grasp the vengeful middlebrow principle if you limit yourself to his economics. Beyond this economic rule, the middlebrow has another principle, one which he keeps to himself: KNOWLEDGE IS NOT POWER BUT CAN BE A TOOL OF POWER. In this is reflected the full depth of his malice and his ambition.

Appalled by the enormous implications of his secret credo—that he himself can rule the world through the manipulation of ideas—the middlebrow dons the disguise of the Middle Way. Should the spotlight fall on him, he will deny any part in the conspiracy. Look squarely into his smiling, reasonable pan, however, and you will have no trouble spotting that it is a mask which he can replace in an instant.

Underneath his make-up of the impartial "communicator" who wants nothing more out of life than to enable you to understand what great minds think, this shrewd, ambitious, and fearful creature is scheming to win everything for himself, including respect for his mediocre mental fabrications. Were he to have his way, both highbrows and lowbrows would be extinguished and his breed alone would survive as the type intended by evolution.

Ideas as tools can never conquer completely, for there are men who are *haunted* by ideas.

By embracing the idea as a living presence, such a man fills it with his own self, which interferes with its merely working parts, a kind of monkey in the machinery.

No idea will function efficiently if someone is going to insist on taking it with absolute seriousness. The idea of freedom began to work poorly when John Brown appeared, as did the idea of Communism when revolutionary Hungarian students momentarily rescued it from the textbooks.

American literature is becoming more sophisticated about persons who manipulate ideas and are manipulated by them—for example, editors, hucksters, PR [1] people. Yet despite the thirties and its casualties, America has still to learn how to deal with people haunted by ideas.

One reason our literature fails to rise to the comedy and tragedy

1. PR here stands for public relations, not *Partisan Review*.

of the idea-haunted intellectual is that the American intellectual fails to recognize his own case. Struck with a nineteenth-century concept of the free personality and a belated romanticism, he apprehends life as a struggle to preserve his uniqueness from damage by "the material weight of society." It never occurs to him that this uniqueness does not exist except through an idea, and that it is his idea that he ought to defend at all costs. Instead, it is for the illusion of self that he struggles, *even against his idea.* For the sake of his constantly vanishing ego—and just because it is always vanishing—he will forsake not only his family, his love, his vocation, but even his deepest conviction, lest it dilute the original man in him. So he wars against everything, like a swami turned inside out, and, naturally, he loses—how could he win?—and must console himself with the old song and dance about his personality being crushed by social forces. "Keep complaining," reply his keepers. "So long as social power remains in our hands, we can afford to let personalities fall like leaves."

It is possible to get sick of outlaws. Especially if their only justification for being outlaws is a position that uttered its last word a century ago. As for the real world, it has entered into an age of infighting.

One also gets sick of victims, whether their injuries were inflicted upon them individually or as members of a group. The proper response is to rush them to a hospital and to clean up the conditions that brought them to their sorry pass. Our aim should be to eliminate the victims through philanthropy and social justice. To cherish their complaints as literature is to cover up indifference with aesthetic hypocrisy. Yet where would America's official literature be without hypocrisy? Without MacLeish's *J. B.,* soap opera of the common man as victim. An epic—of liberalism, no doubt. Fake pity which covers up real self-pity.

Though a victim, Ahab was justified because in retaliation for one mere leg he put into practice his idea that to be a free individual meant that no one could take him for a sucker and get away with it. In a nation of confidence men this was a pretty good idea, though to make the principle universal, Ahab had to extend it to include nature and accident, which made his idea grotesque (e.g., no hurricane is going to beat *me* up).

In any case, *Moby Dick* is a drama of *the refusal to be a victim,* of the going over of injury into freedom by means of an uncompromising idea of justice. The Fitzgerald trauma is something quite different.

Ahab, like Raskolnikov, was outlawed by his idea. Having his

leg bitten off inspired him; without this inspiration he would have been a mere handicapped sea captain. Had he complained about his accident or attempted to explain it by unsafe conditions in the fishing industry, all the worse for him. "Aw, stop whining," they would have told him on the bench.

As it was, his amputation became the pretext for a string of aggressive formulas, derived from capitalism but transcending it:

> *Every loss a profit.*
> *Impossible to break even, but only a slave lets*
> *himself be subtracted*
> *Freedom means* $1 = 1$. *Minus a leg, plus a world.*

Ahab, outlawed by his idea, cannot be rehabilitated. To the sociologist, as to the doctor, he is a hopeless case. Since there is nothing they can do for him—actually, he's making out much too well—he has become a proper subject for the researches of poetry. (However, in no way does Ahab's ordeal reflect discredit on medicine or sociology—as does human suffering in reactionary fiction, where the limitations of science are gleefully seized upon as an argument in behalf of superstition, as if medicine were worthless if it cannot grow back legs eaten off by fish.)

In the Fitzgerald trauma, inherited by Faulkner and many of his literary descendants, the heavens are closed like a scar. Misery aplenty, but no storms. The hero fights to break even. Who will deny that, had it been up to him, Gatsby or Joe Christmas would have chosen to live without his handicap? Of course, being a romantic, he had use for his blemish: it made him mysterious, a personality, "unique"—and provided him with an issue, that of being low class or black. This issue contained his drama: to "pass" or not to "pass."

What haunts this hero is not an idea but the image of another social self, a tonier one, a whiter one, which he might have were he not prevented. He wishes to be somebody else, and an abstract somebody at that. He is an outlaw through conformity—like one who steals a pair of silk gloves at Tripler's—a conformity made passionate through frustration.

Thus his pained presence gives pleasure and reassurance to those on the inside, who, through him, think themselves desirable (which they are not to themselves). Why have Fitzgerald and Faulkner become so popular since World War II?—I mean, not in literary circles, where apart from their mental qualities they deserve to be appreciated for their verbal and visionary gifts, but on Broadway, in the movies, and with masses of paperback readers. As the literature of hunger added savor to the giant

meals of the Victorians, so today the literature of the outcast draws philistines closer together as they recognize themselves in both the excluded and the excluders.

But are Gatsby and Christmas genuine human outcasts, as Ahab is by his idea? Why shouldn't they "pass"? There are so many things to pass into, every one of them as good as the Long Island elite or the Southern pure white. (It's an insult to expect me to take Gatsby's predicament seriously, as if I, too, ought to concede that my life is worthless unless I can climb into the social set where he wanted to belong.)

But no, no passing! To the author, the heavens, and the earth too, are closed like a scar. As he himself is ideologically committed to being "crushed by the material weight of society," so must his hero. To keep the latter's case from being settled amicably (perhaps with the aid of the "social dynamics" that those despised big-city intellectuals are so fond of talking about), it is necessary to insist that his hero's blemish is more than skin-deep. The author is on the side of the hero's flaw and against his hero.

This is another way of saying that the author is against man, in favor of a parochial hierarchy of values that is devoid of any idea. No wonder Faulkner had Christmas ritualistically *sacrificed* by a human vermin whose beastliness he covered with seraphic refulgence. While Fitzgerald practiced upon Gatsby a species of persecution, with the aim of demonstrating his solidarity with those who assumed the right to despise him—like a Communist under a cloud who to prove his loyalty puts the finger on a comrade. Fitzgerald's tale succumbs as under a decree of fate (of course, he's personally on Gatsby's side) to the enemy's condemnation of Gatsby and its satisfaction with itself. His work groans and leaps with the hardships, humiliations, elations, and stoical afterthoughts of social climbing, the laws of which in modern United States literature are generally mistaken for a metaphysics of identity.

The ostracism of Gatsby and the damnation of Christmas repeat the old theme of romantic revolt—but in reverse. Instead of attacking society, the author tries to fuse himself into it as its backbone. One might say that he does not revolt against it but toward it. The more it repels him, the more he needs to be in it. If he does attack it, it is only after he has invited it inside himself as his judge, like the fellow in the story who says: "Throw that bum out," and, being told "He isn't here," replies, "Well, bring him in and throw him out."

The reason for the shift from attacking society to being willingly

victimized by it is that social change has destroyed the old romantic situation. How can one *revolt* against one's social environment in America today? The prejudices and snobberies of those in charge no longer exist as structural attributes of an accepted order, but rather as sneaky, private vices like those of the outsiders. The manners of the pillars of your community may fill you with disgust, but for revolt the target of your struggle needs to have authority over you. This authority no section of American society—whether the Philadelphia Main Line, a new Four Hundred, or the worthies of a middle-class suburb—possesses over any individual who refuses to accord it of his own free will. Revolt today has no more content than buying a bus ticket.

Any genuine attack on society today must occur on the level of abstraction—that is, it must be directed not against individuals and their manners but against the system of power and its mystifications. The drama of social reform is as dead as the drama of nature; the struggle against the aesthetic or moral qualities of a class is no more meaningful than the struggle against the sea or the desert. It is for the popular media that such obsolete literature is destined, regardless of the "seriousness" of the author. The only true wrestle is with the abstraction: the credo, the slogan, the symbol.

From the passive yielding to social snobbery and prejudice comes our literature of dispossession, with its stylized intransigence, devoid of radical fervor and eager for a goodnight kiss. Modeled on the mental case, into which the romantic rebel degenerates when the target of his rebellion has lost its contours, the new alienation consists of rancor and peevishness resulting from wounds inflicted by social discrimination, actual or imagined.

New kinds of social climbing appear—and American literature can depend on them to distract it from the rigors of thought. In the United States, social climbing—which includes climbing *down,* as when a Harvard man becomes a fisherman, a farmer, a bum— achieves a profundity and complexity unmatched elsewhere. In a nation founded on the concept that salvation is a matter of geographical change, who you are normally depends on where you are—and there is nothing to prevent one from moving. With individuals constantly climbing over and under one another, the question of status is never settled, and people are likely to try to get past themselves by a detour. Still, the striving to get on an invitation list is not the equivalent of an idea.

A Guide to Profundity: or, How to Interpret the Twentieth

Century as a Disaster. Be an equal of Spengler, Ortega, Mumford.

The Nothing, once the secret of adepts, has become a platitude.

The social equivalent of the Nothing of the Existentialists is the proletarianized mass at the center of all civilized societies— a cultural proletariat produced by the "decomposition of all classes."

University metaphysicians suffering from the current "crisis of philosophy" ought to turn their energies toward a realistic study of society, paying particular attention to existing agencies of "nothinging" in both their liberal (class-destroying) and their nihilistic (mind-destroying) functions. Such a turn toward sociology on the part of the "existing thinkers" of the philosophy departments would at least keep them away from literature, which has already suffered enough at the hands of learned "disciplines" in search of a new subject matter.

Is proof needed that the void of the Existentialists and the mystics is a *historical* phenomenon? Today, anyone who looks into himself is certain to discover the debris of his class heritage in a desert of freedom and aimlessness without limit.

Yet Montaigne found something different from the ontological zero. "There is no man (if he listen to himselfe) that doth not discover in himselfe a peculiar forme of his, a swaying forme, which wrestleth against the art and the institution, and against the tempests of passions, which are contrary to him."

Comparing Montaigne's moment in history with our moment, Montaigne's wins, because in his time, being "wrestleth," while in our time it "nothings."

Too much reflection on the "degradation of modern man" leads the oddest people to put on the air of feudal aristocrats.

"The individual" is an idea like other ideas.

When we speak of the ideas that prevail in the given time and place, we have in mind not the concepts people talk and write about but something that has much more resemblance to prevailing winds. Under the influence of the idea, different actions incline in the same direction. The idea always reveals itself in *collective* phenomena, although no one can put an idea into words without making something unique of it. In its wordless state, an idea can carry along individuals who are in complete disagreement with one another. Later, when approximations of the idea are verbalized, the most terrible purges take place.

Regardless of what he thinks, anyone who speaks or acts is an agent of someone or something else. For that very reason, to

submit consciously to being an agent is to throw one's life away. It is not necessary, and, besides, the conscious agent merely obeys a formulated thought rather than the prevailing idea. Were he really devoted to the idea, he would have realized that in attempting to serve it he could only reduce it to something personal.

An idea that can be adopted is only the distorted reflection of another idea which is inexpressible. The idea of Communism, for example, is such a surface idea; underneath it, a world solidarity may actually be in the process of formulation. But this universal idea will never be thinkable in verbal terms; and before it comes into being, how many Communisms will have to be overthrown!

If world solidarity is the destined idea, everyone is an agent of Communism, but the Communists are those who throw their lives away and make Communism personal. The idea of solidarity will prevail, but in the meantime all theories of solidarity are superficial and false.

"In the meantime," however, is History—which means that our lives are governed by ideas of solidarity that keep marshaling their armies for the bloody division of the world as the means for making it One.

Yet what reason is there to accept the notion of a universal idea? More likely, no idea can conquer the world, any more than the world can conquer an idea. Perhaps after a certain time, an idea simply fades of its own accord. More likely, though, all ideas that come into being continue to live on side by side, as the iguana lives on by the side of the nuclear reactor.

III

SCALE. It is desirable at times for ideas to possess a certain roughness, like drawings on heavy-grain paper. Thoughts having this quality are most likely to match the texture of actual experiences. Under the influence of methodology and scholarship, our concepts tend more and more to become either microscopic or cosmic. Objective techniques are unable to guarantee that concepts will keep relations of size appropriate to things and events. To get these right, the thinker must be aware of his own self and use it as a measure. But if this awareness is an honest one, it is bound to dispel evenness and excessive finesse.

EDUCATION. Aristocrats have a talent for memoirs, the declassed for religion and sensibility, the poor for mathematics and musical performance. As the mind descends the social scale, it becomes increasingly abstract.

The present epoch takes its style neither from those long in power nor from those excluded from power, but from masses who came into the world without possessions. Hence computation, horn-blowing, and nonfigurative art are the most faithful reflections of the age. The political leaders, however, identifying themselves with the property holders of all periods, are hostile to generalization and to rhythm and wish attention to be paid to their memoirs—even when they must use force to compel people to recall the happenings that brought them to power.

THE CULT OF PERSONALITY. Bureaucracy is the social realization of the arithmetical point of view, that is, the point of view of the mass that is ruled. The sage of bureaucracy is the statistician. But counting depends on the existence of the single unit. Hence bureaucracy must have one Person as its measure. Should there be more than one, each would insist on his absolute difference and statistics would become impossible.

GEOPOLITICS. The global revolution of today is thrusting man into outer space, as the national and class revolutions of the nineteenth century drove Europeans across the seas to people the American prairies.

MANUSCRIPT FOUND IN A BOTTLE. "By refusing to stay fixed in a single place and in a lasting relation to those above him, man in our time is violating his essential nature."

THE END OF MEANINGLESSNESS. Life has meaning only within a context. Taken in themselves, actions lack definition, and things change into one another as in dreams—which is why those who have observed it most nakedly say that life is a dream.

Today, of course, dreams themselves have been arranged to constitute a context. Thus one gifted with a persistent loss of the sense of proportion is thought to have a firmer grasp on the meaning of life than one who is *square.*

Conceiving life to be its own context, modern dream and nonsense literature has closed the door to meaninglessness. Through this tour de force, everything in life becomes full of significance, while life itself is meaningless.

The notion that life provides the meaning of life is nihilism in disguise. The literary masterpiece of this mood is Tolstoy's "Death of Ivan Ilyich." In "Death," the context of Ilyich's existence as a typical successful Russian functionary, far from providing the meaning of his life, is presented as falsifying it and reducing it to zero; only when Ilyich is pulled out of this context by a fatal

illness does he throw off the lie imposed upon him by the facts of his life.

Why not say flatly, then, that the void of death is the only reality, and that as against this reality life is meaningless? No, Tolstoy will not say it. On the contrary, he would have it that life is infinitely meaningful, but only on the condition that every actuality in it be seen as illusory. Each concrete situation experienced by Ilyich is a negation or inhibition of life.

But if life thus repels all content, life is meaningless. Tolstoy does say this, but he says it dramatically, not as an idea. When he has painstakingly plucked Ilyich strand by strand, fiber by fiber, from his casing of court sessions, card games, and family routines; when he has released him at last into the dark current of being—he finds nothing for his hero to do or to be, and with the sure instinct of the storyteller, he gives him up and lets him die. Ilyich has achieved Life—and that is the end of him. Whatever Tolstoy may have wished us to understand, he ended by delivering a corpse to the dissecting room of the Absurd.

In Tolstoy's day, the intuition of nothingness had to be given the appearance of meaning—the nihilists, for example, assumed the role of revolutionary liberators—much as the early model auto had to appear as a version of the carriage. Ilyich's death howl was presented as also his birth cry. Had he lived in the West, he might have survived his nameless malady and taken passage for the South Seas. Had he been born a few decades later, the ex-judge might have married a circus performer and set himself up as a Surrealist.

For Ilyich, unfortunately, neither time nor place was apt for affirming Life as a *professional point of view,* one able to compete with business or jurisprudence. After canceling all civilized contexts (except, of course, the context of literature, which he was too shrewd to share with Ilyich), Tolstoy had found only one that seemed harmonious with pure being: the peasant's context of nature and toil. In living for life, the peasant made the void positive: when the servant rested Ilyich's feet on his shoulders, the dying magistrate felt a great communion and was comforted and enlightened. The peasant was the model on which Ilyich, had he been cured, would have had to be rebuilt. Unluckily for Ilyich, Tolstoy had gotten there before him and was thoroughly aware that this peasant and his life-for-himself context was a poetic fiction. The actual Russian peasant lived in a cruel context of forced labor; it was the wheel of hardship and hunger, not the cycle of the ripening seed, that set the meaning of his life, as the

pleasant round of dinners and court cases set the meaning of Ilyich's. Between the context of soil drudgery and dependence and that of rich proprietor, Tolstoy had made his choice, keeping the peasant shirt as an emblem that all meanings of life could be subverted by the notion of life itself as *the* meaning. But this shirt was not for Ilyich: a great writer can be frivolous in his living, but in his fiction things have to be taken seriously.

Released from the mechanics of the social context, Ilyich had no place to go but the grave—the "organic" context is death. The actual peasant, on the other hand, had to go the way of the October Revolution, which tore him out of one social context and enclosed him in another. The context of human life is History.

THE MEANING OF LIFE. Organic life was the absolute context of Tolstoy's fictional peasant, as Heaven and Hell were the eternal context of the medieval soul. History is the constant displacement of contexts; its dimension is Time, which is an indefinite dimension. No one can stay in History forever. Thus History threatens with a lapse of existence all who are conscious of being in it, and this threat impels them to make every effort to remain in it as long as possible. Still, to enter History even for a moment is sufficient to differentiate a person from those whose lives count only to the census taker.

In our time, life has meaning only for those who are in History; all the rest are mere "mass," confined to the arithmetic of birth, labor-and-consumption, and death.

Hence the primary passion of contemporary man is to enter the historical context. For this he will sacrifice life itself. To win a place in History—and lengthen his stay in it—anything is justified. Moreover, he is obligated, he owes it to his humanity, to stop at nothing in order that his living-time shall not be absorbed into animal nullity.

History is made from moment to moment; the open door into it is News. Before a person can become part of the permanent record, there must be tidings of him, as when the messenger arrives in the play and adds the action off-stage to the intrigue.

The effort to project a person into News—an effort on which hinges the issue of life or death in the literal sense—has been organized into an art, the art of "publicity." The techniques for inserting into the common attention and (hopefully) memory the image which an individual has chosen to represent him constitute the most rapidly rising of professions, and has already eclipsed the clergy in spiritual importance. The frenzy for public-

ity is nothing less than a manifestation of the craving for meaning in life. One's name in the papers, one's picture in the weekly, brings reassurance that one has a place in the human record. The success of totalitarian movements has owed much to the philosophy that all party members escape the organic context and enter into that of History.

Publicity should not be mistaken for a mere tool of success or exhibitionism. The appetite for wealth or for flattery is a limited appetite: it can be satisfied by status and is not inconsistent with quiet enjoyment. Publicity, on the other hand, must keep pace with time: it is an effort to affect a man's metaphysical situation; and its results are watched with an anxiety inseparable from that aroused by the consciousness of death.

Since it is the quantity and duration of public attention that counts for survival in History, the hunger for it cannot be appeased by the act done or the thing made. A good deed or a masterpiece produced in concealment may be sufficient for one convinced that life is meaningless, some unlikely knight of the unmarked grave. To fabricate today an object to be kept from the eyes of men would imply an apathy toward values, if not extreme perversity.

Except for men drunk with immediacy, the human world is divided into two species: the few who are accompanied by their reflections in the mirrors of anticipated memory, and the hundreds of millions of unseen onlookers of attention-getting feats. In Freudian terms, they appear as two generations rather than two species: the oversized infants of the front pages and the little gray fathers and mothers who have watched over their cradles— History emanates from the lost hordes.

Crime in our time flourishes as the most popular medium of transcendence into the seen; as the Nazis proved, in the wake of Raskolnikov, violence is a way into History that is available to anyone. Murders and robberies are prompted, in the first instance, by the greed for meaning; were the showcase of the News to be closed to them, crimes would be cut to a fraction. One who cannot endure the certainty of his own extinction can by crime sieze a moment of public time and thus rescue himself from the abyss, as when a clerk in a small New Jersey bank steals $20,000 and is arrested two hours later contentedly drinking beer in a bar around the corner. For the extraordinary criminal there is, of course, the chance that the act by which he projects himself into the minds of others may earn him a near-immortality.

A criminal, a statesman, an athlete, an artist, once he has

mounted into an expectation of enduring visibility, is aware of himself as a double being who moves simultaneously within two substances: the insensible material of daily fact and the golden jelly of significance that extends upward into the Heaven of Names. The meaning of life is to attain the intoxication of floating in the shining aspic of potential lastingness while being conscious that one has already been changed into a phantom.

IV

An artist is a person who has invented an artist.

"Burn the museums!" This old revolutionary slogan can now be realized by the museums themselves. A museum set on fire would today attract the usual crowd that visits its exhibitions. "Burn the museums," it turns out, calls not for the end of art but for the expansion of art institutions to include the medium of combustion.

Duchamp cut the tie between art and the handicrafts, thus immersing art in endless talk.

> The Object Answers Back
> When did I invite it to debate?
> Let it lie down on its plate
> Like an apple in still life—
> But the Object is a wife.

Artists are people who tamper with what makes them artists.

In the past, Nature offered Americans deeper satisfactions than did art. There was not much to induce an individual to become an artist, but everyone wanted to go off to a lonely mountain or be tossed in a boat on a moonlit sea. When the camera made it possible to take Nature home as a souvenir, art became superfluous. In our time it has been revived as a profession through which one can escape practicing some other profession. In other words, the motive of art is still to enable one to go off to a lonely mountain or a storm-tossed boat; that is, to enjoy Nature, if only within oneself.

"Your generation against my generation." "All generations are composed of the same people. People like you."

In the nineteenth century ideologies replaced myths as visions of how things are. Now the great ideologies have broken down— we live in the rubble of socialism, evolution (the Superman), humanism, nationalism. Superficial observers believe that the "end of the ideologies" must result in the reign of practical reason—this thought was even made the subject of a major speech

by President John F. Kennedy. But collapsed ideologies are not blown away by the winds. On the contrary, they spread throughout society and take the form of popular culture. Thus our "age of non-belief" is in reality an age of faith in bits of fragmented systems accepted as facts.

"It is true that my impulses are conventional. But I am not so conventional as to go against them."

METHOD. He loiters in the neighborhood of a problem. After a while a solution strolls by.

A writer who lives long enough becomes an academic subject and almost qualified to teach it himself.

LITERATURE. For Nabokov, writing is a way of licking himself with pleasure. This is the cat's style of detachment, which enables it to feel at home anywhere.

PERSONAL. *"...les cris douloureux de mes vains adversaires."*
—Boileau

Norman Mailer enters History:

> Walk, do not run,
> To the nearest Pentagon.

DURATION OF THE "EXISTENTIALIST EXPERIENCE." The human equivalent to the Nothing of the Existentialists is the mass of empty minds in the center of society and the empty will in the center of individuals. In both society and the self there exists an abyss of freedom and aimlessness that opened up during World War I, and which in each decade since makes its presence felt more acutely and within an expanding range of human affairs.

Current avant-garde art reveals desperate attitudes, though under a veil of relaxation. It demands—e.g., Cage, Kaprow, earthworks artists—the mixing of art and life. But this mixture is actually a repudiation of life, except insofar as life is made into art. On one hand, there is art-life; on the other, the death-laden environment which the mind is powerless to affect. The art-life mixture hides the fear and despair inherent in contemporary existence. Random art, as proposed by Cage and others, is a prayer to be saved from moment to moment by a continuous run of luck, like Dostoevsky's "raw youth" repeatedly staking everything on double-zero.

TEMPORARINESS OF REPUTATIONS. Warhol's idea about every-

one being "famous for fifteen minutes" is a mass-media idea, a "King for a Day" program. Someone ought to figure out if there are enough minutes in the life-expectancy of all the present inhabitants of the earth to make the distribution of 15-minute crowns possible for everyone.

Assuming that a primary motive of art has been to represent permanence, to have abandoned this motive in favor of an art of fashion and of ephemeral materials is another evidence of modern man's lowered resistence to death.

Yet the hope of an after-life has not altogether faded. Though modern artists accept the transitory nature of the art object, they hope to survive as individuals to the same degree as did artists of the past. They have learned, however, that it is not through the objects they create that artists survive but through records of those objects—descriptions, analyses, photos, and so on. That is, the artist survives not through art but through art history. The expectation of outlasting their physical lives through art history accounts for the life-and-death ferocity of art-world struggles over who "did it first." To have a firm place in the story—saved!

TALES OF THE EMPEROR INCOGNITO. The passion for identity goes counter to the instinct for freedom. It is a rare philosopher who would rather be free than be Somebody. Terror of the consciousness in the fact of anonymous crowds. Fetishism of identity. Sacred hair.

"Emptiness," said Koheleth, "emptiness. All is routine, repetition. Do we need illustrations? The sun also rises, et cetera. There is no objectively privileged fact. No awakening bray. Nothing magnificent. Nothing to which a mood is attached, not even failure. No movement of a snake on a rock. No stance of a king. No seduction. No quality. Red, yellow and blue exist for their own sake."

THE POPULAR NOVEL.

> That poet's pen will never rest
> Who sings of ladies he undressed.

HISTORY. V. Drubeznev has provided eye-witness testimony that V. I. Lenin would become violently car sick if he passed a Red Guard walking backward.

FAMILY LIFE OF ART. His generation has fallen into decline and he has no one to talk to. He hopes that the new girl friend will fill the gap. She is everything to him. . . . In time she is even himself

to him. He is no longer frustrated by the surrounding silence. Her chatter has destroyed his desire for the presence of others.

> Behind the watery mists
> The muted night clubs of the dead

TRADITION. Once the idea of tradition arose, it was inevitable that it would produce its antithesis, the idea of a break with tradition. The idea of tradition itself suggests this break by lamenting the absence of tradition—a fact which, after all, we have been able to live with.

"Never mind the editorials," he warned her. "Let's stick to the sporting section."

SCIENCE AND HISTORY. He then became a scientist and invented the apple. This discovery, as we know, introduced nakedness and made Adam and Eve run for their lives.

He was repaid by revels of shame and hair.

Poets of all epochs have celebrated his infernal creation by orgies of sleep.

In our day the nude disappeared from painting and sculpture and reemerged in the daylight of the photograph.

The apple has been split in halves and surrounds its black seeds with the mathematical outline of a heart.

The most dangerous thing in the art world, especially for collectors, is a dying art movement. Reputations seem unassailable and prices reach absurd heights. Then suddenly the silences start spreading. Now the collector is face to face with an object. Can he think of it as a treasure?

T. has decided to provide his Abstract Expressionist brush strokes with a geometrical underpinning. It is like placing a concrete foundation under a locomotive in order to make it run more smoothly.

We continue to speak of vanguard art. Yet radical intentions, the impulse to be in the forefront of change, have been rare among genuine innovators. Rather than consciously seeking to take the lead in their profession, they have struggled with realities that had become self-evident but which the profession had ignored. Genuine novelties always include a resurrection of something old, so that professing vanguardists ignore them on principle. We ought to drop the term "vanguardist" and find one to designate the "classical" innovators, that is, perpetrators of permanent revolution in a mild, objective form.

ART AND ENVIRONMENT. A character, whether in history or fiction, is one to whom his environment is not a habitat but a stage on which to play his part. To Trotsky, world politics, whether in Moscow or Cuernavaca, was a *scene,* as the ocean was for Ahab or the slums of Petrograd for Raskolnikov. A character is either a madman or a demon. He "descends" into this world but is not of it.

In contrast, Stephen Dedalus, Hans Castorp, and Marcel Proust are not characters but men of ideas, observers. Dedalus *dwelt* in Dublin; Castorp, on the Magic Mountain; Proust, in bedrooms and drawing rooms. Those who inhabit an environment are zoological specimens rather than characters. It was zoology, not the possibilities of action, that frustrated Joyce, Mann, and Proust— the zoology of the human organism as modified by the inherited culture of Western Europe.

THE PACKAGE: CULTURAL FORMAT OF THE TWENTIETH CENTURY. The package is presumably a modest thing, a mere container. In fact, however, the package continually strives to call attention to itself at the expense of its contents. It is fitting that an article on Christo, who wraps staircases, landscapes, buildings, should have been entitled "The Will to Power." Obviously. To wrap up is to appropriate. Also to make final (as in "wrapping up the deal").

The film producer, the art dealer, the editor of popular magazines, the museum curator is the personification of the package. He wraps himself around the creations of others and offers *himself* to the public.

THE FUNCTION OF ART. An artist is an artificial construction. Selected by chance, natural and social (X has a certain talent; at a critical moment he met Y), he makes himself up through whatever means lie at hand. When he is able to make himself up in the same way as earlier artists, he is said to belong to a tradition. Among the Greeks, the "madness of the poet" was brought about in accordance with inherited disciplines. In our time, madness is an individual matter, though it is occasionally assisted by the collective practices and ideologies of art movements.

The survival of art depends on the continued fabrication of the artist type. The urge to transform oneself into an artist is provided by the artist myth, with its lure of fame, glamorous sex, and wealth. The difficulty is that the artist type can no longer be copied from existing models, since these have been appropriated

by the mass media and reproduced in deteriorated form—for example, the Poes, Van Goghs, and Toulouse-Lautrecs of the movies.

Today, each artist must undertake to invent himself, a lifelong act of creation that constitutes the essential content of the artist's work. The meaning of art in our time flows from this function of self-creation. Art is the laboratory for making new men.

Abstract Art: To be obsessed like the lover or fanatic, but without an object.

America is the civilization of people engaged in transforming themselves. In the past, the stars of the performance were the pioneer and the immigrant. Today, it is youth and the Black.

The story of Americans is the story of arrested metamorphoses. Those who achieve success come to a halt and accept themselves as they are. Those who fail become resigned and accept themselves as they are.

Politics in the United States consists of the struggle between those whose change has been arrested by success or failure, on one side, and those who are still engaged in changing themselves, on the other. Agitators of arrested metamorphosis versus agitators of continued metamorphosis. The former have the advantage of numbers (since most people accept themselves as successes or failures quite early), the latter of vitality and visibility (since self-transformation, though it begins from within, with ideology, religion, drugs, tends to express itself publicly through costume and jargon).

Agitators of permanent metamorphosis: Cage, McLuhan, Timothy Leary.

Agitators of arrested metamorphosis: Daniel Bell, *The Public Interest, Commentary.*

The drama of American art lies in its dream of attaining not art but an image of things as they really are. The realm of things is, however, a realm of endless unrelatedness, which overpowers the mind with a sense of disorder and futility. To escape this condition American artists tend to resort to systems and recipes. In sum, the impossible ambition of American art to produce a real world of its own leads it to mediocrity.

Looked at too closely, a work of art is always false to its principle.

Cherub of the Question: Why into a pillar of salt?

Cherub of the Answer: Because the sea is salt, and bodies come from the sea.

Cherub of the Question: Did she look that far back?

Cherub of the Answer: The perversions of the body follow close behind.

To make a new move in art, an artist needs a new character structure. In the absence of this, stupidity can provide a temporary substitute.

Art is different from factory goods in that in it the process of production does not "disappear in the product" (Marx). In appreciating a work of art, one is aware of the means that brought it into being. There are, however, modes of painting and sculpture —for example, color-field, minimalist—in which the artist's activity, psychological and physical, comes as close as possible to hiding itself. These modes have led inevitably to multiples and factory-made "art." (I put art in quotes because if art is a certain kind of human product, works that belong to a different order of making cannot be changed into art by the opinions of artists or critics.)

But the whole idea of the art object is in question. With the end of fixed truths and their replacement by sequences of events, art objects lost their separateness and became "moments" in the evolution of forms of doing.

COMBAT-CREATION. Combat requires taking into account the maneuvers of the enemy. Creation is free and needs only to concern itself about its own energies.

In our time, combat and creation often exchange strategies. Creation is practiced as if it consisted in defeating an enemy, while wars are carried on by whipping up feelings and paying no attention to what the foe is doing.

He becomes who he is through asking, Who am I?

The most exhilarating thought of the twentieth century: "We are making History!"

> HCE
> Down with "I"
> Down with He
> Hooray! Here comes
> Everybody.

1939–71

V
Pledged to the Marvelous

25 Is There a Jewish Art?

Is there a Jewish art? They build a Jewish Museum, then ask, Is there a Jewish art? Jews! As to the question itself, there is a Gentile answer and a Jewish answer. The Gentile answer is: Yes, there is a Jewish art, and No, there is no Jewish art. The Jewish answer is: What do you mean by Jewish art?

Needless to say, the Gentile answer, either way, is anti-Semitic. Consider first that there is a Jewish art. A German art historian named Haftmann has written a history of 20th-century painting in which he divides art into a Mediterranean mode and a Northern or Germanic mode. French, Italian, and Spanish art—including Cubism, Fauvism, Futurism, post-Impressionism—is Mediterranean in feeling and is characterized by rationality, harmony, sensibility.

This piece, adapted from a talk given at the Jewish Museum in New York in 1966, was published in *Commentary*, vol. 42 (July 1966).

In contrast, Germanic art, with its Expressionism, Bauhaus, Blue Rider group, is profoundly subjective, metaphysical, speculative. Where do the Jews come in?

In a small section by themselves. It turns out that Chagall, who came from Russia; Modigliani, who came from Italy; Soutine, who came from Poland, do not belong either with the Mediterraneans or the Nordics (though the Russian, Kandinsky, is treated as strictly Germanic). They are grouped together as Jewish artists. They lived in the same neighborhood in prewar Paris, and Haftmann conceives that little street as a kind of ghetto where Chagall, Modigliani, and Soutine produced a Jewish art.

Now in fact there is very little resemblance between the art of Chagall, the art of Soutine, and the art of Modigliani. Each stems from a different tradition and underwent a highly individual development. But Haftmann finds a principle of identity and answers: Yes, there is a Jewish art. By the same principle, Haftmann could have included Lipschitz, Epstein, and Max Weber. He could have come to America and gathered up Gottlieb and Rothko, Newman, Guston, Saul Steinberg, and dozens more and placed them in his small off-track confine called Jewish art, without in any way being able to explain what it was in their art that made it Jewish.

Here, then, is an example of a Gentile saying that there is a Jewish art, and for saying so, deserving to be regarded with suspicion—one reviewer of Haftmann's history flatly accused him of anti-Semitism.

Now take the opposite view: No, there is no Jewish art. What does that mean? Shortly after the war, Jean-Paul Sartre wrote a book entitled *Anti-Semite and Jew*. In it Sartre argued vehemently against the anti-Semites, and indeed he has always been a friend of the Jews. But in attacking the notion that the Jews were a destructive force in history, Sartre maintained that, actually, the Jews had no history and existed only because anti-Semitism prevented them from disappearing. They were not themselves a nation with a feeling for a common soil, and they did not participate in the national feeling of the Germans, Frenchmen, or Russians among whom they sojourned. They were a people of big cities, also of logic and argument—in a word, intellectuals. They were identified with abstract ideas (coming from a man like Sartre, this is not necessarily insulting), and while they were capable of building mathematical and metaphysical theories, they lacked the dimension of sensibility and that continuity with physical things necessary for the creation of art.

I repeat, Sartre abhors anti-Semitism. But accept his premise of the Jewish mind with its incapacity for art and you have the raw material out of which anti-Semitism has been formed. From the image of the man limited to abstract ideas, it is but a step to that of the man dedicated to cash, since the chief abstraction in the modern world is, of course, money. The explanation of why the Jews don't have art and the conception that they are devoted to money fit together and provide a description of a kind of unlikable people.

In short, whether one says that the Jews have art (but off the beaten track) or that the Jews have no art, one tends to wind up with notions not very flattering to Jews.

As to the facts of the matter, they are not much help. In the last fifty years, Jews have become quite prominent in painting and sculpture, and if Jews produce art, it would seem that there must be Jewish art. On the other hand, it is generally agreed that there is no such thing as a Jewish style in art. The upshot is that while Jews produce art, they don't produce Jewish art.

Assigning national identities is a very tricky affair, and final conclusions as to them ought to be delayed as long as possible. For example, most of us believe that there is such a thing as a Jew (and Sartre should be praised for taking a positive stand on this). Yet many people have tried to get rid of the anti-Semitic caricature by arguing that only individuals exist; that there are no qualities that can properly be attributed to Germans or Americans or Frenchmen. Thus, if one says that there was something about the Nazis that wasn't entirely produced by ideology, that there was something German in Nazism, one will be accused by liberals of race prejudice, chauvinism, bigotry. "What?" they demand. "Are you going to hold a whole people responsible?" Similarly, many people deny the reality of Jewishness. They say, for instance, that there is no such thing as looking like a Jew; everyone knows, they say, that there are people who look like Jews who are not Jews. Very well. But if there are non-Jews who look like Jews, there must be such a thing as looking like a Jew. And if there is such a thing as looking like a Jew, does it not follow that the art Jews produce must also have a look of its own—that this art must look like Jewish art? In that case, there is a Jewish style—for in art the look is the thing.

The same problem exists with regard to American art. I have been attacked in Europe for saying that there is an American art. American art, according to some critics, is simply a development of European art. American painting in the past twenty

years has been Surrealist, Expressionist, Pop—it has no specifically American quality. And indeed, a young professor at the University of Pennsylvania who tried to isolate what is visually American in American painting failed dismally.

Yet in a mysterious way we know that there is such a thing as American art, though it is difficult to say precisely when it became more than a mere offshoot, and what characteristics make it American. Jewish art is in an even more ambiguous situation.

I have thought of at least six possible meanings that the term might have. First and most obviously, Jewish art might mean art produced by Jews. This is the practical definition usually applied by Jewish historical societies. The sixth annual American Jewish History Week taking place this year has been planned around the theme, "The Jew in American Art." No doubt, biographies of American artists will be examined to determine which among them were Jews, and then their accomplishments will be discussed, as well as whether or not they went to the synagogue and the possible connection, if any, between their work and Judaism. In this manner, an account of Jews in American art becomes an account of Jewish art. It is a way of establishing Jewish cultural activity in the United States without being compelled to lay claim to any particular characteristics of that activity. One looks through American history and points to the Jew in American literature, the Jew as an officer in the armed forces, the Jew as a scientist. All national minorities use this type of research as the basis for prestige campaigns designed to establish the fact that they are an asset to America and have a right to be respected. Having artists and generals proves that they are almost as good as people who have done nothing special, but do have the proper background. In sum, they present their achievements as credentials entitling them to the status of ordinary Anglo-Saxons.

The idea of Jewish achievement in American—or French or British—art might be one definition of Jewish art and perhaps not altogether an empty one. Imagine that some Jewish gentleman whose ancestors arrived in America at the time of Peter Stuyvesant moved to the South, bought slaves, became a member of North Carolina society, and then decided to paint. (Very likely, such a gentleman would have gone to the synagogue.) Would there not have been some Jewish ingredient in the portrait this Southern Jew might have painted of his neighbor? Very likely, though no one would be able to say exactly what it is; perhaps it would not be an aesthetic quality. Yet we may assume that if

this hypothetical artist had been endowed with a fair amount of talent, something of his personality would have entered into his art and to that degree it would have been Jewish art. The "Jew in American Art" thus turns out to be creating Jewish art, or at least Jewish-American art. This might have some significance. But I, for one, cannot say what that significance is.

We now come to a more serious conception of Jewish art, which is art depicting Jews or containing Jewish subject matter. In this century, a substantial body of such work has been produced. Beginning in the 1920s, an extraordinary development in art took place on the Lower East Side of New York. Under the influence of the American Ash Can School, this art (which might be called East Side realism) dedicated itself to studying the artist's environment—the prevailing idea was for the artist to paint what he saw and what he was deeply familiar with—and the environment happened to contain a multitude of Jews. Quantities of paintings and sculptures were done by Jews of old men with beards, grandmothers sitting in front of tenements on Essex Street, people going to synagogue, street ceremonies of dedicating a Torah—subjects that tended to branch out and include other Jewish themes in the artist's memory or imagination (Wailing Walls, etc.). If one were to judge by subject matter, this is as legitimately Jewish art as the painting of Christian subjects is Christian art.

But Christian art in this sense is not an aesthetically meaningful concept. Though art may be characterized by its subject matter, subject matter does not characterize it as art. Crucifixions and Annunciations have been painted on every level of skill and in every Western style from Andrea del Sarto to the Polish primitive on Second Avenue. To lump all these works together as Christian art can only create confusion as to what art is and does. As art, paintings are related to other paintings not by their subjects but by their style. Style, not subject matter or theme, will determine whether or not paintings should be considered Christian or Jewish or placed in some other category.

For example, I recall a very sensitive picture, painted, I believe, by one of the Soyers in the thirties, of the artist's parents seated at the table after a Friday night supper. The candles are beginning to melt, and the middle-aged couple are also melting into half sleep. They look as if they had eaten a good deal—a golden glow as of chicken soup permeates the picture. With the droopy, worn quality of the parents in the midst of the Sabbath haze, the scene is authentically Jewish, but the painting is

not Jewish. Aesthetically, this was a French and not a Jewish painting. As a translation of a Jewish situation into the idiom of French genre painting, it had a sensitivity all it own. But its style had no relation to that of the Jews or the Lower East Side. It stemmed from French middle-class life.

This brings me to a less disputable area of Jewish art, that with which the Jewish Museum is involved—I mean the art of Jewish ceremonial objects: silver menorahs and drinking goblets, embroidered Torah coverings, wood carvings. Over the centuries, Jewish craftsmen produced these treasures, which have served Jewish ritual purposes and displayed the symbols of Judaism. In the old days, the symbolism was most strictly regulated. To-day, many of the old crafts are being revived with sophisticated modernist variations.

In short, a Jewish handicraft exists and a handicraft tradition. This is what scholars usually accept as Jewish art. Without troubling themselves as to whether Chagall bears any relation to Modigliani through the fact of their both being Jews, the scholars give their attention to the stream of carvings, silver castings, and embroideries with a Jewish iconography and biblical references. I doubt, however, that this priestly work is art in the sense in which the word is used in the twentieth century. My own interest in it is extremely limited. And this seems to be generally the case. Otherwise, why would the Jewish Museum feel compelled to supplement its exhibition of Jewish crafts with showings of con-temporary paintings and sculptures, to stage imposing retro-spectives of Rauschenberg, Johns, and Rivers?

There is, in addition, an underground of Jewish handicraft which is largely lost, a kind of ceremonial and semiceremonial folk art of an ephemeral nature, emanating from the daily life of the Jewish communities. (M. Sartre was unaware of Jewish folk artists living on the land and in the village like any Norman peasant.) I know about this art only because my grandfather was a *shochet* and a *mohel* who was extremely skillful with tools. He used to cast for us Chanukah *dreidlach* made of lead in his own design; and out of some kind of leaden-colored pastry he modeled miniature tables, chairs, and beds which you could eat when you got through playing with them. Nobody ever thought of my grandfather as an artist; his art was cutting the throats of steers and executing his sculpture on the male babies of Brooklyn. To match him, my grandmother used to bake *chaleh* in the shape of birds with folded tails and pepper-corns for eyes. She also had terrific prestige for the thinness of her noodles and the light-

ning speed with which she chopped the rolled-up dough.

I haven't seen any home-made *dreidlach*, bird breads, and noodles like blond hairs for a long time, but I assume that Jewish men and women are still doing these things, which might be considered art—that is, if you wish to consider chopping noodles a Jewish art form.

Ceremonial and folk art lead to another possible category of Jewish art, one that we might call metaphysical Judaica. Perhaps this is the Jewish art of the future. Perhaps a genuine Jewish style will come out of Jewish philosophy. Ben Shahn has experimented with the Hebrew alphabet and has done reading in Jewish mysticism. Yaacov Agam, a well-known Israeli painter who lives in Paris, expresses a passionate interest in the subject of Jewish art. Agam's position, as I understand it from a letter and some published statements he recently sent me, is that up to now there has not been a Jewish art, but that the time has come to create one. He desires, he says, "to give plastic and artistic expression to the ancient Hebrew concept of reality, which differs in its essence from that of all other civilizations."

I shall not attempt to summarize here the reasoning which carries Agam from the uniqueness of the Hebrew conception of reality, through the Commandment against graven images, to the description of his own non-figurative paintings (he was included in the "Responsive Eye" exhibition of the Museum of Modern Art) as "more reality than abstraction." In practice, Agam is a painter of optical effects whose abstractions are closer to the paintings of Vasarely than to the Tables of the Law. Jewish metaphysics may be a way of lending an aura of difference to Agam's work, but there is nothing in that work to convince me that it stands at the dawn of a unique Hebrew conception of reality in art.

Speaking of the Second Commandment, whenever anything is said about Jewish art, someone is bound to bring up the ban against graven images in the Old Testament. There are, of course, many explanations of this anti-image complex: apart from the connection between figurative art and idol worship, the Jews were literally crushed by art while they were in Egypt, and the notion of sculpture must have induced tribal nightmares.

I have, however, my own fanciful "modernist" theory of why the Old Testament excluded carvings and paintings. It is that in a world of miracles, the fabrications of the human hand are a distraction. In the landscape of the Old Testament, anything (a garment, a slingshot, the jawbone of an ass) or anybody (a shep-

herd boy, a concubine) may start to glisten with meaning and become memorable. (One finds a trace of something similar in Whitman: instead of constructing images, he catalogues objects of the American scene, the idea being that art is anything that appears in the aura of the wonderful.) Thus, the Old Testament is filled with a peculiar kind of "art," which we have begun to appreciate in this century: Joseph's coat, Balaam's ass, the burning bush, Aaron's rod. If there were a Jewish museum with those items in it, would anyone miss madonnas? I am not suggesting that the ancient Hebrews were the inventors of Surrealism. But the idea that if you inhabit a sacred world you *find* art rather than *make* it, is clearly present in the Old Testament. When the mind of the people is loaded with magical objects and events, which unfortunately cannot be assembled physically, what is there for artists to do but make cups for ceremonial drinking and ornaments for the Torah?

Jewish art, then, may exist in the negative sense of creating objects in the mind and banning physical works of art. In this sense, the Second Commandment was the manifesto of Jewish art. In our day, an anti-art tradition has been developing, within which it could be asserted that Jewish art has always existed in not existing. At least I prefer that idea to Agam's.

Returning to the real world, I believe we are obliged to conclude that there is no Jewish art in the sense of a Jewish style in painting and sculpture. Whether there ever will be such a style is a matter of speculation—a speculation that ought to take into account the progressive fading of national styles in modern art generally.

Still, Jewish creation in art has been very vital in this century, and the important thing is that while Jewish artists have not been creating as Jews, they have not been working as non-Jews either. Their art has been the closest expression of themselves as they are, including the fact that they are Jews, each in his individual degree.

The most serious theme in Jewish life is the problem of identity. The Jew, of course, has no monopoly on this problem. But the Jewish artist has felt it in an especially deep and immediate way. It has been a tremendously passionate concern of his thought. It's not a Jewish problem; it is a situation of the twentieth century, a century of displaced persons, of people moving from one class into another, from one national context into another.

In the chaos of the twentieth century, the metaphysical theme of identity has entered into art, and most strongly since the war.

Is There a Jewish Art?

It is from this point that the activity of Jewish artists has risen to a new level. Instead of continuing in the masquerade of conforming to the model of the American painter by acquiring the mannerisms of European art, American Jewish artists, together with artists of other immigrant backgrounds—Dutchmen, Armenians, Italians, Greeks—began to assert their individual relation to art in an independent and personal way. Artists such as Rothko, Newman, Gottlieb, Nevelson, Guston, Lassaw, Rivers, Steinberg, and many others helped to inaugurate a genuine American art by creating as individuals.

This work, inspired by the will to identity, has constituted a new art by Jews which, though not a Jewish art, is a profound Jewish expression, at the same time that it is loaded with meaning for all people of this era. To be engaged with the aesthetics of self has liberated the Jew as artist by eliminating his need to ask himself whether a Jewish art exists or can exist.

1966

26 Refractions

Pictures of Jews

A thing that is photographed automatically turns into a work of art. In photos streets look like stage sets, people like actors. They have an air of having been made, or at least made ready. Even the candid shot, in which the subject is caught off guard, contains its hint of pose, almost of makeup. The world of the photo is akin to the world of the theatre.

In addition to this theatricalism of photography in general, photos of ghetto Jews often possess a quality of the more-than-natural that belongs to the subjects themselves. The Jews of Eastern Europe, and their streets, synagogues, homes, were to a

"Pictures of Jews" was originally published as a review of Roman Vishniac, *Polish Jews: A Pictorial Record*, and Raphael Abramovitch, ed., *The Vanished World*, in *Jewish Frontier*, November 1947.

great extent works of art of a special character. Their clothes tended to become costumes, their faces masks of yearning, meditation, care. The bearded scholars one sees in both these books in their round fur hats and long black coats, with *talesim* showing underneath, discoursing with graceful gestures, put one in mind of a conference of city fathers in a Roman or Elizabethan play, and the buildings behind them and the slushy gutter they are crossing seem at first sight a court painted on a drop curtain. The illuminated faces of children grouped in study resemble a detail in a religious mural.

So we are led to respond to many of these pictures as to works of art, at the expense of the reaction we would have at recognizing human beings like ourselves. To some degree this is unavoidable in photos. And, also to some degree, it is justified when we look at Jews who *are* works of art, who exist at a remove from the actual. There are Jews who seem to feel their bodies and their surroundings to be unreal, to belong to a picture into which they had fallen from the sky, props which provide a momentary place for their spirits. They seem engrossed in something else, it is by chance that they are where they are. That man selling fish is a scholar, that drayman is a finance expert poorly disguised. Neither their faces nor their clothes are functional, they represent a principle of distraction from the visible.

But the artistic treatment of the Jews and the conception of the Jews as visitors in the world can be carried too far. *Polish Jews* does carry it too far.

The key is given in A. J. Heschel's introduction, "The Inner World of the Polish Jew": "The little Jewish communities in Eastern Europe were like sacred texts opened before the eyes of God." Maybe they were; one has no way of knowing. But however they looked to God, the photographer could have found more in these communities than "sacred texts." After a quick acknowledgment of the ignorance and poverty there, Heschel deals with Jewish life in the ghetto as if it were identical with Hasidic passion and its remoulding of the world. Actually, of course, Polish Jewish life, even its inner life, was in no sense synonymous with Hasidism. Besides, Hasidism itself had its contradictions; above all, it had its *history*—if it did bring "heaven to earth" it was unable to keep it there. Hence it is a distortion to talk of the life of the Polish ghettoes in terms of the highest moments of Hasidism.

In the twentieth century there was still a good deal of "heaven" among the Jews that could be photographed. But there was a

lot of unleavened earth, too—plenty. *Polish Jews* consistently
and programmatically excludes the earth and shoots for the sky.
Every picture is a picture of spirit, that is to say, of the individual
Jew as a work of art. The photos are excellent and beautifully
printed. That they are predominantly of religious types and
activities and of sure-fire "scenes" is obviously not owing to
narrow interests on the part of Vishniac; as we can tell from his
contributions to *The Vanished World,* he was also concerned
with other types and with things as such. The fault of the book
lies in the mistaken idea of whoever is responsible for the selec-
tion, that Jews should be pictured as pure spirit, embodied in
persons who are stuck in stores, tenements, and synagogues—
in brief, as only accidentally human.

I do not find that this commonplace idealism is made more
valid by the fact that the 500-year-old mother group of Judaism
has been tragically destroyed. Too artistic and too spiritual, *Polish
Jews* has in it something of the false funeral oration that conceals
the true beauties of the dead by detaching them from the body
that was once alive.

In contrast, *The Vanished World,* with its hundreds of photo-
graphs, including snapshots and old postal cards sent in by readers
of *The Jewish Daily Forward* (a sound and much more *modern*
approach than the tastefulness of the Schocken volume), is a
serious memorial to the Jewish world of East Europe that was
wiped out by the Nazis. It is huge family album, even in shape,
and its purpose is to cause the reader to know or to remember.
The editor is to be congratulated for his decision to refuse to
retouch the pictures, and for otherwise showing his love of the
object by resisting the transformations wrought by the art of the
camera. This does not mean that *The Vanished World* is without
beauty; on the contrary, the beauty is more genuine and expressive
through being less consciously sought in the medium itself.

In short, here is not the "greatness" of Israel nor the "spiritual-
ity" of Israel, but Jews. About fifty pictures of Jews at work show
the grandfathers, uncles, cousins, who ran shops, labored in small
factories, peddled, baked bread, tilled farms, cut lumber, drove
hacks. A section on children has them not only in *Cheder,* as in
the Schoken book, but in the streets selling *bagel,* in poverty-
stricken bedrooms, in summer camps, in line at a public school.
There are pictures of old wooden synagogues that remind one of
early American blockhouses. There are streets as modern as New
York; peasant fairs; young tough guys hanging around, smoking
cigarettes; a social worker executive dictating to his secretary;

unemployed; dignitaries discussing a project; the mansion of a textile magnate; a railroad viaduct. The Jews of Eastern Europe looked different from one another, spent their time differently, were surrounded by different settings—variety was probably their outstanding characteristic.

By gathering enough details of Jewish life, and by frequently allowing the camera to overcome its own artfulness (*not* composing, preserving the scraped look of old photos, over- and underexposing, missing the "right" relations of light and shadow, help maintain a sense of reality), *The Vanished World* has succeeded in achieving a visual impression of the Jews of Eastern Europe. If in the midst of the activity and variegation of their life, the luminous eyes, the contemplative smile, the dignified step, the raised finger of instruction, the open child's look on the face of the greybeard, keep reappearing as images of inner movements and harmonies—if spirit walks on the streets of the actual as a human actuality—the evidence of the creativeness of the East European Jews is not less but more than when spirituality is sought out as a Jewish quintessence.

1947

Rediscovering Judaism

During the centuries of exile, Jewish thought was born and lived in a state of siege, both physical and moral, and the gates could be opened but rarely. To remain erect in his beleaguered world, the Jew had to assume a posture of more than usual moral rigidity. Since History was his enemy, he was obliged to keep his eyes fixed at a point above events, securing himself to the eternal by the strands of the Law. Desire, the Evil Nature, had to be beaten to nothingness within his mind and his community, lest the recognition of its power should cause him to sink down in helplessness. For the universe was decisively out of balance, its entire metaphysical structure was sagging—on account of the Exile. Says the Zohar: "At the present time this door [of righteousness] remains unknown because Israel is in exile; and therefore all the doors are removed from them, so that they cannot know or commune; but when Israel will return from exile, all the supernal grades are destined to rest harmoniously on this one."

Suppressing "this world"—which was tainted by the absence of the Jews from the Land of the Fathers, an absence equivalent

"Rediscovering Judaism" is an excerpt from "The Rediscovery of Judaism," a review of Nahum N. Glatzer, ed., *In Time and Eternity: A Jewish Reader,* in *Commentary* 3, no. 3 (March 1947).

to Original Sin in contaminating the Creation—became the supreme vocation of the Jews of the Diaspora. And the instruments of this suppression had to be those inherited and tested for generations, and perpetually refined and officially safeguarded. Some notion of what this meant for thinking may be drawn from the item "Not in Heaven," quoted from the Talmud in *In Time and Eternity*. Rabbi Eliezer, disagreeing with the rest of the sages, brought "all the proof in the world" to support his argument, including, finally, a voice from heaven which declared that Eliezer was right. Yet Eliezer was overruled by the majority, and heaven with him. For since the Torah had been given on Mount Sinai, it was no longer for the divine to decide issues, but for the custodians of tradition. It is to the immortal glory of the rabbis, and a sign of their security, that he who had heaven on his side against them was not dispatched to the gallows, excommunicated, or even silenced, but that the Talmud was willing to teach that the opposition of one against all is possible, even if futile. Yet the firm moral of the story is that revelation had ceased long ago, that heaven itself could not open a new door, that the world had been left to the exegetists and commentators, and that community discipline was the highest law.

With heaven closed, tradition prevailed over originality, rationalism over revelation and intuition, salvation by good works over faith, the community over the individual, authority over freedom. It is only with the rise of Hasidism that the scholastic formula is breached.

Much as we may admire the steadfastness and moral dignity of the Jew produced by this authoritarian world-negating thought structure, we must face a fundamental question with respect to it: to what degree and on what level is it possible to be today really interested in the main body of post-Biblical Jewish ideas, with its unremitting moralizing, its image of man as a child doing good and bad deeds and being rewarded and punished for them, its overemphasis on the rights and awesomeness of parents, its teleology? "The more important a thing is for living creatures the more common and the cheaper it is. . . . This is a revelation of the mercy of God, blessed be He . . . etc., etc."

There is no doubt that the bulk of medieval literature generally is lacking in permanent meaning; and the state of intellectual affairs among the Jews of those centuries was not such as to lead them to outstrip the rest of Europe. Their own personality they had, one very fascinating when seen from certain sides, but their ideas are not *necessarily* significant to us. "It must be remem-

bered," says Dr. Glatzer, "that the ideas offered here have not lost their relevance with the passing of their time." But that these ideas are relevant is not something that can be "remembered": the relevance must be established. The fact that they were Jews is in itself not an intellectual reason why "the reader of today should enter into a living relationship with the men who speak in these documents," nor is it a guarantee that even with all the goodwill in the world the modern reader *can* enter into such a relationship with them. When typical Talmudic passages are given to us as thought (not as history), without a new perspective, the effect is frequently to revive the sense of boredom and constriction that Jews of this century invariably experienced in their early religious training. The surface of Jewish "time and eternity" since the Dispersion is for the most part the bleak steppe of a literature of conscience, of submission to precept, the father, the congregation.

Under these circumstances, the problem of our relation to the past—and such a past!—can no longer be solved in traditional Jewish fashion by declaring it a moral duty to become one with it. It would seem rather a matter of the creative discovery of what in it is *actually still alive.* In such an enterprise, an obscure phrase, an isolated insight, an unintentional stroke of fancy, is likely to show more vitality and unveil more about Jewish genius than a score of representative pages. A mind that has begun to yawn over Raba's assertion that "the final goal of wisdom is to turn to God and do good works," that has drowsed over repeated listings of the virtues, has gone to sleep over Maimonides' proof of moral design in the universe (which has no specific Jewish quality and can only represent to us a characteristic weakness of medieval speculation)—this mind, smothering in "typical" Jewish thinking, will awaken with a start when Rabbi Tarfon lets fall the observation that "It is not incumbent upon you to complete the work, but neither are you free to withdraw from it"; or at the remark of the beggar in the *Massiyoth,* "No one despairs of goodness in the world save the dead"; or the account of Reb Susia whistling to amuse God because he loved Him and wanted to do something for Him; or the Baal Shem's interpretation of "Cast me not off on the time of old age" to mean "Do not let my world grow old . . . that the world is new to us every morning—that is Your great faithfulness."

At these points, a living Jewish countenance suddenly flashes through the mesh of traditional concepts. A heroic love of the real world calls to us from behind the muffling shroud of penitence

and rectitude. It is where the concrete individual insight has risen above the pattern that we glimpse the direction in which a redis- covery of the Jewish mind and imagination is possible in the perspective of modern intellectual interest.

1947

Mystics of This World

For Hasidim to repeat tales about their rabbis was not folk rem- iniscence in the usual sense, but a way of making the teacher become present to them as an edifying influence. Their recollec- tion of, for instance, the Baal Shem and his deeds had in it an emotional elevation like that experienced by the friends of Soc- rates when they celebrated the memory of their master. Phaedo said: "To be reminded of Socrates is always the greatest delight to me, whether I speak myself or hear another speak of him."

Myth-making tends to be an essential feature of movements of thought that go beyond system building to a re-education of indi- viduals through personal communion and the exchange of living intuitions. And Hasidism—which was through and through an experimental discipline of the individual spirit, not only in what Kierkegaard called the "God-relation" but in the love between zaddik and disciple as well—produced a body of genuine legend as its most intimate and characteristic language.

Martin Buber, that rare combination of folk researcher and philosopher, has been collecting and transcribing the oral literature of Hasidism for the past forty years. His purpose has been "to express and document the association between zaddikim and Hasidism"—that is, to go behind Hasidic doctrine to the vital ties of fervor, belief, and striving which coiled through the imagina- tions of these singular philosophers of being. In a valuable in- troduction to his collection of Hasidic tales, Buber outlines the world-view of Hasidism as a religion of joy and the place in it of the zaddik or "helper"—and sketches the biographies of the leaders about whom the tales were told. One may question Buber's rather aesthetic generalization that "the underlying purpose of all great religions . . . is to beget a life of elation, of fervor." No doubt is left, however, that Hasidism was a revival of religious enthusiasm of a unique order and—despite the superstitions, magic, sectarianism, and other vices from which it was never free, and which Buber does not hesitate to list—an expansion of

"Mystics of This World" was originally published as a review of Martin Buber's *Tales of the Hasidim: The Early Masters*, in *Commentary* 3, no. 5 (May 1947).

238

consciousness stirred by, to quote Gershom G. Scholem's *Major Trends In Jewish Mysticism,* "the breath of modernity."

In what way modern? While retaining the older cabalistic metaphysics, Hasidism was primarily a training of individuals in the direction of an infinitely extended and subtilized discovery and re-creation of the self. "No other religious movement of the modern era," says Buber, "has produced so many and so varied independent personalities in so short a time." To become himself was actually the *moral* goal of the Hasid. Said Rabbi Zusya: "In the world to come they will not ask me, 'Why were you not Moses?' They will ask, 'Why were you not Zusya?'" The road to the absolute was "to choose one's own way with all his strength," and the sense of self often reached an affirmation more consonant with the most daring modern individualism than with traditional religious mentality with its fears and social measure. When the Baal Shem threatened Yehiel Mikhal with the loss of "this world and the coming world too," his disciple replied, "Even if I lose both worlds, I shall not accept what does not befit me." To which the Baal Shem responded, "My son, you have withstood temptation."

"The inner grace," the Maggid said, "is his who begins with himself and not with the Creator." Beginning with oneself was the core of the communion between the zaddik and his disciples. The disciple came to the zaddik to make himself over, not to learn "learning," and it was from the whole being of his master that he was "helped" toward his own uniqueness. "I did not go to the Maggid in order to hear Torah from him, but to see how he unlaces his felt boots and laces them up again." Suggestion and influence flowed outward from the zaddik. Yet the master could not by his effort, or by his status in the divine, alleviate the disciple's need to make his own way in the unknown.

As in other mysticisms, the self of the Hasidic adept was not the ego conceived as complete and defined, but always something still to be attained. The only existing "I" is God—"except for Him nothing is definitely there." Rabbi Aaron was in a world tradition (though inimitably Jewish in style) when he refused to open the window to his friend because he answered "I" when the rabbi asked who was knocking. "Who is it that dares to call himself 'I' as befits only God!" The tension of Hasidic life is thus expressed in the general mystical paradox that you must strive constantly to become what you already are.

But unlike other mysticisms, Hasidism did not seek Reality through self-annihilation in the Other—it is a peculiarity of Jewish

religious feeling that even in its ecstasies it rarely overleaps the space between the human being and God. The Hasid reached toward his highest possibility, not through a denial of the world, but through the world itself, through his way of appropriating concrete things and relations into his subjective experience. God needs your uniqueness—in each man something precious is hidden.

This movement toward the actual world gives the specific Hasidic meaning to the zaddik's mystical "changing the something back into nothing." It is an effort comparable to that outlined by Rilke: "Our task is so deeply and passionately to impress upon ourselves this provisional and perishable earth that its essential being will arise again 'invisibly' in us. . . . Transience everywhere plunges into a deep being. . . . *Not,* however, *in the Christian sense* (from which I more and more passionately depart); but, in an earthly, a deeply earthly, a blissfully earthly consciousness, we must introduce what is *here* seen and touched into that wider, that widest current" (italics his). Or as Rabbi Aaron put it: "This world is the lowest, and yet the loftiest of all."

A holy joy in the world as it is constituted is therefore, as Buber points out, the key to Hasidic worship. A major theme of the tales is Hasidic antagonism to both asceticism and despair. Contempt for the pride of the ascetic and his fumbling with his impulses is epitomized with extraordinary subtlety and good humor in the tale of the "Seer" of Lublin entitled "Patchwork." Despair is worse than sin, and one has the duty to guard against it—the Evil Urge is not so much concerned with plunging a man into sin as "into despondency by way of his sinning." Hasidism turns away from emotional repression as from the anguish and formless lusts that result from repression. Its ideal is the continual shaping and freeing of desire into ecstasy, which is the means of "lifting up" the world, of "releasing the sparks" in things. Here again one may be reminded of Rilke's "continual conversions of the beloved visible and tangible into the invisible vibration and animation of our nature, which introduces new frequencies into the vibration-spheres of the universe . . . preparing new substances, metals, nebulae and stars."

Hence the heroes of Hasidism are almost never self-denying anchorites, but rather radiating centers of heightened human qualities, to whom even humor, commonly shunned by inspirational figures, is by no means alien. ("Don't worry. You have not gotten high enough for the Evil Urge to pursue you. For the time being, you are still pursuing it.") One is tempted to speculate that the ancient Jewish condemnation of celibacy, as violating

the commandment to be fruitful and multiply, has had something to do with checking the Jewish saint from seeking his perfection beyond the borders of the human. For this positive doctrinal attitude toward sex confronts him with a most crucial practical and metaphysical challenge, and turns him back to the world at precisely that point in his passion when he might be tempted to depart permanently into the dark night of the soul. The *married* saint is almost sure to develop, like Socrates, qualities of humanism and irony. And these were by no means the least of the gifts that enabled the zaddikim to overcome in original ways what Professor Scholem calls "the paradox of solitude and communion"; and to demonstrate, through creating an interdependent relation with others, that the individual ego does not have to sacrifice its subjective development in order to avoid becoming indifferent or hostile to society.

<div align="right">1947</div>

Man as Anti-Semite

Ben Hecht, a Jew born "in the ghetto of New York," who became a reporter, a romantic novelist, and a sophisticated Hollywood scenarist, comes out of his corner swinging against anti-Semites everywhere and in all times. Like many American Jews, Hecht only became conscious of himself as a Jew when the anti-Semites went to work; he is one of their many contributions to Jewish self-awareness. Hecht doesn't know much about Jewish history— not more than most other Americans know about American history. Nor does history seem very important to him in his fight against the killers of Jews. What counts for Hecht is to assert himself personally against the enemy, an enemy whom he regards as a stupid, cowardly sadist impelled by one desire: to kill and to get away with it.

To "guide the bedevilled," Hecht tells the story of his life as a Jew in America, meanwhile throwing punches at anti-Semites of many types—from Voltaire and Belloc to the watery-eyed, fat-necked German degenerate who operates the machine guns, gas chambers, and lime kilns that have done to death three million Jews in Europe. In a prose that hooks, feints, jabs, and shows off like a top-flight lightweight going to work on a heavyweight bum, Hecht counterattacks the anti-Semite as a depraved subman who disgraces the human race. The general effect of the book is tonic,

"Man as Anti-Semite," originally entitled "The Possessed," was published as a review of Ben Hecht, *A Guide for the Bedevilled,* in *Contemporary Jewish Record,* vol. 1 (1944).

and it will actually guide the bedevilled to the extent that it tones him up to battle without self-questioning or despair against those who are out for his blood.

Too many writers on "the Jewish problem" have developed the habit of treating anti-Semitism as if it were a cultural, historical, or political *theory*, which, while it might contain certain errors and lead to certain misfortunes, has arisen because of the peculiar character, attitudes, and traditions of the Jew himself. No, says Hecht—and this "no" cannot be too firmly and loudly stated—anti-Semitism is not a theory, not a "point of view": it is murder and the work of murderers. "What I write must sound, to a degree, unbelievable, even to Jews. Jews have seldom been able to believe that they are killed by murderers. They have imagined usually that philosophies were killing them, bigotries, arguments, greeds, and political plots. To those who look on at the extermination of Jews from non-Jewish sidelines, the theory that Jews are being killed by murderers is even more untenable." Of course, a murderer may act out of bigotry or greed or politics and still be a murderer. But Hecht is most acute in stressing the fact that should be obvious and yet is not: that regardless of who he is or what his instigation was, the violent anti-Semite is a murderer who wants to kill Jews. His arguments have nothing to do with a search for truth—they are the handle of his knife.

If you want to understand anti-Semites, you should analyze the anti-Semites, not the Jews. Those who ask: What is it *about the Jews* that causes people to hate and attack them?—these questioners have already decided that the Jews are responsible for anti-Semitism, that the victim is guilty of the crime. Such individuals, thinks Hecht, are anti-Semites, even when they are not aware of it, even when they feel that they are being "objective" so that they may get to "the root of the matter" and thus help defend the Jews.

In my opinion, Hecht is correct in deriding the good intentions of such people. The study of anti-Semitism is not an objective science. The investigator needs moral outrage and indignation in order to approach his data intelligently—just as he who studies arson or mayhem must study it as an act condemned by human values and not just as the "objective" activity of burning down houses or gouging out eyes.

But Hecht is neither a correct nor a good guide to the bedevilled when he tries to look behind the thing that is anti-Semitism to its causes, or when he attempts to describe the characteristics that identify the Jew among the peoples of the world. In Hecht's

view, anti-Semitism is simply a spontaneous outcropping of the stupid killer instinct of humanity, likely to show up in anyone because man himself is stupid, backward, and striated with murderous impulses. The Germans, thinks Hecht, kill Jews in the twentieth century because they have "slid back" a little farther than the rest into the hereditary sadistic senselessness of man—a senselessness relieved only by rare and superior individuals who are responsible for all creative achievement. The Germans, according to Hecht's guide, suffer from "under-development of ego," and are therefore all Jew-killers and abominations. But even the Germans would not be dangerous were it not for the more general, intrinsic, and indestructible rage of the human mind against reason and light. "I understand that anti-Semitism is not part of history at all. It is part of man—a version of an old appetite that has found new delicacies. When I look at this seeming human [the German] at his desk, I know that there were no Dark Ages. There was only Dark Man. And he is still with us."

Hecht presents a little scenario to illustrate his point of the stupidity of humanity in the face of the superior mental type. The fable is dedicated to the French misanthrope Céline, author of *Journey to the End of the Night.* (I wonder if Hecht knows his later writings, murderously anti-Semitic.)

If the "objective" analyst of anti-Semitism is like the policeman who solves the crime by arresting the corpse, Hecht himself, in his irrelevant indictment of "human nature," is like the one who solves the murder by locking up everybody in the neighborhood. Since *man* seems to Hecht to account for anti-Semitism, and since *the German* as a psychological type accounts for the murder of the European Jews today, Hecht has little to say in particular about Hitler, the Nazis, or the political and economic uses of anti-Semitism.

In line with this thinking about man and the German, Hecht also attempts to identify *the Jew* as a psychological type. The Jew is the great egotist—"The violent God of the Jews was the violent ego of the Jew"—practically identical with genius. Hecht's Jew is a likeable gypsy—heroic, detached, fantastic, talented, and bemused. But of course this Jew is as much a caricature as the unpleasant image that forms the imaginative background of anti-Semitism. In playing off the Jew against the German and against man, Hecht is yielding to primitive mental processes not unfamiliar in Hollywood.

This matter of caricature brings us to a necessary distinction

between those human traits which make anti-Semitism possible and those factors which actually cause it. The urge toward simplified and exaggerated images is the age-old creator of demigods and dark angels, and it is in respect to this urge toward caricature that anti-Semitism may be said to originate in "human nature." Caricature has cost the Jews much—more perhaps than it has cost the Quaker or the Negro or any other persecuted group. For two thousand years Western civilization has drawn a persistently grotesque image of the Jew and has thus always been psychologically prepared for anti-Semitism. Vicious caricature is a perfect instrument for the instigation of massacres and for justifying them after the fact.

But evil dreams are not the same as hating and killing living people. And it is the latter that constitutes the crime of anti-Semitism. Anti-Semitism is not just an image but an intent of the will, and actual pogroms against Jews have for the most part been deliberately instigated—very often by individuals who were not at all misled by the popular Punch and Judy. The most crushing and malignant anti-Semitism is not based on instinct at all, though the readiness for crime is there. It is a planned "solution" of problems with which the Jew, as he is or appears to his neighbors, may be totally unconnected. The question as to the exact degree to which these deliberate "theoretical" anti-Semites are responsible for crimes against Jews has still to be measured. But the example of Russia gives a very strong hint: under the Czars, "spontaneous" massacres at frequent intervals—after the Revolution, no massacres. Hecht would have to say that "human nature" changed in Russia within the space of one year. But the fact is that the opening of the archives of the Okhranna showed that the stimulation of Jewish pogroms was a settled technique of provocation and suppression perfected by the Czar's secret police for use against the Russian people. The "Protocols of the Elders of Zion," which so deeply influenced Nazi anti-Semitism, also emanated from this Czarist factory for producing the "murder instinct."

This does not mean that the drunken peasant egged on by official provocateurs was not a murderer. But, as they say in the movies: Catch the higher-ups. Whatever else it has been, anti-Semitism, from Nero to Hitler, has been an instrument of conspiracy forged behind closed doors.

Hecht, whose social ideas are based on the *la bohème* artist-versus-the-mediocre-mass formula, avoids the historical detective work involved in tracking down the true criminals. He gets more satisfaction out of beating the German *Golem* with a Nietzschean

bladder and kicking man in the shins for being what he is. This may satisfy the bedevilled emotionally, but it does not suggest a strategy for putting an end to his bedevilment.

1944

The "Jew" in Literature

"The Jew" in literature is a mask. He is created for play, like other personifications. Before such figures—also simple and definite, so plainly what things are said to be, rather than what they are—the mind lets go and the spectator enjoys easy loves and hates. Heartless, money-loving, vengeful Jew; crafty, treacherous, poison-dealing Florentine; bland, witty Chinese—having closed the investigation regarding actual persons, the cliché raises the curtain and starts the music.

From the Elizabethan cliché of Jewish unfeeling and cupidity, Shakespeare created the dramatic image of Shylock *in order to give pleasure.* The pleasure communicates itself to me when I see or read *The Merchant.* The villainies of Shylock have never interfered with it. Shylock is not my brother, but brother to those other Shakespearean pigstickers, Iago, Claudius, Macbeth. One is labeled Jew, the others Italian, Dane, Scot. But all are made of the same material, like those dolls in native costume one sees in shop windows. They are made of the pleasurable papier mâché of poetry, not of the human clay of contempt and violence. So Jews enjoy Shylock, Italians the "Machiavellian" Iago, and no doubt the "deaf and dumb Danes," as Joyce called them, appreciate Hamlet and his uncle.

Shylock is not a nightmare figure with a knife. Shylock is an actor, and his knife is rubber. To his famous question, "Hath not a Jew eyes," etc., the theater gives a double response. One: the Jew is a man like others, he has eyes, and if you prick him he bleeds. Two: this altogether offensive Jew is not a man but an actor, his eyes are painted, his hooked nose is made of putty, and if you prick him the pin folds up. *While watching the play,* everybody experiences this double and contradictory recognition. If, instead, a fear of being murdered by "the Jew" were evoked, it would be time to ring for the ambulance.

Moving from the cliché to the theatrical personification, art does no harm. What does the harm is the movement in the opposite direction, from the personification to the cliché. This

"The 'Jew' in Literature," written in response to Leslie Fiedler's "The Jewish Writer and the English Literary Tradition," was originally published in *Commentary* 8, no. 7 (July 1949).

second movement is made by the propagandist and the sociological critic. With these, the personifications made by artists for pleasure become descriptions of "reality."

An illustration is Leslie Fiedler, though of course he means no harm. He starts with Shylock and ends with "the Jew with the Knife" as an "archetype inhabiting the collective unconscious of the English-speaking people." He begins with art and ends with a cliché (of psychoanalysis) conceived as a reality. I see less danger in a thousand performances of *The Merchant of Venice,* than in this interpretation.

A more complete illustration is Fiedler's nineteenth-century German critic who "returns from a performance full of anti-Semitic fire to jot down the terrible words of Luther, which he felt confirmed by Shylock." This is supposed to prove how dangerous *The Merchant* is. Now, first, the German is a critic; second, he has "returned" from the performance, i.e. he is engaged in after-thoughts; third, the personification "confirmed" a passion he already had. A layman, *in* the theater, would have experienced the double response of art and would not have regarded this particular semi-comic "Jew" as evidence condemning an entire people.

But our fellow is a professional opinion-shaper of the kind that uses art to support programs of action, and who translates art into reality. So *The Merchant* confirms his belief that the Jew is the devil. Hearing "Kill him, he's a poet," in *Julius Caesar,* this same critic might insist that the good of the state demands the extermination of artists, as demonstrated by such great minds as Plato and Shakespeare.

I "confront the presence of the Jew" in literature as a series of particular instances, each with its own artistic quality and intellectual seriousness. Why should I resent Eliot's poem for its Jewish landlord repulsive to the aristocrat who lost his property? Alas, says Eliot, in the modern world there is no entailed real estate, no integrated culture, no "roots," no high ritual, nothing but capitalism, Jews, and progress, tsk, tsk. I take this music as I do that of a Hungarian string trio in a restaurant with atmosphere (the very restaurant of "Rachel *née* Rabinovich"). So aristocratic, dancers in genuine ermine. What if the waiter is a White Guardist and an ex-pogromchick? Another chilled vodka, please!

It is quite a different thing when Eliot puts down his harmonica, mistakes himself for the dispossessed Prince Romanoff, and proposes communities with NO JEWS signs on them. Here we face the fact that there is no cultural tradition that does not contain an

enormous amount of stupidity, to say nothing of dope-taking, sexual infirmity, and actual madness. Is this "an important block to full participation and integration"? It depends on what you mean. To the academician, participation means being on the side of all who contribute to literature. A sailor, however, who picks up a beer bottle and starts swinging it in a free-for-all is also participating and integrating. The presence in "the Anglo-American tradition" of the customary quota of fools and angry men bars no one from full involvement in it in the latter sense.

In sum, "the Jew" is not a literary problem. He is a social problem related to the use of literature as a weapon. The question is not one of excluding any image from literature, but of fighting anti-Semitism—including that of literary men who offer this miserableness as a sociology to their fellow citizens.

1949

27 Letter to a Jewish Theologian

"Tell me where all lost years are."
—John Donne

My dear Herberg:

Your confession of faith in the ability of Judaism to go beyond Marxism in solving the problems of the twentieth century reminds me of the contention advanced several years ago by an American poet that our country's social and economic problems could be solved not by political programs, plans, institutions (he referred to these contemptuously as "concentrating on the means"), but

Originally published under the title "Pledged to the Marvelous" in *Commentary* 3, no. 2 (February 1947), this essay was written in response to Will Herberg's "From Marxism to Judaism" (*Commentary*, January 1947).

by poetry (which alone could supply the "ends" of social effort)! The point is that this exorbitant "challenge of poetry" came in 1938, when American verse had long since fallen from the heights of the Imagist movement, had already lost even the "revolutionary" excitement of the 1930s, and had plunged into hopeless academic eclecticism. Thus the claim that poetry could solve the problems of society simply underlined the fact that it could no longer solve its own problems.

I am afraid your claims for Judaism reflect the presence of a similar demoralization. The present atmosphere of despair among Jews is not inconsistent with pretensions toward an exaggerated world role, accompanied by the suggestion that such is the grandeur of Israel's "message" that the Jews must be willing to suffer for its sake "persecution, humiliation, agonies of pain and death," as you put it. But to look to Judaism for things that are not in it can only result in increased uneasiness and a heightening of the "martyred apostle" feeling.

Naturally, no one would object to your finding in Judaism a personal "basis and support" for your socialist ideals. Apparently, one may derive such support from any doctrine or emotion. The Surrealists, for instance, saw a drive toward socialism in the subconscious; Silone found it in Catholicism and later in apostolic mysticism. What is objectionable is that you present the values of democracy and socialism as the fundamental *interest* of Jewish history and thinking. Here lies the main danger of distortion, wish-fulfillment, and despair which we must analyze.

You say that you "felt intensely the need for a religion that would better [than Marxism] square with my ideal, which in tenor and spirit could give impulse and direction to the radical reconstruction of society which I so deeply desired." For this "impulse and direction" you finally turned to Judaism, and you now demand that Judaism equip itself theologically to provide a "philosophy and dynamic" for socialism.

This gesture of yours seems to me to raise the whole question of the relation between secular goals, like socialism, and the values of religion. For in turning to Judaism, you also ask Judaism to turn to you. Hence we must inquire whether it is desirable for religion to lend support to historical values, aims acquired through secular experience. The issue is of particular importance today, when so many people, disillusioned both with existing political institutions and with scientific and rationalistic programs for changing them, lay their hopes for a better life at the doors of religion, and when (to change the metaphor) so many churches

and synagogues have hitched up their skirts in order to dance to the tempo of events. Let us keep in mind that religion today is often only a special kind of inexact rhetoric in which to compose Sunday editorials on strikes or the United Nations; while in other instances it has become an added instrument for coercion by the state.

To be sure, the aims to which you are asking Judaism to give itself are very noble ones. There is no comparison between them and, for instance, the values which Hitler commanded the Church to support in Germany, or those other values now being supported by Russian Orthodoxy. Yet, whether the values are good values, like those of democratic socialism, or bad values, like race supremacy or the all-powerful state, the same principle applies as soon as religion coordinates itself with a set of goals coming to it *from the outside*. Then, instead of a theology, we get a typical modern "rationalization" by which a particular religion achieves its "true meaning" through becoming a device of secular politics.

You mention neo-Catholicism and Barth and Niebuhr. No doubt you have in mind a neo-Judaism that will compare favorably with their doctrines. But a distinction must be made between the position of the neo-Christians and your position. For they assert that they found their values in their creeds; while you confess that you had your present values *long before you came to Judaism*. Once, you say, Marxism was your "religion" on the same basis. Thus you present nakedly the issue of placing a religion in the service of secular ideals. Maritain did not turn to Catholicism because he believed in democracy and felt that secular democratic movement were inadequate. He began by embracing the Church's view of the world, and there he encountered a political theory of a very special kind which he calls democracy and supports as a form of Catholic virtue. You, however, do not even pretend that you obtained your present concept of democracy from religion. You merely argue that "essential Judaism" has the same values that you have, and you make an effort to find them there. But, apparently, Judaism does not have them in a sufficiently decisive manner, for you call for a new theology.

Since you had your present ideals before you came to Judaism, what you are doing amounts to saying to the Jewish religion: See here, make me up a theology that will fit these specifications of freedom, justice, and brotherhood. You are actually giving directions to the neo-Judaism which is supposed to give "impulse and direction" to your radicalism.

Wouldn't Jewish theology therefore be justified in replying:

Brother Herberg, I should like to fill your order and, as you put it, "provide the groundwork" for what you already believe in. But, you know, theology is a system of ideas based on a study of God and revelation. Theology doesn't set out to solve social problems; if it does solve them, it is only by the way, because of the nature of God and what has been revealed. If the Jews are devoted to righteousness, it is not because of a philosophy of justice in general but because of the Covenant with God the Father and what he said to Moses on Sinai. I mean, you cannot anticipate the values of a theology or that they will "square with" the needs of modern life. In fact, theology is true to itself only in so far as it looks *backwards*. It must keep fixed on the revelation that has already taken place.

Can't you make it look forward? you ask respectfully.

At your request, theology goes on, I am about to embark on a fresh study of Hebrew scriptures. But I warn you, I don't know what will happen. The revelations to Abraham and Moses *may* favor democracy when we get to the bottom of them again, but then they may not favor it. What if they should call for a monarchy or a priestly oligarchy as the most virtuous form of the state? You wouldn't accept that, would you? And justice—what if the old iron symmetry of an eye for an eye refused to be shaken by our modern dialectics? I don't say it *will* refuse, but just suppose it did? That would let you down, just as Marxism did. Then take God—especially our "God of the living"; you say he is "holy and transcendent." That may well prove to be so in our new theology, but we'll have to go a little further into his attributes before we can be sure. Suppose his old jealousy is still there? What if he still looks down his nose at the *goyim*? You know, a transcendent God is free to do as he likes; he's not tied down to natural law like an immanent God. Maybe you don't really want a transcendent God. Perhaps something Spinozistic would be better. And then, progress—

But let us interrupt this long-winded objection of theology—and theology is, of course, always long-winded, and you might spend the rest of your life merely listening to it and have no time left for politics at all—this objection to your plans for a new Judaism that will support what you say "came to me as a revelation in my perplexities." Religion, it would seem, means submission; it means a readiness to give up what one brings from the outside; yes, even if necessary such grand things as justice, freedom, and democracy. Unless you are ready to give up your former self and its values and to adopt the specific views of

Judaism, you have not come to a religion but are asking for a metaphysics of liberal socialism. Or you are asking to be the founder of a new religion—a neo-Judaism that will concentrate on what was revealed to you instead of on the revelation to Moses.

Let us assume, however, that you are ready to accept Judaism for what is actually in it. Do you thereby move closer to a solution of the problems of the modern world? Are the basic assumptions, feelings, and ways of looking at earth and heaven which have been peculiar to Jews throughout history favorable to, or even relevant to, the work of building a good future society? Are universals like justice, democracy, the free individual, the fundamental interest of Jewish religion?

It seems to me that Judaism displays the following persisting characteristics which are antagonistic to your social thesis and which create values of a quite different order:

1. When Judaism looks forward, it sees a repetition on the plane of perfection of what once was in Israel—it does not see a "radical reconstruction of society."

A celebrated teacher of recent years, Chufaits Chaim, daily instructed his disciples who were *Kohanim* in the sacrifices of the Temple at Jerusalem, so that in case the Messiah arrived that day, no time would be lost in resuming the ancient rituals. Chufaits Chaim was an *ethical* teacher; his ethics, however, were welded to the Jewish religion in that they revolved about the redemption of Israel that was bound to take place. Let us analyze what this means.

If Judaism as a way of life is to give you what you seek, its image of salvation must be consistent with your socialist hopes. For though each religion contains general ideas of God, man, justice, it is in its peculiar conception of salvation that we see the kind of world the believer wants. Now what is Jewish salvation? I am happy that you reject the notion of those modern rabbis who regard salvation either as an improvement of personality or as progressive social activity. You are right, of course, to be suspicious. Religious salvation, whether among Jews or non-Jews, is nothing so sane and useful. Salvation is never anything less than the coming into being, for the individual or for a group, of a world that is *perfect*. When you are saved, you enter some sort of Paradise, a Kingdom of Heaven; in Paradise you don't need an integrated personality, and your sole activity is praising God.

Instead of a better world through human action, Judaism, like other religions, anticipates a perfect world through an act of

God. The believer is not the source of the good, as in democratic undertakings—he can but prepare (among Jews through righteousness, charity, etc.) for the coming of God's good. Religion, in short, does not look to the future for an improvement of the present world *but as the possibility of a miracle.* Instead of the constant emergence of the new out of the old seen by historians, religious insight envisions the manifestation of the marvelous "which was and will be."

Which was and will be! The flesh and blood of every faith is the expected happening *again* of a particular event that will bring salvation—for example, the repeated death and resurrection of the god in paganism. It is by the event that it wishes to see repeated that a religion is identified and marked off from all other religions and from mere philosophies (which may comprise everything to be found in a religion except the hope of an event by which the believer will be redeemed).

Now the event that will save Israel is the resumption of the reign of God's Anointed One in Jerusalem. This conception of salvation was already present in Judaism before the destruction of the Temple; since the oldest days Judaism has looked to a repetition of God's direct rule over Israel as in the time of Moses. The peculiarity of the Jewish religion thus lies in this fact: that its salvation depends upon the recurrence of a historical and political event rather than upon the incarnation of a God or some symbolic or transcendental happening. It is a divine wonder, but it is not one that brings the world to an end. The Jew's "perfect world," his paradise, can only exist in Palestine. Israel's miracle, prayed for daily, is the repetition of the folk past in the future, the physical return to Eretz Yisrael, the rebuilding of Jerusalem as an "everlasting building" and the reestablishment of the Throne and the Temple. The return to Palestine is the Jew's religious "mystery," equivalent to the reappearance of the god in paganism or Christianity.

Hence one is not a Jew because he cries out for righteousness, nor because he believes in one God—men everywhere have done that. One is a Jew in desiring above all to repeat what happened "to him" centuries ago and in believing literally (and who else is so literal about the marvelous?) that this repetition is inevitable. A Jew will live to see the Sea divide, the Mountain burn, the manna fall, David reign, the Temple rise. That we are here dealing with genuine religious repetition and not mere nostalgia—as, say, an Englishman's yearning for the days of Elizabeth—is proven by the rage of the congregations against the early Zionists for

proposing a return to Palestine by secular means, that is, a return that would not be a true miraculous repetition.

You must make a choice: either you have not really "found your way" to Judaism, or your personal desires have become identical with this ancient passion of the Jews for self-repetition, in which case your generalized interest in the future of the world has been drowned in the concrete image of the Jewish home-coming. For to be a Jew means, as Thomas Mann divined, to take one's place on the track of an ever-widening series of concentric circles of return: Abraham returning to Canaan, Jacob to Isaac, Joseph to Jacob, Moses to the Promised Land... the captivity of Babylon to Jerusalem's ruins... the Dispersion of Europe to twentieth-century Palestine.

2. The religious Jew totally identifies his personal being with the history and future of the Jews as a group—in thus renouncing his metaphysical "openness," the Jew is not a "free individual" in the modern sense.

Jewish prayers and rituals repeatedly initiate the individual Jew into the collective biography and passion for the return. The Seder, for instance, is through and through a rite of identification and "remembering forward" to Zion. If I assert at the Seder: "Every man must regard himself as if he personally came out of Egypt"; if I repeat the account of the Exodus; if I recite the lesson of the son who is the wicked one because he separates himself by asking: "What is this to *you*?"; if I conclude with, "Next year in Jerusalem"—what am I doing but making the story of Israel my own personal story and the salvation of the Jews my salvation? The Jew's religion consists precisely in extending his individual identity backwards into the real past and forward into endless time. Every Jew is three thousand years old. From the first "begats," through the struggles against pagan "abomina-tions," to the "Jewish-problem" writings of the present day, the question of retaining identity has been the foremost question among Jews, and freeing himself from the collective "I" has always been presented to the individual Jew as the ultimate horror.

3. Since, as an individual, the Jew is completely defined by the group identity, he stands removed from the mystery of trans-figuration; the finite aim of his religion makes it utterly foreign to Christianity, as it was to paganism.

Unlike the pagan or the Christian, the Jew cannot be saved by a subjective or symbolic event which obliterates the individual's past identity, resurrects him in the spirit, and makes him one

with his god. This is perhaps the most vital single factor in the formation of the Jew's character and of his attitude toward the world. The Jew cares nothing for the processes of dying to oneself and being reborn outside the human; his rituals contain no aids for extricating the self from the trap of existence. Having asserted his historical identity as the son of Abraham, Isaac, and Jacob, the Jew can discover no new condition through transcendence. To be removed into Pure Being from the specific concerns of living Jews, past and present, is inconceivable to him. On the contrary—instead of wiping out his past, the Jew's religion stretches it backwards to the beginning of the world; instead of raising him to the Eternal, it loads him with Time; instead of baptizing him in the Spirit, it identifies him as a Jew. The Jew remains with himself endlessly as a finite individual Jew—in the Christian sense one may well question whether there is such a thing as a Jewish "religion"—and demands to be saved by the restoration of his own past in the real world. As Sören Kierkegaard, the great modern analyst of Christianity, observed admiringly: "That's the difficulty of it, that one has both the Old and New Testament; for the Old Testament has entirely different categories. For what would the New Testament say to a faith which thinks it should get things quite to its liking in the world, in the temporal, instead of letting this go and grasping the eternal?"

Isn't the true meaning of Judaism to be found in this categorical difference between Judaism and Christianity rather than in your notion of their "spiritual kinship"?

4. The physical realization of Abraham's Covenant with God by which the Jew will be saved (as he is, as Shmuel ben Yankel, not through being transfigured) depends on a special relation to the deity—Judaism is the opposite of "universal."

Judaism is the religion of a family—the sons of Abraham. The unfailing physical presence of the restored world of the Fathers to which Jews for thousands of years would awaken next morning in perfect happiness—in the stone cities of Egypt, in the desert, in Babylon, in the alleys of Rome, the holes of Orchard Street—is not a gift of universal monotheism. So that you may actually be given the land flowing with milk and honey, God must be your father, you must please him as a son, and he must have a father's interest in your material welfare. No one but the Jews have God in the family in this way. As Guignebert states in his *Jesus*: "It is precisely this sense of sonship which is characteristic of Israel's relation to God, and which distinguishes them as a people from all other nations."

5. Since the Jew stakes his existence on the recurrence of the past, he has pledged himself to the impossible—it is fruitless to see in Judaism a system of rational values.

The Jew triumphs in the absurd, which is the language of desire and faith. In an essay, "Grace After Bread," Professor Baumgardt points to the audacity of Jewish feeling in regarding Eretz Yisrael as the provider of bread for all Jews to this day, and observes: "Seen in purely rational terms, this is the most absurd nonsense." Judaism is not rational, Herberg, as your values are, not even as rational as Christianity. For the subjectivity of Christianity quickly carries it beyond the realm of external measure, but a Jew risks his redemption and his entire being on the repetition of a historical situation, and for two thousand years he could be proven to be mistaken by material fact.

Of course, the Jew is conscious that the past cannot be repeated. But this consciousness is worthless to him, for he is utterly convinced that it will be repeated. And because something that cannot happen will happen, the Jew constantly dances on the brink of a miracle. If this expectation, perhaps subconscious, of the miracle has not since childhood undermined your practical estimation of the world, you have escaped the Jewish vertigo. The imminence of the miracle ("Tomorrow everything will be different") must have filtered like a dye through the tissue of your personality (as in Sholom Aleichem's Jews) and translated itself into all sorts of passionate absurdities.

Regardless of his personal beliefs, the individual Jew inherits the passion for the wonderful, perhaps "to the third generation." Take, for instance, the tendency of modern non-religious Jews to join movements for a better world. Aren't they impelled by their fathers' sense of the nearness of a perfect world on this earth? Jewish radicalism seems actually a case of mistaken identity brought about through reasoning—for the impossible, but existing, Jewish dreamworld, the radicals substitute a political utopia less outrageous to the mind. In this unconscious transference of Jewish craving from its original object to a more universal one, Judaism may have some connection with socialism. But a craving that has lost its way is not a social doctrine.

"When the Lord returns the captivity of Zion, we shall be as dreamers." Because the impossible has happened, and yet it was expected, it was bound to happen, through the power of desire, exactly as in a dream. Is it an exaggeration to say that in their dream of Zion, Jews have been forever in the state of poets, of lovers, of whoever is obsessed by a unique image which has become the absolute sign, equivalent, and definition of his deepest

self? The Jews take on universal meaning through the madness of the concrete, through their absolute faithfulness to the demands of desire.

6. In his refusal to accept from life less than full satisfaction in the face of all obstacles, in the absoluteness of his will to return to his childhood, the Jew comes to represent the pathos of human existence.

Marx observed that man tries to meet every new historical situation, regardless of its demands, by evoking forms, out of the past. Only the Jew, however, has dared to make this rebirth of his past the conscious formula of his fate and to enact its drama on the stage of civilization. Convinced of his homecoming according to a pattern which is eternal, the Jew plunges deeper and deeper into the wilderness of the world, never losing the instinctive assurance ("faith" is too weak a word) that he will be gathered with his brothers on the road to Canaan. Like Homer's Odysseus, the Jew long ago discovered the bittersweet wine of human joy—to struggle forward to the halls of yesterday. And if this ever-present yesterday is the least attainable of goals, therein, too, the drive to reach it represents the human condition. As Kafka noted in his diary: "Moses failed to reach Canaan not because his life was too short, but because it was a human life."

The tragic irony of the Jew's position is that he wars against time from the inside of time. Nor, in a sense, does he fail to triumph. The most reverend Jew is beset by childhood, like puppies pulling at his black caftan, the childhood of his people repeated in him as his personal future. When he was thirteen years of age, he was old enough to be bowed under the Burden, but sixty years later he is still to be transformed by the coming of the Messiah into the youthful Jacob or Joseph, as they were before their brothers drove them forth—can the idea of the Brotherhood of Man mean anything else than the healing of the family?—or as when *they* returned and renewed their childhood in the blessing.

7. The Jew suffers because, having solved the problem of his identity, he must remain infinitely faithful to himself—he does not suffer in order to carry out some "mission" to save the world.

As we have seen, the Jew, committed to a historical identity, cannot cease to be himself by being transfigured into higher being. The Jew must repeat the plot of his existence or become—nothing. The Jew knows that should he forget Zion, not only will his right arm "lose its cunning," but his whole being will be estranged.

Yet the Jew, like Hamlet, is tempted by nothingness and for-

getfulness, since his identification as a Jew is the source of all his misery. Thus, he constantly raises the question of existence in his own mind and in that of others: "Why should the Jew exist?"

Reason attempts to reply with demands that the Jews disappear, or with notions of a "mission" or "message of Israel" that would justify Jewish misery. But while to raise the question of existence seriously is a mark of tragic feeling, to answer the question is proof that one has not understood it. The Jew suffers under the pressure of events because he has no escape from being. He helps the enemy by making it easy to identify him. The Jew's misery is the price of being someone; it does not arise because "Israel was chosen for a mission and for suffering"; there is no transcendental "reason" for it; it is not a matter of function, of being a messenger of high ideals. The suffering of the Jew is a quality of the kind of life that insists on being nothing but itself. Judaism is altogether a matter of remaining unique, rather than, as you say, of having "insights" that can be "viewed in the light of the development they have undergone in Christian doctrine." (Incidentally, if, as you say, the Jews suffer because of the "universalism" of their message, and the Christians have gone beyond the Jews in universalism, as they undoubtedly have, shouldn't the Christians suffer more than the Jews?)

In every generation the Jews reiterate what was known to the Greek tragic poets: that to remain inflexibly true to oneself is to be exposed to all the ruses of events. Yet once the roots of a human identity have been revealed, there is no turning aside.

In sum, my dear Herberg, I do not believe you will find in "essential Judaism" a "philosophy and dynamic" for your ideals of universal justice, freedom, and socialism. Judaism is not in competition with Marxism; no philosophy can match the powers of distortion of a great religion. If you turn to the Jewish tradition it must be for other things—self-recognition, a sense of the weight of existence, of childhood and the marvelous, of love for Abraham or David, of a landscape of the mind in which every object is charged with meaning like a symbolist poem—above all, for a sense of the dread of daring to be subjective in the real world. Jewish passion illuminates the inescapable particularity and concreteness of existence. It is hopelessly at odds with the neutral arrangements of good sense, but one may see in it some of the wonderful gifts of unreason by which great peoples and classes give life to what truly concerns them.

1947

28 Jewish Identity in a Free Society

What have I in common with Jews? I have hardly anything in common with myself.

—Franz Kafka

Few of us are duplicates of our grandfathers, in either thought, feeling, speech, or appearance. Very often we even differ from our fathers, too, in most of these respects. We are, to a large extent, new people—as everything in America, and in many other parts of the world, tends, for better or worse, to be new.

To be new means to lack a given identity, to be, in the deepest sense, anonymous. We can "make a name for ourselves." But

The text of this essay is based on a lecture delivered to a club of Jewish graduate students in engineering at Columbia University. It was first published in *Commentary* 9, no. 6 (June 1950).

until we have done so we are "nobody," atoms of that feature-less mass which certain journalists condescendingly term "the little people." Quite a different matter from being born labeled with the name of a ready-made entity, like the ancient family or the aristocrat's estate.

Our anonymity has gone so far that it often seems complete. Thus certain contemporary philosophers have boldly asserted that man *is* not but *makes* himself. And to the degree that modern man begins without a given identity, it is true that he becomes somebody only through the acts by which he projects himself into the future. Whatever he is to be, will be the result of his self-creation or his choice—whether he defines himself as something unique through original activity or in terms of the collective self of some group or tradition to which he elects to adhere. One might say that in our time man has a *naturalized* ego; it is not native to him; he has acquired it as an immigrant acquires citizenship in the country of his choice.

In this ability to choose who we shall be, we possess a kind of freedom never known before. Not only have we the freedom to decide and to act; by making the very self who is to decide for us, we replace nature and tradition and, like the First Maker, create a man in the image we desire.

If this new, modern anonymity, and the freedom that accompanies it, were actually brought to fulfillment, all fixed differences in people would be dissolved. There would be no Jews, no Frenchmen, no Catholics, except insofar as individuals elected to make themselves Jews, Frenchmen, or Catholics. Even racial identifications, such as kinky hair or a long nose, would be eliminated as an insufferable obstacle to free decision. Humanity would appear as a raw material, physical and mental—from which individuals would be constantly fabricating selves according to their tastes. A fantasy? Perhaps. But the curl of the hair and dimensions of the nose already offer no insuperable problem to our power over nature and our will to make ourselves what we wish to be. As for national and religious colorations, more than one has during the past century in America ebbed into a common gray.

Yet, though full anonymity may be man's ultimate fate, we have not yet arrived at it—and perhaps, despite apparent trends, we never shall. It may even be that, for all the difficulty (and the "absurdity") of being something we have not chosen, we do not want to arrive at it. Not everyone would, like Bernard in André Gide's *The Counterfeiters*, react with enthusiasm to the discovery that he is illegitimate, hence born with a clean slate.

But even those who do want a clean slate usually find that some particular form has been rather heavily, if not ineradicably, engraved upon them. Be it preferred or not, we are not altogether Nobody. Nevertheless, we are not altogether Somebody either. We are anonymous enough to have to make ourselves; yet we *are,* too, and cannot make ourselves in utter freedom. Thus the problem of the *voluntary* aspect of modern identity is definitely upon us, even if we lack its solution.

As is usual with metaphysical problems, this issue of what we are and what we shall choose to be presents itself among Jews in an immediately practical, not to say painful, form. Almost every shade of Jewish opinion recognizes that being a Jew is no longer settled in any positive sense by the fact that one was born a Jew—as it was in those times and in those circumstances when being born a Jew meant being a scarcely altered copy of one's father, and through him a member of a series of replicas extending backwards into the past as far as one could imagine. Today, Jewish origin does not necessarily establish that one has anything definite in common with other Jews, past or present. There are Jews, though probably fewer than there were before the crisis of the past decade, to whom all other Jews are strangers. More important—even when Jewish parenthood does give us something in common, that something is not all there is to us, nor even, often, a very large part of us. In most of us there is an area, frequently much larger than our Jewishness, in which we go our own anonymous ways or along a common road with non-Jews. Being born a Jew does not save us from—or, if you prefer, deprive us of—the modern condition of freedom to make ourselves according to an image we choose. Jewish birth may confer an identity upon us that is quite empty of content, a mere external title applied by others. Perhaps American Jews, to the discomfiture of assimilationists, are born with less group anonymity than most other Americans. Still it must be granted that they tend to be born with at least as much anonymity as Jewishness. And this anonymity goes along with them as a constant possibility of ceasing to be Jewish to a greater or lesser degree.

The new anonymity of the human being, whether as a fact or as a possibility, puts an enormous emphasis on the act of defining oneself. To a man who feels himself to be nothing in particular, it may come to seem highly desirable, especially in those crises where the meaning of his life is put into question, to be able to say decisively and once for all, I am *this.* By assuming

himself to be a single thing, he will have overcome the porousness of modern personality. His enlistment in a given ego promises him clarity of outline and fullness of purpose. By his conscious act, provided it has committed him completely, he seems to have achieved that firm inner coherence which men of former times derived from a lifetime of largely automatic responses to tradition and code.

Is not the basic attraction in our time of orthodoxies and totalitarian philosophies, including nationalism, to be found in the relief they offer from anonymity and multiple identity? Not only do they supply to the individual a super-personal collective "I" and a role in a continuing enterprise; by assigning him his place within a whole, they eliminate in him the free man's gnawing recognition that by a new act he can change himself into something else. People freely choose to subject themselves to totalitarian disciplines in order to be something—perhaps even more, however, in order to quiet the anguish of possibility. As T. S. Eliot testified when he made himself an Anglo-Catholic: "Because I do not hope to turn again." Did he mean to reveal in the "because" that it was not so much the Church that drew him as the desire to be irrevocably fixed and no longer tempted to turn? To close the question of identity brings rest to the soul.

Isn't it the presence of the same modern impulse to be one who is one-hundred-percent-something that makes Jews so uncomfortable when they debate whether one can be both an American and a Jew? In comparison with the apparently single identification of others, being twice identified seems embarrassingly ambiguous. It is not the *fact* that counts here, the fact that there is "room" in the contemporary human being to be many things and nothing, and that being an American means being free precisely in that the American possesses that room, and can keep multiplying and transforming himself without regarding his deepest "I" as set by his nationality. What creates the embarrassment is not any actual, greater singleness among non-Jewish Americans than among Jews but the prevalent *ideology* of total choice with its exclusion of the *possibility* of being anything else.

Those who have committed themselves feel morally superior to those who remain more or less undefined. The party member feels morally superior to the fellow-traveler or liberal, the practicing Catholic to the person who is simply religious. Moral systems have grown up in the past century in which attachment to some corporate entity is the entire basis of judgment—the individual is measured not by his personal character but by the temperature

of his allegiance. In the kind of moral universe thus created, he who has not attached himself to some fixed body of value has no recognizable moral status. He is an outsider and has no right to speak concerning the situation which he shared with others.

Such a declaration of no rights for the noncommitted individual was illustrated in recent criticisms of certain Jewish writers-in-English made by the Yiddish press and various institutional leaders. It is of primary significance that, though varying in tone and aim, the criticism of these writers rested in every case on one point: that they were on the wrong side in a conflict that exists between the individual as individual and what one rabbi referred to as "the organized group." Specific works of the writers under attack were not analyzed. It seemed enough to charge that they were isolated intellectuals writing about their own thoughts and feelings as Jews and without community aspirations. From this it followed that they were detached from the Jewish mass, ignorant of its hopes and values, callous to its sentiments, and unconcerned about its future. Their "negativity" toward the group could only result, it was asserted, in dislike and contempt (stimulated by self-contempt) for Jewish character and custom. Hence these Jews who have ventured to write about themselves as Jews, but who have only chosen to make themselves into Jews to the extent that they *are* Jews, were disqualified to speak of the Jewish situation. One eminent rabbi summed up the case by pointing out that while criticism of Jewish life and tradition is always welcome, such criticism ought to be constructive criticism—but that constructive criticism could not come from the detached individual, since he is "rootless" and without commitment to "the Jewish enterprise." Needless to add, the rabbi concluded by urging a turn toward such a commitment.

Now it is undeniable that there are individual Jews, even Jews who write about their experience of Jewishness, whose tastes, sense of humor, ideas of what is important, are vastly different from those of the Yiddish-speaking mass or of any organized group of Jews in America. Such Jews may even find themselves amused or attracted by what offends other Jews. And a "cultural" separation of individuals from the mass of this magnitude is an extremely serious matter. It indicates that the collective identity has been disintegrating into its component parts, or perhaps changing into something else. Who knows under such circumstances where the decomposition will disclose itself next? Any family may suddenly discover that it is harboring a stranger.

But is the morality of commitment the best way of meeting

the crisis of disintegrating modern collective identities? If the "rootless" intellectuals are not interested in the Yiddish press and the rabbis, is it necessarily because they are defeatist and destructive people who need to be called to order? Isn't it possible that they are not interested because those other intellectuals (and, after all, the Yiddish writers and the American rabbis, however much they may pretend to be the very body of Judaism, are today only professionals representing particular points of view) are simply not interesting? The fact is that a tremendous number of young Jews cease to listen to these voices and that they separate themselves as quickly as they can from Jewish life. Experience would hardly indicate that continuing to insist that the Jewish collective "I" ought to be considered, as a matter of duty, as the basic reality of the life of the individual, will reverse this trend. On the other hand, some of those same young Jews have arrested their flight from Judaism as least long enough to read the studies written by the rootless ones, and to that extent at any rate have accepted themselves as Jews. Of course, nobody knows what value this has. But it does suggest that the morality of commitment may not be as constructive, nor the self-examination and doubts of the isolated intellectual as destructive, as might seem at first glance. At any rate, the test of programs of commitment is not to be found in the presumed low moral character of the "individualists" but in the long-range effect of these programs on the mass of American Jews.

If there were a Jewish community in the old sense, with Jewish identity established beyond question by one's membership in that community, to be anything less than a total Jew would be an individual aberration. Such, however, is plainly not the case with us, when Jewish identity is so much a matter of acts of the will and intellect. Since it is a matter of seeking one's identity within an open community, the perspective of the semioutsider also has its validity, and it might be a great loss to exclude him more than he has excluded himself. It is easy enough to tell him: You may criticize, but make sure your criticism is constructive criticism, that it contributes toward building the Jewish community. But that is begging the question, which is: given the present condition of the Jewish community, is it always known what will be constructive and what destructive?

There is the story of the Hasidic rabbi who said to another Hasid, I have more learning than you and more righteousness—how is it that so many come to you and so few to me? Said the other, Perhaps they come to me because I am surprised that they

come, and they don't come to you because you are surprised that they don't come.

If attraction to the Jewish community is absent, no amount of scholarship and righteousness will take its place. And at times attraction has come from the most unexpected sources. For instance, few Orthodox Jews of two generations ago would have expected that the ideas of the "goy" Herzl would become a center of Jewish feeling.

There is therefore much to be said for seeking the truth of our actual inner situation without attempting to judge in advance whether that truth will be constructive or destructive. To pretend that by an act of the will the crumbling of a tradition can be reversed and a direct equivalent of past relations be brought into being seems a very dubious, not to say dangerous, procedure. The loss of innocence carries with it certain consequences—it becomes necessary to look deeper in order to discover virtue. After all, the reprehensible rootlessness of the intellectuals was not brought about by them but by the historical situation in which Jewish identity is rooted. The most extreme acts of "affirmation" do not change that condition so much as reveal it. It is difficult to believe that the young Jewish religious fanatics in Israel who attack Sabbath violators and girls in shorts, and those who demand legislation designed to keep Jewish blood pure and Jewish culture intact, are moved by the ancient holiness. Today, it is not God who inspires such aggressiveness concerning sexual matters. It seems more likely that the twentieth-century Sadducees wish to treat as an absolute something which they sense to be quite relative—relative, for example, to a supra-national ecclesiastical solidarity, which, noble though it may be, is something rather different from loving the Torah. They wish the Sabbath and feminine modesty to be for them what they were for their grandfathers, and, recognizing that such is not the case, are determined to make it so by force.

In terms of my theme, those wildly traditional young Jews, too, are *modern* men who, having had to choose, have chosen to be Jews in the old style. Even those who come from older communities of Europe and the Near East are within our contemporary predicament in that their communal springs have been too disrupted by change any longer to feed them a pure unquestioned identity. They could have chosen to be something other than their fathers; in choosing to be Orthodox Jews they chose to define the Jew in terms of his religious beliefs and practices. Apart from their violence and orthodoxy, their position is similar

to that of Jews in America who see in the practice of the Jewish religion—in one form or another—the essential and exclusive content of Jewish existence. In this country the display of identity tends to be subdued. Here, most Orthodox Jews hesitate to imitate those interesting strangers one sees on the street who seem to hold that only a costume consisting of caftan, round hat, earlocks, and beard, is appropriate to Jews. But whether or not a uniform of Jewishness is adopted, Jewish religion takes on the character of a modern ideology rather than of a traditional faith, when it declares that its main purpose is to serve as the identifying sign of a descendant of Abraham. The style of the choice is less important than the fact that a conscious choice is being put into play.

By setting up a measure of who is a proper Jew and who isn't, ideologists of positive Judaism no doubt hope to bind American Jews more closely together. They risk, however, producing an exactly opposite effect. To define is to exclude. Spontaneous fidelity to tradition, or the awakening of collective passion in the manner of the prophets, also excludes, but the loss in numbers is compensated for by the increased solidarity at the core. When the East European Jew with the *payes* and round hat dismisses us American Jews with his abstraction that a Jew is one who looks and speaks thus and so, we know that our exclusion is the result of his immersion in one historic aspect of the Jewish self, and that he and others like him will remain together. Not so when Jews are wiped off the books as rootless by leaders of American congregations who thunder the word "constructive" in book reviews delivered as sermons. An ideology that has the authority neither of a lived tradition nor of supernatural command does not necessarily have any binding influence. One knows how this machinery works in contemporary politics and social life—it creates pseudo-communions which quickly disintegrate unless force is available to rivet them together. The Jew who has chosen to be a Jew and thereupon insists that other Jews conform to the image of the Jew he has created, may he not provoke other Jews, especially the youngest and the newest, to seek, in dislike or despair of being *that,* to choose not to be a Jew at all? The "constructive" moralist may, under certain conditions, drive away more than he marshals together. It would seem to be wiser—and more useful, too—to apply the principle of the Hasid: Each man is indispensable; and in the spirit of that humanism to reject the "Jewish" Jew's rejection of the others.

Against the excluding impulse of those who have chosen to

make being a Jew the central fact of their lives, I therefore support the value of the perspective of the semi-outsider who has not willed his Jewishness and is only a Jew in whatever respect and to whatever depth he finds that he *is* a Jew. Admittedly, this perspective imposes no conditions upon history. But perhaps precisely in that lies its worth. Instead of willing what the Jew shall be, the outsider may cast light on what the Jew is—including whatever indifference and ignorance of their own past is found among individuals.

And, after all, isn't it true that the Jew is something even before he has willed to be something? Something that preserves *itself*? Something that in being communicated from man to man builds its own solidarity, without appeals to duty?

The individual who seeks in himself the hidden content of his Jewishness must accept the risk of what he may find. Like all serious adventures in self-discovery, such a search is an affirmation of a faith in value and demands moral courage as well as a certain inner stability; his daring implies a sense of being secure in his worth. This the ideologist of commitment cannot comprehend. To him, exposing oneself to the research of one's confusion and negations appears as both immoral and painful. For his own part, he tries to evade the perils of discovery by formulating in advance a content for Jewishness that will by-pass or overcome his fears and doubts and guide him to psychological security. But these external values created without regard to his own inner condition or that of other Jews must be kept constantly inflated by pretended certainty and induced enthusiasm. So that at length his defense of a program in which he does not wholly believe tends to breed in him a concealed nihilism and a desperate awareness of aimlessness and ultimate defeat.

In an article in *Commentary* some years ago, I objected to the notion that Judaism was a rational ethical or social ideology and tried to point to a basic element that bound Jews together. Underneath the separation of individual Jews, I thought I discerned the form of a certain emotion—an emotion that was actually present, not one that had to be simulated or brought into being by laudable intentions. This emotion which I seemed to find in the Jewish psyche arose from the sense of living within a cycle of repetitions that time after time brought Jews to re-enact, individually and collectively, certain characteristic events of their history, such as the return to the Land of the Fathers.

With some Jews this sense of collective repetition produced a passion for the past that completely dominated their lives; in

others, of course, it was extremely faint. But even where it was faint it seemed to me to exist—indeed to be so definite a characteristic that it could even be denied or hidden, or take the form of apparently unrelated desires and hopes, and still be recognized.

Jewish feeling regarding the recurrence of the folk past in the future, assuming that it was present (for could one speak of it except as a speculation?), evidently reached beyond the Jewish religion, of which I took it to be the essence, since it appeared also among Zionists who were not religious at all, who were indeed anti-religious. At the same time, it appeared also in Jews who were not Zionists. As an emotion it was present among Orthodox Jews who had never known Zionism and among mystics who had re-interpreted Orthodoxy.

It was only such a *sentiment*, deeper than religion considered as an ideology, and deeper than political and social ideology, that could explain for me the surprising surge of identification during the recent events in Palestine among Jews who had not chosen their Jewishness and who had been content with their whole or partial anonymity or with a non-Jewish identity and who despised nationalist values.

It has been said that all that recent passion was only a reflex of the terror against the Jews of Europe. Perhaps it *was* something in the nature of a reaction to anti-Semitic violence. But suppose it be granted that the sudden turn toward Palestine did take place in response to the crisis in Europe. Ought it not be asked, why that reaction instead of some other? Just that reaction was the Jewish reaction. In his crisis, the Jew showed that Jewishness had a historical content for him by turning toward *his* history instead of toward the history or the ideas of others.

So the Jew may be identified by his history, by the presence of the Jewish past within him. He is a Jew in that his experience contains the possibility of linking itself with the collective and individual experiences of earlier Jews. Through him the dead ancestors can take their place in the present. And this occurs not through his revival of the forms which they created—their doctrines, rituals, institutions—but through his own creative acts which they inspire.

The identification of the Jew by his history will, however, also exclude too many unless it be recognized that today the past is a varying and oscillating presence, sometimes occupying a man entirely and becoming his veritable self-consciousness, sometimes diminishing to a vague sentiment or receding from his awareness altogether. For the modern individual his history is not a solid

continuous plane upon which he firmly stands but a moving mass full of holes and vacuums which may envelop and carry him forward or veer away and let him fall. The area covered by the Jewish history-mass cannot be delineated by any static concept of Judaism nor represented monopolistically by any "organized group." Does it not also comprise those who at any given moment refuse to take responsibility for themselves as Jews, as well as those who recognize themselves as Jews only under certain circumstances? The Jew whom the Jewish past has ceased to stir, whom every collective anguish or battle for salvation passes by, may tomorrow find himself in the very center of the movement toward the future. Like the reputation of the *zaddik*, a community is often built by surprise. Perhaps it is just those Jews who arrive from nowhere who will come to resemble most closely their remotest and most venerable grandfathers.

1950

Sartre's Jewish Morality Play

Eternity changes him into himself.

Mallarmé

In considering Sartre's conception of the Jew and his relation to anti-Semitism, we must not forget that his *Reflections on the Jewish Question* was written immediately after the downfall of the Nazis. It was a moment of intense confusion as to the meaning of the terrible events that had just taken place and of uncertainty as to the attitudes and groupings that would emerge in liberated France. The Occupation had enlivened the current of

This essay is a revised version of "Does the Jew Exist?: Sartre's Morality Play about Anti-Semitism," originally published in *Commentary* 7, no. 1 (January 1949).

anti-Semitism among Frenchmen of all classes. With the return of those Jews who had escaped the German hangman, everyone was most anxious that this "question" should not once more stir up hidden rancors. Thus, as Sartre tells us, in the midst of the general greeting of returned prisoners and deportees, not a word about the Jews, for fear of irritating the anti-Semites. This testimony is supported by André Spire's account, in his preface to *Bilan Juif,* of the difficulties experienced in finding a publisher in Paris by those who wished to speak of what had happened. "There has been too much hate," they were told. "Let's have a love story."

Under such circumstances, for Sartre to have challenged the anti-Semite as a menace to Frenchmen, to have called upon Gentiles to organize in a war on anti-Semitism, and to have welcomed the French Jews into the French nation was an act of generosity, feeling, courage, and good sense. With different shadings of collaborationists and supporters of the Resistance bitterly eyeing one another, no opportunist or politician calculating the advantages to be derived from attracting segments of public opinion would have *isolated* the question of anti-Semitism. Yet here was the ultimate poison of the mind from which many cocial contaminations had flowed and could still be expected to flow. The Dreyfus Affair had permanently established the role of anti-Semitism in all conspiracies against the French people. Precisely because it might have been bad politics at this instant to launch an assault against the slanderers and murderers of Jews, it was sound patriotism and a gesture of human solidarity.

So as an *act* performed in a given circumstance, Sartre's *Réflexions sur la Question Juive* ought to be enthusiastically applauded. With its three characters—the vicious leering psychopathic anti-Semite, the "inauthentic" Jew vainly trying to escape in disguise, and the "authentic" Jew proudly turning upon his tormentors—the work in its original appearance can be considered as a kind of twentieth-century morality play sent to do service at a political battle front. Anyone coming upon it was meant to be stirred to greater effort against the enemy and against the traitor in himself.

Reading Sartre's essay in America at the present moment [1949] is, however, a somewhat different matter. Not that the battle against anti-Semitism is over, of course. But Sartre's study cannot play the same part in it at this date and in this country. Hence we are not tempted to ask, "Is it useful?" rather than, "Is it true?" Although still attracted by the magnanimity of

Sartre's act, we can scrutinize dispassionately his image both of the Jew and of the anti-Semite.

For Sartre, the Jew exists. The Jewishness of the Jew is not merely, as with the democratic thinkers, a few ethnic, Religious, and physical traits added to a *man*. In dissociating himself from liberal rationalism and its abstract man, Sartre asserts the reality of the Jewish identity as a "concrete synthesis" created by history. There is, in short, THE JEW, not only men and women who happen to be Jewish. With this conclusion, "unscientific" as it may appear, it is necessary, I believe, to agree. In fact, the best passage for me in Sartre's essay is his criticism of the democratic defender of the Jew, for whom all men are essentially alike, for whom the Jew can belong to human society only to the extent that he suppresses himself as a Jew, and for whom the assertion by Jews of Jewish difference is a sign of stubbornness, backwardness, or ill will. The liberal-scientific concept of the human being, and the demands for uniformity that go with it, somehow seemed sounder while plans for a universal society were on the order of the day. Individuals were willing to lose themselves as they were for the sake of the men they might become.

The dream of eliminating all inherited differences among peoples has proven, however, to be Utopian, and not only not possible but not even desirable. Has not democratic universalism meant in practice not a society of man but the absorption of small nations and minorities into large ones, even if with full equality and freedom? Theoretically, the democrat is for the assimilation of all nations into man in general; actually, man turns out to be the American, the Englishman, the Frenchman, the Russian. As soon as concrete questions of the language, the mores, the style of the future One World are raised, the difficulties involved in universalism become visible. Sartre is justified in beginning with these difficulties, with the concrete historical "syntheses" represented by nations, peoples, cultures. The Jewish question centers on the fact of Jewish difference.

Yet Sartre's recognition of the Jewish fact does not take him beyond the democratic conception of the big nation assimilating minorities. For in the end he, too, wishes to dissolve the Jewish collective identity into its abstract particles, that is, into men made more human by ceasing to be Jews. He wants the French Jew to become a Frenchman, as the democrats do. Sartre differs from the democrats only in falling short of the idealism of their theory of man which seeks the ultimate homegeneity of human beings. Though he comes out for socialism he does not say a word

about dissolving the French identity. For Sartre it is enough that *the Jews* should be assimilated.

This exceptionalism he maintains on the grounds of the peculiar nature of the Jewish identity, that the Jews "have no history" and are but the wretched creatures of anti-Semitism. We shall take up this characterization shortly. Here let us note that Sartre offers us much less than the liberals. For it makes sense that the Jews should assimilate into *man* (though it makes sense only as a theory.) But why, especially for a Socialist, should the Jew look forward to becoming a *Frenchman*? Even if, as Sartre says, "bit by bit and by the very course of history." The Frenchman himself, from the Socialist point of view, should look forward to becoming something else, through, to use Sartre's term, "choosing himself" as a European or as a Socialist.

After all, the democrat is really not unaware that the Jews exist. He simply does not believe that they *have* to exist as Jews. He believes that by changing their situation, by creating a situation common to all men, the Jews, together with all peoples, will shed their particularities "bit by bit." Sartre, like the liberal, anticipates that with social improvement both the Jew and the anti-Semite will be eliminated, but he does not anticipate that the Frenchman will be eliminated. Thus what Sartre calls "concrete liberalism" is nothing else than liberalism that has discarded its abstract theory of man and embraced its nationalist reality, the Frenchman, the American, the Englishman, though with an ideology of good will. It leads Sartre to a nationalist Socialism in which the democratic ideal of a free, equitable, and united community is conceived as realizable within the confines of the old nation-state. But in such a socialism, at least as much as among the liberals criticized by Sartre, the Jew as Jew is felt to be an obstacle inherited from the past, and the sooner he liquidates himself into the larger "whole" the better.

It seems to Sartre that all Jews wish to disappear into the nations in which they live and would do so were they not prevented by anti-Semitism: the authentic Jew . . . is not opposed to assimilation." No doubt many Jews agree that if there were no anti-Semitism there would be no Jews. They reason as follows: Political freedom and social opportunities for the Jews have gone hand in hand with enlightenment; enlightenment has brought assimilation. The flight from Judaism has been stopped only by persecution and discrimination. Hence it is a "law" of history that the perfection of liberty and enlightenment will see the end of the Jews. If that were the case, Sartre, regardless of the validity

of his arguments, would have gotten to the heart of the matter.

The fault in this reasoning is that it links the process of assimilation with one aspect of the situation in the free Western countries during the past one hundred fifty years—their liberalism—but not with its other aspects—their racial and national prejudice. The conditions under which minorities such as the Jews have tended to merge into the cultures around them have not been those of complete freedom and equality but of partial liberty and limited equality. Even in the most liberal democracies, where the greatest opportunities for merging have been available, prejudice against "aliens" has never ceased to exist. To overcome handicaps, Poles, Irishmen, Italians, Ukrainians, and Jews have desired in various countries to lose their identifying marks. The drive to assimilation, in short, represents reaction to pressures exercised by a more powerful culture at least as much as it does to liberty and enlightenment.

Jewish assimilation of the past century belongs to transitional conditions of partial freedom and partial enlightenment. No "law" of assimilation can be deduced from this experience. We have no historical proof that in a completely free world the Jews, or any other minority, would choose to dissolve themselves. There are equal grounds to assume that in such a world every group, regional or cultural, would find no opposition between its interest in itself and its past and its interest in the rest of mankind. Just as the individual would remain interested in himself, his history, and his development and not feel forced to "assimilate" his uniqueness into a collective identity. The assimilationism of Jews in France thus provides no basis for Sartre's thesis that the Jew wants to get rid of his Jewishness.

The Jew exists, says Sartre, but he exists in a mirror. "It is the anti-Semite who creates the Jew." The entire life of the Jew, his innermost sentiment of self as well as his relations to other men, is made of the substance of the anti-Semite's glare. In himself and for himself the Jew is nothing: he is "one whom other men consider a Jew."

To establish this anti-Semitic "being" of the Jew, Sartre relies on the theory that a man "cannot be distinguished from his situation." If we look at the situation of the Jew, we see only the anti-Semite and the victim of his peculiar hatred. For the Jew today, Sartre insists, can point to no historical identity save that springing from anti-Semitism.

Let us analyze this method of defining the Jew. "If I wish to know *who* the Jew is," says Sartre, "I must first inquire into the

situation surrounding him, since he is a being in a situation"
(his italics). This could imply that human identity can be deduced
from "environment." To know a Flemish miner I would study
his work and conditions and the landscape in which he lives,
etc.; the same for a Parisian novelist. But such an approach, de-
fining human reality by external factors, would be frankly mech-
anistic, and Sartre rejects mechanism. For him the individual
and his situation "form a synthetic whole," not in the sense of
deriving the man from the situation but in that the man is a
free actor within it. To know the situation means for Sartre also
to know the "being" in it, whether one's own or another's. To
know "who the Jew is," we have been told, we have to inquire
into his situation; but to know his situation, we have to inquire
who the Jew is.

Sartre breaks out of this circle by adopting in practice the ex-
ternality which he rejects in theory, just as he adopts in practice
the conclusion of liberalism whose philosophy of man he criticizes.
His Jew, though he "makes himself" by his choices, has his being
given by his environment, defined as the immovable scrutiny of
the anti-Semite. But Sartre's externality is more limited than that
of the materialists. Besides anti-Semitism the latter would include
in the situation of the Jew various developments of modern
history: the Industrial Revolution, the breakup of the old com-
munities, the decline of church and family, the establishment of
cosmopolitan cultures. They would recognize that to the extent
that the modern Jew is the product of other men, the democrat
too has "created" him by *his* glance. Sartre refers to such factors
only as explanations for various unpleasant "Jewish traits." The
self of the Jew he defines *demoniacally* as formed by anti-Sem-
itism, which to Sartre is a free, autonomous, uncaused, disem-
bodied, and measureless spirit of evil.

If the situation is to reveal the "who" of the man in it, its
dimensions must extend to his beginnings. For instance, the situa-
tion of Oedipus at the opening of Sophocles' tragedy does not
tell us who Oedipus is. Here the situation, which includes the
present and a limited portion of the past but stops short of
Oedipus' origins, *conceals* the identity of the hero. If, following
Sartre, I were "to inquire into the situation surrounding him,"
I should learn that King Oedipus is the son of Polybus and that
he is now "choosing" with respect to the plague in Thebes. This
knowledge of the situation would cause me to be mistaken as to
Oedipus' identity, as it would prevent Oedipus from "choosing
himself." My ignorance could not be overcome until the situa-

tion, which now proves Oedipus to be another, had been changed into one that reveals the content of the moment when Oedipus came into the world. *In brief, a man is not always knowable through his situation.* The situation will form a genuine "synthetic whole" with the individual in it only when the fact *originating his identity*—that Oedipus is the son of Laius and Jocasta—becomes a visible part of it.

The situation of the Jew does not reveal who the Jew is except when it becomes a situation that discloses his link with Abraham, Moses, and David, from whom the Jewish identity sprang. Such a revealing situation has come into being during the various movements to regain the Land of the Fathers, whether by prayer or politics. In these moments—and with the Orthodox Jew the "moment" has lasted for two thousand years, since his constant prayer is a continuing act directed toward redeeming the Land—the Jew and his situation are indeed one.

Sartre fails to consider the Jew and his situation in relation to his beginnings. He splits his "being" in time and in place. "It is the Christians," he says, "who have created the Jew." The opposite is, of course, the case: the Jews created Christianity. But Sartre has cut the Jews off from their past; he even thinks it possible to speak of the Jews while "limiting my description to the Jews in France." If, nevertheless, the Jew's historical feet still protrude from under the blanket of the situation with which Sartre has "surrounded" him, Sartre has misunderstood fundamentally the problem of identity. It is surely not enough simply to state that the Jews of the Exile are in a different predicament from those who "at a remote time in the past [possessed] a religious and historical community that was called Israel." The position of King Oedipus of Thebes differed in the most extreme degree from that of the infant exposed on the mountain—yet he was the same individual. To show that the origin of the Jew lies not in Abraham but in the anti-Semite, Sartre would have to indicate *at what point* the Jew of former times ceased to exist and a different Jew was born out of anti-Semitism. It was not when they were driven out by the Romans, for Sartre himself asserts that the Christian created the Jew "by putting a stop to his assimilation"—in other words, that the Jew remained a Jew even in the Diaspora.

Thus Sartre's argument that the Jews of the Exile are disconnected from the Jews of antiquity rests entirely on external considerations; they no longer live in the same place, perform the same rites, possess the same institutions. But the continuity of the

modern Jew with the Jews of the Old Testament is established
by those acts that arise from his sense of cohesion with his ul-
timate beginnings, in which his future is contained as possible
destiny—the acts of turning toward the promised Land in his
crises. These acts, not deducible from his surroundings, *make* the
Jew's situation and reveal who the Jew is.

Having mistaken the Jew's identity, Sartre cannot comprehend
his history, his creative accomplishments, his possibilities. Meas-
uring the Jews by general standards of ethnic uniformity, sovereign-
ty, and church-going, he finds that the Jews are not a people or
a race (or that all members of this "race" have "a hooked nose,
protruding ears, thick lips"), not a nation, not a religion. From
this he concludes that "the sole tie that binds them is the hostility
and disdain of the societies that surround them." The Jews, says
Sartre, "have no history. . . . Twenty centuries of dispersion and
political impotence forbids its [the Jewish community's] having
a *historic past*" (his italics).

What is the conception of history that excludes the Jews from
possessing a historic past? Sartre refers to Hegel's idea that "a
community is historical to the degree that it remembers its past."
Obviously, *remembering* is not something that can be "forbidden"
by "dispersion and political impotence." What can be forbidden
is that this remembered past should be "historical" in the nation-
alist sense of civil rebellions and wars. That this is precisely
what Sartre means by a historic past becomes plain when he adds
to Hegel's dictum, "the Jewish community is the least historical
of all, for it keeps a memory of nothing but a long martyrdom,
that is, of a long passivity." The Jews, of course, remember many
things besides martyrdom, and even in that relation they may
recall not passivity but resistance; for instance, the dialectical
battles of the rabbis against the overwhelming power of the
medieval Church. But they were not able to resort to arms. On
this score alone can Sartre deny them a history.

Only if warfare is the essence of the historical is the memory
of the Jew during the past two thousand years without historical
quality. Is not this period of exile, with its hopes, coherent with
earlier exiles, previous redemptions? The entire story of the
Jew—*including the movements toward assimilation that form
part of it from the beginning*—has an inner meaning and a struct-
ure that would seem to make it history *par excellence*. To such an
extent is the Jew identified by the story he remembers, that
political and social institutions, linguistic and semantic character-
istics, even religious beliefs and practices appear superficial as

compared to the common autobiography: these may change; through the uniqueness of his tale, the Jew remains himself. In fact, history is the burden under which the Jew all but breaks.

The *common story* of the Jews and not "the hostility and disdain" of others is the principle of their togetherness. That each member of a group has the same story to tell, which is the story of all as well as the story of the teller, is the basis of collective identities, whether it be the story of the miraculous founding of a cult or of the exploitation and struggles of trade union members. This story alive in the individual may not make itself manifest in his behavior except in peculiar circumstances, perhaps even to his surprise, for no man acts "historically" all the time. The Jews have shown that without being a race, a nation, or a religion, it is possible for people to remain linked together in a net of memory and expectation.

It is because of his presumed lack of history that the French Jew is to become a good Frenchman. "We have only to welcome him without reserve; our history will be his history, or at least his son's." The motive is no doubt laudable. But to say that the Jew has no history in comparison with the French *worker*—for to Sartre only a socialist France will absorb the Jews—is to create a nationalist confusion with respect to the history of both the Jews and of France.

Each community has a common story, beginning in an event—a revolution, a conquest, a miracle, the founding of a city—which gave birth to its identity, creating it, so to speak, out of nothingness. The Jews differ from other peoples, both ancient and modern, in that every Jew, regardless of class or even of blood origin, is included equally in the entire common account. Whether he begins with himself as a French Jew, an American, a Pole, a Turk, or as worker, scholar, or millionaire, the Jew who extends his story backwards in time reaches the same substance of events converging into the Old Testament and its lucid geography of his childhood. The survival of the Jews may well be attributable to this "democratic" participation in the Jewish past which appears in the earliest Biblical situations and which was immeasurably strengthened by the prophets. The peasants and the urban proletariat of Greece and Rome were not, and could not remain, the vessels of ancient Greek or Roman history, which was created above them and to their exclusion by aristocrats, intellectuals, and heroes. With the decline of their elites, those historic identities, classical Greece and Rome, disappeared. Each Jew, however, possessing from the first the equal status of a member of a

clan, could call himself by the primary name of Son of Abraham and preserve the whole in his single existence. In this respect the history of the Jews resembles that of a religion, in which all believers have the same status, more than it does the history of nations. The vision that sees the Jews as "a nation of priests and a holy people" stresses this totality equivalent to the religious. Yet Jewish history is the history of a people, not of a cult, since the participation is not metaphysical but in an actual past.

It is likely that there are Jews in France who feel that they have no history, except a history of persecution. But if such sentiments exist among Jews, they give no support to Sartre's "no-history" thesis, since he is attempting to derive his definition of the Jew not from what the Jews feel about themselves but from their situation. Besides, not all Jews even in post-Vichy France regard Jewish history as a prison sentence that is not yet over. The various contributors to *Bilan Juif*, referred to above, are witnesses that very lively and positive conceptions of the Jewish past exist in France today.

Jewish history belongs to all Jews; most Frenchmen possess only a portion of theirs—at least, so a Socialist should insist. This implies no advantage—perhaps the less history the better. At any rate, French history as the history of the worker goes back only to 1789. Beyond that point another France appears, in the story of which he has no part. The French worker cannot hear the story of aristocratic France, its court, its clergy, its great men, without recognizing his own anonymity in it. From the Revolution backwards he has lost his identity—he does not embody the France of feudalism. He cannot say as Roosevelt did: "Let us not forget that we are all descendants from revolutionaries and poor immigrants." The ultra-nationalist anti-Semite attempts to bridge the subjective gap between the two Frances, of before and after 1789. Even putting aside Marx's contention that "the workers have no fatherland." Sartre should be concerned as a Socialist with denying history to the French workingman or with limiting it to the France of the Revolution. Instead, it is of the French Jews that he makes the unfounded and brutal observation: "These are Frenchmen who have no part in the history of France."

To reinforce his notion that anti-Semitism provides the exclusive content of Jewishness, Sartre claims that the Jews "cannot take pride in any collective work that is specifically Jewish." If he means a national style of architecture or of painting, he is undoubtedly correct. If he means a Jewish post-office system or a Jewish army, he *was* correct. There is, of course, a fairly large

literature that is "specifically Jewish," and the world is becoming increasingly aware of Jewish philosophical and mystical thinking throughout the centuries. Sartre is either ignorant of, or indifferent to, this. I shall, therefore, mention one collective work of which he must be aware—I mean the creation of a unique type of human being, the "Jewish intellectual," who springs from the tradition of the *talmid hacham,* the lifelong student. For two thousand years the main energies of Jewish communities in various parts of the world have gone into the mass production of intellectuals. From among these have emerged several noble traditional models: the pure-minded judge, the scholarly man of affairs, the poverty-loving saint. I estimate this enterprise of the Jews to be as civilized and "historical" as the catching of herring to which the Dutch devoted themselves in their great period, or the processing of cotton by the British. True, the Jewish output of intellectuals was not a "planned" project and often resulted in surpluses. This occurs in any one-crop or one-product economy, and peanut growers or pottery makers then experience a crisis. When the Jews began to "export" their major commodity in the nineteenth century, they found themselves competing against "home products." While this is, of course, not all there is to modern anti-Semitism, the peculiarly odious form of "protectionism" which denounces Jews as "cold-blooded intellectuals" attests to "the collective work that is specifically Jewish."

The unique "culture heroes" created by Jewish communities continue to live in the imagination and memories of individual Jews. They play their part in that "mystical and prelogical feeling of kinship" among Jews which to Sartre is but a reaction to a common history of humiliation. If the Western Jew is, as Sartre claims, a "haunted man" (the term is rather melodramatic), whose life is doubled by self-disguise and self-scrutiny, it is not by the opaque eye of the anti-Semite that he has been haunted but by the sweetness and metaphysical security of his sages and by the sense of treachery and degradation that overcomes him when he decides to renounce such grandfathers.

The Jew, Sartre maintains, having no original existence, has his identity to create. He will "make" himself by his choices in his present anti-Semitic situation. The Jew can either consciously become what this situation demands that he be and, "accepting it in pride and humiliation," attain "authenticity." Or he can strive, futilely, to evade his situation and make himself "inauthentic."

In that it seems to offer us a clear choice in dealing with anti-Semitism—to stand our ground come what may, or waste our

lives in fruitless ruses of disguise and escape—Sartre's formulation has a tonic quality. The lens of the anti-Semite is permanently trained upon us; it will not allow us to be anything but Jews. We cannot dare to pretend that it is not there; we must decide how we shall behave under this scrutiny.

Were "authentic" and "inauthentic" simply different ways of confronting anti-Semitism, we could have no objection. But Sartre *is not offering a choice in action.* In fact, he feels that the Jew can do little about anti-Semitism, and in general "his situation is such that everything he does turns against him." What is left to the Jew is the choince of *being* "authentic," that is, of accepting himself as the creature of anti-Semitism and nothing else. Let this be clear—not choosing to *do* but choosing to *be.* Nor is it to be Orthodox or a Zionist or openly a Jew in any specific manner. It means ceasing voluntarily to be a man: "the authentic *Jew makes himself a Jew* in the face of all and against all" (his italics). He proudly becomes what the anti-Semite says he is, for "he knows himself and wills himself into history as a historic and damned creature." Not only does he accept the hatred and disgust of his neighbors; he makes himself what they hate and despise.

Naturally, most Jews reject this choice. Some write philosophical works like Bergson, novels like Proust, create mathematical theories like Einstein—in a word, they behave as if they were men in a world, not reflections in the glass of anti-Semitism. According to Sartre, such gestures of belonging to the human race render them "inauthentic." They amount to falsifying their natures and "being ashamed of their own kind." These Jews develop the characteristics of people who are permanently in flight from the truth and from themselves. Sartre's inauthentic Jew is a quivering, self-conscious creature, anxiously hiding his inescapable Jewishness or masochistically embracing it as degradation. This Jew is a rationalist without intuitions or spontaneity; he is tactless, acquisitive, denies his very body, etc. Sartre is careful to tell us that it is only the "inauthentic" Jew that he has thus portrayed. But it turns out that this painful and, in large part, repulsive figure is none other than *the Jew,* because very few people are authentic and those that are contribute nothing to Sartre's image, since, as he tells us, the authentic man "escapes description."

In short, on the basis of his authentic-inauthentic conception, Sartre has consciously permitted himself to accept the anti-Semite's stereotype of the Jew. His disagreement with anti-Semitism reduces itself to arguing that these Jewish traits which he

enumerates are not so bad; besides, not the Jew himself but the anti-Semite is responsible for the Jew and his character. Though about this responsibility for the Jew he is not altogether certain, since it seems to him that it was "by taking advantage of certain aspects of the conduct of inauthentic Jews that the anti-Semite has forged his general mythology of the Jew." If this is the case, the behavior of Jews, of most Jews, provides the material for the anti-Semitic caricature.

The fallacy in Sartre's notion of "authentic" and "inauthentic," which results in such profound distortions, may be traced to his erroneous conception of a "situation." "Authenticity," Sartre tells us, "consists in having a true and lucid consciousness of the situation, in assuming the responsibilities and risks involved, in accepting it in pride and humiliation, sometimes in horror and hate." Can one have a "true and lucid consciousness" of his situation? Only if "situation" is defined in terms of external relations. I can be conscious that I am an American, a Jew, a husband, a father. But to Sartre, one's self is part of the situation. Therefore, to know my situation I must know myself. I must have solved the Socratic problem. But if we Jews strove to arrive at such a consciousness of our situation and of ourselves, we should surely develop that "almost continuously reflective attitude" which for Sartre is "the first trait" of the inauthentic Jew. If like Socrates, Pascal, Hamlet, Kierkegaard, we really attempted to reach a "true and lucid consciousness" of ourselves, we should not attain to authenticity at all but merely demonstrate to Sartre that we are inauthentic Jews.

Here again Sartre, attempting to leap from instrumentalism to subjectivity, falls into an abyss. The choice between being authentic or inauthentic has to do not with any specific historical or social condition in which one may find oneself, but with one's metaphysical situation, with the fact of being alive as a unique individual. In the particular situation we cannot *choose* ourselves, since our action in it is the means by which we *discover* ourselves. Could Oedipus, while still unconscious of his origin, have chosen himself and achieved authenticity by "assuming the risks and responsibilities" of his situation as king, father, husband? The distinction between choosing to be oneself and choosing not to be oneself was made by Kierkegaard. But to Kierkegaard, both to choose to be oneself and to choose not to be oneself are *forms of despair*, not of authenticity and inauthenticity. The Jew who wills to make himself nothing-but-a-Jew (and, according to Sartre, as a Jew nothing) does not thereby become more authentic than

the Jew who wills not to be a Jew. Both have taken the way of despair, since they have willed to transform themselves from what they are, as given, into what they conceive the situation to demand them to be. They are guilty of the Sartrian fallacy of imagining that they have a total knowledge of the situation and can, therefore, like God, create the "being" in it.

There is a situation in which a man's choices appear to "make" him entirely, instead of altering what was given by his origin and his past: the concentration-camp situation. Sartre's categories of authentic and inauthentic apply to the concentration-camp victim. He has been deprived of his identity; his entire past has been wiped out; he was born again "in horror and hate" upon the closing of the gate. Starting in nothingness, he will make himself by his choices in his situation, of which he can have a "true and lucid" consciousness, since its limits and those of his existence in it are visible from moment to moment. The prisoner, the pure human Nobody, is restricted to authentic and inauthentic, an adjective without a noun.

This concentration-camp vision of beginning one's life anew within a situation imposed by others is primary in Sartre's metaphysics. It has a traumatic fixity in him; it also inspires him. I suspect it came upon him with the force of a religious conversion during the Occupation. It is *the* Sartrian situation, decorated with a "no-exit" sign, and inhabited not by "concrete syntheses" but by the watched and the watchers, the prisoners and the guards.

Sartre's Jew is a personification of the man in the camp, and it is as a concentration-camp drama that his study of the Jew hangs together. First appears the anti-Semite, murderous lord of a "total" world.[1] Even when he does not kill outright, his ultimate

1. For all his viciousness and "mediocrity," Sartre's anti-Semite is more human than his Jew. True, the anti-Semite is "inauthentic," in that instead of possessing a true consciousness of his situation, he interprets his miseries as caused by Jewish malevolence. Yet he is a man of passionate conviction and has the glamor and initiative of one who has made "a total choice of himself and the meaning of the world"— while the Jew, no matter what he does, thinks, or feels, is degraded and impotent.

Concentrating on his sentimental image of the "passionate" anti-Semite, Sartre fails to consider a type much more menacing historically: the anti-Semitic conspirator. This anti-Semite may be quite lacking in the "passion" and the world outlook of the anti-Semite in Sartre's portrait (Sartre might have called him the "authentic" anti-Semite, since he is conscious of his situation, and of the uses of anti-Semitism in it). In a given historical situation this cold manipulator of anti-Semitism may prove far more deadly than Sartre's "Manichean" and

intent is to slay. His victim, the Jew, like the concentration-camp prisoner, has no history because he has been cut off from it; he is nothing but what his guards have made of him. His life is a choice between trying to hide this fact from himself through philosophizing or dreaming or making plans like other men—or consciously confronting the situation and the existence that the camp has imposed upon him. It is peculiar to Sartre's philosophy that the latter choice means to recover one's humanity and one's "freedom" in the very degradation which he accepts. But free or not, the Jew will not alter his fate by becoming "authentic"; his situation "is such that everything he does turns against him." Nor will authenticity establish for him any connection with the "outside" world of humanity: his choice must be "in the face of all and against all." For the point is that there is no Jew on this side of the walls where human beings dwell. The sole Jewish fact is the camp of the anti-Semite. Under the circumstances, the Jew would have but one goal—to get out. He would assimilate to anything, for outside are human beings—and what imprisoned nothing does not dream of becoming *any* human being? But assimilation, escape, is not possible. First the camp has to be removed by the acts of the good men outside (all Gentiles).

Such is the image behind Sartre's *Reflections*. When Sartre says "Jew" he means someone else, the prisoner. For instance, the Jew to him, like the camp inmate, feels solidarity only with those who have suffered the same experience—no fraternity is possible with outsiders. Were he not carried away by his fantasy, could Sartre have made the following dreadful statement? "In effect the Jew is to another Jew the only man to whom he can say 'we.' " If this were true, the most destructive accusations of the anti-Semite would be justified. Unable to enter into community with non-Jews for whatever reason, the Jew would deserve to

folklorist. Robert Pick's observation (*Commentary*, September 1948) that the fatal point in the development of anti-Semitism occurs when it receives encouragement from above seems to touch the essence of the problem. The Jew is truly endangered when different forms of anti-Semitism come together and achieve the power to act. Sartre fails to take note of this turning point, since for him the Jew is always a marked man. Thus he fails to distinguish between the regime of the yellow star and the normal environment of the Jew in Western democracies. "The Nazi ordinances," he says, "only carried to its extreme a situation to which we had formerly accommodated ourselves very well." But the very life of the Jew depends on distinguishing sharply between a situation in which he will be killed if he arouses someone's hostility and one in which his enemy can only try to injure him through prejudice or disdain.

be shunned. A Jew in a trade union whose "we" was weaker than his brother's; a Jew on a baseball team; a Jew in a political party or a military squad, with his "we" restricted to the other Jews in it, would deserve to be kicked out, at least. This person without a positive historical tie to his fellow Jews would yet be fused to them in rejecting humanity—one almost detects here the leer of the Elders of Zion munching their conspiratorial matzot.

But we need not be shocked, because Sartre is not really talking about the Jew at all but about his favorite theme, the concentration-camp situation and the man in it, a man hopelessly cut off from the world and subjected to the behavior of his enemies. We see this most clearly in Sartre's discussion of Bergson. The world thinks of Bergson as a philosopher of intuition. Benda, a Jew, attacked Bergson as the demiurge of modern irrationalism and the type of the "musical Jew" who scorns rationality. But Jews, say the anti-Semites, are incapable of intuition; they are all just clever rationalists. Yes, Sartre agrees, the anti-Semites have made rationalists of the Jews. Since Bergson is a Jew his "system is a rationalism that has undergone a change of name." (Not a bad characterization of Sartre's Existentialism, by the way.) "For my part, I see it as the supreme defense of the persecuted." Spinoza and Husserl, too, are rationalists in spite of themselves. Bergson, among other inauthentic Jews, thought as he did, and what he did, because he was defending himself against a "true and lucid consciousness" of his Jewish situation. His philosophy is an inutile attempt to say "we" with all mankind when he could only really say "we" with Jews. Bergson's entire intellectual life— which Valéry hailed during the Occupation as embodying the quintessence of French thought, in contrast to the system-building of the German philosophers—this entire life is to Sartre but a symbolic activity designed to conceal from Bergson himself the impermeable fact of his Jewishness. Jews are incapable of metaphysics—"metaphysics is the special privilege of the 'Aryan' governing classes"—they can only defend themselves. At this point the Existentialist philosophy of freedom, dominated by its terrible dream, has dropped far below the deepest cellars of psychological and historical determinism. Even the most rigid Freudian sees the source of a writer's involuntary fictiveness in some private fact that may be changed through consciousness; while the most mechanical Marxist regards an individual's thought as influenced by broad movements of world history. For Sartre, Bergson is moved neither by himself nor by the world. He is locked into a middle area, the Jewish situation. And in it he is

moved absolutely, for that is what he *is*. "Whatever he does, his course is set for him. . . . He cannot choose not to be a Jew."

Here are some other characteristics of the inauthentic Jew adduced by Sartre. He is uneasy, but his uneasiness is social rather than metaphysical (in the camp, anguish comes not from God or the universe but from society). He is not a Surrealist, for he does not believe in destructiveness (destruction has chosen him as its victim). He feels himself forever surrounded by others; no Jew can "perceive the loneliness of each man in a silent universe" (in the camp one never has the chance to be alone). Let Sartre poll Paris today to see how many Frenchmen are secure, metaphysical, Surrealist, and in love with solitude. The irony is, however, that Sartre himself, precisely because the concentration camp is central to his thought, is outstandingly anxious, rationalistic, lacking in the metaphysical sense, opposed to Surrealism, and "disengaged" poetry, and conceives every situation as a purely social one. (I am not suggesting that he is secretly a Jew.)

Those "Jewish traits" collected by Sartre which are not directly deducible from the concentration-camp situation belong to the modern city man, Gentile or Jew, as he appears in the perspective of nostalgia. For instance, Sartre comments about the Jews that "they do not feel toward their bodies that tranquil sentiment of property which characterizes most 'Aryans.' For these latter the body is a fruit of French soil." One recalls what D. H. Lawrence had to say about the "tranquil" physicalness of the "Aryans." Sartre's remarks are in the tradition of twentieth-century ideologists of "aristocracy." Like them he ascribes to the Jew, regardless of class or locality, the personality of the big-city bourgeois ("he prefers this form of property [commodities] to all others . . . because it is universal") seen in contrast with the sentimentalized peasant. This identification of the Jew and the cosmopolitan plays an enormous role in modern anti-Semitism.

In sum, Sartre's inauthentic Jew is a fiction justified neither by philosophy, history, nor direct observation. Not that there are no Jews who have psychological qualities mentioned by Sartre. Jews in the United States may recognize them as typical of the assimilationist who nervously tries to "lose himself in the Christian world." And they will approve Sartre's moral enjoinder to this harassed man: Be a Jew, be yourself, whatever the cost. But in the midst of our approval let us remember that we cannot agree with Sartre (and with the assimilationist) that the Jew is nothing but anti-Semite bait. This is a distortion common to Gentile friends of the Jew. To them the Jew is one who against his will is kept

from being a "man like everybody else" by the anti-Semite, who includes every *goy* who has not made anti-anti-Semitism his vocation. But here in America, where Jews are not the only "foreigners," nor the only target of racism, it should be clear that being singled out by an enemy is not the cause of our difference from others, is not what makes us Jews.

In opposition to Sartre's compendium of Jewish nothingness, Jewish imprisonment in his situation, and Jewish traits, we may assert the following: Since the Jew possesses a unique identity which springs from his origin and his story, it is possible for him to be any kind of man—rationalist, irrationalist, heroic, cowardly, Zionist or good European—and still be a Jew. The Jew exists, but there are no Jewish traits. The Jew who chooses to flee his Jewishness does not thereby turn into something other than a man, any more than does an Italian who decides to become an American. Whatever it is, the desire to assimilate is not "inauthentic"; one may choose to suppress the past in oneself or to surpass it. Today, all collective identities, Jewish and non-Jewish, are undergoing deep changes and no longer exist in individuals as firmly and persuasively as they once did.

1949

VI
Myth and History

30 Notes on Fascism and Bohemia

"You don't have a taste, sir, for the Sublime—or the Ridiculous?"

"Perhaps," Rowe said, "I prefer human nature plain."

Graham Greene, *The Ministry of Fear*

Modern Man—An Object of Suspicion

That modern man could turn Nazi—this is the sphinx that challenges every moralist and psychologist of our day.

It is not that Nazism suddenly made one aware of the human capacity for crime. After all, this generation had been nourished from infancy on daily dispatches of murder, rape, individual and mass lynching, atrocities. New territories of man's viciousness—

Originally published in *Partisan Review* 11, no. 2 (Spring 1944).

sadism, real and symbolic—were as familiar to us as ghosts and witches to our ancestors.

Not increased familiarity with viciousness but a revelation of the viciousness of the familiar was the Nazi contribution towards making man once more an object of suspicion. That a nation, a whole society—milkmen, mothers, schoolboys, policemen— should have given itself up easily to a policy of insults, blows, and torture, seemed proof that the monster is lurking in the average and everyday. In this respect the triumph of the Nazis in Germany paralleled, on a more obvious and threatening plane, the disclosures of Dr. Freud.

Thus, at first glance, a certain reassurance seems offered in the explanation of Konrad Heiden's *Der Fuehrer* that the Nazi uprising was the revolution of a special group, "the armed bohemians." We think of "bohemians" as social outsiders, inhabiting small isolated pockets, and generally consider them to be eccentric and far from typical people. Commonly, the word designates artists and late sleepers, who live in odd neighborhoods of big cities. Heiden uses the term in a broader meaning: with him, as with Karl Marx, "bohemian" means the offscourings of all classes—gangsters or international café adventurers, as well as poets and left-wingers. Even in this broader application, however, the "bohemian" is still, to use an ugly journalistic word, a "misfit."

It would indeed be a good thing, then, if these bohemians, this gang of outlaws, self-declared aristocrats, Raskolnikovs, Dandys, free-lovers, unemployed, and poets, whom everyone has long suspected anyway, were convicted of the crime of Fascism, and humanity itself were absolved.

But to pin responsibility on this human flea market will not do, apparently. For Heiden's definition is deep as well as broad. The bohemian, he says, is an "intellectual" who has not found his place in society. And an "intellectual"? He is the "type of the pragmatical and mechanistically minded modern man, product of mass education [who isn't], whose sole criterion is: Will it work?"

According to this, the "intellectual" is practically everybody who has gone to school—the exceptions would be certain rare individuals who were educated privately and who shun the test of utility, or measure it in turn by some system of higher values.

Heiden's intellectual *is* modern man, and he is a bohemian or potential bohemian, while only the exceptions are not bohemians— for man does not have a private tutor. So the bohemian won't

do as a scapegoat after all, and humanity itself is once more under suspicion.

Heiden's image of the bohemian villain who springs out of cultural conditions bears certain resemblances to that of the alienated and divided modern personality—conceived by the sociological Freudian, Erich Fromm—who inevitably contains the dangerous "outsider" within the depths of his self.

A: It is modern man, then, that has tendencies towards Fascism?

B: Well, only under certain conditions—unemployment, social upheavals. The monster is there, of course, but—we keep to the Freudian parallel—he comes out only in black weather.

A: But the positive source of evil is still the nature of man himself, who, if his order breaks down even momentarily, reaches for the ax?

C: Through all psychological theories of man-the-Fascist runs the thread of original sin and the belief that the major function of society is to restrain the evil nature of man. Once we grant this, the whole democratic movement, the entire spirit of the French and the American revolutions, the educational crusade begun by Rousseau, the Socialist and anarchist ideals of a stateless society—all these appear as idle and fairly vulgar illusions. For they depend on the belief that man is inherently capable of leaving behind murder and slavery.

A: But Fromm in *Escape From Freedom* places the blame for the Fascist impulses on modern social institutions. Once these are corrected, the drives will disappear.

C: It's true that to Fromm modern man is twisted by the pressures of modern social relations and that he will rise into a higher life once a truly creative democratic society is achieved. Yet even Fromm seems to me to go too far in linking Fascism with the contemporary soul. For it has not been demonstrated that the Fascist state was created by man's desires, however neurotic. On the contrary, everything points to the fact that it was the result of a conspiracy and that the mass-following of the Nazis did not represent the common man in Germany. The outstanding moral fact in the history of Fascism is that Hitler, despite unenmployment, despite the paralysis of all political opposition, despite the Storm Troopers and the connivance of Reichswehr officials, despite the big money, was unable to win a majority or enough dynamic support to capture the state by force as genuine revolutions do. That Hitler could take power only

through a coalition arranged behind the scenes by the ruling groups of Germany proves that it was "society" that corrupted the people, not the people who ran amuck against social values.

A: You must admit, though, that Fromm contributes a great deal towards our understanding of why some people joined the Nazis and the others lacked the strength and the will to resist Fascism more effectively.

C: Even if Fromm does throw light on what made Fascism able to win converts and seize the state, his theory does not explain what caused Fascism. A concrete political movement does not arise from the general condition of man at any given moment—democracy, for instance, did not come into being because man suddenly became good or eager for freedom. The positive causes of Fascism are to be discovered by analyzing objective political, economic, and social relations, as well as Germany's cultural past—rather than by conceiving the image of some type of individual through psychological or metaphysical speculation.

Class Sociology or Bohemian Monster

Heiden borrows from Marx one-half an idea—or rather, the shadow of an idea. The idea is Marx's conception of the economic class structure of modern society, and the shadow is his notion that each class exudes certain elements that separate themselves from the class—for example, bankrupts from the middle class, *lumpenproletariat* from the workers. Heiden rejects the idea but preserves the shadow—he is not interested in economic classes yet tries to explain Fascism on the basis of economic classlessness!

But if the presence in society of businessmen and workers does not determine historical events, how can history be determined by the presence of *bankrupt* businessmen and *unemployed* workers? According to this view, only those who drop out of a class are effective politically.

Sociologically, as by definition, classlessness is simply a negation of class. The bohemian fights against all classes—as politician, in order to achieve power; as poet, to reach "pure" art, that is, art free of class tastes.

But power and purity are empty, and the bohemian's act derives its substance from what it opposes—the avant-garde parody of conventional art. The core of Hitler's politics was propaganda against class. All classes stood in his way. "There was one place

in Germany in which there was no class division. That was the front-line company. There no one ever heard of a bourgeois and a proletarian platoon; there was just the company and that was the end of it."

It is entirely accurate to say that the Nazi party was formed out of bohemian personnel. For instance, Leudecke, one of the early familiars of Hitler, told without a trace of self-consciousness that he became a Nazi only after it was no longer possible to get money from rich American women. But just because the Nazi movement was an uprising of the classless, its history is inseparable from the inner history of Germany's classes, their political consciousness, their economic collapse and moral apathy.

Tremendous fluctuations occurred in the Nazi movement up to the final consolidation of state power. The party of the classless was constantly being drained and refilled through rhythms in the depths of each class in Germany. The very existence of the Nazi party was dependent on these organic processes taking place outside itself. The peculiarity of Fascism as a parasitic growth lies precisely in this inability to develop from within but only through absorbing the secretions and evacuations of the whole social organism. No doubt this has something to do with Hitler's sense of identity with the German folk.

But the dependent character of Nazism places definite limits on the meaning of Hitler's own acts and ideas—many of which are eccentric and quite lacking in political significance. A good starting point for the biographer interested in the political form of Hitlerism and the essential contribution of the Führer would be Marx's comments on Louis Bonaparte: "The Society of December 10 [Bonaparte's bohemian army] belonged to him, it was *his* work, his very own idea. Whatever else he gets hold of is put into his hands by the force of circumstance; whatever else he does the circumstances do for him or he is content to copy from the deeds of others."

The facts in Heiden's book show that Hitler's sole consistent strategy was to keep his gang intact and to remain at the head of it, until power was "put into his hands." That this gift actually descended upon him is his Miracle, which he never fails to call upon in his state speeches.

Heiden fails to uncover the class sources of the life streams of the Nazi party. Conceiving classlessness as a thing in itself, as a category describing a certain modern psychological condition, Heiden traces the adventures of Hitler only against the background of surface political events, such as the French policy in

the Ruhr or the maneuverings of Hindenburg. Thus he tells us in sum that the Nazis were a strange rabble; that their policy was improvised out of a wide range of clichés and the absurd, noxious, and romantic notions of several nineteenth-century provocateurs, xenophobes, and theoretical world conquerors; that this policy was changed at will—and that through a series of accidents, brutalities, and conspiracies this Hitlerite Noah's Ark finally emptied its contents into the offices of the German state.

The blocks of generalizations concerning the nature and history of bohemianism which Heiden intersperses throughout his narrative do not indicate why classlessness was victorious in Germany.

The Genius of Der Führer

Some of Heiden's conclusions about the personality of Hitler seem inescapable, in view of the literary style of *Mein Kampf*. To understand Hitler, we must probably start with the contradiction put forward by Heiden that Hitler is a gray, colorless, empty character—"the void, it might be said, disguised as a man"— who, at the same time, secretes in certain areas of his ego an immense strength. Most likely we ought to shave off a bit from the stature which Hitler has taken on in Heiden's mind, and analyze more sharply the cultural meaning of Hitler's constant babbling about "the artist" and his habit of pronouncing the last word on every subject, from how women react in the theater to the need for superhighways. There are executives in all countries today who decide on such matters, after listening to the conflicting opinions of experts, without knowing more about them than Hitler. It may be that one of the things that gave Hitler his "nerve" was an early discovery that, with strong enough backing or forceful assertion, almost any opinion can, apparently, be put over, especially in matters of taste and theory. A mediocre artist? Silence the highbrow critics, then who will know? Perhaps it is not the "intellectuals" who are responsible for Hitler, even indirectly, but the unintellectuality, the enmity toward intellect, promoted by modern "men of affairs." After all, France, which had a larger proportion of intellectual bohemians than Germany, never yielded to the Fascist bait—and I see no reason for denying some credit for this restraint to the Left Bank sophistication as well as to the rational tradition of French culture. "Damn the intellectuals!" is a slogan not inconsistent with Fascism.

It would also be possible to go deeper than Heiden into the relation of Hitler's personal experiences to his political stresses

if one were not burdened by Heiden's pseudo-aristocratic (a synonym for bohemian?) prejudice that Hitler is "a pure fragment of the modern mass soul." Both the emptiness and the strength of Hitler are more characteristic of the visionary neurotic than of the average man, who is a class man, molded and limited by social participation, and who has not had his ego wiped out and released by ecstasy. Heiden passes too lightly over Hitler's testimony concerning his "ecstatic feeling" in the trenches, "in the night when the roaring of twenty-one-centimeter cannons suddenly began to speak and illumine the horizon with lightnings." It is worth pursuing the hypothesis that this frontline experience, which contains all the psychological conditions of conversion, fixed in Hitler's psyche the passion that changed him, once for all, into the furious Maker of Soldiers—which, in the last analysis, is both the chief content of his politics and his supreme service to the rulers of Germany.

<div align="right">1944</div>

31 On the Art of Escape

All proficient fugitives, from Odysseus to Dillinger, have possessed the following (1) physical and mental ingenuity; (2) emotional detachment and a capacity for standing outside oneself; (3) a talent for dissimulation and disguise, bordering on the power of invisibility; (4) luck. These are the classical attributes of the artist of escape.

In democratic society this art tends, like all the other arts, to become Pure. The art of evasion detaches itself, as a form of skill, from all moral and social contingencies, in the same manner as Pure Painting or Pure Poetry. In the last analysis, it is limited only by the genius of the individual fugitive. If he can combine within himself perfectly all the elements of the art, he will be

Originally published in *View* 3, no. 1 (Spring 1943).

able to free himself perpetually. The model escapist is Houdini.

The "medium" to be mastered by the artist of escape consists of the mechanical obstacles to individual freedom created by other human beings. In a democracy the construction and supervision of these obstacles are delegated to a professional body, the police. Society as a whole is aware that measures of confinement exist; but when these are challenged, society remains a spectator of the chase and rarely intervenes in it. The fugitive successfully completes his work when he has defeated the police in a professional engagement. His relations to society are, however, no more altered by this accomplishment than are, say, Stevens' when he has finished a poem.

Hence a jail-break in a democracy tests the capabilities of those who execute the law, but it neither comments on nor affects the condition of society itself.

Stories of escape usually belong therefore to minor literature and exploit the sensations of the chase or the excitement of watching the master mind at work.

In Anna Seghers' *The Seventh Cross,* a novel dealing with the escape of seven men from a Nazi concentration camp, the traditional tricks of the fugitive reappear. The hero, George, crawls through ditches, disguises himself as a workingman by carrying a piece of machinery out of a shed, joins a crowd at church, changes his clothing. These ancient devices are inevitable in a getaway, which, like other arts, derives many of its inspirations from legends, dreams, and tales heard in childhood.

But *The Seventh Cross* has an additional dimension. For the outcome of this escape is not dependent upon the relative skills of the fugitive and his professional pursuers but upon the behavior of society itself.

According to Nazi theory, an individual escape is inconceivable. "No longer does our country offer a haven for criminals," says the commander of Westhoven Concentration Camp. "Our people is healthy; it shakes off the diseased and kills the insane." The "total" ideal is that society shall ceaselessly fold over and re-absorb each of its parts, like a protozoan its food. And the pulsations of this Wholeness will prevent concealment by constantly turning out on the surface what has been absorbed within. No sooner do the fugitives from the concentration camp come into contact with the Germany outside the fence than this rhythm begins. People go out of their way to turn over clues to the authorities. . . . But movements are also started in the other direction—unless Germany contained these counter-forces to the mael-

strom of the state, George's attempt would be hopeless.

The result is that in Nazi Germany the fugitive is no longer practicing an individual art, but has become the "representative" and instigator of a social process. The escape takes on tremendous importance as a test of how much courage, resourcefulness, and desire for freedom still exist in the country.

Anna Seghers makes it clear that Odyssean talents are not enough to complete the getaway. Of the seven men who made the break, two were better fitted than George by training and temperament to reach the border. Wallau was an expert in the psychology of escape, a student of the attitudes the fugitive must be able to assume in tight places: "If you can no longer get out of people's way, you must walk straight toward them, into their very midst." "You shouldn't jump off suddenly, and try this, and then that. Pretend to be calm and secure." Yet Wallau gets caught, as does Belloni, one of the country's best acrobats, who could swing from roof to roof and who knew where to lay hands on costumes. Either of these would make a more efficient hero for the conventional escape story than the too-human George. But their skill is of no avail when the community fails them. It is George who gets away—because through a series of lucky chances he manages to hold out long enough to allow several strangers (who do not know they are going to do it) to join together on his side.

Thus a jail break in a totalitarian state turns into a social struggle, a small revolution. The Gestapo itself has ordained that it shall not be a purely professional contest—it commands each citizen to choose between becoming a policeman or a potential fugitive, an informer or an accessory. By its own will, the Gestapo makes society a party to the escape.

Through ruling out escape as an individual art, totalitarianism converts it into the social art of revolt. *The Seventh Cross* shows how the approach of the fugitive, or even the mere appearance of his picture in the newspapers, forces scores of people to go over their pasts and to make a decision that will determine the character of their entire future existence. The zigzag of the escaper's path becomes a huge scratch on the surface of towns and villages.

As with literature and painting, the totalitarian state forces the art of evasion to become involved in politics. Self-extrication proves to be a group act—and its story a drama of moral pathos, instead of a picaresque saga of skill and playacting.

1948

32 The Cold War

The cold war is a delusionary struggle between real interests. *We* affirm everyone's right to the advantages of freedom; *they,* to the advantages of socialism. Freedom and socialism being both good things, the world is in danger of being blown up out of altruism.

Why blown up? Freedom could win the world without a blow if "the West" were really fighting for it. So could socialism if that's what the Soviets were after. Would any people reject a program of using the resources of society for the free self-development of themselves and their neighbors? But what else is freedom, and what else is socialism? The joke of the cold war is that each of the rivals is aware that the other's idea would be

Previously published in *Partisan Review* 29, no. 1 (Winter 1962).

irresistible if it were actually put into practice. Whoever first demonstrates that he means what he says gets the prize. Each knows, however, that there is no danger of this happening, and is therefore not afraid to twit the other about the opportunities he is missing. "Think of where you'd be today," the West nudges Moscow, "if, instead of suppressing insurrections in East Berlin and Hungary, you opened the Iron Curtain and had workers pouring out to tell their comrades in other countries what a glorious life they are building through their ownership and control of the means of production." "Very funny," growls Echo from behind the Curtain. "And a tough time you'd be having in Latin America, Europe or Africa if your enthusiasm for individual liberty caused you to use that tremendous power and productive capacity of yours to free people from poverty and from oppression by the Trujillos, the Francos, and the French *colons*."

Yet the hostile propaganda of each side against the other is not altogether true either. It is too simple to say that the West cherishes capitalism not freedom and that the Soviets cynically mask their totalitarianism in socialist phrases. The ideals of a society, which reflect the revolution that originally brought it into being, are serious factors in the formation of events. The West wants freedom to the extent that freedom is compatible with private ownership and with profits; the Soviets want socialism to the extent that socialism is compatible with the dictatorship of the Communist bureaucracy. In both instances, the "issues" for which they fight mean something, but what they mean is modified by the presence of a concrete self-interest.

Is the modified issue a valid issue? Is the preservation of capitalist self-interest of any importance to those dedicated to the preservation of freedom? The question is not easy to answer. In fact, nobody knows to what degree the freedom we value is tied to the capitalist mode of freedom. It is a subject for analysis and experiment.

Assuming that we are, above all, devoted to freedom, we might rephrase the problem. What is the extent to which the expansion of freedom is consistent with profits (and the realization of socialism with the rule of the Communist party)? If these questions could be answered, it might be possible to develop an effective reformist politics in both the USA and the USSR. A U.S. party, whether in power or in loyal opposition, could say: We advocate going thus far with freedom, then it must be slowed to a halt in order to protect capitalist interests. The same with a Soviet party, just so far with socialism then stopped to protect

the interests of the C.P. leadership. Such a politics of pursuing stated values while maintaining the power status quo could be genuinely conservative *and peaceful*.

But conservatism of this kind has not been achieved on either side. Instead of conservatives, the U.S. has greedy, disgraceful little Birchers and sophists of privilege, to whom the history of freedom means only what it has left in their pockets; while the Soviets have Stalinists, to whom socialism *is* the interests of the party. People blind to the limits of their ideas and aware only of what they want are the opposite of conservative. Lacking a true conservatism, both sides keep insisting hypocritically on the purity of their positions and fly into frenetic reflexes when revolutions challenge their fictions.

As against conservatives seeking to save both their values and the systems that presently support them, there might be radicals whose view would be: freedom for everyone all the way and the hell with the system. Or: socialism now and out with the fat boys. Between radicals on both sides there could also be peace, since the radicals are going toward each other from opposite ends of the tunnel: revolutions in the twentieth century are for freedom *and* socialism.

The cold war is the product of people who are neither radicals nor conservatives and who therefore feel threatened by every revolutionary event, to which their own limits have contributed. Today, both East and West are run by "liberals" who would like to serve the ideal of freedom, on one side, and that of socialism, on the other. The Western liberals are for revolutions against tyranny, but when such a revolution shows its socialist outline they complain that the revolution has gotten off the track; while the Moscow anti-Stalinists are for revolutions against capital, but when the revolution shows its libertarian side they denounce it as reactionary.

"Do you think the issues at stake in the cold war so decisive as to be worth a nuclear war?" To answer "yes" to this question, one would have to have lost his mind. Among the war-willing on the "Radical Right," many themselves suspect they are mad, and out of fear of being locked up, direct part of their belligerence against state legislation to control mental illness, the National Association for Mental Health, and the World Health Organization of the U.N. The lunatics on the "Left" are not so modest; I mean those liberal professors and politicians who demonstrate their "realism" and rocklike determination by crying, Better the Bomb than—

303

Better the Bomb than slavery? Imagine enslaving 180,000,000 Americans by force of arms. Khrushchev cannot tell China what to do, cannot tell Albania what to think. But 180,000,000 Americans, born and brought up in the conviction of their uniqueness, of being as good as the next guy and no crap from anybody, are so menaced in their independence that it would be worth forty million or more corpses to protect them. What a patriotic image! What faith in one's country and its traditions!

Americans can lose their freedom only from within. I agree with Birchers: if there's a Communist menace, it's under the skin. If it's not found there, it doesn't exist. The Communists can no more deprive us of freedom (the fear of intellectuals today) than they could bring us socialism (the hope of intellectuals twenty-five years ago). They can provide a model from which Americans can learn how to deprive themselves of freedom through a collectivism which is the enemy of the individual. Our strategists of anti-Communism have been studying this model eagerly since the cold war began.

In sum, there is a Communist antagonist. But having an antagonist does not mean that you must be ready for murder and suicide. An antagonist does not threaten your being, as a menace does—your own character may even be heightened by his presence. There was a Communist antagonist in 1938, but the menace then was the Nazis. Today the menace is nuclear war. To abate this menace, a realistic politics is essential, a politics which would get rid once and for all of the fraud of freedom versus socialism and put ideals and facts on the table.

1962

33 Stopping Communism

The renewed debate over liberal anti-Communism viewed in the perspective of events in Vietnam raises the vital issue of confusing anti-Communism with "containment"—that is, with stopping Communism *geographically*.

Containment means not only checking the spread of Communism as a social theory or political movement but stopping the expansion of Communist nations. Such expansion, it is assumed, cannot be arrested by arguments or rival political organizations but only by the economic, political, and military force of anti-Communist nations. In a program of containing Communism, anti-Communist thinking becomes an aspect of national power politics.

To combine the notion of fighting an ideology with that of

Previously published under the title "Liberal Anti-Communism Revisited," in *Commentary* 44, no. 9 (September 1967).

blocking off physical terrains from certain countries results in a hybrid logic that can easily get out of control. Phantoms take on flesh. An argument and a massacre become equivalents. Minds are searched for contraband. A professor advocates a super-police regime in order to repel error. General Westmoreland stands as the outpost of the free mind. The CIA drops depth charges among American intellectuals and is defended as the spearhead of anti-Communist radicalism.

The nub of it is that containment channels the ideological conflict with Communism into the alternatives of national wars. Either we or they. "We" means those who accept the national ideology, "they" anyone who opposes it. All anti-Communists are united by force of the enemy.

This interchangeability of nation and ideology is a heritage of Bolshevism. It lay behind the logic that led to Lenin's famous World War I slogan: "The main enemy is at home." By the same logic Russia became after the October Revolution synonymous with socialism, and "defense of the USSR" synonymous with world progress.

What madness this mixing of nation and ideology can lead to is exemplified in the revival by the Trotskyites of the old "Main enemy is at home" slogan when the Red Army invaded Finland. Workers of Finland, defend the USSR, the fatherland of socialism! As a Marxist, I, a Finn, was supposed to fire at my neighbor who was firing at the Russians who were going to put me against the wall as a Fascist . . . This is what I mean by logic getting out of control.

Containment is the application of the same blending of intellectual and state aims. As a free man opposed to Communism, I am supposed to fire at people who are trying to free themselves from all kinds of tyrants who might be friends of Stennis or Nixon.

When it is a matter of your country confronting a Communist country, what does it mean to say that your anti-Communism is "Left"? Both the Communists and the Communist-containers will answer: it means nothing.

To the Communist, Left anti-Communism is simply anti-Communism that strikes from the left side, an ally of imperialism that refuses to admit its complicity. (To Mao, the Soviets are Left anti-Communists.)

To the container of Communism, on the other hand, Left anti-Communism is simply being "soft on Communism," that is, an anti-Communism that is prepared to lose.

Given the struggle for containment, both the Communist and the anti-Communist patriot are right against the Left. They have fixed it that way between them. The logic that flows from identifying a social philosophy with the national interest has been forced upon the Left by the act of the Bolsheviks in transforming socialism into an instrument of Soviet foreign policy, and by the reflex action of the United States since Truman in transforming American foreign policy into an instrument of anti-Communist ideology.

In the struggles for spheres of influence in Asia, Latin America, Africa, and the Near East, to be a Left anti-Communist can mean little more than to insist on limiting the fight against Communism to certain methods and allies, while renouncing others—for instance, to fight Communism with economic aid but not with napalm, and to help anti-Communist peasant movements but not anti-Communist dictators.

But the methods you use in a fight, and the allies you line up with, are not always for you to determine—your antagonist also has a voice in what you are compelled to do. If the whole issue is one of weapons, of tactics, Washington is justified in saying to the Left, We know more about what is effective in given situations than you do. We have tried everything else, and now it's napalm. Unless you're ready to match Communist dirty tricks, including infiltration of cultural institutions in the United States by the CIA, you're really prepared to let the Communists take over.

Washington knows that so long as containment is postulated, the government has the advantage in the argument of being able to talk in terms of relations of forces—and Washington keeps pressing this advantage. All it needs to do to silence the Left is to declare all civil wars which the CIA has been unable to control to be wars of aggression by Communist countries. Trapped in the logic of limiting the expansion of Communist areas, the Left can only respond with antagonism and frustration.

Anti-Communism of all varieties—democratic, socialist, anarchist—leads potentially to Vietnams so long as the axis of American foreign policy is blocking the spread of Communist regimes. It matters not whether the objectives of my politics are the free individual or the cooperative society; if I am determined to keep Communist powers out of new places, I may have to support actions (including the most stupid) that I have every reason to fear and condemn. My will to "contain" Communism cannot carry the precondition that there be socialists in the White House or philos-

ophers in the Pentagon, or that American banks and black marketeers not rush in behind the troops to get theirs out of the natives.

Containing Communism leads to lesser-evil politics with the *idée fixe* that, compared to Communism, *anything* is a lesser evil. An anarchist anti-Communist, for example, faced with the possibility of a Communist takeover, no matter from whom, must be prepared to embrace Pentagon belligerency.

Once it accepts the philosophy of containing Communism, the Left is on the spot: it has acknowledged dependency on the "enemy at home" to protect it against being eliminated by Communist violence. Nor does the fact that there are now several Marxist-Leninist power centers make the spot it is on any the less difficult. Each of the Communist centers is capable of spurring aggression both to win victories in non-Communist areas and to advance its position in the Communist world. Thus anti-Communism will continue to be confronted by situations in which ideology is embodied in national power and in the direct confrontation with which the concept "Left" is rendered meaningless.

So one is compelled to choose between renouncing the policy of containment and giving up Left politics. In this situation, containment must go, and a normal, non-ideological foreign policy must be restored in Washington. Such a policy is quite adequate to stop countries that may be a menace to the U.S. But containment not only tries to stop *all* countries of whose ideology it disapproves, it also sabotages American freedom and the conflict of ideas.

Getting rid of containment is necessary not because there is any virtue in Left politics as such, but because certain truths considered to be Left cannot be neglected without plunging this country and the world into disaster. Containment, on the other hand, which mixes up places and ideas, destroys all truth by the mad logic it has derived from Communism. For instance, it is a "Left" truth that the revolution of the peoples throughout the world cannot be confined within the framework of capitalism, and that the attempt so to confine it results in wars of repression. Containment cannot tolerate this truth and would rather see people killed, including Americans, than put up with it—any more than Communism can tolerate the truth that its kind of revolution is not necessary for progress and is even an obstacle to it.

I do not believe that containment is, or ever has been, a *moral* position. On the contrary, containment is an inverse extension of Communist power thinking. It presupposes the victory of a

one-world system, theirs or "ours." Morality might have led America to interfere with the suppression of the Hungarian revolution by the Red Army, but containment prevents such concrete responses. Its first step is to destroy traditional diplomacy and to conduct foreign policy on a totalitarian basis, including the manipulation of trade unions, scientific conferences, and festivals as tools of international scheming.

Could I have a moral obligation to keep Communism out of South Africa or out of Spain? Do I have to protect dictators from Communist dictation? Only if the ground of all virtue is not freedom or justice but the negative program of defeating Communism. But freedom is not a system and, as we are discovering in Vietnam, it cannot be introduced by system builders. We have trouble enough keeping it going in Alabama and Mississippi. The ex-slaveholders are sabotaging it daily, and no one has yet found it necessary to interfere with their current program of discharging the fruits of their evil throughout the length and breadth of America. The mere presence of a free country is a force for the containment of tyranny—but countries do not act against tyranny but against those who threaten the interests of their rulers. Without the presence of the U.S., the revolution of Juan Bosch could not have taken place, because long before that revolution, the Dominican Republic and all of Latin America would have been subjugated by the Spanish, the Germans, the Russians, the Chinese. But in the presence of a U.S. dedicated to containment, Bosch's revolution could not take place either, because it did not fit into our totalitarian foreign policy.

Not only is containment the opposite of moral, it is also the opposite of practical. It is being defeated at enormous cost to the U.S. just as its Communist model has been defeated again and again since Tito successfully defied Stalin. The anti-Communist strategy pursued by this country is leading not to a firm anti-Communist world but to the disintegration of American relations with all free countries comparable to the breakdown or loosening of ties between the USSR and Communist countries. The idea of setting up a world system either Communist or anti-Communist is a sick idea in which the mind substitutes its own classifications and subclassifications for the variety of human inventiveness. For this sick idea promulgated in the United States by vengeful ex-Communists, the U.S., unnerved in the face of a new world situation, has surrendered its traditional pragmatism and the values of fair play.

No state stands for freedom. It stands for itself and its spheres

of influence. The maintenance of those spheres is the function of normal diplomacy.

Containment ought to be abandoned as quickly as possible in favor of a foreign policy released from the totalitarian hypnosis and subject to determination by free conflict among the diverse interests in American society.

First of all, containment must be abandoned by the Left itself. There must be an end to thinking in terms of world systems and world anti-systems. The notion of a global politics emanating from a center and embodying a uniform concept of social and economic development is an inheritance of Leninism in its worst aspect, the aspect that led to the formation of the Third International and its control and destruction of socialist parties. It is an attempt to manage mankind, a species of *hubris,* which, whether its intention be good or bad, will by the irony of history lead to self-deceit, crime, and crack-up.

The intrusion of the CIA into American intellectual life is a manifestation of this country's crack-up through the instrumentalities of containment. It represents the demoralized conviction that no one is to be trusted and that free men opposed to Communism cannot remain free unless they are coordinated into the anti-Communist system and manipulated by anti-Communist programmers. When the CIA deceives free minds in order to contain Communism, it is actually engaged in containing freedom by segregating individuals from one another and habituating them to control. The suspicion of one another aroused among intellectuals, trade unionists, and students by the CIA exposes, by its resemblance to conditions in totalitarian countries, the nature of the threat that has grown up in this country in the epoch of containment.

1967

310

34

What's Happening to America
1967

Proletarianization is spreading. It now extends far beyond the category of factory workers. All professions detach themselves from general intellectual and human concerns and assert their autonomy. Whether as physics professor or as pole vaulter, the performer functions as part of a system that excludes him. Since the outbreak of the cold war, the vacuity of individuals and the supremacy of their métier have become the central theme of American culture. In physics or in oil painting the "responsible" practitioner is the one who comes closest to resembling the computer. The arts are being "programmed," and an empty mind has become a credential of both artists and critics.

In politics there has dawned the terrifying era of the comedian.

Previously published in *Partisan Review* 34, no. 1 (Winter 1967).

The president of the United States imprints his monogram on roads, lakes, forests, cattle, towns in order to provide confirmation of his existence and as a talisman against oblivion. He tries out his style of handshaking in the Far East, convinced that mankind is a Texan who hasn't yet made it.

The United States today is governed by professional illusionists. Not only are officials elected through campaigns of image-building based on fiction and caricature, but, once in office, their actions are decided not by anticipating consequences to the nation and/or humanity but by the kind of image those actions will enable them to present to the public. Washington acts by putting on an act. The same is true of every state capitol and city hall. With sheriffs behaving like movie actors, movie actors aspire to the highest offices.

Politics increasingly takes on the forms of mass culture, in which the picture of a thing, or the publicity about it, achieves precedence over the thing itself, since the latter is seen by very few people. This is saying nothing less than that the American public is out of its mind, lucid at moments but subject to fits of apathy and nose-thumbing. If the country doesn't collapse or blow up, it is because strings pulled from different angles behind the scene cause a temporary balancing of stresses. It has yet to be proved, however, that this balance can last for any appreciable period of time (in spots all over the country it has not lasted), or that the string pullers themselves are adequately innoculated against the mirages they release into the atmosphere.

Actually, the public wackiness is most likely an epidemic spread from the top. The French, with their genius for formulas, have two terms that go to the heart of the matter: one is the *"société anonyme,"* which means a corporation, the other is *"aliéné,"* which means a madman. Our corporation-controlled society is a society controlled anonymously by men who in their actions are alienated from themselves and respond to the ventriloquist voices of the abstract entities which they serve. They personify *sociétés anonymes,* and personifying in real life is a species of madness. One is dominated by an emblem—for example, the big yellow shell—from which issue incontrovertible commands. In their professional, that is, their active, power-laden lives, the fetishists who decide things for us are utterly mad, though privately, as individuals like ourselves, they may be very nice fellows.

Here in the U.S. our orgmen block one another. Outside America, however, they tend to see as a group. What they visualize are forces like themselves but with less power. To these person-

ifications, the notion of humanity is meaningless. Humanity is simply another abstraction, but an unorganized one—something like nature, which needs the tractor.

LBJ has *chosen* to represent the consensus of corporate personifications—political, economic, military (including the civil rights movement in so far as it is abstract). I italicize *chosen* to emphasize that his behavior is not forced upon him and that he is responsible for his actions. No one could be forced to act as Johnson has been acting. LBJ is an original creation, a self-contrived source. He could insist that all decisions include consideration of human beings. Instead he is concerned only with abstractions. He listens only to the consensus of humanly vacant personifications. For this concept of the nation he will have to answer to the future.

Returning to our politics of illusion—events are contrived out of the whole cloth in order to provide occasions for actions or statements of policy. Events are made to happen for the sake of words, instead of words being used to give an account of events. History has been turned inside out; writing it takes place in advance of its occurrence, and every statesman is an author in embryo. (We have seen the results of rule by failed painters and divinity students in Germany and Russia.) To complicate the farce, professional historians are brought in to participate in the action, and wind up by getting into fights with politician-historians as to what actually took place.

Current events may be defined as the means by which privileged authors—presidents, generals, heads of secret intelligence agencies—confirm their fictional creations by means of putting pressure on foreign governments and by invasions, bombings, etc. The philosophy taught by the modern superstate is that events are nothing but propaganda.

Naturally, this puts the government into unfair competition with novelists, playwrights, critics, who have to be convincing through words alone. Literature has the same complaint against Washington as any other business or profession whose field of activity has been encroached upon by the government's superior resources. If all lies are to be socialized, what chance has individual enterprise? To make matters worse, like all image-makers the government demands an end to criticism—it wants "constructive suggestions," in a word, assent. Those who personify abstract aims have no use for people with doubts and who are professionally dedicated to raising questions. The White House finds the intellectuals a nuisance for the same reason that the Communist

party did. The government would like them to back up its fictions, but the best it has to offer in return is: Sing, then shut up. The intellectuals are willing to sing but if they shut up they lose their identity as intellectuals. As Valéry said: "This species complains; therefore it exists." There is an impasse here. To the White House, the intellectuals are not so different from the Vietcong. If only they'd come out, fight like men, and get it over with.

The split between the administration and the American intellectuals is a split between competitors. The government started the battle by moving into literary territory. It declared war on us Indians. It wants to take us over. 'Tis the final conflict. If Washington gains complete control of the fabrication of illusions and can prevent the exposure of its bad craftsmanship, it is all up for us.

That integration became a popular idea had nothing to do with Blacks. Integration is a passion of our atomized society in which everybody feels segregated in one way or another. The nuts on the Right oppose Black integration because through this opposition they can integrate themselves with other right-wing nuts. The Blacks, held together by their color, are in the minds of the whites the last cohesive social entity (today, it's harder to say that "Jews stick together"). The white Liberal problem is how to integrate this Black entity into the general social disintegration. It can be done only by disregarding its color. Treat each Black as a separate individual. Make the Black into a social atom like the whites, each in his own sac. Since the civil rights movement cannot of itself overcome the cultural breakdown that has been a feature of American life since the beginning of the Eisenhower administration, Blacks must be, and will continue to be, of two minds about integration, and so will whites.

The activities of young people always contain "promise," by definition. The New Left, however, is barking up the wrong tree. It imagines that the Old Left was too much ridden by ideology; to avoid this trap, it sets itself against systematic social analysis. This is merely to substitute one form of futility for another. The essential question in politics is the question of power. The Old Left veiled this question by its faith in Communist clichés. It thought it was interested in the working class—actually, each Leftist was concerned with his own identity. The Communists gave their adherents a uniform and a set of ideas through which they could obtain group cohesion. Today, the same effect is achieved through blue jeans, beards, marches, electronic music. One could be anonymous as a Party member and at the same

time superior to outsiders. But uniforms and ideology are magical substitutes for thinking about the problem of political power. So are uniforms and anti-ideology.

1967

35 Politics of Illusion

In his account of the coup d'état of Louis Bonaparte, Marx introduced aesthetic categories. "All great world-historical facts and personages," he began, quoting Hegel, "occur, as it were, twice"; then he added, "the first time as tragedy, the second as farce." [1] Louis, Marx set out to demonstrate, was a caricature of Napoleon Bonaparte, and his seizure of power in December 1851 a parody of Napoleon's coup half a century earlier. To underline his theme

The text of this essay is based on a lecture delivered at the Center for the Humanities, Wesleyan University, February 1970. It was first published in Ahab Hassan, ed., *Liberations: New Essays on the Humanities in Revolution* (Middletown, Conn.: Wesleyan University Press, 1971).

1. Karl Marx, *The Eighteenth Brumaire of Louis Bonaparte*, ed. C. P. Duff (New York: International Publishers, 1964).

of historic repetition. Marx called his book *The Eighteenth Brumaire of Louis Bonaparte,* a satiric reference to the date on which, according to the new calendar of the Great French Revolution, Napoleon I concentrated political power in his hands.

The aesthetics, or dramatistics (to use Kenneth Burke's term), of Marx have not been widely discussed, except in relation to theories that consider works of art and literature to be "reflections" of social developments. In dealing with history, Marxists restrict themselves to material, social and ideological factors. In *The Eighteenth Brumaire,* however, the concepts of drama and poetic illusion are applied by Marx not to literature but to revolutionary situations. Moreover, the label *tragedy* or *farce* is applied as an absolute judgment of the events.

To deal with modern revolutions, Marx supplements his theory of the conflict of social classes with an analysis of the mechanism of deception and self-deception in politics. Unreality appears as serving a specific historical function—indeed, two contrary functions. In times of revolutionary crisis, Marx found, class conflict, the normal condition of civilized societies, is either veiled or actually arrested. Heroes come to the fore, and theater forces itself upon history. The great French Revolution took on the appearance of a classical revival. "Camille-Desmoulins, Danton, Robespierre, Saint-Just, Napoleon," said Marx, "the heroes, as well as the parties and the masses of the old French Revolution, performed the task of their time in Roman costume and with Roman phrases." This casting backward in the imagination in order to advance in reality was conceived by Marx as a law of the collective psyche in critical situations—a law that led him to consider revolutions as tragic. "The tradition of all the dead generations," he announced in a celebrated sentence, "weighs like a nightmare on the brain of the living. And just when they seem engaged in revolutionizing themselves and things, in creating something entirely new, precisely in such epochs of revolutionary crisis they anxiously conjure up the spirits of the past to their service and borrow from them names, battle slogans and costumes, in order to present the new scene of world history in this time-honored disguise and this borrowed language."

In Marx's theory of social creation, reversion to the past is automatic, a reflex of the crisis that has made creation necessary. (Some may wish to compare this creative escape from the present with Freud's theory of sublimation.) The tragedy consists in the grip of the past upon the psyche, in the fact that, to use Marx's phrase in *Capital, "le mort saisit le vif."* In twentieth-century

aesthetics it is assumed that the dead can be driven out by the avant-garde will, as when Apollinaire in *The Cubist Painters* instructs the reader that "you cannot forever carry around the corpse of your dead father." Picasso, Miró, Modigliani, however, and Pound and Eliot—by their foragings in ancient Greece, medieval Europe, seventeenth-century Italy and Holland, ageless Africa—have accepted in practice Marx's principle of "conjuring up the spirits of the past to their service" and borrowing earlier images in order "to present the new scene in time-honored disguise."

The twentieth-century artists act on the basis of a consciousness of history, while the actors of the late eighteenth century were automatically thrown back among the dead by the enthusiasm of revolutionary creation. It may be that the element of farce in Picasso, Miró, Eliot is related to the self-consciousness of their historical revivals. The great revolutions, as Marx sees them, were naïve. The new was born, as it were, surreptitiously, while its creators, in a trance of glory, were emulating the heroes of past epochs. History in those great periods had lost its sense of time. It had been captivated by form and become incapable, so to speak, of thinking historically—that is to say, of itself.

For society, as for Stephen Dedalus in revolt against tradition, "history is a nightmare from which I am trying to awake." Marx could have agreed with Joyce's conception in *Finnegans Wake* that man is a dreamer "with that fellow fearing of his own misshapes." Marx's problem, however, was more complex than Joyce's, since he was speaking of the condition of the psyche in relation to political action. A dream confined to the mind of the dreamer is a constantly changing spectacle, but a dream performed as a public event is drama, either tragic, as in Sophocles' *Ajax*, or farcical, as in *The Merry Wives of Windsor*. Delusion in politics is not merely a disorder of language and imagery but a recasting of circumstances in defiance of those solid, continuous, and comprehensible conditions known as reality. Acting in history is *acting,* both as performance and as doing.

Hence Marx is not content to compare the present and the past, Napoleon and Caesar. History is not mere appearance. To the politics of illusion, Marx applies his materialistic dialectic of class struggle, in order to distinguish between tragedy and farce on the basis of the social character of events. For him the issue of seriousness or absurdity, social creation or social impotence, depends not on the stature of the individual protagonists but on the state of development of the social classes which they represent

and on the capacity of those classes to meet the needs of the time. Behind the playacting of the heroes operates the destiny of the class, so that without being aware of it the Robespierres and Napoleons are guided by the subplot of class struggle—which is in turn geared into impersonal economic and social processes, equivalent to the all-regulating divinities of Greek theater. Propelled by a vigorous class, the "nightmare" of the heroes will thus serve a creative end; in the French Revolution it supplied (to quote *The Eighteenth Brumaire*) "the self-deceptions that they needed in order to conceal from themselves the limitations of the content of their struggles and to keep their passions at the height of the great historical tragedy." In its poetic frenzy, the revolution of 1789 destroyed feudalism and set up the foundations of middle-class society, while Napoleon's military campaigns created a favorable environment for the new bourgeois order throughout much of Europe.

Once these ends had been achieved, the French middle class woke up from their grand dream-gestures on the battlefield and in the forum to what Marx calls "the sober reality" of industrial production, economic competition, and profits. With this denouement, the costume play was at an end. "The new social formation once established," writes Marx, "the antediluvian Colossuses disappeared and with them the resurrected Romans." In the daylight of Monday through Friday the new business society could no longer comprehend, Marx explains, "that ghosts from the days of Rome had watched over its cradle." One might add that in the strictly political daylight, Marxists, applying the principles of *Capital* and techniques of Socialist recruitment, could no longer comprehend that dramatic mimesis and tragic and farcical illusion constitute essential ingredients of Marx's conception of history.

The Eighteenth Brumaire presents "the great historical tragedy" of 1789 as a prologue to the coup of Louis Bonaparte in 1851 in order to draw the contrast between a genuine revolution and a counterfeit one. In both, the politics of illusion prevailed. With Marx, the issue was not reason and fact, as the trademark of genuine revolution, versus deception and fantasy, as marks of a fake. The issue was illusion versus illusion. Both the coup of Napoleon and the coup of Louis endeavored to resolve social crises through seeing the present in the disguise of the past—in Marx's phrase, through "conjurings up of the dead." Through the tragic theatricalism of the first revolution a tremendous social transformation was consummated, while the absurd heroics of

Louis' repetition of the old gestures brought forth nothing new. "The awakening of the dead," which according to Marx had once served to stimulate the struggle for innovation, now provided a comical parody of the great days of the past. With Napoleon, myth "magnified historical tasks in the imagination"; with Louis it was a means for escaping from reality.

The difference between historical playacting that tragically accomplishes social creation and playacting that is a farcical pantomime concealing social impotence is determined, as mentioned, by the subplot of class struggle. In the French Revolution the energies of the emerging middle class changed performing into doing and introduced a new social order. In the Revolution of 1848 all classes were stalemated—the middle class was *already* in decline—and the class struggle could reach no outcome. Once the June insurrection of the workingmen had been suppressed, society became politically lifeless—its conflicts lacked direction and, according to Marx, "wearied with constant repetition of the same tensions and relaxations" (the description of a society in a state of neurosis). "If any section of history," Marx comments, "has been painted grey on grey, this is it." The proletariat, in his words, has "passed into the background of the revolutionary stage. Henceforth, it seeks to achieve its salvation behind society's back."

With the workers out of the way, the middle class fights itself. One layer after another is disarmed through force, threats, parliamentary intrigue, or political ineptitude, until, Marx reports, "all classes with which the proletariat had contended in June themselves lie prostrate beside it." Once the class struggle has been liquidated, history loses its content. It becomes mere stage performance, featuring personifications of past glory, marshals chattering in gibberish, outbursts of meaningless violence—in a word, farce. In Napoleon III, Marx contends, underlining the power of the class to determine the quality of the hero, the French "have not only a caricature of the old Napoleon, they have the old Napoleon himself, caricatured as he would inevitably appear in the middle of the nineteenth century." The passage of time has transformed the hero into a clown. In the absence of the revolutionary bourgeoisie, the Napoleonic politics of illusion has become an illusion of politics. Marx goes so far as to speak of "history without events."

Evidently, the class struggle can be dissolved. Then history, as Marx conceives it, stops—though this does not prevent people from being slaughtered in non-events. At any rate, the dialectical

materialistic method of interpretation ceases to apply, since there is nothing for it to interpret. Or rather, the method applies *in reverse*. Instead of explaining political actions in terms of class struggle, it explains their futility by the failure of the social classes to function politically. Since history now has no direction, the conclusion of the analysis is qualitative: this is an age of farce. *The Eighteenth Brumaire* is the most important work of Karl Marx for the twentieth century because it deals with the characteristic political situation of the twentieth century: social crisis in which the socio-economic classes—farmers, wageworkers, middle class—lack cohesion, fail to act politically, and leave history to be given its shape (or "misshape") by nonclass elements. Under these circumstances, events are determined, not by economic and social needs and developments, but by the theatrics of revolutionary revivals, including costumes, salutes, cult jargon (e.g., new calendars such as that of Mussolini's Year One), and the cult of the leader.

To meet this type of situation Marx discards economic analysis, except to account for the disintegration of classes, and concentrates on qualitative labeling and ironical exposure designed to shatter popular illusions. Very little attention is paid in *The Eighteenth Brumaire* to the current economy of France, which under the Second Empire was to enter into a new wave of expanded production, trade, and profiteering. Economics has become historically irrelevant to the degree that the social classes of France have been rendered politically inactive. Marx analyzes the economic condition of the classes only to explain why nothing is to be expected of them. Two years after the defeat of the proletarian uprising in 1848, he finds the workers "forgetting the revolutionary interest of their class for a momentary ease and comfort"—a familiar accusation heard on the Left in America and Europe for the past hundred years—and he concludes that "the historical process would have to go forward *over* their heads," italicizing *over*. *That history can take place over the heads of classes is for Marxism a highly unorthodox idea.* As for the middle class, "the ordinary bourgeois," says Marx, "is always inclined to sacrifice the general interest of his class for this or that private motive"—an inclination which the bourgeois seems to share with members of all classes, including the proletariat. Marx could have used his findings in *The Eighteenth Brumaire* to disprove his theory that the class struggle can be relied on as the motor of history.

In any case, it is the suspension of the class struggle in 1848–

51 that dooms representative government in its combat with the pretender. At one point, Marx wistfully suggests that to save freedom, the parliamentary parties, whose primary demand had become law and order, "ought to have allowed the class struggle more elbow room." To safeguard its property, however, the middle class, Marx found, was prepared to abandon its social values. Historically, this class is in conflict with its own ideals of liberty and progress and is prepared in times of stress to condemn them, even in their mildest forms, as socialistic.

The accompaniment of the political disintegration of the classes is the rise to power of the clown-hero Louis by means of a politics of sleight of hand—imposture, bribery, behind-the-scenes deals and conspiracies, even bedroom intrigues. Through the election of 10 December 1848 Louis had become president of the Republic, but a fictitious president, since from the start he intended to do away with the Republic he headed in order to assume the imperial throne of his glorified uncle. His ambition was realized for him primarily through the self-defeat of his opponents, that is to say, of all the solid elements of French society—in the manner comparable to that of a husband bringing about the success of his wife's lover through his own behavior.

"The Constitution of 1848," says Marx, "was overthrown not by a head but fell at the touch of a mere hat; this hat, to be sure, was a three-cornered Napoleonic Hat." The degree to which a society has become undermined is difficult to spot; and Louis, cautious to the point of cowardice compared with his uncle's dash, kept vacillating for months about the timing of his coup while all of Paris talked about the secret. The Pretender's presence swelled as normal politics shrank, with the propertied classes constantly thrown off balance by the Red Specter used as a weapon against one party after another. The conservative Party of Order tightened the vise around the National Assembly until Louis was in a position to tighten the vise around the Party of Order. The final choice was embodied in the principle, "Rather an end with terror than terror without end." In the demand for a regime of order above classes, the Pretender, who owed allegiance to no class, had the advantage over class parties. Bonaparte offered himself as leader of all the people as against any or all sections of the people. His program is translated by Marx into a philanthropic swindle: "He would like to steal the whole France in order to be able to make a present of her to France." The rise of Louis is the comedy of respectable values turned inside out: "Only disorder can save order." "Only war can save peace." And so on.

Louis can claim to rise above the friction of classes and bring order and stability because he himself belongs to no class. In Marx's terms he is the "princely *lumpenproletarian*," the Emperor of la Bohème. In him the negation of classes finds its physical embodiment; he is the chief and representative of the disorderly, antisocial elements in France. His private army, the Society of December 10, is the complement of the moral and political decay of French society; it is, in fact, the direct product of that decay. Marx's analysis of the *lumpenproletarian,* or bohemian, composition of the Society of December 10 is one of his most valuable contributions to modern political dynamics. Bohemians are a phenomenon of middle-class societies and can therefore be understood only by reference to the particular layers—aristocratic, capitalist, worker, peasant—from which they have separated themselves. The political impotence of the social classes in times of crisis opens the door to adventures on the part of the socially declassed. Among the declassed the myths of all classes, from utopian socialism to anarchy and cultural elitism, mingle and converge. Intellectual unreality is the vertical line that unites all levels of bohemia in a common impulse toward extreme behavior. For Marx the economic philosophy of bohemianism is based on the hope of living at the expense of society.

On his tours through France, Marx relates, Louis was accompanied by associates of the Society of December 10. In their army of myth, founded by Louis on the pretext of a benevolent society, "the *lumpenproletariat* of Paris," says Marx, had been organized into secret sections, each section being led by Bonapartist agents, with a Bonapartist general at the head of the whole.

Alongside decayed roués with doubtful means of subsistence and doubtful origin, alongside ruined and adventurous offshoots of the bourgeoisie, were vagabonds, discharged soldiers, discharged jailbirds, escaped galley-slaves, swindlers, mountebanks, lazzaroni, pickpockets, tricksters, gamblers, maquereaux, brothel-keepers, porters, *literati,* organ grinders, rag-pickers, knife grinders, tinkers, beggars, in short the whole indefinite, disintegrated mass thrown hither and thither which the French term *la Bohème.* From this kindred element Bonaparte formed the basis of the Society of December 10. This Bonaparte who constitutes himself chief of the *lumpenproletariat,* who here alone rediscovers in mass form the interests which he personally pursues, who recognizes in this scum, offal, *refuse of all classes,* the only class weapon on which he can base himself unconditionally, he is the real Bonaparte. An old

crafty "roué," he conceives the historical life of the nations and their principal and state actions as comedy in the most vulgar sense, as a masquerade where the grand costumes, words and postures merely serve to mask the pettiest knavishness.

Continuing in the same vein, Marx concludes that, given the present absurdity of French middle-class conflicts, "the adventurer who took the comedy as plain comedy was bound to conquer."

Marx's description of the lumpenproletariat and their leader is the crux of his Shakespearian vision of how politics as farce can overwhelm society in periods of crisis.

The Society of December 10 was for Bonaparte the party force peculiar to him. On his journeys the detachments of this Society packing the railways had to improvise a public for him, display the public enthusiasm, howl *vive l'Empereur*, insult and thrash the republicans, of course, under the protection of the police. On his return journeys to Paris they had to form the advance guard, forestall counter-demonstrations or disperse them.

The Society, says Marx, unwittingly crediting Louis as a prophet of twentieth-century action parties, was Louis' own work, his very own idea.

Whatever else he appropriates is put into his hands by force of circumstance; whatever else he does, the circumstances do for him or he is content to copy from the deeds of others. But Bonaparte with the official phrase of order, religion, family, property before him, behind him the secret society of disorder, prostitution and theft, that is Bonaparte himself as original author, and the history of the Society of December 10 is his own history.

Here Louis is no longer the farcical imitator, but the serious originator of farcical anti-class dictatorships.

Other voices confirm aspects of Marx's testimony. Says Albert Guérard in his short biography of Louis Bonaparte: "The Bohemian emperor, a revolutionary at heart, had 'saved society,' 'stemmed the Red tide,' restored order, bolstered property. The Czar and the Catholic hierarchy had heartily approved the Coup d'État."

Bonaparte was compelled officially to disband the Society because of its acts of violence and plots for assassinations. In reality, however, Marx contends, "the Society of December 10 was to remain the private army of Bonaparte until he succeeded in transforming the public army into a Society of December 10."

I shall pass briefly over other anti-class forces marshalled against society by the above-class Pretender. Complementing the Paris Bohemians were the small peasants, for Marx a rural *lumpenproletariat* bypassed by capitalism, who, though they share common economic and cultural characteristics "do not form a class." Politically they "belong to the underworld of history" (another unorthodoxy for Marxists to meditate on).

To the four million (including children, etc.) officially recognized paupers, vagabonds, criminals and prostitutes in France, must be added five millions who hover on the margin of existence and either have their haunts in the countryside itself or, with their rags and their children, continually desert the countryside for the towns and the towns for the countryside.

In addition, there were the bureaucracy, swelled out by Louis as an "artificial caste" existing "alongside the actual classes of society," and the army, no longer as in the days of Napoleon "the flower of the peasant youth" but now "the swampflower of the peasant *lumpenproletariat*." These static and unproductive human aggregations constitute the social reality behind the Napoleonic idea of grandeur. To Marx the height of the comedy is the enthusiastic acceptance of the power of this mob by the respectable elements of France: "Only the chief of the Society of December 10 can now save bourgeois society; only theft can save property; only perjury, religion; only bastardy, the family; only disorder, order."

Unfortunately, it was not consistent with Marx's class theory of history to take the *lumpenproletariat* seriously—to say nothing of the philistinism that hovers over his description of society's victims, outcasts, and enemies. He understood the farce of the bohemian emperor and that in real life farce can be deadly. But he could think of Louis' coup only as a temporary deviation from real history; he could not conceive the farcical dictatorship of the non-class King Ubu as a recurrent condition with which man might have to deal. *The Eighteenth Brumaire* proposes no prescription for coping with this type of political crisis, nor any theory as to the likely effects of the adventurer's victory. "All great world-historical facts and personages occur, as it were, twice, the first time as tragedy, the second as farce." The farce follows the tragedy and puts an end to its illusions once and for all. But why twice? Why not three times? Four? Five? An indefinite series?

For Marx, bourgeois heroics could only manifest themselves

twice because the proletariat stood in the wings—and the next act was theirs. The illusory politics of Louis would be followed by "the sober reality" of working-class revolution, as the illusory politics of Napoleon was followed by the sober reality of the new middle-class order. The all-powerful state set up by Louis, Marx says, contained the "germ" of the working-class revolution. Marx's hopes went even further. The farce of Louis' coup would be the last seizure of society by the nightmare of history, whether tragic or heroic. The socialist uprising would have a new style, the style of realistic apprehension of historical tasks. The proletariat would release history from mimicry of the past and from theater. "The social revolution of the nineteenth century," Marx interjected into *The Eighteenth Brumaire,* "cannot draw its poetry from the past, but only from the future. It cannot begin with itself before it has stripped off all superstition in regard to the past. Earlier revolutions required world-historical recollections in order to drug themselves concerning their own content. In order to arrive at its own content, the revolution of the nineteenth century must let the dead bury their dead. There the phrase went beyond the content; here the content goes beyond the phrase." Here Marx speaks of the socialist revolution as "the revolution of the nineteenth century." He sees the uprising of the workers as imminent, as history's *next act.*

The Bohemian Emperor thus seems to Marx to be realizing the same objective as that of Marx himself in writing *The Eighteenth Brumaire,* that is, the task of dissolving the Napoleonic myth. Louis and Marx might be said to be collaborating in what Marx termed "this tremendous mental revolution," the overthrow of the cult of the leader. In Marx's view, Louis' farcical duplication of Napoleon in action would be even more decisive than his own exposure of the farce in words. History would be purged by history. Thus the concluding sentence of *The Eighteenth Brumaire* is oracular: "If the imperial mantle finally falls on the shoulders of Louis Bonaparte, the iron statue of Napoleon will crash from the top of the Vendôme column."

And the Bohemians? the *lumpenproletariat* of both the big cities and the countryside? Presumably, they would vanish automatically with the victory of the working class. In the Communist, classless society there would be no classes for individuals to defect from. All would be productive citizens.

Instead of passing the torch, however, from class to class, history has preferred to explode into frenzies of motion without direction. Instead of the prosaic self-scrutiny, the "criticism of

weapons," of the proletariat, bands undefined by class are formed, united by rituals, leaders, and costumes (shirts, hoods, hairdos) —the armies of the politics of illusion. As the study of a false revolution, a repetition in which nothing new is created, *The Eighteenth Brumaire* is more pertinent to the history of this century than are Marx's efforts to demonstrate how the class struggle would be resolved in proletarian victory. For the very reason that *The Eighteenth Brumaire* is the study of a spurious event, it goes to the heart of our epoch of false appearances and aimless adventures. It is the political complement of our culture of nonplot theater, art ade by chance, avant-gardism without a program or message.

Seen in the perspective of *The Eighteenth Brumaire,* contemporary class societies seem to have entered not so much a crisis as a crisis-series from which they cannot recover unless a new historical protagonist appears. There is no evidence, however, that such a protagonist is in the course of emerging. Hence the general pattern of 1848–51—political self-defeat by the social classes, "heroic" calls to order—will probably keep repeating itself. Under these circumstances, self-deception and the deception of others become the normal procedures of political life; falsification is even regarded as morally laudable in that it contributes to stability. In feverish crusades for discipline and calm, absurd persons, absurd events, absurd slogans cease to arouse surprise or resentment. Political candidates publicly make themselves up as pseudopersonages in order to convince the public of their integrity. The techniques of advertising and mass entertainment are used to recast events to blend with popular fiction, or events are simply concocted out of the whole cloth to provide occasions for actions or formulations of policy. History is regarded as consisting, not of events that have happened, but of the books that have been written about them. With professional actors aspiring to the highest office, professional historians are brought into government administrations in order to guarantee that the desired account of their deeds will be transmitted to posterity.

The Eighteenth Brumaire warns, however, that there is a social dimension to farce in modern politics: it represents the spreading paralysis of the productive classes of society and the abandonment of their traditional values. A recent editorial in the *New Yorker* describes this condition as currently prevalent in the United States. (That the *New Yorker* is a "comic" magazine may have contributed to its deep insight in this instance.) It speaks of "a rapidly developing national crisis" in which "the politicians and the men

in the press from whom we might expect a defense of liberty are strangely silent and seem to be in disarray. Instead of mustering and rallying their forces, they appear to sit puzzled and becalmed —almost oblivious of what is going on. The concerned citizen is apt to follow the crumbling of our democracy in the back pages of his newspaper." The editorial goes on to quote the Mayor of New York as complaining that people "are being tempted into a simplistic faith in repression as an answer to deep-seated, complex dilemmas" and deploring "the strange silence of so many in public life."

Evidently, American society is responding to its present crisis with a class inertia matching that of the classes of France from 1848 to 1851. Hopes for a leader are synchronized with promises of "law and order." All that is missing for the preparation of a coup is the personification of a myth and the emergence of the *lumpenproletariat* as a force to rule the streets. So far these have failed to appear, perhaps because America has both too many myths and wealth enough to provide prosperity among the unproductive. Yet the fact that the middle class can no longer be relied upon for leadership marks a decisive break in American political and cultural history.

1971

Index

Index

330

Index

Bureaucracy and bureaucrats, 4, 63, 97, 138, 144, 145, 170, 174, 190, 210, 302
Burke, Edmund, 177-78, 180

Cage, John, 120, 215, 219
Camus, Albert, 52, 183, 184
Capitalism, 4, 163, 167, 168, 177, 302, 308, 324
Carrà, Carlo, 92
Céline, 243
Cervantes, Miguel de, 149, 150
Cézanne, Paul, 71, 75, 77, 79, 84, 184
Chagall, Marc, 89, 91, 188, 224, 228
Chaplin, Charlie, 21
Chirico, Giorgio de, 89, 91
Christo, 218
Classes, social, 168, 174, 177, 209, 317-28 passim: americans (lower-case), 200-201; beatnik, 55; hippy, xii, 86, 195; middle (bourgeois), 76, 79-80 , 95, 105, 177, 180, 286, 294, 295, 319-25 passim, 328; peasant, 211-12, 278, 286, 307, 323, 324; in small-town America, 30, 31-36 passim; struggle among, 317-28 passim; upper, 108, 201, 278-79, 286, 323; working (proletariat), 45, 63, 155, 167, 180, 187, 201, 208, 278, 279, 294, 295, 311, 314, 320, 321, 323, 325-27. See also Bohemias and bohemians
Cold war, the, 170, 300-304
Commercial art, 66, 97, 109. See also Mass culture
Communism (and/or Communists), 9, 12, 21, 22, 77, 96-98, 154-65 passim, 184, 191, 203, 206, 209, 302-10, 313-14; anti-, 304-10; and intellectuals, 23-24, 105, 155, 179
Communitarianism, 184, 186
Community, the, 106; agrarian and folk, 146-48, 162, 178, 180, 211; Communism seen in terms of, 160-65; Jewish, 278-79; sociology of, 29-36, 143-53 passim; as solution to alienation, 183-85; as source of alienation, 185-86
Conservativism,ix, x, xii, 94, 176-77, 303
"Containment," foreign policy of, 305-10
Coser, Lewis A., 142, 190-94
Crafts. See Art(s), and the crafts
Crestwood Heights (Seely, Sim, and Loosely), 144, 148, 150-53 passim
Criticism, x, xi, 13, 14, 16, 21, 66, 123-26 passim, 129, 131-33, 182, 190, 220, 246-47; art as, 63-64, 132
Crockett, Campbell, 50
Cubism, 77, 89, 90, 92, 223, 318

Culture and Society (Williams), 176-80
Culture, concept of, in England, 176-80
Cummings, E. E., 25, 28, 45, 76, 107

Dada, 8, 79, 84, 86, 89, 90, 91
Dali, Salvador, 81, 83-84, 128
"Death of Ivan Ilyich, The" (Tolstoy), 27, 210-12
Democracy, 9, 34, 36, 138, 163, 176, 177, 179, 249, 250, 251, 272-75 passim, 278, 293, 294, 299, 327
Dix, Otto, 91
Dollard, J., 143
Dostoevsky, Fyodor, 3-4, 7-8, 12, 20, 21, 25, 77, 78, 83, 84, 146, 153, 188, 190, 192, 193, 204, 213, 215, 218, 292
Dove, Arthur G., 89
Dreiser, Theodore, 11, 188
Dubuffet, Jean, 90
Duchamp, Marcel, xii, 76, 89-92 passim, 214
Durante, Jimmy, 21, 182
Durkheim, Emile, 144

Eakins, Thomas, 89
Eclipse of Community, The (Stein), 143-53
Education, 56, 145, 176, 181-83, 208, 209, 293; and art, 66, 97, 108, 110, 117, 125-30; discrimination against women in, 40; as fostering mass culture, 59; institutions of, and the intellectual, 189-95 passim; and leisure, 58; via mass media, 126; and the role of museums, 134-36; seduction as means of, 38; in small-town America, 34-35
Efanov, 96
Eichmann, Adolf, 137
Eighteenth Brumaire of Louis Bonaparte, The (Marx), 316-28
Eisenhower, Dwight D., 132, 169, 178, 314
Eliot, T. S., 4, 7, 78, 81, 84, 85, 177, 179, 184, 185, 199, 246, 262, 318
Engels, Friedrich, 99
Erikson, Erik, 50, 52, 146
Erler, Fritz, 96
Establishment, the American art, ix-x, 110-18
Existentialism, 23, 184, 185, 208, 215, 260; and psychoanalysis, 50-52, 121, 146
Expressionism, 75, 89, 97, 224, 226

Fascism, 96, 99, 171, 184, 185, 306; and "bohemians," 292-97 passim
Faulkner, William, 205-6
Feldman, Morton, 82-83
Fiedler, Leslie, 246-47

Index

Fitzgerald, F. Scott, 204-6
Formalism and anti-formalism, artistic, 8, 9, 12, 63-64. *See also* Anti-art
French Revolution, the, 75, 191, 279, 293, 317, 319, 320
Freud, Sigmund, 49, 50, 53, 90, 183, 213, 292, 317
Friedmann, Georges, 54, 57, 59
"From Marxism to Judaism" (Herberg), 248-58
Fromm, Erich, 52-53, 293-94
Fuehrer, Der (Heiden), 292-97
Fuller, Buckminster, 77
Futurism, 12, 89, 97, 99, 223

Gerasimov, Sergei, 97
Gide, André, 20-23 passim, 25, 28, 84, 260
Ginsberg, Allen, 121
Glatzer, Nahum N., 235-38
Gogh, Vincent van, 10, 21, 80, 82, 91, 219
Goncharova, Natalya, 91
Gorky, Arshile, 90, 92, 102, 128
Gottlieb, Adolph, 81, 111, 224, 231
Great Gatsby, The (Fitzgerald), 204-6
Greenberg, Clement, xii
Greenwich Village, 102-3, 104, 107, 191
Guide for the Bedevilled, A (Hecht), 241-45
Guston, Philip 102, 111, 224, 231

Haftmann, Werner, 223-24
Hare, David, 114
Hartley, Marsden, 89, 90
Hasidism, 233, 236, 238-41, 264, 266. *See also* Jews; Judaism
Hecht, Ben, 241-45
Hegel, G. W. F., 185, 277, 316
Heiden, Konrad, 292-97
Hemingway, Ernest, 44-46, 81, 126
Herberg, Will, 248-58
Hitler, Adolf, 96-99, 244, 250, 293-97 passim
Hofmann, Hans, 102, 111
Hofstadter, Richard, 44, 189, 192
Hollywood (Calif.), 18, 20, 21, 25, 56, 65, 96, 106, 201, 241, 243. *See also* Mass culture
Hopper, Edward, 103
Hughes, H. Stuart, 189, 190, 192
Husserl, Edmund, 185, 285
Huxley, Aldous, 12, 178

Identity, problem of, 181-86; and the artist, 10, 16, 230-31; and the Black American, 10, 17, 46, 219; and the Jew, 10, 225, 230-31, 253-55, 257-69 passim, 272-87; and leisure, 55, 57, 60;

and the male, 40, 41, 42-47, 52; and the modern American woman, 37-41; and modern technology, 62, 145, 183, 275, 312; as studied by sociology, 145-48 passim; and the task of psychoanalysis, 49, 51, 53; as a theme in the arts, 10-11, 62, 121, 182-84. *See also* Alienation
Ideologies, political and economic. *See* Bolshevism; Capitalism; Communism; Conservativism; Democracy; Fascism; the Left; Leninism; Liberalism; Marxism; Nazism; Radicalism; Socialism; Stalinism; Totalitarianism
Impressionism, 76, 77, 86, 94
Indiana, Robert, 90
Individualism: American, 10-11, 30, 53, 106, 182, 188; Jewish, 239, 264
Industrialization. *See* Automation; Technology, modern
Intellectuals: in America, 35, 36, 167-74, 187-90, 192-95, 204, 313-14; and Communism, 23-24., 155, 163, 167, 179, 304, 306; and educational institutions, 189-95; in France, 167-68, 171-72; Jews as, 224, 263-64, 280; mass culture of, 21-26; and the Nazi-Fascist movements, 292, 296; relationship of, to power structures, 190-91, 278; as viewed by the cult of masculinity, 43-44
In Time and Eternity: A Jewish Reader (Glatzer, ed.), 235-38

James, Henry, 5, 21, 201
Jarry, Alfred, 85
Jenkins, Paul, 90
"Jewish Writer and the English Literary Tradition, The" (Fiedler), 246-47
Jews, 25, 27, 137, 141, 174; and art, 223-31; and "authenticity," 271-87 passim; as intellectuals, 224, 263-64, 280; in literature, 245-47; and the Nazis, 62, 234, 243, 244, 270, 284n; photographs of, in Eastern Europe, 232-35; and the problem of identity, 10, 27, 225, 230-31, 242, 253-55, 257-69, 272-87. *See also* Anti-Semitism; Hasidism; Judaism; Zionism
Johns, Jasper, 110, 228
Johnson, Lyndon B. 132, 312, 313
Joyce, James, 11, 12, 64, 77, 78, 84, 85, 119, 150, 184, 201, 218, 318
Judaism, 226, 228-29, 235-41, 248-58, 265-69, 273, 276; contrasted with Christianity, 254-55; essential features of, 252-58; and relationship to

Index

Index

or mentioned briefly, ix, x, 58-59, 71n, 111-13, 117, 129, 132, 134-38, 201, 214, 218; Baltimore Museum of Art, 88-92 passim; Jewish Museum (New York City), 223, 228, Metropolitan Museum of Art, New York, 134-38; Museum of Modern Art, 111-13, 229
Mussolini, Benito, 99, 321

Nabokov, Vladimir, 215
Napoleon I (Bonaparte), 95, 178, 190, 295, 316-20 passim
Napoleon III (Louis), 95, 295, 316, 319-20, 322-26
National Organization for Women (NOW), 39-41
Nazism, 62, 159, 175, 183, 184, 213, 225, 234, 299-300, 304; and art, 96-99; and "bohemians," 291-97; and the Jews, 62, 234, 243, 244, 270, 284n
Negro, the. *See* Black Americans
New Deal, the, 24, 171, 188, 190, 191
Newman, Barnett, 92, 102, 111, 128, 134, 224, 231
Niebuhr, Reinhold, 151, 250
Nietzsche, Friedrich, 16, 78, 90, 147, 168, 244
Nixon, Richard M., xii, 97, 306
Nostalgia, for rural and folk culture, 29-36 passim, 146-48, 183-85

October Revolution. *See* Russian Revolution
Odalisque, the: in art, 38; the American woman as, 38
O'Keeffe, Georgia, 90
O'Neill, Eugene, 105, 107
Op art, 93, 120-21
Operational Code of the Politburo, The (Leites), 156-60
Opium of the Intellectuals, The (Aron), 167-74, 176, 189
Organization Man, The (Whyte), 13, 31, 172, 192
Organization men (orgmen), 30, 31, 190, 312
Ortega y Gasset, José, 71, 185-86, 208

Park, Robert E., 144
Picabia, Francis, 79, 89, 91
Picasso, Pablo, 64, 77, 80, 85, 90, 91, 92, 94, 184, 188, 318
Pieper, Josef, 56
Plato, 5, 25, 38, 55, 56, 246
Poe, Edgar Allan, 25, 83, 120, 188, 200, 201, 219
Polish Jews: A Pictorial Record (Vishniac), 232-34
Politburo, the, 156-59

Politics, 210, 183, 188, 218, 219, 271, 311-12; and art, xii, 67, 77, 79, 86-87, 94-99, 105, 177, 188, 300; and culture, 175-77, 327-28; and the de-classed, 292-97; in France, analyzed by Marx, 317-28; and leisure, 57; and mass culture, 18-19, 312; and the problem of identity, 51; and psychoanalysis, 49-50, 52; recent, in the U. S., 311-15, 327-28; in small-town America, 34; in the Soviet Union, 154-65 passim. *See also* Ideologies, political and economic, *for additional entries*
Pollock, Jackson, 93, 102, 110, 111, 116-17, 119
Pop art, 65-66, 86, 90, 93, 112, 120, 121, 122, 226
Popular culture. *See* Mass culture
Pound, Ezra, 64, 75, 78, 81, 84, 119, 176, 184, 188, 201, 318
Proletariat, the. *See* Classes, social
Proust, Marcel, 13, 27, 77, 84, 218, 281
Psychiatry, 13, 57, 72, 170, 182. *See also* Psychoanalysis, American neo- and post-Freudian
Psychoanalysis, American neo- and post-Freudian, 48-53, 146, 293-94; as an aspect of popular culture, 49, 51-53; in collaboration with sociology, 50-52; and the problem of identity, 49, 51-53
Psychoanalysis and Contemporary American Culture (ed. Ruitenbeek), 49-53

Radicalism, xi, xii, 4, 23, 79, 94, 96, 168, 176, 256, 303, 306
Radin, Paul, 147, 150
RAND Corporation: studies of Soviet Communism by, 156-65
Rauschenberg, Robert, 111, 128, 228
Redon, Odilon, 91, 92
Reflections on the Jewish Question (Sartre), 270-87
Reinhardt, Ad, 102
Riesman, David, 31, 50, 149
Rilke, Rainer Maria, 75, 78, 85, 184, 240
Rimbaud, Arthur, 21, 25, 80-84 passim, 188
Rivers, Larry, 102, 228, 231
Robbe-Grillet, Alain, 121, 123
Rodchenko, Alexander, 96
Romains, Jules, 18, 32
Romanticism, xii, 17, 121, 177, 179, 186, 199, 204, 206
Roosevelt, Theodore, 45
Rothko, Mark, 92, 111, 224, 231
Rousseau, J. J., 6, 293
Ruitenbeek, Hendrik M., 49-52

Index

Index